R

OMAN

EYES

VISUA

LITY & SUB

JECTIVITY

IN · ART & TEXT

ROMAN EYES

VISUALITY & SUBJECTIVITY

IN ART &

TEXT

Jaś Elsner

PRINCETON UNIVERSITY PRESS | PRINCETON AND OXFORD

Elsner, Jaś.
Roman eyes : visuality and subjectivity in art and text / Jaś Elsner.
 p. cm.
Includes bibliographical references and index.
ISBN-13: 978-0-691-09677-3 (cloth : alk. paper)
ISBN-10: 0-691-09677-5 (cloth : alk. paper)
1. Arts, Classical. 2. Aesthetics, Roman. 3. Visual Perception. I. Title.
NX448.5.E47 2007
700.937—dc22 2006051366

British Library Cataloging-in-Publication Data is available

This book has been composed in Aldus and Trajan
Printed on acid-free paper. ∞
pup.princeton.edu

Printed in the United States of America

1 3 5 7 9 10 8 6 4 2

Whose idea it was

CONTENTS

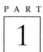

ACKNOWLEDGMENTS

THIS BOOK IS THE RESULT of a series of essays on related themes written over the last fifteen years. Most have been published earlier, in different forms; all those have been revised here. Chapter 4 and the Epilogue have been written specially for this volume—although I have been persuaded to publish sections of chapter 4, in the course of rather different arguments, elsewhere as well. I thank the original publishers in detail below. Many people have helped me as I have worked on these studies—too many to name individually, especially as one might easily but invidiously forget someone, given the length of time over which this project has evolved. But my gratitude is especially due to Froma Zeitlin, who is to be blamed for the idea of this book; to my classical colleagues at Corpus Christi College and my art historical colleagues in Chicago over the years, on whom quite a bit of this has from time to time been inflicted; and to my students at the Courtauld, Oxford, and Chicago, who have never let me get away without at least trying to make myself clear.

For their help and advice in the complex and arduous business of getting hold of photographs, I am particularly grateful to Lucinda Dirven, Milette Gaifman, Ted Kaizer, Roger Ling, Katerina Lorenz, Marlia Mango, Michael Padgett, Verity Platt, Susan Walker, Roger Wilson, Stephanie Wyler, and the photographic services of the British Museum and of the German Archaeological Institute in Rome. Ian Cartwright has been wonderful and indefatigable in his help with the digitizing of images. The Charles Oldham Fund at Corpus has generously supported the costs of reproducing, digitizating, and publishing these images. Thanks are due also to a number of providers of photographs for their willingness to waive reproduction fees in the case of a scholarly publication in the wider interest of academic research. This is a far-sighted policy which deserves applause, especially at a difficult time financially for public

institutions. So I am happy to mention the British Museum, the Yale University Art Gallery, the Cabinet des Médailles at the Bibliothèque Nationale in Paris, the German Archaeological Institute in Rome, and the Conway Library.

Finally, I am most grateful to the editorial team at Princeton University Press for their help and care with my manuscript. In particular, I should mention Ian Malcolm, Meera Vaidyanathan, Lys Ann Weiss, and Elizabeth Gilbert.

Chapter 1 originally appeared as "Between Mimesis and Divine Power: Visuality in the Graeco-Roman World," in Robert S. Nelson, ed., *Visuality before and beyond the Renaissance* (Cambridge, 2000), 45–69. Chapter 2 appeared first as "Image and Ritual: Reflections on the Graeco-Roman Appreciation of Art," *Classical Quarterly* 46 (1996): 515–31. Chapter 3 appeared initially as "Ancient Viewing and Modern Art History," *METIS* 13 (1998): 417–37. Sections of chapter 4 have appeared in "Art and Text," in S. Harrison, ed., *The Blackwell Companion to Latin Literature* (Oxford, 2005), 300–318, and in "Gazing in Ekphrasis and in Roman Art," *Classical Philology*, forthcoming. Chapter 5 originally appeared as "Visual Mimesis and the Myth of the Real: Ovid's Pygmalion as Viewer," *Ramus* 20 (1991): 154–68. Sections of chapter 6 have appeared in "Naturalism and the Erotics of the Gaze: Intimations of Narcissus," in N. B. Kampen, ed., *Sexuality in Ancient Art* (Cambridge, 1996), 247–61, and in "Caught in the Ocular: Visualising Narcissus in the Roman World," in L. Spaas, ed., *Reflections of Narcissus* (Oxford, 2000), 89–110. The substance of chapter 7 appeared as "Seductions of Art: Encolpius and Eumolpus in a Neronian Picture Gallery," *Proceedings of the Cambridge Philological Society* 39 (1993): 30–47. Chapter 8 appeared as "Visualising Woman in Late Antique Rome: The Projecta Casket," in C. Entwhistle, ed., *Through a Glass Brightly: Studies in Byzantine and Medieval Art and Archaeology Presented to David Buckton* (Oxford, 2003), 22–36. Chapter 9 appeared as "The Origins of the Icon: Pilgrimage, Religion, and Visual Culture in the Roman East as 'Resistance' to the Centre," in S. E. Alcock, ed., *The Roman Empire in the East* (Oxford, 1997), 178–99. Chapter 10 appeared as "Cultural Resistance and the Visual Image: The Case of Dura Europos," *Classical Philology* 96 (2001): 269–304.

ACKNOWLEDGMENTS

PROLOGUE

He gazed and gazed and gazed and gazed,
Amazed, amazed, amazed, amazed.

—Robert Browning (1812–1889)

MY EPIGRAPH, A BRIEF POEM by Browning from about 1872 entitled "Rhyme for a Child Viewing a Naked Venus in a Painting of the Judgment of Paris," captures many ramifications of the issues I want to address in this book.[1] We may think that art is an objective matter of material objects to be studied, appreciated, and collected in the world out there—in the case of Browning's poem, a painting of the Judgment of Paris. But when we turn to the gaze, we move from the material and the objective into the world of subjectivities. This is a realm of impression, fantasy, and creativity—framed, certainly, by the particular objects on which the gaze may fasten in specific contexts—but nonetheless subject to all kinds of psychological (and indeed psychopathological) investments, both collective and individual, to which our historical, documentary, and visual sources usually fail to give access.

Of Browning's epigram, we may ask, is the reiteration of the gaze in the first line relentlessly intensive, with the crescendo of amazement overwhelming the mind in line 2 as its result? Or do the "ands" of line 1 string together a range of gazes—different in kind, feeling, effect—which give rise to a variety of amazements,[2] discretely separated by the commas of line 2? Is the boy—perhaps for the first time sexualised in his confrontation with female nudity—caught in the eddies of his own gaze, so that, Narcissus-like, he falls

[1] The epigraph is from Cunningham (2000), 378. I am most grateful to Val Cunningham for drawing this poem to my attention.

[2] The very first lecture I attended at university, in Cambridge in the Michaelmas of 1982, consisted of Michael Lynn-George affirming (more than once) that "repetition is difference," a view expressed with more complexity in Lynn-George (1988), 91–92, 105–6. The second lecture I went to, in the same week, was John Henderson's (never published) bravura account of the poetics of "and" (Latin *et*) in Catullus 85. I see that my beginnings here have my past catching up with me.

into a whirlpool of amazement, a maze of wonder from which the poem offers no extrication? In this reading the child's youth, indicated by the poem's title, and gender become significant. Or do the "ands" of the first line indicate a dynamic and creative activity of investment ("he gazed *ánd* gazed *ánd* gazed *ánd* gazed"), inverting the normal emphasis of the iambic rhythm, so that the boy fashions, Pygmalion-like, out of the picture an object worthy of his amazement? And what of the focalization? The title deliberately marks out not only a whole picture (and the long mythological ancestry of the "Judgment of Paris" in literary and art historical tradition) but also a specific element in that picture. Naked Venus too—the focalization of Browning's child's looking and amazement—evokes a long art historical ancestry of famous artists and famous works, reaching back to Praxiteles and Apelles. But in looking at Venus, is the child amazed by her nudity—the sexuality of *Naked Venus*—or by her divinity, the dazzling epiphany of an ancient god clothed in her usual accoutrements of nudity? Is the poem's gaze and wonder directed at a specific picture (never exactly identified, never illustrated—like so many ladies addressed in love poems from antiquity to Browning's own English heritage)? Or is it, following the epigram's literary and textual dynamic as poetry, not rather a gaze of amazement at Classical themes in general (as much literary as visual) from the author of the Browning Version of Aeschylus' *Agamemnon*?

The gaze, in Browning's recognition, is more than an object or an activity of the subject. It is active ("he gazed" in line 1), but its results are passive ("[he was] amazed" in line 2). The process cannot be separated from its effects; the viewer's subjective link via the gaze to that which he sees (never stated in the poem, but only in its title) causes an internal effect—amazement—which may or may not alter that initial act of gazing. That processual linkage, a constant subjectivizing of the object so that what naked Venus provokes is all the intimations of four-fold "amazement," is both the difficulty and the attraction of studying the gaze.

But beyond the poem's specific immersion in the act of gazing and its amazing effects, the title signals a further and crucial dimension of the gaze. By making his epigram a "rhyme for a child viewing . . . ," Browning opens the possibility of disjunction between the gaze as such and the gaze observed. Is the child fully and ideally immersed in his gaze, or is he aware of the gaze of another watching him as he looks? Does every "and" in line 1 signal an increasing self-consciousness, so that the amazements are the effects of not simply the subject in confrontation with naked Venus but of the subject's performance of a socially conditioned and expected amazement for the benefit of an observing gaze of which he is consciously or unconsciously aware? If he is consciously aware of being observed, are his gaze and its results altogether an

act? Has he turned himself into a picture to create an effect on the viewer he knows is watching him? If he is unconsciously aware—that is, if the act of gazing always carries the implicit sense that it may be observed and even reciprocated, then even in his most spontaneous and intimate response of amazement, is there a conditioned (even a policed) element of the sort of reaction a child in an art gallery ought to be offering when confronted with "great art"? The shift from the poem's own apparent unselfconsciousness to a title which emphasizes looking at another's looking cannot but suggest the problem of the consciousness of being looked at while looking. Alongside this move from the entirely subjective gaze to the gaze in an expanded sphere of reciprocal gazing, the poem performs a shift from looking to words about looking—from the preverbal response to art (gazed and amazed) to the artfully formulated expression of that response as a "rhyme for a child." The opening of the epigram's title, "Rhyme for a Child Viewing . . . ," makes clear this move to the verbal and again undermines the apparently unmediated directness of the poem's two lines with the reminder that they are a rhyme—the careful exposition of experience through textual artifice. Again Browning implicitly raises the complex problems of the verbal nature of the gaze—its dominance by words (at least when we think, talk, or rhyme about it) and the difficulty of ever conceiving it as free of words. In terms of both the place of the gaze in the wider field of gazing and the relation of the gaze to its verbal articulation, the juxtaposition of rhyme and title offers a potential series of worries highly pertinent to the problems of the gaze in connection with the art of the Roman world.

The wonder of Browning's poem is how many potential readings its four words (all but "he" much repeated), plus the title, are capable of bearing without strain. The gaze is indeed like the poem—apparently simple, but so diverse, intricately textured, emotionally calibrated, and differentiated even in a single individual at different times let alone across numerous people and cultures. Of course we must be wary of overgeneralizing beyond a particular nineteenth-century context the specifically Romantic construction of the subject which Browning effects. His child appears to be in a culturally charged setting like a museum (they were all built to look like Greek temples in Browning's day) and to be engaged in an act of visual contemplation indebted to Kantian aesthetics.[3] Even if we remember that the Elder Pliny too seems to talk of Kantian moments in first-century Rome,[4] ancient Romans would not

[3] On Kantian contemplation, see Kant's *Critique of Judgment* (1790), 204–5, 211 (= Meredith, 1952, 42–44 and 50, and Pluhar, 1987, 45–46 and 53), with, for example, Guyer (1997), 148–83.

[4] See Pliny the Elder, *Natural History* 36.27: "The multitude of official functions and business activities must, after all, deter anyone from serious study [of art], since the appreciation involved needs leisure and deep silence in our surroundings."

have focused (at least not in the same ways as moderns) on the undercurrents of innocence and experience or on the kind of mythology of childhood and education implicit in the historically specific charge of Browning's poem.

Although there has been a large literature on the gaze in theoretical and art historical writing since the 1970s,[5] to which much of my discussion of Browning's poem is indebted, in Classical studies little was said until the mid-1990s.[6] This book traces some aspects and variables of the gaze (at works of art) in Roman antiquity. It focuses on objects and on texts that describe objects and their viewing. It largely proceeds by means of close readings (of texts about viewing, or of objects, or of both together) without giving excessive space to overt theorizing. It suffers, to be sure, from all the inevitable shortcomings of reliance on this kind of evidence, particularly a bias toward the elite (who wrote and read most of what survives of ancient literature relating to art, and who owned and commissioned most of the objects)[7] and an emphasis on male viewers (since men comprise the vast majority of ancient authors and artists). Moreover, because the "controls" which can be applied to our interpretative takes on the evidence are so limited—effectively constrained by that most dangerous of guides, "common sense" (which means only the current collective prejudice of the moment), we can never be wholly sure whether we are "pushing" an interpretation of an object or text well beyond what would have been credible in antiquity or not far enough. But this problem is also an advantage. For it highlights the fact that however deeply we may attempt to ground our interpretations in the ancient context, they are—like the gaze of Browning's child—our own. In meditating on the visualities of antiquity, we confront them with our own (more or less examined) ways of viewing, and in this confrontation there is perhaps a charge of genuine value.[8]

It may be worth asking, at least for clarity's sake, what this book is not. It is neither specifically an art history of surviving monuments and artifacts nor

[5] The classic theoretical texts are Foucault (1970), 3–17, and Lacan (1979), 67–119, the latter drawing on Sartre (1956), 254–302, all now with vast commentarial literatures. Significant art historical and film theoretical accounts include Mulvey (1989 [1975]), 3–26; Bryson (1983), 87–132; Bryson (1988); Crary (1990); Gandelman (1991); Jay (1993); Silverman (1996), 125–93; Jay and Brennan (1996); and Nelson (2000b).

[6] In the study of Roman art, one thinks of Elsner (1995), Platt (2002a), and Fredrick (2002). There has been more discussion in literary and cultural studies—for instance, Bartsch (1989, 1994), Goldhill (1994, 2001b), Hardie (2002b), Henderson (1991, 1996, and 2002), Morales (1996a), G. Zanker (2004), and the essays in the second part of Ancona and Greene (2005), 113–268.

[7] This is true even of the so-called Skoptic epigram, a "low" subgenre of satirical poems whose authors are nonetheless largely from an elite circle. See Nisbet (2003).

[8] One area where we shall be persistently confronted by the history of modern interpretative engagements is in Campanian wall painting, where many pictures survive only in the versions of nineteenth-century draftsmen and watercolorists, some of whom seem radically to contradict one another even in the depiction of the same original.

a literary account of various (mainly Roman) texts that relate to art. But the study of visuality is relevant to both these subjects—especially when one wants to ground them in their contemporary ideological contexts.[9] In terms of Roman art, a field still dominated by the study of official monuments (and rightly so, in that the survivals are so impressive), I rather bypass the public sphere.[10] This is not to say that civic monuments and statues, with their complex culture of donation, propaganda, and patronage (both local and central), have no interesting visualities to offer. But I have been led by our texts (a problematic gesture to the priority of the literary over the material in the eyes of some art historians and archeologists, I admit) to the spheres where ancient writers locate special problems, fissures, and traumas in the Greco-Roman gaze. These texts highlight the intensity of the personal gaze—its problems with delusion in a regime of naturalism and its self-consciousness when found to be itself under the gaze of others. The texts take us into the arena of sexuality and identity, and ancient Roman meditations on these matters—whether related to the social, mythological, or aesthetic spheres—find remarkable parallels with the visually formulated concerns of art in the domestic context. Particularly in Campanian painting, with its overt insistence on gazes and in staging the observation of the gaze by what formalist art historians somewhat drily call "supernumerary figures," the verbally expressed visual concerns of texts find a fascinating foil in a visually expressed pictorial commentary on issues and themes that cannot be wholly divorced from those of Hellenistic and Roman poetry or fiction. Sculpture and silverware offer further visual support for these cultural reflections.

Beyond sexual identity, our texts show a remarkable culture of visual investment in religion—both the personal choices of second-century initiates such as Lucius in the *Golden Ass* of Apuleius, or the orator Aelius Aristides, and the more public culture of civic religion. The world of religious art—cult statues, dedications, wall paintings which both decorate sacred space and demarcate it as special, even sanctified, for the group that uses that space—offers a rich seam of visually conducted commentary on other religions and on the world outside as seen through the special lens of an initiate cult. Here the naturalism so assiduously developed by Greek art, so fondly exploited by Roman art, and so playfully interrogated by Greco-Roman art writing is interestingly eschewed for much more symbolic and self-consciously schematic visual choices. Both religion and sexuality, while never immune from the potential appropriations of moral rhetoric, apologetic indulgence, and polemical

[9] Indeed, as Whitmarsh (2001), 234–36, implies, beyond the specifics of art and text, visuality has much to tell us, about issues such as pedagogy and the dialectics of power.

[10] On some aspects of this, see Elsner (1995), 161–76, 192–210; P. Zanker (1994, 1997); and J. R. Clarke (2003b), 19–67.

condemnation, could in different ways figure as countercultural claims to personal and collective sectarian identity against the perceived prevailing attitudes of the time. In this sense, despite my general avoidance of public monuments, the latter chapters (especially chapters 9 and 10) of the book nonetheless examine an implicit politics in what may at first sight seem apparently unpolitical religious art.

I focus on the era of the Roman empire, including its Greek and near eastern provinces as well as the west, between Augustus (second half of the first century B.C.) and Theodosius (toward the end of the fourth century A.D.). Of course this period encompassed many diachronic changes—not least the granting of universal citizenship in A.D. 212 and the rise of Christianity as an official religion after A.D. 313 (though not yet the banning of pagan polytheism).[11] But in terms of the social ideals envisaged by the elite within a broadly similar geographical scope, there is a good deal of continuity amid the change—enough continuity, I hope, for my study of the relations of visuality and subjectivity within these boundaries to hold water.

The question of how viewing and visuality may give rise to subjectivity, whether individual or collective, is a big one. I do not here get immersed in a philosophical exploration of these issues. Rather, this book both takes for granted the amazement in the gaze and assumes, further, that some sense of who one is (that is, subjectivity) cannot be denied either to the results of that amazement or to the impetus that got the gaze going in the first place. But I do not pursue any simple or rigid categorization: one of the interesting complexities of visuality is that the desires in the gaze can shift so swiftly in relation not only to different objects but even to the same object (for example, Naked Venus, whether seen as an available woman or as a potent deity).

Thus this book does not provide a series of unequivocal facts about certain events or monuments, about who commissioned, made, or looked at what, and when. Nor does this book offer any "authoritative" readings of selected texts and objects, readings whose purpose would be to define unequivocally how these things were experienced in their time. On the contrary, I explore, first, the discussion, appreciation, and viewing of art current in Greco-Roman antiquity; and second, some case studies of the gaze that indicate the wide and remarkable range of visualities and viewings that ancient Greeks and Romans under the empire were able to apply to what they looked at. It is

[11] In cultural terms this period was one of growing hellenization of the Roman empire, culminating in the so-called Second Sophistic (from about A.D. 50 to well into the fourth century), on which see further chapter 6, text at note 5, and note 7. On the citizenship question, see Garnsey (2004) with bibliography. For the complex coexistence of pagan polytheism and Christianity throughout the fourth century, see Beard, North, and Price (1998), 1:364–88, and J. Curran (2000), 161–259 (on Rome); on the moves against paganism in the 390s, see, for example, Williams and Friell (1994), 119–33.

within this range—from illusionistic naturalism to more schematic abstraction on the formal side of objects, from the personal psychological appropriations of wish-fulfillment fantasy to the acceptance of a shared subjectivity of cult initiation on the side of viewers, from looking as such to being aware of being looked at while looking—that Roman eyes were trained, and it is to this range that they responded. My focus then is on the pattern of cultural constructs and social discourses that stand between the retina and the world, a screen through which the subjects of this inquiry (that is, Greek and Roman people) had no choice but to look and through which they acquired (at least in part) their sense of subjectivity.[12] Just as that screen—what I am calling "visuality"—was itself made up of subjective investments while being limited by the material and ideological constraints of the ancient cultural context, so our examination of it must depend upon a certain amount of empathetic imagination as well as critical analysis.[13]

[12] I am indebted here to the definition of visuality in Bryson (1988), 91–92.

[13] For empathetic imagination and critical analysis as key weapons in the historian's armory, see Hopkins (1999), 2.

<div style="text-align:center">

1

</div>

BETWEEN MIMESIS AND DIVINE POWER

Visuality in the Greco-Roman World

A PRINCIPAL ARGUMENT supporting the assertion of a great divide between the arts of Classical antiquity and the Middle Ages has been an assumption about naturalism. Classical art, we have been told, is the supreme precursor of the Renaissance—not only in its search for illusionistic forms and in its celebration of the artists who led the way in creating such forms[1] but also in the kinds of visuality associated with naturalistic verisimilitude. Even in the "coldly classicizing academic" copies of the Roman imperial period,[2] sophisticated viewers, like the essayist Lucian or the rhetorician and historian Philostratus, were able to indulge the most complex and elegant wish-fulfillment fantasies in front of naturalistically rendered objects. The power of naturalism encouraged (and still does encourage) the imagination to believe that the visual world of a painting or sculpture is just like our world, even an extension of it. This kind of Classical visuality—leading ultimately to fantasies of (and apparently, according to our sources, even attempts at) sexual intercourse with statues so perfectly beautiful as to be better than the real thing— anticipates the frisson of Renaissance masterpieces from Michelangelo's *David* to Titian's *Venus of Urbino*.[3] The superlative naturalism of the image—its

[1] This interpretation of Classical art is ubiquitous and ultimately goes back to the Renaissance itself. One of the most elegant and influential formulations of this position in this century has been by Gombrich (1960), 99–125, and (1976), 3–18.

[2] I quote from Robertson (1975), 609. Cf. his comments on "beautiful quality" and "hackwork" in Roman "copies," p. xiv. Robertson's view of "copies" is now out of date: on the problematics of Roman replication, see, for example, Marvin (1993, 1997), Trimble (2000), and Gazda (2002).

[3] There is a rich ancient literature on *agalmatophilia* (making love with statues): see Euripides, *Alcestis* vv. 348–52; Ovid, *Metamorphoses* 10.245–97 (Pygmalion); Pliny, *Natural History* 36.21; Lucian, *Imagines* 4; Ps-Lucian, *Amores* 13–17; Clement of Alexandria, *Protrepticus* 4.50; Onomarchus in Philostratus, *Vit. Soph.* 2.18; Philostratus, *Vit. Apoll.* 6.40; Athenaeus, *Deipnosophistae* 13.605f–606b;

artifice so brilliant as to disguise the fact that it is merely art, as Ovid puts it[4]—prompts the willing viewer to suspend his or her disbelief that the image is more than pigment or stone. Entrapped, like Narcissus, in the enchanting waters of desire and illusion, the viewer identifies with, objectifies, and may even be seen by the image into which the imagination has poured so much aspiration.[5]

Writing on art within the Roman empire shows extraordinary self-awareness of the problematics of visuality in relation to naturalism. Just as Narcissus sees himself reflected in the pool and is deceived into a fatal love, so we who look at his image in a painting (and at his image in the pool within the painting) are ourselves putting a toe into the dangerous waters of his visual desire. In the Elder Philostratus' scintillating account of a painting of Narcissus, the realism is so vibrant that the writer (and his audience) cannot tell whether a "real bee has been deceived by the painted flowers or whether we are to be deceived into thinking that a painted bee is real."[6] In one sense this is a literary topos of the sort which occurs in Pliny the Elder's chapters on art history,[7] but at the same time this very dilemma (*our* dilemma as viewers) is a version of the fatal delusion of Narcissus himself.[8] Philostratus, in his description of a painting showing huntsmen, with superior psychological insight sees the pursuit of a boar (the painting's ostensible subject) as a sublimation of its real theme, the hunters' pursuit of a pretty boy whom they seek simultaneously to impress by their exertions and to touch physically (1.28.1). Yet at the moment the writer discovers the image's deeper meaning as a presentation of desire, he draws back, seeing his own desire as interpreter thwarted by the fact that naturalism is not nature, that what is realistically realized may not necessarily be real:

Hyginus, *Fabulae* 103–4; Aristaenetus, *Epistula* 2.10; Ps-Libanius, *Ethopoeiae* 27. On issues of images and sexual arousal, see Freedberg (1989), 12–26, 317–77. On the nude and desire in the Western naturalistic tradition, see Bryson (1984), 130–57 (focusing on Ingres); Pointon (1991), 11–34; Nead (1992), 5–33, 96–108. Further on this thematics, see chapter 5 on Pygmalion below.

[4] Ovid, *Met.* 10.252: *ars adeo latet arte sua.*

[5] For some stimulating accounts of ancient visuality in terms of desire and the gaze, see Bryson (1990), 17–30, and (1994); Morales (1996a); Platt (2002a).

[6] Philostratus, *Imagines* 1.23.2. Throughout this book, wherever I cite Philostratus without an epithet, I mean the Elder Philostratus, whom I take to be the author of the *Lives of the Sophists*, the *Life of Apollonius*, the *Heroicus*, and the *Imagines*, as well as several other works. Occasionally I refer to his grandson the Younger Philostratus, but will always call him "the Younger." I use the Loeb translation by A. Fairbanks of Philostratus, *Imagines* (Cambridge, MA: Harvard University Press, 1931), sometimes emended.

[7] For instance, Pliny, *Natural History* 35. 65–66, 95. For some discussion of this topos and its place in art history's critical self-reflections, see Bryson (1983), 6–35, and Bann (1989), 27–67.

[8] On Philostratus' Narcissus, see Bann (1989), 105–201; Frontisi-Ducroux and Vernant (1997), 225–30; and chapter 6 below.

How I have been deceived! I was deluded by the painting into thinking that the figures were not painted but were real beings, moving and loving—at any rate I shout at them as though they could hear and I imagine I hear some response—and you [that is, Philostratus' listeners or readers] did not utter a single word to turn me back from my mistake, being as much overcome as I was and unable to free yourself from the deception and stupefaction induced by it.[9]

Yet this kind of sophistication, and the concomitant fascination with the sheer artistry of art—the anecdotes of famous painters, the exquisite skillfulness of technique, the works which deceived even animals and birds—are only part of the story. For if antiquity was the ancestor of the Renaissance, it was also the mother of the Middle Ages. Alongside wish-fulfillment fantasies in the aesthetic sphere of the art gallery[10] went a culture of sacred images and ritual-centered viewing, in which art served within a religious sphere of experience strikingly similar to the world of icons, relics, and miracles of medieval and Byzantine piety. I will briefly sketch Roman art's "Renaissance" visuality, and then explore the "medieval" visuality of its oracular, liturgical, and epiphanic experience of images. My question is in part how these apparently exclusive worlds could be reconciled. My answer will be that, to some extent at least, in looking at a culture that is not just foreign but also ancestral to us our own expectations and interpretations have distorted the ancient evidence and material to suit our own desires and preconceptions. The predominant trends of ancient visuality, I suggest, were stranger and less familiar than is usually supposed when we subsume the arts of antiquity into a discourse inflected by the assumptions of Renaissance naturalism.

VISUALITIES OF NATURALISM

The extent of antiquity's "Renaissance" visuality can be indicated by a quick comparison of some images and texts. Let us begin with two visual realizations of the mythological tale of Perseus and Andromeda. The first is a wall painting excavated from the *villa rustica* at Boscotrecase near Pompeii in the first decade of the twentieth century. It dates from about 10 B.C. and is now in the Metropolitan Museum in New York (figure 1.1).[11] The second is a sculpted relief panel now in the Capitoline Museum in Rome and earlier in the Villa Doria Pamphilj and Albani collections. It dates from the mid-second century A.D., probably from the reign of Hadrian (figure 1.2).[12]

[9] Philostratus, *Imagines* 1.28.2. On the Hunters, see Elsner (1995), 33–37.
[10] Parodied to brilliant effect by Petronius in his *Satyrica*, chapter 9 below.
[11] See the discussion of Leach (1988), 364–68; von Blanckenhagen and Alexander (1990), 33–35; and Fitzgerald (1995), 144–46. Generally on the iconography, see Philips (1968), 3–6, and Roccos (1994).
[12] See Helbig (1963–72), vol. 2, no. 1330, 156–57; and Calza (1977), 104–5, with bibliography.

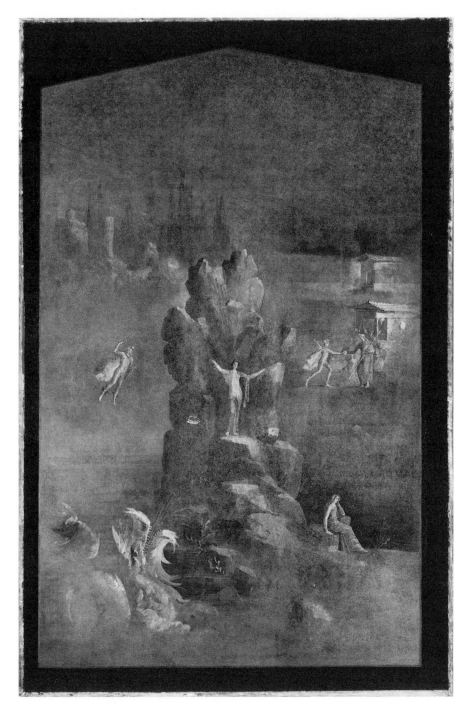

FIGURE 1.1. Landscape with the myth of Perseus and Andromeda, fresco from the east wall of a room in the villa at Boscotrecase. Roughly 10 B.C. Now in Metropolitan Museum of Art, New York (20.192.16). (Photo: The Metropolitan Museum of Art, Rogers Fund, 1920.)

CHAPTER ONE

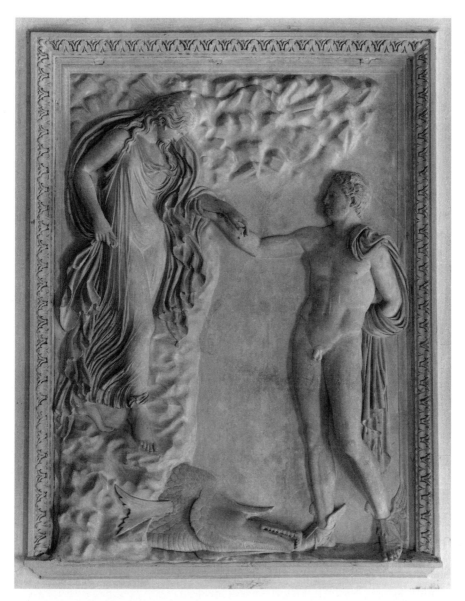

FIGURE 1.2. Perseus rescuing Andromeda, marble relief from the Capitoline Museum, Rome. Second quarter of the second century A.D. (Photo: Koppermann, DAI, 65.1703.)

Beside the fresco, place the following description of a painting from the great second-century novel *Leucippe and Clitophon*, written by Achilles Tatius:

> The girl was placed in a recess of the rock which was just her size. It seemed to suggest that this was not a man-made but a natural hollow, a concavity drawn by the artist in rough, irregular folds, just as the earth produced it. Looking more closely at her installed in her shelter, you might surmise from her beauty

that she was a new and unusual icon, but the sight of her chains and the approaching monster would rather call to mind an improvised grave.

There is a curious blend of beauty and terror on her face: fear appears on her cheeks, but a bloomlike beauty rests in her eyes. Her cheeks are not quite perfectly pale, but brushed with a light red wash; nor is the flowering quality of her eyes untouched by care—they seem like violets in the earliest stage of wilting. The artist enhanced her beauty with this touch of lovely fear.

Her arms were spread against the rock, bound above her head by a manacle bolted in the stone. Her hands hung loose at the wrist like clusters of grapes. The color of her arms shaded from pure white to livid and her fingers looked dead. She was chained up waiting for death, wearing a wedding garment, adorned as a bride for Hades. Her robe reached the ground—the whitest of robes, delicately woven, like spider-web more than sheep's wool, or the airy threads that Indian women draw from the trees and weave into silk. . . .

Between the monster and the girl, Perseus was drawn descending from the air, in the direction of the beast. He was entirely naked but for a cloak thrown over his shoulders and winged sandals on his feet. A felt cap covered his head, representing Hades' helmet of invisibility. In his left hand he held the Gorgon's head, wielding it like a shield . . . his right hand was armed with a twin-bladed implement, a scythe and sword in one. The single hilt contains a blade that divides halfway along its extent—one part narrows to a straight tip, the other is curved; the one element begins and ends as a sword, the other is bent into a sinister sickle, so a single manoeuvre can produce both a deadly lunge and a lethal slash. This was Andromeda's drama.[13]

However a modern spectator might refrain from (admitting to) such an excessive response to a work of art, for Achilles Tatius a painting perhaps somewhat like the Boscotrecase mural was the occasion for indulging his readers in an intense sexual fantasy. The maiden, ravishing in her "curious blend of beauty and terror," is exposed to be ravished by the viewer's (as well as the reader's and the monster's) gaze—tied up, powerless, in a posture worthy of Ingres' spectacularly voyeuristic painting of *Roger and Angelica*.[14] The writer dwells on voyeurism, virtually caressing the young woman's "lovely

[13] Achilles Tatius, *Leucippe and Clitophon* 3.7. For Achilles Tatius, I use the translation by J. Winkler in Reardon (1989). On this remarkable novel, see the discussions by Bartsch (1989), 55–57 on this passage; Goldhill (1995), 66–111, 115–20, and especially on this passage Morales (1996b), 143–46, and (2004), 174–77.

[14] This painting, obviously a reworking of the Perseus and Andromeda theme, was completed in 1819 and now hangs in the Louvre. A smaller version, dated to the 1830s, is in the National Gallery in London. On the eroticism of Ingres' rendering of the body, male and female, see Ockman (1995). On *Roger and Angelica*, see Duncan (1991), 60 (though note that the date is wrongly given as 1867); and Vigne (1995), 137–44.

fear," playing with descriptive pseudo–art criticism ("drawn by the artist in rough, irregular folds," "a light red wash," "the colour of her arms shaded from pure white to livid") and with suggestive similes and metaphors (Andromeda's "flowering" eyes, the "violets in the earliest stage of wilting," the hands splayed from the wrists "like clusters of grapes"). To the brutal penetration of the male gaze—equally that of the writer, readers, and viewers as well as of both Perseus and the sea monster within the picture—the "airy threads" of her wedding garments reveal more than they disguise. It is no surprise that this passage of hypersexualized male objectification, a voyeur's anticipation of the violence of rape, climaxes on the sword's phallic conquest of the sea monster, which is as much a hint of the hero's future domination of the lady as it is a description of his valorous feat.[15] "A deadly lunge and a lethal slash" would indeed be "Andromeda's drama." She is "spread out against the rock" as an erotic vision to satisfy and excite the viewer of the picture and the reader of the text as well as the viewers (Perseus and the monster) within the image. The strategies of description are enticing us to identify with the twin-bladed hero in anticipation of both his conquests, the monster and the girl.

Turning back to the Pompeian fresco from the erotic intensity of Achilles' description, one might be forgiven for wondering at the extent of the novelist's rhetorical "reading in." The painting broadly represents a version of the iconography Achilles expected his readers to bring to mind, but its narrative takes place in the distant spaciousness of landscape, while Achilles' story is all about impassioned identification with characters whose emotions and deeds loom larger than the everyday.[16] Yet "reading in" is a key aspect of the rhetorical nature of ekphrasis, the literary device of describing people, situations, or works of art in such a way as to bring them vividly to mind in the reader's or listener's mind's eye, as well as being an essential invitation of the visuality of naturalism.[17] As we are enticed by a picture to tell its story, which is always, to some extent, *our* story or at least a story plausible to us, so we identify with, allegorize, and fantasize about the image, thereby transforming its content into a narrative which suits us. Achilles' description of Andromeda certainly suits the voyeurism, violence, and sexuality of his novel, even if someone else might offer a very different (and differently flavored) account from looking at the Boscotrecase fresco. Interestingly, the erotic focus of the Boscotrecase fresco is significantly stronger than that of a somewhat later

[15] On phallic swords in the novel, cf. 2.35.5, with Morales (1996b), 139–46, and (2004), 177.

[16] One factor which might have focused the interpretation of the Boscotrecase panel is that, like Achilles' painting, it had a pendant and may well have been intended as part of a diptych. See von Blanckenhagen and Alexander (1990), 28–40, and Goldhill (1995), 21, 72.

[17] On ekphrastic "reading in," see Alpers (1960), 190–94, and Elsner (1995), 23–39.

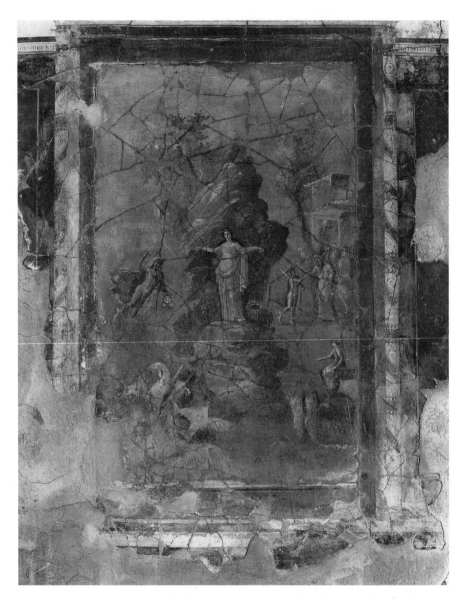

FIGURE 1.3. Landscape with the myth of Perseus and Andromeda, fresco from west wall of triclinium b, Casa di Sacerdos Amandus, Pompeii. Mid-first century A.D. (Photo: Koppermann, DAI 66.1785.)

painting deriving from the same basic model from the Casa di Sacerdos Amandus at Pompeii (I.7.7, figure 1.3).[18] The latter replaces the still potentially erotic maiden caressed by wispy draperies with a fully dressed Roman matron going through the motions of Andromeda's drama.

[18] PPM I.602–5. Interestingly, this painting (from about A.D. 40–50), from triclinium b, has a pendant of Polyphemus and Galatea like the pendant of the Perseus panel from Boscoreale, which is likewise dependent on the same pictorial model.

The Capitoline panel (figure 1.2) enters the myth from another point in the story, as does the painting which Philostratus describes in his *Imagines* (1.29). In the Capitoline panel, the contest is over and the maiden has been rescued. The triangular complex of the Boscotrecase painting, where man and monster fight over a woman chained and passive at the picture's center, is a world away from the atmosphere of relief after a crisis as boy and girl gaze into each other's eyes. Yet this immediacy of erotic entanglement (something any viewer can instantly identify with) is set against a certain formal academicism, as the nude hero with his elegantly draped cloak is adapted from a late classical type of Hermes that seems derived from the work of Praxiteles, while Andromeda in her swirling draperies is a neo-Attic dancing girl, related to a lost fifth-century B.C. prototype of a dancing Maenad that was popular with Roman copyists.[19] As with the two frescoes which belonged in rooms with other pictures on amatory themes, the panel's meanings would be affected if it were part of a group or a program, like the so-called Spada reliefs of roughly the same date.[20]

Here is how Philostratus, writing in the early third century A.D.,[21] describes a painting in some ways similar to the Capitoline relief:

> The contest is already finished and the monster lies stretched out on the strand, weltering in streams of blood—the reason the sea is red. Eros frees Andromeda from her bonds. He is painted with wings as usual, but here—unusually—he is a young man, panting and still showing the effects of his toil; for before the deed Perseus put up a prayer to Eros that he should come and swoop down with him upon the beast, and Eros came for he heard the Greek's prayer. The maiden is charming in that she is fair of skin though in Ethiopia, and charming is the very beauty of her form; she would surpass a Lydian girl in daintiness, an Attic girl in stateliness, a Spartan in sturdiness. Her beauty is enhanced by the circumstances of the moment; for she seems to be incredulous, her joy is mingled with fear, and as she gazes at Perseus she begins to send a smile towards him. . . . He lifts his chest, filled with breath through panting, and keeps his gaze upon the maiden. . . . Beautiful as he is and ruddy of face, his bloom has been enhanced by his toil and his veins are swollen, as is wont to happen when the breath comes quickly. Much gratitude also does he win from the maiden.[22]

[19] On the eclecticism of the Perseus and Andromeda panel, see Wace (1910), 190. On the Maenads and their fortunes in Roman art, see Touchette (1995).

[20] See, most recently, Newby (2002a), with bibliography.

[21] On Philostratus, see G. Anderson (1986), Billault (2000), and now Bowie and Elsner (forthcoming). On the *Imagines*, see, for example, Cämmerer (1967), Webb (1992), Schönberger (1995), Leach (2000), and Elsner (2000), with bibliography.

[22] Philostratus, *Imagines* 1.29.2–4.

Although Philostratus here shares Achilles Tatius' trope of beauty mixed with fear, his subject is not, however, the violence of anticipated dismemberment and sexual satisfaction, but the coy theme of boy and girl falling in love. Even the slaying of the monster is presented as an appeal to Eros. Eros' descriptive presence is a reflection of Perseus; he appears as the very double of the hero, a young man (rather than a putto) panting and sweating from the toil of battle, swooping down with Perseus in accomplishing the deed. Instead of a thinly disguised metaphor of the sex act, the battle is the preliminary of seduction; instead of a narrative of rape, we are offered the intimations of foreplay. The description of the girl is a superlative literary transformation of the "academic classicism" of the painting's style, with its clear indebtedness to earlier models (like the Maenad of the Capitoline relief). Philostratus turns this into a set of comparisons by which Andromeda surpasses the girls of Ethiopia, Lydia, Attica, and Sparta (whose forms in earlier Classical art her painter may have borrowed). Like Achilles' description, all this is a "take" on the myth—a "reading in" to the picture of a series of cliché expectations of what happens when boys and girls are thrown together in unusual circumstances, when their gazes meet.

The viewer implied by Philostratus, like the viewer of the Capitoline relief, is offered the sight of lovers transfixed. It is ambiguous whether the panting of the hero's chest is due to his exertions in slaying the monster or to his anticipation of getting the girl. The Capitoline panel, though different in some aspects of its iconography (the absence of Eros, the fact that Philostratus' Perseus is lying on the grass), offers ample potential for this kind of voyeuristic viewing. On the relief, Andromeda's otherwise profuse draperies cling fortuitously, virtually see-through ("like spider-web") around her breasts and thighs. Her erotic nudity is displayed full frontal (to Perseus and to the viewer) through this apology for clothing, while he stands nude before her, the sea monster quelled beneath them. The maiden's eyes are cast modestly down, looking with apprehension at the monstrous fate from which she has just been saved, or is she glancing upward to transfix her future lover's gaze, as in Philostratus? Does "she [begin] to send a smile towards him"? What are the rewards for the "gratitude" he wins "from the maiden"?

The naturalism of this kind of art, not just in its forms but in its imitation (and intimations) of "real-life" desires and fantasies on an idealizing mythological level, brings a confident assertion of a particular visuality. It is the form of ancient Greco-Roman visuality most familiar to us, since it is precisely the kind of viewing which post-Renaissance art and art history have identified with and practiced. This is our version of "reading in," signaled at crucial junctures of the modern art historical enterprise by the

great ekphraseis (themselves deeply influenced by antiquity) which punctuate the work of the founders of the discipline, especially Vasari and Winckelmann.[23] But it is my claim that this visuality—of identification, objectification, ultimately erotic desire—is only one part of antiquity's armory of the visual.

RELIGION AND THE PRIMACY OF RITUAL

Beside the visual culture of the art gallery, with its hyper-realized celebration of naturalistic visuality in rhetorical set-pieces and erotic fiction, antiquity offered a world of sacred images. It was, for instance, not always possible to differentiate the deity from his or her statue.[24] In the Greek language this gives rise to the interesting ambiguity that, for example, "Artemis" can mean equally the goddess herself or an image of her.[25] In the handling of images, this ambiguity afforded an edge of danger, since incorrect treatment of a statue could be construed as an assault on the deity embodied in it.[26] In the context of a temple, the statues adorning its sacred enclosure, including the cult image inside the temple, were themselves part of a broad culture of ritual (similar in many respects to the cultivation of icons in Byzantium and medieval Italy).[27] Statues might be dressed, paraded, washed, fed, and worshipped;[28] they were imagined to have volition and magical power (oracular, talismanic, healing, or malevolent);[29] and the more important statues were

[23] On ekphrasis and "reading in" in Vasari, see Alpers (1960). On ekphrasis and desire in Winckelmann, see Potts (1994), 96–181. For the influence of such "reading in" beyond Winckelmann (for instance, on Walter Pater), see ibid., 238–53.

[24] See Beard (1985), 211; Barasch (1992), 23–48; and Spivey (1996), 43–52, 78–104.

[25] See Gordon (1979), 7–8. Likewise in ancient dream theory, it makes no difference whether the dreamer sees the statue of a god or the god himself. See Artemidorus of Daldis, *Oneirocritica* 2.35 (Zeus), 2.37 (Heracles), 2.38 (Poseidon, Amphitrite, Nereus and the Nereids), 2.39 (Serapis, Isis, Anubis and Harpocrates), with Barasch (1992), 32–33.

[26] Certainly this seems the lesson of Pseudo-Lucian's *Amores* 15–16, where "the violent tension" of a young man's desire for the statue of Aphrodite at Cnidos "turned to desperation." After his sexual assault on the statue ("the reckless deed of that unmentionable night") the image is forever stained with a "black mark" while the youth "hurled himself over a cliff or down into the waves of the sea and . . . vanished utterly." Likewise, according to the Christian apologist Clement of Alexandria (*Protrepticus* 4. 50–51), any image of a naked woman could be understood as "golden Aphrodite" and hence carry the dangers of divine (or—for Clement—demonic) temptations.

[27] The most detailed account of the medieval material is Belting (1994); specifically on Byzantium, see Cormack (1985, 1997). Also important is the wide-ranging if insufficiently historicized account of Freedberg (1989), 27–316.

[28] On images within ritual in antiquity, see Barasch (1992), 31–37; Bettinetti (2001), 137–231; and chapter 2 below. Still useful, though its subject is really attitudes toward idolatry, is Clerc (1915).

[29] For discussion of animated images in antiquity, see especially Faraone (1992); also Barasch (1992), 36–39; and Freedberg (1989), 33–40, 65–76. Two particularly striking examples are Artemis Orthia (Pausanias 3.16.11) and Apollo of Hierapolis (Lucian, *De Dea Syria* 36–37).

even capable of intervening in legal problems or power politics—by granting sanctuary to fugitives, for instance.[30]

These functions were all highly varied and nuanced by the particular local conditions, myths, and traditions within which any one image might be worshipped. Instead of a broad survey, however, I shall concentrate on the issue of visuality by focusing initially on some remarkable texts. First, I will use Pausanias' *Description of Greece*, the richest account of religious images and their myths and cultivation surviving from antiquity, to outline some aspects of ritual-centeredness. A native Greek-speaker, Pausanias was born in Lydia in Asia Minor, and seems to have traveled for several years between about A.D. 135 and 180 throughout mainland Greece (the Roman province of Achaea), observing rituals, local myths, and works of art in remarkably painstaking and careful detail and writing as he went.[31] His text is a fascinating combination of what we would call antiquarianism as well as genuine art historical (even connoisseurial) expertise with a pilgrim's precise interest in the religious nature and sacred details of myths, rituals, and statues.[32] I will then turn to a discussion of cult images in Lucian's brief pilgrimage narrative *De Dea Syria*, in order to explore the visuality of the cult image in its ancient ritual setting. Writing in Greek at about the same time as Pausanias, the Syrian-born Lucian is antiquity's finest surviving satirical essayist.[33] His *De Dea Syria*, which describes with little apparent irony the process of pilgrimage to the shrine of Atargatis in Hierapolis in Roman Syria, was thought by many in the past to be spurious, but is now accepted as genuine.[34]

Of course one might impute the differences I am suggesting between the texts in the previous section and the following ones as amounting to differences of narrativity and genre rather than differences in visuality. And it is of course the case that fiction and the traditions of ekphrasis engage rhetorical and narrative techniques that are different from those of travel literature or

[30] The climax of Achilles Tatius' novel turns on the appeal of both hero and heroine for asylum in the temple of Artemis at Ephesus (7.13, 7.15, 8.2–3). On statues and sanctuary, see Oster (1976), 35–36; and Price (1984), 192–93. See further chapter 9 below.

[31] The literature on Pausanias is large. For good general accounts, see Habicht (1985), with supplementary material in Arafat (1996) and Alcock, Cherry, and Elsner (2001). The Pausanias industry of the new millennium includes the following excellent studies: Akujärvi (2005), Ellinger (2005), and Hutton (2005b), all with extensive bibliography. For Pausanias in his historical and literary context, see Swain (1996), 330–56.

[32] On Pausanias' connoisseurship, see Arafat (1996), 43–79, and chapter 3 below. On images (*xoana*) within ritual in Pausanias, see Donohue (1988), 140–47.

[33] Generally on Lucian, see C. P. Jones (1986) and Swain (1996), 298–329 with bibliography.

[34] On the *De Dea Syria*, see Oden (1977), Swain (1996), 304–8, Elsner (2001a), and Lightfoot (2003). All these accept the text's Lucianic authorship.

pilgrimage tracts. But I would argue that the genre chosen for the description of art presupposes a kind of visuality within which images are to be received. Whether a particular form of visuality is one of the reasons a writer chooses a particular narrative style, or whether the form of visuality may be said to arise as a result of the literary genre chosen, matters less (for my purposes here) than the claim that more than one kind of visuality existed in antiquity. Here the case of Lucian is significant, since at different times he chose to write in all the genres touched upon here. He was a master of rhetorical ekphrasis (for instance in *De Domo* or *Zeuxis*), of outrageous fiction (especially the *Verae Historiae*), and of religious polemic (*Alexander, Peregrinus*), but in the *De Dea Syria* he deliberately chose a different kind of genre—that of the pilgrim's travel book (which many have found uncomfortably sincere within his corpus of writing)—in order to express a form of piety and religious visuality not possible in his more usual satirical style.

The Ritual Setting

I concentrate first on one of the two sites which Pausanias claims to be the most special in all Greece. At 5.10.1, he announces, "Many are the sights to be seen in Greece, and many the wonders to be heard; but on nothing does heaven bestow more care than on the Eleusinian rites and the Olympic games."[35] Within the Altis, the "sacred grove of Zeus" (5.10.1) which was Olympia's holiest spot (figure 1.4), Pausanias describes in accurate detail the two great temples of Zeus (5.10.1–11.11) and Hera (5.16.1–20.6) with their cult images, decorations, and offerings.[36] Sandwiched between them is a remarkable description of the altars within the Altis, on which I wish to focus (5.13.8–15.12).[37] Although ancient altars are not figural images, they are nonetheless hand-crafted works of material culture (nonanthropomorphic for the most part and perhaps aniconic) and the tenor of Pausanias' enumeration of them is revealing. It shows a ritual-sensitive visuality in which the pilgrim-viewer submits to the liturgical rule book of a holy site in order to be offered its sacred experience. It demonstrates a deeply focused interest in the detailed precision of

[35] I mainly use the Loeb version of Pausanias by W.H.S. Jones and H. A. Ormerod, often slightly adapted.

[36] On Pausanias and the temple of Zeus, see Trendelenburg (1914), 71–102. On the Heraion, see Arafat (1995). For recent commentary on the text, see Meyer (1971) and Maddoli and Saladino (1995). A longer discussion of this passage is in Elsner (2001b), 8–18. For Pausanias and Olympia generally (especially the athletics), see now the excellent discussions of König (2005), 158–204, and Newby (2005), 202–28.

[37] On Pausanias and the altars of Olympia, see Robert (1888), 429–36; Frazer (1898), 3:559–74, with bibliography; Trendelenburg (1914), 39–45; Etienne (1992), 292–97; Elsner (2001b), 11–13; and Akujärvi (2005) for some narratological reflections.

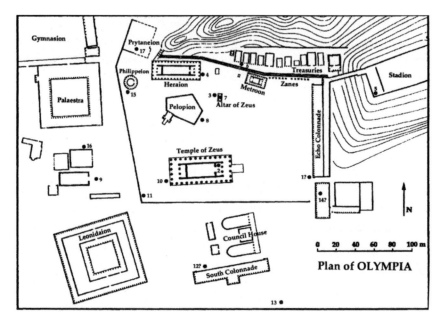

FIGURE 1.4. Plan of Olympia in Pausanias' time, with the likely positions of the altars numbered after his description.

ritual, in which the topographical orchestration of a prime sacred center is rendered, and is experienced by writer and readers alike, both as a temporal process of liturgical action and as a spatial progress through a series of monuments whose order and meaning are dependent on their ritual relations with one another. It is unfortunate that none of these altars have survived, so that all we have to work with now is Pausanias' own text. However, while many of his projected readers would have been to Olympia (which was, after all, at the center of pilgrimage, tourist, and athletic routes in Greece) and seen the altars, some may not have visited the site—and for these, at least, Pausanias' account would have constituted a principal mode of access to perhaps the major panhellenic sanctuary in the Greek-speaking world.[38]

Twice Pausanias announces that he is describing the altars in the order used by the locals in sacrifice. First he tells us what he will do, saying, "Let me proceed to describe all the altars in Olympia. My narrative will follow the order in which the Eleans are accustomed to sacrifice on the altars" (5.14.4). Later on in his account of the altars, he reminds us of his chosen descriptive strategy, when he notes, "The reader must remember that the altars have not been enumerated in the order in which they stand, but the order followed by

[38] For a detailed account of how Pausanias structures topography and landscape through description, focusing on Book 2, see Hutton (2005b), 83–174.

my discussion is that followed by the Eleans in their sacrifices" (5.14.10). Even as he opens this part of his account, Pausanias insists on a ritual-centered dispensation for viewing these monuments in the sanctuary. He is aware of making an odd descriptive choice, but makes it anyway, since to him (in the case of objects whose prime purpose is sacrificial) it is a more natural evocation of what he wants to describe. What matters to him, in effect, is not a topography of geographical accuracy, a map of juncture and position, but a topography of ritual correctness, in which the temporal unfolding of a series of sacred actions becomes the dominant frame for his account. It is significant that, in an author all too often unfairly impugned for lack of literary or intellectual sophistication,[39] the writing (and the reading) of this innovatively organized description is itself a ritualized reiteration of the liturgical process. In reading Pausanias on the altars, we move from altar to altar in a vicarious reenactment of Pausanias' own participation in an ancient ritual activity which was repeated, so we are told, "every month."[40]

The account of the altars opens with that of Olympic Zeus, to which Pausanias devotes by far the largest space.[41] Interestingly, the focus on ritual informs even the altar's material construction: "It has been made from the ash of the thighs of the victims sacrificed to Zeus" (5.13.8). This peculiarity, for which Pausanias finds parallels at Pergamon and Samos, prepares us for a discussion of minute ritual details (5.13.10–11). Pausanias tells us precisely how the altar is designed—with its lower level, or *prothysis*, used for the killing of sacrificial animal victims and its upper level used as the site of the burning of the thighs. Again, what is effectively a discussion of the altar's form (after that of its material) is realized in terms of its ritual functions. The differences between the two levels extend beyond the materials of manufacture (the steps to the *prothysis* are stone, those to the upper part "are, like the altar itself, composed of ashes") to issues of access: Pausanias is careful to tell us that on days when they are not excluded altogether from Olympia, women, both virgins and married women, can only ascend to the *prothysis* while men can go to the higher level.

After having elaborated the structure of the monument in these entirely ritual-centered terms, Pausanias informs us that sacrifice is offered daily both by individuals and by the Eleans as a whole. Moreover, once a year on a

[39] For example, Habicht (1985), 160–62, esp. 162: "well-educated, widely read, fairly intelligent and not uncritical—but it has to be admitted that he did not have a brilliant mind. He lacked originality and the creative spark."

[40] Pausanias, *Description of Greece* 5.15.10. It is remarkably reductive to attribute Pausanias' interest in these sixty-nine altars to nothing more than "pedantic endurance," as does Habicht (1985), 161n82.

[41] Pausanias, *Description of Greece* 5.13.8–14.3. See Frazer (1898), 3:556–59, with bibliography; Trendelenburg (1914), 25–32; Maddoli and Saladino (1995), 257–61.

specified day (the 19th of the month of Elaphius), ash is mixed with water from the river Alpheius, and no other river, to make a paste with which the altar is daubed. These rituals prepare the way for discussing the specific sacrificial action for which the altar is the setting. Pausanias tells us that the Eleans always use "wood of the white poplar and of no other tree" for sacrifices to Zeus, which he attributes to the fact that "when Heracles sacrificed to Zeus at Olympia, he himself burned the thigh bones of the victims upon wood of the white poplar."[42]

What we are offered here, and I would contend this is typical of Pausanias and can be paralleled frequently in his *Description of Greece*,[43] is a striking instance of ritual-centered visuality. There is great empirical precision in the observations, but their descriptive force is evocative not of how the monument looks or where it is so much as of how it works. Everything about the altar in Pausanias' vision relates to the nature of its rituals, which are themselves part of the sacred definition of Olympia as one of ancient polytheism's most important religious centers. The altar's meaning in this context is not merely archeological or aesthetic; it is above all a continuing site for the execution of traditional religion. In the context of Roman-dominated Greece, such an assertion of an ancient (that is, pre-Roman) piety, which was constantly affirmed by reference to mythological, myth-historical, and divine figures who functioned as founders of rites and guarantors of their validity, had political and cultural undertones. Such assertions constituted an affirmation of identity, with at least some flavor of resistance to the appropriations of the imperial center.[44]

This effect of reperforming traditional religion is specially marked in the enumeration of the sixty-nine altars in the order of the Elean ritual procession. In part this serial presentation is a way of celebrating the congruence of deities within the Altis—a celebration enacted as much by the monthly ritual on which Pausanias bases his narrative as by Pausanias' description. For example: "They sacrifice to Hestia first, secondly to Olympic Zeus, going to the altar within the temple, thirdly to Zeus Laoetas and to Poseidon Laoetas. This sacrifice too it is usual to offer on one altar. Fourthly and fifthly they sacrifice to Artemis and to Athena, Goddess of Booty, sixthly to the Worker Goddess."[45]

[42] Pausanias, *Description of Greece* 5.14.1–3.

[43] See chapter 2 below.

[44] On the role of religion in the context of "resistance," see Alcock (1993), 213–14; on identity and resistance in the period, see Woolf (1994) and Swain (1996), 33–42, 87–89; further also chapters 9 and 10 below.

[45] Pausanias, *Description of Greece* 5.14.4–5. Note that this passage is corrupt in the mss tradition. I use the Loeb translation, which renders the text as emended by Buttmann. M. Rocha-Pereira's Teubner text. Pausanias, *Graeciae Descriptio* (Leipzig: Teubner Verlagsgesellschaft, 1989–90) prints a lacuna, 2:35. However, for my purposes the precise text is less important than its "feel" in listing altars and deities in order.

Through the sacrificial process, and equally through the logic of reciting the deities' names in the text, the *presence* of the gods (of each of the sixty-nine altars) is affirmed. As ever, Pausanias is careful to note when an altar is shared by more than one deity, when the recipient of an altar's sacrifice is in doubt or disputed, and who was the altar's dedicator (if this can be found out).[46]

The liturgical order of enumeration requires Pausanias to take what has been described as a "very leisurely and erratic course" in which he more than once retraces his steps and tells us so.[47] For instance, having opened with the altar of Olympian Zeus before beginning the liturgical enumeration, Pausanias returns to it first within the Eleans' monthly procession at 5.14.8, again when he comes to the altar of Zeus Descender ("this altar is near the great altar made of the ashes," 5.14.10), and finally at the close of his enumeration of the altars (5.15.9). Indeed, it is at the moment of return that he reminds us of the processional order along which he has structured his description (5.14.10). In effect, the text at this moment demonstrates the tension between a topographically straightforward narrative and the one upon which its author has embarked. This tension is itself evidence both of the difficulty of rendering ritual as description and of Pausanias' deliberate choice of ritual as his preferred frame for viewing.

At the end of the description of the altars, as a kind of summing up, Pausanias recounts the nature of the sacrificial action as he did in his account of the great altar: "Each month the Eleans sacrifice once on all the altars I have enumerated. They sacrifice in an ancient manner; for they burn incense with wheat which has been kneaded with honey, placing also on the altars twigs of olive, and using wine for a libation. Only to the Nymphs and the Mistresses, it is not their custom to pour wine in libation, nor do they pour it on the altar common to all the gods" (5.15.10). The precise details are again important— that it be wheat (rather than, say, barley) kneaded with honey, that the twigs be olive, that wine be used in the correct libations and for the right deities. These careful enumerations of small details, coupled with the broader sense of a ritual process, bring the gods of the Altis alive through their living sacrifical association with their altars. From our point of view, they provide invaluable contextual and ethnographic richness to understanding the culture of ancient paganism's sacred visuality.

Before we ask how the sacred images themselves speak to their worshippers, it is worth noting that Pausanias' evidence, exceptionally rich, full, and detailed though it is, is not unique. Other ancient authors corroborate the

[46] Shared altars: Alpheius and Artemis, 5.14.6; Apollo and Hermes, 5.14.8. Disputed or doubtful recipients: Hephaestus or Warlike Zeus, 5.14.6; Idas or Acesidas, 5.14.7; the "Bringer of Fate," "plainly a surname of Zeus," 5.15.5.

[47] Wycherley (1935), 56.

ritual-centeredness of Pausanian visuality in interesting ways. The *Sacred Tales* of the distinguished second-century orator Aelius Aristides evoke a pattern of repeated pilgrimage to healing temples (especially those of Asclepius) in Greece and Asia Minor. There a variety of medicinal rituals (bathing, abstinence from bathing, fasting, vomiting, enemas) are enjoined upon the devotee by his god, who appears in dreams and who also instructs Aristides to write it all down. At one point the orator comments: "What should one say of the matter of not bathing? I have not bathed for five consecutive years and some months besides, unless, of course, in winter time, he ordered me to use the sea or rivers or wells. The purgation of my upper intestinal tract has taken place in the same way for nearly two years and two months in succession, together with enemas and phlebotomies, as many as no one has ever counted, and that with little nourishment and that forced."[48]

Here we have a ritual culture mapped not around the liturgy of a sanctuary but about the workings (internal and external) of the body itself. Doubtless Aristides' ability to *see* his god—not just in statues but beyond them in the dream-visions which his text repeatedly affirms and in which his spiritual path of healing was incrementally enjoined upon him—could not be separated from the ascetic effects of his ritual activities. This kind of personal preparation for a divine vision or for healing is attested in Lucian's *De Dea Syria*, where pilgrims shave their heads and eyebrows, use only cold water for drinking and bathing, and always sleep on the ground until their sacred journey is completed (section 55). Pausanias himself, as well as the Delphic priest Plutarch, testifies to similar personal rituals, though with considerably less autobiographical color than Aelius Aristides.[49]

Beside this body-oriented focus, in which the ritual context seems intensely personal, texts like the *De Dea Syria* or Philostratus' hagiography of the pagan holy man Apollonius of Tyana support what might be termed the more broadly sociological context of visuality within a regularly repeated festival full of people.[50] The last part of the *De Dea Syria* presents a prime pilgrimage center in the east in full ritual and festival action (sections 42–60). The climax of the *Life of Apollonius* has Philostratus' sage (lauded as himself an object of pilgrimage in Olympia) perform a Socratic dialogue on the nature

[48] Aelius Aristides, *Sacred Tales* 1 (*Oratio* 47) 59, translated by C. A. Behr. On Aristides (with further bibliography), see Cox Miller (1994), 184–204; Rutherford (1999); and Petsalis-Diomides (2001), 70–163. On seeing the god, see further the epilogue.

[49] For example, in Pausanias, the various abstinences at the oracle of Trophonius in Boeotia (9.39.5), or the purifications necessary at the sanctuary of the Syrian Goddess at Aegeira in Achaea (7.26.7), or the rituals at the oracle of Amphiaraus at Oropus (1.34. 4–5). In Plutarch, see *De Iside et Osiride* 4–5, 7–8 (352C–354A) for purification rites among the Egyptians—with Richter (2001).

[50] On the *Life of Apollonius*, see Elsner (1997), 22–37, with bibliography.

of a festival (8.15, 18).[51] The monthly Elean sacrificial liturgy and the ash-daubing on the 19th of Elaphius are examples of such public holidays. These form some of the proudest set-pieces in Pausanias' account.[52]

Viewing the God

A limestone relief of the second or third century A.D. from the temple of Atargatis at Dura Europos in Syria, now in the Yale University Art Gallery, depicts the two principal gods of the city of Hierapolis, Atargatis and Hadad, enthroned in divine splendor (figure 1.5).[53] In his *De Dea Syria* (sections 31–32), Lucian translates the identities of these deities for the convenience of his Greek readership as Hera (for Atargatis) and Zeus (for Hadad).[54] Yet he describes them precisely. Of the two, Atargatis was the more important, as is shown by her larger size, her larger throne, and her larger footstool in the relief. This is corroborated by Lucian, who devotes the bulk of his description to Hera (section 32) and who regards the whole sanctuary as being under her protection (sections 1 and 16). The gods sit together in the temple chamber, Hera enthroned on lions and Zeus on bulls. Both are crowned (Lucian mentions the "tower" on Hera's head, as well as her girdle), and, at least from the evidence of the written description, both were adorned with costly gems. Between them on the relief is a rather strange object which resembles a Roman military standard.[55] Lucian mentions this too: "Between the two statues stands another golden image, not at all like the other statues."[56]

If we ask how such icons were viewed, at least in the context of a celebratory pilgrimage text like the *De Dea Syria*,[57] Lucian provides evidence which augments his empirical description. Unlike Zeus who, according to Lucian, "certainly looks like Zeus in every respect" (section 31), Hera "also has some-

[51] Lucian's religious satires, *Peregrinus* and *Alexander*, contain much material on festivals. In the former the Cynic philosopher and Christian convert Peregrinus immolates himself on a pyre at the height of the Olympic festival; in the latter Alexander, a self-proclaimed priest of Asclepius, sets up a highly successful business propagating false oracles at Abonouteichos in Paphlagonia.

[52] Some examples: the great festival of the Chthonia at Hermione (2.35.5–8); the festival of Artemis Laphria at Patrae (7.18.9–13); the festival of Demeter performed by the Pheneatai in Arcadia (8.15.1–4).

[53] On this relief, see A. Perkins (1973), 94–96; S. B. Downey (1977), 9–11, no. 2; and Drijvers (1986), 356, no. 19. For further discussion of this cult, see chapter 9 below. Further on the arts of Dura Europos, see chapter 10 below.

[54] For further discussion, see Oden (1977), 47–107; Elsner (2001), 136–41; and Lightfoot (2003), 427–55.

[55] On the possibility that this image might be a military standard, see Millar (1993), 247; and Swain (1996), 306. Further on the *Semeion*, see Oden (1977), 109–55, and Lightfoot (2003), 540–47.

[56] Lucian, *De Dea Syria* 33. I use the translation of Attridge and Oden (1976), sometimes adapted.

[57] On pilgrimage in the *De Dea Syria*, see now Lightfoot (2005).

FIGURE 1.5. Gypsum relief of Atargatis and Hadad from the temple of Atargatis, Dura Europos, Syria. Late second or early third century A.D. Now in Yale University Art Gallery. (Photo: Courtesy of Ted Kaizer.)

CHAPTER ONE

thing of Athena, Aphrodite, Selene, Rhea, Artemis, Nemesis and the Fates" (section 32). In effect, she encompasses all the major female deities in the Greco-Roman pantheon. Her special nature is marked out by her precious adornments and gems brought by devotees from all over the known world (Lucian mentions pilgrims who include Greeks, Egyptians, Indians, Ethiopians, Medes, Armenians, Babylonians, Phoenicians, Cappadocians, Cilicians, Arabs, and Assyrians, sections 10 and 32). Her power is especially manifested by her gaze: "There is another wondrous feature in the statue. If you stand opposite and look directly at it, it looks back at you and as you move its glance follows. If someone else looks at it from another side, it does the same things for him" (section 32).

Here the divine being of the goddess is presented on multiple levels: through the value and splendor of her ornaments, through her occupation of a sociological position in the center of a whole sacred world looking both east (to the Parthian lands not controlled by the Roman empire) and west (to Lucian's Greek-speaking readers), and above all through her power to hold the gaze of the individual worshipper. Her power encompasses the devotee's body, looking back at the viewer and watching him or her; and it extends beyond the individual to encompass all worshippers collectively, since she can presumably hold and follow the gazes of all the pilgrims who look at her. Indeed, through the miraculous ruby on her forehead (from which "a great light shines by night and the whole temple is illumined by it as if by lamps," section 32), she herself generates the light by which she may be seen.

This passage affords a rare glimpse of the effect of a great cult deity in antiquity. She is the center-piece and ultimate cult object both of personal rituals (head shaving, sacrifices, the dedication of locks of hair, sections 55–60) and of large public festivals. The latter include processions of all the deities to the temple's great lake (sections 45–47), the festival observed by the sea (in which Lucian did not himself participate, section 48), the fire or lamp festival (section 49), and the festival in which the temple's castrate priests (*galli*) perform various acts of self-mortification, of which the ultimate is the self-castration of those destined by the act to become future *galli* (sections 50–53). It is as if her gaze encompasses all these activities—from mass pilgrimage to the most intensely personal acts of physical asceticism, castration being the most extreme example.

Returning to the relief, one may argue that the sculpture—by emphasizing the paired enthronement of Atargatis-Hera and Hadad-Zeus—is less emphatic than Lucian in proclaiming the centrality of Hera's power. To a significant extent, the supremacy of Hera was established by liturgical and ritual custom rather than just iconography. For instance, in the procession to the lake at Hierapolis, Lucian says that the image of Hera always went first (section 47). The difference here between the implications of what Lucian says

and what one might infer directly from the Dura relief indicates not so much the primacy of text over image as the fact that images on their own represent only a small part of the visual culture of their use and function, which in this case a text helps to supply.

What the iconography of the Dura relief does suggest, however, is that it was frontality which Lucian had in mind in his account of the encompassing power of the goddess's gaze. Certainly this is what distinguishes not only Atargatis but many of antiquity's cult statues from the naturalism of Classical mimesis. Comparison with a mythological relief like that of Perseus and Andromeda (figure 1.2), where the figures are wrapped up in their own world, oblivious to the viewer who intrudes on their incipient love affair like a voyeur, may seem forced, since one can argue that it is hardly a pairing of like with like; but no naturalistic statues offer the arresting frontal gaze of such cult icons. Indeed, one definition of naturalism is precisely the avoidance of the kind of gaze that encompasses all who worship at Hierapolis.[58] Where Atargatis and Hadad demand that worshippers be incorporated in the gods' sacred world by eyeballing those that approach into submission,[59] the typical images of naturalism look away, involved in their own worlds, their own narratives, and their own realities. Naturalistic images elicit a series of identifications, objectifications, and narratives from us as viewers to read our way into the picture, as it were. Philostratus and Achilles Tatius provide excellent models of how that might be done. Here, in the sacred visuality of Hierapolis, itself the product of a complex ritual culture, viewing is much more direct.

VISUALITY AND THE SACRED

The confrontation with the direct gaze of the deity, a kind of gaze which is one of the most striking formal elements of medieval icons (see, for example, the St. Peter icon from Sinai and especially the medallions at the top, figure 3.1) as well as pre-Christian cult statues, is a key aspect of ancient ritual-centered visuality, at least as presented by Lucian. The viewer has prepared for his or

[58] See the useful definition of the earliest Greek naturalistic sculpture in Ridgway (1970), 8–11, especially the emphasis on motion, emotion and narrative (p. 10), all of which require a gaze that looks away from the viewer into the image's own world. At greater length, see Elsner (2006). It is worth noting that "frontality" has been seen as a key formal trait of the *Spätantike*, the transformation of classical art in late antiquity into the arts of the Middle Ages. See, for example, Riegl (1985), 52, 117, 120, 122, and Rodenwaldt (1940), 43.

[59] In *Art and Illusion*, Gombrich argues that this kind of frontality in late antique art "no longer waits to be wooed and interpreted but seeks to awe [the beholder] into submission," removing any sense of "free fiction" in the viewer's responses (Gombrich 1960, 125). I would rather say that the religious choice of entering the sphere of a deity like Atargatis is a freely chosen option where "submission" is tantamount to worship.

her epiphany with the god through a series of ritual acts, whether they be physical mortifications and abstinences (like Aristides' purges and enemas or the head shaving of Hierapolis), liturgical processes (like Pausanias' Elean procession), or the ordeals of a long pilgrim's journey.[60] Viewer-pilgrims, already taken out of their normal social realities through rituals which affect on the external level the body itself and on a more interior level the individual's sense of subjectivity, bring their identities to the house of the god.[61] This house is already an especially holy place. As Lucian says, in relation to the temple at Hierapolis, "no other temple could be more sacred, nor any other region more holy. . . . The gods [here] are especially manifest to the inhabitants. For statues among them sweat and move about and give oracles, and a shouting often occurs in the temple when the sanctuary is locked, and many have heard it" (section 10). Within the temple, at the culmination of the journey (from a pilgrim's personal point of view) and at the pivotal center of the site (from the viewpoint of both liturgical action and sacred geography), the viewer confronts the god.

It is important that the vision of the god be seen as a culmination of a ritual process. The texts we have been using are complex documents, with political, ideological, and literary purposes as well as religious ones. But it is in their most strongly defined aspects as insider texts, written by religious devotees, that their evidence for ritual-centered visuality (always an initiate's, and never a skeptic's, way of viewing) can be assessed. Both authors are explicit about being religious insiders: Pausanias particularly in his reticence to give away initiate secrets,[62] and Lucian (very elegantly) in the last sentence of the *De Dea Syria*, where, having discussed a ritual of hair dedication in the temple, he comments, "When I was still a youth I, too, performed this ceremony and even now my locks and name are in the sanctuary" (section 60).

Viewing the sacred is a process of divesting the spectator of all the social and discursive elements which distinguish his or her subjectivity from that of the god into whose space the viewer will come.[63] In the reciprocal gaze of divine confrontation, there is a form of visuality in which the image does not just *look back* at the viewer, but in which the viewer has specifically made the journey *in order that* the image should look back. Far from the paranoia

[60] On the ordeals and dangers of ancient pilgrimage, see, for example, Rutherford (1995). For a general account of ancient Greek pilgrimage, primarily focused on the pre-Roman period, see Dillon (1997) and the essays collected in Elsner and Rutherford (2005).

[61] For the idea of pilgrimage as "antistructure," reversing the social norms of pilgrims' home cultures, see the influential discussion of Turner and Turner (1978). For a recent and stimulating set of case studies on Christian pilgrimage, see Eade and Sallnow (1991). For a useful summary of theories of ritual, though with almost no discussion of the place of images, see Bell (1992).

[62] See Elsner (1995), 144–50.

[63] See ibid., 91–96.

surrounding the voyeurs of naturalism, who may discover themselves *being seen* watching what they should perhaps not have seen,[64] this is an intentional confrontation, prepared by ritual. The word for it in Greek is *theoria*, which from Plato to the church fathers means contemplation, meditation, vision.[65]

The difference from the visuality of naturalism is fundamental. For in mimesis, the viewer stands apart from the world of the image, which operates illusionistically in its own space (just like nature) and according to its own narrative logic. That space and logic may be realistic (like our own world, our own sense of perspective, time, form, and so forth), but looking at it is like looking through a screen into someone else's life. The viewer is invited to enter that world vicariously and voyeuristically, to penetrate the screen through an act of imaginative fantasy. Appropriations of the world of the image may involve identifying with the narratives governing its characters (as Achilles Tatius invites us to do), or imagining what the story might be and perhaps second-guessing the psychological motivations of its characters (as Philostratus likes to do). But there is no contact. Indeed, the more the possibility for contact is offered, and the more the image's illusionism tempts us into believing that it is real, the closer we come to the tragedy of Narcissus or the deception of Pliny's birds, who flew up to the canvas of Zeuxis' famous painting only to find that the grapes they desired were but pigment.[66] Ultimately, because there is no contact in the regime of naturalist representation, there is only longing, nostalgia, and frustrated erotic desire.[67]

By contrast, in ritual-centered viewing, the grounds for a direct relationship have been prepared. The viewer enters a sacred space, a special place set apart from ordinary life, in which the god dwells. In this liminal site, the viewer enters the god's world and likewise the deity intrudes directly into the viewer's world in a highly ritualized context. The reciprocal gaze of this visuality is a kind of epiphanic fulfillment both of the viewer-pilgrim, who discovers his or her deepest identity in the presence of the god, and of the god himself, who receives the offerings and worship appropriate to his divinity in the process of pilgrimage rites.

I have been arguing for a visuality which is deeply different from that of naturalism. Let me follow Norman Bryson in this definition of the visuality of naturalistic art: "Between subject and object is inserted the entire sum of

[64] On this "paranoid or terrorist coloration" given to the gaze, see Bryson (1988), 88–94, on the gaze using Sartre and Lacan, and 104–8, on the paranoia of Lacanian subjectivity.

[65] See Rutherford (1995), 277, with n. 5 for bibliography; Rutherford (2000); and especially Nightingale (2004), 3–4, 40–71.

[66] See Pliny, *Natural History* 35.65–66, with the discussions of Bann (1989), 27–40; Bryson (1990), 30–2; Elsner (1995), 17, 89–90; and Morales (1996a), 184–88.

[67] The fundamental discussion of this remains Lacan (1979), 67–119.

discourses which make up visuality, that cultural construct, and make visuality different from vision, the notion of unmediated visual experience. Between retina and world is inserted a screen of signs, a screen consisting of all the multiple discourses on vision built into the social arena."[68] Ritual-centered visuality is no less a cultural construct. But its aim, within a sacred context, is to undermine the multiple discourses of the social arena, the screen of signs produced by and carried over from "everyday life." Instead the pilgrim is put through a process of purification of body and mind, in which the self is prepared in a liminal space for the meeting with a being from the Other World.

This ritual-centered visuality may be defined in many ways—as the putting aside of normal identity and the acquisition of a temporary cult-generated identity, or as the surrendering of individuality to a more collective form of subjectivity constructed and controlled by the sacred site, or as the provision of the deity as a vessel into which individual pilgrims can pour their devotions and their aspirations. But its positive definition (which is always open to contestation, depending on how much of an insider's or an outsider's view one takes) is less important than what this kind of visuality negates. In effect, ritual-centered visuality denies the appropriateness of a Philostratean strategy of interpreting images through the rules and desires of everyday life. It constructs a ritual barrier to the identifications and objectifications of the screen of discourse and posits a sacred possibility for vision, which is by definition more significant since it opens the viewer to confronting his or her god.

The formal appearance of a particular image is less important here than what one might call the naturalism or non-naturalism of viewing. Some cult images (Aphrodite of Cnidos, for instance) were very naturalistic indeed, but the correct ritual preparations and attitudes could prevent the viewer from succumbing to the dangers of voyeuristic projection.[69] The naturalism of the Cnidian Aphrodite—one of antiquity's sexiest and yet most sacredly charged cult images—shows that we are not looking at mutually exclusive visualities that were separate in antiquity, though they may seem so to modern sensibilities. Rather we have a dynamic spectrum of interchanging visualities that appear to have existed in a permanent dialectic and that could manifest together in the same viewer. Temples were not only the centers of pilgrimage but also the prime sites for ancient art galleries (in which images capable of all the naturalistic wiles extolled by Pliny or Philostratus were some of the main exhibits), while cult icons like the Cnidian Aphrodite were among the ultimate

[68] Bryson (1988), 91–92.

[69] Indeed the naturalistic viewing was one of the pitfalls which pilgrims had to circumvent in getting their sacred contemplation right. Other dangers included excessive contemplation and excessively emotional responses. See on all this, Rutherford (1995), 283–86. Further on Aphrodite of Cnidos, see chapter 5 and epilogue below.

BETWEEN MIMESIS AND DIVINE POWER

pinacles of illusionistic verisimilitude. Pausanias, the Greco-Roman viewer whose narrative gives us by far the richest evidence for responses to art, is certainly capable of both kinds of visuality in his text.[70] At issue, then, was the kind of viewing which a spectator might choose at any one time; and of great importance to the choice a spectator might make was the ritual context. What is, by our standards, so strange about ancient visuality is its conflation of regimes of spectatorship, incorporating what may seem to us such antithetical archetypes as "medieval" and "Renaissance," "abstract" and "naturalistic."

Ultimately, in a sacred context, naturalistic images ceased to be necessary, since the kinds of viewing they enticed were at odds with the suppression of such viewing ideally encouraged and policed by ritual. In the context of Greek art and cultural attitudes toward art in the Roman empire, this kind of sacred visuality became gradually associated with archaism. The entire text of Lucian's *De Dea Syria* is self-consciously archaizing, especially in its use of Herodotus' dialect of Ionic Greek instead of the more usual Attic of the period. Pausanias specifically praises the divine nature of the archaic when he comments on the statues of the mythical sculptor Daedalus: "All the works made by Daedalus are somewhat uncouth to look at, but something divine stands out in them."[71] Yet ironicially the archaic would become the modern. It would be in the visual space of sacred ritual, a space inherited from pagan antiquity though of course transformed by the tenets of its own doctrine, that medieval and especially Byzantine Christianity would establish not only its very particular and characteristic sacred forms but also its remarkable theological theorizing of the image.

[70] See Elsner (1995), 150–52.
[71] Pausanias, *Description of Greece* 2.4.5. On Pausanias and Daedalus, see Morris (1992), 246–51; Arafat (1996), 56–57, 67–74; and Freedberg (1989), 34–37.

ANCIENT DISCOURSES OF ART

IMAGE AND RITUAL

Pausanias and the Sacred Culture of Greek Art

IT IS A CLICHÉ THAT MOST GREEK ART (indeed most ancient art) was religious in function.[1] Yet our histories of Classical art, having acknowledged this truism, systematically ignore the religious nuances and associations of images while focusing on diverse art historical issues from style and form, to patronage and production, to mimesis and aesthetics.[2] In general, the emphasis on naturalism in classical art and its reception has tended to present that as divorced from what is perceived as the overwhelmingly religious nature of post-Constantinian Christian art. The insulation of Greek and Roman art from theological and ritual concerns has been colluded in by most historians of medieval images. Take for instance Ernst Kitzinger's monographic article entitled "The Cult of Images in the Age before Iconoclasm."[3] Despite its title and despite Kitzinger's willingness to situate Christian emperor worship in an antique context, this classic essay contains nothing on the Classical ancestry of magical images, palladia, and miracle-working icons in Christian art. There has been the odd valiant exception (especially in recent years),[4] but in general it is fair to say that the religiousness of antiquity's religious art is skirted by the art historians and left to the experts on religion.[5]

[1] See, for example, Stewart (1990), 43–51, and Gordon (1979). Specific discussions of Greek religious images include Gladigow (1985–86, 1990), Scheer (2000), and Bettinetti (2001).

[2] The standard volume for art historians on ancient views of art, Pollitt (1974), is strikingly silent about any aspect of ritual or religion, as already pointed out by Gordon (1979), 8.

[3] Kitzinger (1954).

[4] For example, Barasch (1992), whose history of medieval concepts of the image gives two chapters to antiquity (23–62); and Belting (1994), 36–41 on images and religion, 78–101 on funerary and saints' portraits, 102–114 on the imperial image.

[5] See, for example, Faraone (1992).

It is clearly the case that religious ways of viewing images began to predominate over what may be described as more aesthetic (or even secular) responses to art in the culture of late antiquity.[6] But, while the Second Sophistic produced some of the most impressive aesthetic celebrations of images ever composed in the ancient world,[7] it is also true that it simultaneously generated a remarkable literature which testifies to the ritual, prophetic, and magical importance of art in the Greco-Roman imagination.

To Artemidorus of Daldis (who wrote in the second century A.D.), for instance, statues of gods seen in dreams were no different, from the point of view of a dream interpreter, from the gods themselves (*Oneir.* 2.35, 2.39).[8] Moreover, it was important to be aware of the precise materials from which the divine statue was made,[9] of its position and context,[10] if one was to find the correct interpretation of a dream. In effect, in order to predict the future, the dreamer had to develop an acute and precise visual memory, sensitive to the aesthetics and attributes of divine statues and cult images.

What is particularly striking about texts which refer to images in the second and third centuries A.D. is that ritually motivated, talismanic, and religious modes of viewing existed side by side with aesthetic responses to images—often in the same writer and sometimes in the same text. Take, for example, this aestheticist flourish from Aelius Aristides' speech "Against those who burlesque the mysteries," delivered in early 170 A.D. (*Or.* 34.28): "In modelling and sculpture, by what is the spectator most overcome? Is it not by the fairest and most magnificent statues, the ones which have achieved the limits of perfection in these matters? The Olympian Zeus, the Athena at Athens—I mean the ivory one, and also, if you wish, the bronze one, and by Zeus, if you wish, the Lemnian Athena—all these statues embody the unsurpassable skill of the craftsman and offer unsurpassable pleasure to the spectator." Compare this

[6] See Elsner (1995), 249–87.

[7] For a brief discussion of the ekphrastic literature, see G. Anderson (1993), 147–55. The key texts are the ekphraseis in the novels, in the collections by the Elder and Younger Philostratus and by Callistratus, and in Lucian. The latter have been conveniently collected and edited by Maffei (1994). For discussion, see, on the novels, Bartsch (1989) and Zeitlin (1990); and on the Elder Philostatus, for example, M. E. Blanchard (1986), Bryson (1994), and Elsner (2000).

[8] See Barasch (1992), 32–33.

[9] *Oneir.* 2.39: "Statues that are fashioned from a substance that is hard and incorruptible as, for example, those that are made of gold, silver, bronze, ivory, stone, amber or ebony, are auspicious. Statues fashioned from any other material as, for example, those that are made from terra cotta, clay, plaster, or wax, those that are painted, and the like, are less auspicious and often even inauspicious." See Cox Miller (1994), 29–31.

[10] *Oneir.* 2.37: "If Asclepius is set up in a temple and stands upon a pedestal, if he is seen and adored, it means good luck for all. But if he moves and approaches or goes into a house, it prophesies sickness. For then especially do men need the god. But for those who are already sick, it signifies recovery."

with the following, from the second of Aristides' *Sacred Tales*, composed during his retreat in the winter of A.D. 170–71 (*Or.* 48.41–43):

> Athena appeared with her aegis and the beauty and magnitude and the whole form of the Athena of Phidias in Athens. There was also a scent from the aegis as sweet as could be, and it was like wax, and it too was marvellous in beauty and magnitude. She appeared to me alone, standing before me, even from where I would behold her as well as possible. I also pointed her out to those who were present—there were two of my friends and my foster sister—and I cried out and I named her Athena, saying that she stood before me and spoke to me, and I pointed out her aegis. They did not know what they should do, but were at a loss, and were afraid I had become delirious, until they saw that my strength was being restored and heard the words which I had heard from the goddess. Thus the goddess appeared and consoled me, and saved me, while I was in my sick bed and nothing was wanting for my death. And it immediately occurred to me to have an enema of Attic honey, and there was a purge of my bile.

The appreciation of Phidias' ivory Athena in this vision from the *Sacred Tales* (with its intense emphasis on the goddess's beauty, magnitude, scent, and visual presence) is no less aesthetic or impassioned than in the rhetorical equation of unsurpassable pleasure and unsurpassable skill. But the aesthetics are animated by a spirit of salvific revelation, personally vouchsafed to the sick visionary, which goes beyond art appreciation—beyond the museum visitor's list of "the fairest and most magnificent statues"—into the realms of epiphany and miraculous healing. The enema of Attic honey, one assumes, is the final gift of Phidias' Attic Athena—providing at least temporary alleviation for the sick man's ills.

Even in those ekphrastic texts which one would most clearly identify with a rhetorical celebration of ancient art at its most naturalistic, we occasionally find a prophetic, allegorical, or talismanic flavor to the description of images. In Achilles Tatius' novel *Leucippe and Clitophon* (probably composed in the third quarter of the second century A.D.), a number of key moments are punctuated by vivid ekphraseis of paintings.[11] At 5.4, the sight of an ill-omened picture is taken as a sign: "Those who profess to interpret signs bid us pay attention to the stories of pictures, if such happen to meet our eye as we set forth to our business, and to conclude that what is likely to happen to us will be of the same character as the event of the painted story. You see then how full of miseries is this drawing—unlawful love, shameless adultery, women's woes; I therefore recommend you to desist from this expedition of yours."[12]

[11] See the discussion of Bartsch (1989), 40–79, and chapter 1 above.

[12] On this passage, see Bartsch (1989), 65–69, 72–76; and Goldhill (1995), 71–72.

Needless to say, despite the precautions of the novel's protagonists, the painting's awesome predictions come true. In the ekphraseis of Callistratus, an unjustly neglected series of descriptions of ancient statues written in the third or fourth century, we find a fusion of the ideals of naturalism in art with those of sanctity. In 3.1, discussing the Eros of Praxiteles, as a "sacred work of art," Callistratus proclaims "Bronze gave expression to him, and as though giving expression to Eros as a great and dominating god, it was itself subdued by Eros, for it could not endure to be only bronze; but it became Eros just as he was." Here, in a masterly rhetorical fusion of the traditional tropes of mimesis, desire, and the sacred identity of god and statue, Callistratus presents the very naturalistic illusionism of the sculpture as part of its divine nature as a statue of the god of Desire.[13]

My concern in this chapter is not with the rhetorical alignment of aesthetic and religious discourses of art in the Second Sophistic, nor with a full anthropology of ancient visions, dreams, and functions of images.[14] Rather, one particular element of that anthropology—the use of images in religion and ritual—is my focus. The use of images in religious ritual is a key element in their incorporation into the imaginative and spiritual life of antiquity. It was precisely because of the existence of festivals in which images were periodically dressed, paraded, washed and worshipped, and because of the stories which such repeated sacred actions came to generate, that art could attain the epiphanic and emotional heights of Aristides' vision of Athena, Lucius' devotion to Isis in the *Golden Ass* (*Met.* 11.3–6, 24–25), or Calasiris' worship of Isis in Heliodorus' *Aethiopica* (7.8.7). Such charged moments of religious experience were the energized product of centuries of careful cultivation of sacred images.

As a source on the issue of art and ritual, one text stands out beyond all others in its richness of information about ancient attitudes and practices in relation to images. This is the evidence of Pausanias' *Description of Greece*, written (like the works of Achilles Tatius, Artemidorus, and Aelius Aristides) in the second half of the second century A.D. While other texts, in particular Plutarch's *De Iside et Osiride* and Lucian's *De Dea Syria*, may supplement Pausanias' information-taking with intimations of antiquity's reflections on art and ritual beyond Greece into Egypt and the Levant, no ancient source is so

[13] Compare Callistratus 10.1–2 where, after an elaborate opening which presents the power of Asclepius as dwelling within his statue, the orator reverses the conceit to imply that art, having the power to delineate character and to portray the god in an image of Paean "even passes over into the god himself. Matter though it is, it gives forth divine intelligence, and though it is a work of human hands, it succeeds in doing what handicrafts cannot accomplish." Also Callistratus 8, with Elsner (1998), 245–46.

[14] See Clerc (1915), 9–85. See also Barasch (1992), 23–49.

rich in its discussion of images or in its presentation of antiquarian,[15] mytho-
logical,[16] and religious detail.[17] For my purposes here, it is worth stating that
Pausanias' text belongs with a host of Second Sophistic pilgrimage-related ac-
counts, from the world of Artemidorus' catalogue of dreams, collected in the
temples of Asia Minor, Italy and Greece,[18] via Aelius Aristides' long-held devo-
tion to the cult of Asclepius,[19] to Plutarch's priestly and philosophical reflec-
tions on image and ritual,[20] as well as pilgrimage in the east as evoked by
Philostratus' early-third-century *Life of Apollonius*,[21] and the *De Dea Syria*.[22]

But in the wealth of information offered through Pausanias' systematic
autopsy, in the open juxtaposition of overtly connoisseurial attitudes with
overtly religious ones, in his concern with the sacred heartland of Greece,
Pausanias remains unrivaled.[23] Just as his text offers a kind of schizophrenia
in its combination of myth-historical information with sacred material whose
existence Pausanias signals but which he cannot reveal (except to other initi-
ates),[24] so in his discussion of images, Pausanias presents two discourses of art
(the "art historical" and the "ritual-centered") on an equal level. These dis-
courses, whose simultaneity and coexistence are so distinctive in the Second
Sophistic's writing on art, would eventually—by the fifth and sixth centuries
A.D.—become mutually exclusive. Ultimately the masterpieces and cult im-
ages which Pausanias admires in the temples of Greece, would (after their
removal as prestige museum pieces to Constantinople) be feared, and even
destroyed, as demonic idols.[25]

[15] On Pausanias' antiquarianism, see Hunt (1984), 398–401; Arafat (1992); and Arafat (1996),
43–79. Further on Pausanias, see chapter 1 above.

[16] On Pausanias' myths, see Veyne (1988), 3, 95–102.

[17] For the focus on religion see especially Heer (1979); Frazer (1898), 1: xxxiii; and Habicht (1985),
23 with n. 91.

[18] See Cox Miller (1994), 29–31, 77–91, with bibliography.

[19] On Aelius Aristides and Asclepius, see Behr (1968); Cox Miller (1994), 84–204; Rutherford
(1999); and Petsalis-Diomidis (2002), 88–91.

[20] Some passages of Plutarch evince as much interest in ritual as does Pausanias—for instance, the
discussion of priestly lifestyles and eating habits in *De Iside et Osiride* 4–5, 7–8 (352C–354A), or the
different kinds of offerings in the daily ritual timetable in the same text (79, 383A–384C).

In the *De E apud Delphos*, Plutarch writes of various ritual details which need explaining (2,
385CD). The early-twentieth-century French literature on Plutarch was rich on this topic (if marred
by a series of perhaps inevitable christianizing assumptions)—see Decharme (1904), 413–501, and
Clerc (1914).

[21] See Elsner (1997).

[22] See Elsner (2001a) and Lightfoot (2003).

[23] On the "sacred landscape" of Greece and Pausanias' place in helping us to reconstruct that, see
Alcock (1993), 172–214 (especially 173–75); see also Alcock (1994), 257–59.

[24] See Elsner (1995), 144–52.

[25] On the removal of antiquities to Constantinople, see Mango (1963), Bassett (1991), Madden
(1992), and Bassett (1996, 2000, and 2004). On Byzantine attitudes, see Mango (1963), 56, 59–70;
Saradi-Mendelovici (1990); and L. James (1996).

I concentrate in this chapter on three aspects of the relation of images and ritual in Pausanias.[26] The first is the distinction of a ritual-centered language for art in Pausanias' work from what we might regard as a more conventionally connoisseurial or art historical discourse. The second is where specific images are associated with unusual or remarkable rites, which occasion explicit discussion in the text. The third is where images themselves serve a ritual function.

DISCOURSES OF ART HISTORY AND DISCOURSES OF RITUAL

It is striking that, immediately before entering the Parthenon, Pausanias should devote a longish paragraph to a ritual associated with a statue of Zeus outside the temple:

> . . . and there are statues of Zeus, one made by Leochares and one called Polieus. I shall give the customary mode of sacrificing to the latter without adding its traditional cause. Upon the altar of Zeus Polieus they place barley mixed with wheat and leave it unguarded. The ox, which they keep already prepared for sacrifice, goes to the altar and partakes of the grain. One of the priests they call the ox-slayer, kills the ox and then, casting aside the axe here according to the ritual, runs away. The others bring the axe to trial, as though they do not know the man who did the deed. Their ritual, then, is such as I have described. As you enter the temple they name the Parthenon, all the sculptures you see on what is called the pediment refer to the birth of Athena, those on the rear pediment represent the contest for the land between Athena and Poseidon. (Pausanias 1.24.4–5)[27]

Pausanias here seems more interested in describing the details of the ritual than in the sculptures of the Parthenon, most of which he never mentions. While perhaps he can be accused of somewhat sketchy art history (by the modern student of Greek sculpture in search of a rare glimpse of ancient autopsy), Pausanias presents the anthropologist of ancient religion with a most precise account of the ritual details at the altar of Zeus Polieus. Indeed, in the case of the two statues of Zeus he mentions, we might say that the ritual narrative of sacrifice constitutes a different mode for relating to the image from the art historical. The first statue is described as "made by Leochares" (1.24.4), a famous sculptor of the mid-fourth century B.C. associated in ancient art

[26] Contextual accounts of religion in the Roman empire include MacMullen (1981); Lane Fox (1986), 27–261 (159–60 on statues); especially Beard, North, and Price (1998) and North (2000). Briefly on image and ritual, see Barasch (1992), 33–36.

[27] On this passage, Verrall and Harrison (1890), 423–29; Frazer (1898), ad loc., 2:302–4; and Beschi and Musti (1982), ad loc., 351.

historical legend both with the Mausoleum of Halicarnassus and with Alexander.[28] The second image, which is not linked to a famous artist, is defined by its title "Polieus" and by its particular rites. At the very least, an art historical and a religious appreciation of images are placed side by side. Moreover, when relating the narrative of sacrificial action, it matters to Pausanias that barley be mixed with wheat, that it remain unguarded, that the priest who slays the ox should run away, that it be the axe rather than the man which is brought to trial, and so forth.[29] All this implies not only a very specific selectivity about this particular ritual on the part of those who performed it but also a deep sensitivity and inquisitiveness on the part of Pausanias as participant and observer.[30]

Pausanias emphasizes the entirety of the ritual process from beginning to end. He places the image of Zeus Polieus not within an art history of its commission, creation, and reception, or within an artist-centered narrative of the development of illusionistic form (like the kind of art history we find in Pliny the Elder and occasionally in Pausanias himself), but within a ritual history which describes an exceptional but repeatable process. One might speculate that Pausanias' retelling itself constitutes a literary but still religiously meaningful repetition of the ritual act.[31] Certain details of the ritual—for instance, the mixture of barley and wheat, the use of an axe for the slaughter, the animal being bovine rather than, say, a sheep (the ritual was called the Bouphonia, after all)—are clearly important to its nature; others (for instance, the

[28] See Pliny, *Natural History* 36.30 and Vitruvius, *De Architectura* 7.praef 13, with Stuart Jones (1895), 172–75.

[29] This ritual, the Bouphonia, is also described as length by Theophrastus, quoted by Porphyry, *De Abstinentia* 2.29f. There, unlike in Pausanias, the *aition*-myth for the cause of the ritual is given; see Bruit Zaidman and Schmitt Pantel (1992), 169–71.

[30] As a compiler of local rituals Pausanias rates quite as highly as he does in the collection of myths. On Pausanias as mythographer, see especially Veyne (1988), 3, 13–14. For further examples of Pausanias' ritual precision, see 1.27.2–3 (on the Arrhephoria); 2.11.7–8 and 12.1 (on the image of Coronis and sacrificial practice at the sanctuary of Asclepius at Titane); 2.35.5–8 (the festival of Chthonia at Hermione); 3.14.9–10 (comparative puppy sacrifices at Sparta and Colophon); 5.13.2–3 (sacrificial rules at the Pelopium in Olympia and a comparison with those at Pergamus on the river Caicus); 5.13.8–5.14.3 (the sacrificial rituals at the altar of Olympian Zeus); 5.15.10–11 (the monthly Elean sacrificial liturgy at all the altars at Olympia—whose order Pausanias follows in his description at 5.14.4–10); 5.16.7–8 (women's rituals at the Heraean games in Olympia); 6.20.2–4 (the rituals in honor of Eileithuia and Sosipolis at Mount Cronius); 7.18.9–13 (the Laphria festival at Patrae in honor of Artemis); 7.20.1–2 (the rituals at the Eurypylus festival, Patrae); 8.2.2–3 (comparison of human and nonanimal sacrificial practice); 8.13.1 (rituals in the lifestyle of the priest and priestess of Artemis Hymnia at Orchomenos, with comparanda from the cult of Artemis of Ephesus); 8.15.2–4 (rites of Demeter at Pheneus); 8.37.8 (unusual sacrificial rituals to the Mistress near Acacesium); 9.2.7–9.3.8 (the festival of Daedala at Plataea); 9.39.5–14 (rituals at the oracular shrine of Trophonius).

[31] For writing as *rite de passage*, see Harbsmeier (1987), 337. For writing as itself a form of literary pilgrimage, see (on Gregory of Tours in late antique Gaul) Van Dam (1993), 142–49.

number of priests involved in this sacrifice, which Pausanias does not specify) are perhaps not essential and could be varied. In the case of this ritual, unlike a historian, whom we might expect to search out a reason for a historical phenomenon, Pausanias is quite explicit about not going into the ritual's "traditional cause." In this kind of narrative and this kind of viewing, certain issues are taboo. Later in his description of the Acropolis, when approaching the Erechtheum (1.26.5), Pausanias again gives precise information about the ritual niceties of its altars:

> There is also a building called the Erechtheum. Before the entrance is an altar of Zeus the Most High, on which they never sacrifice a living creature, but offer cakes, not being wont to use any wine either. Inside the entrance are altars, one to Poseidon, on which in obedience to an oracle they sacrifice also to Erechtheus, the second to the hero Boutes, and the third to Hephaestus. On the walls are paintings representing members of the clan Boutadae; there is also inside—the building is double—sea-water in a cistern. This is no great marvel, for other inland regions have similar wells, in particular Aphrodisias in Caria. But this cistern is remarkable for the noise of waves it sends forth when a south wind blows. On the rock is the outline of a trident. Legend says that these appeared as evidence in support of Poseidon's claim to the land.[32]

Whereas he fails to mention the Caryatids, Pausanias nonetheless focuses carefully on which foods cannot be offered at the altar of Zeus and on how the altar of Poseidon is shared by Erechtheus as a recipient of sacrifice. He is far from insensitive to either visual or architectural matters (he mentions both the paintings and the fact that the "building is double"), but his focus is principally on ritual details and on natural wonders or phenomena (the sea-water cistern, the sign of the trident) and their mythological causes in the ancient foundation myths of Athens. Note that this time Pausanias gives causes—the origins of natural wonders are not problematic in the way that the origins of ritual acts may be. Through myth, especially the link to Poseidon, these sights are tied directly back to the rituals with which Pausanias opens his account of the Erechtheum—namely the linkage of Poseidon with Erechtheus through the shared altar. In effect, Pausanias offers here a hint at an ancient view of these sacred precincts not in terms of modern art historical notions of decoration or architecture but in the light of ancient mythic and liturgical expectations within a holy place.

In trying to construct a cultural history of ancient Greek art—of what

[32] On this passage, see Verrall and Harrison (1890), 483–96; Frazer (1890), ad loc., 2:330–40; and Beschi and Musti (1982), ad loc., 361–62.

images meant and how they were related to—we must look not only at the objects which survive or the ways such images were imagined in highly literary texts like the *Imagines* of Philostratus or the novels, but also at the religious reflexes of viewers like Pausanias. In this respect what matters is the stories that were told and believed about rituals, not the historicity of the claims about past events that Pausanias relates. Of course, Pausanias does offer a significant discourse of art history in a recognizable sense. There are hints in his text of an evolutionary account of the development of sculpture parallel to that of Pliny.[33] There are frequent lengthy descriptions of important works of art, from programs of painting and sculpture,[34] to highly decorated objects like the chest of Cypselus at Olympia or the throne of Apollo at Amyclae,[35] to the major cult statues.[36] Some of these offer a marked aesthetic sensibility, as when Pausanias comments on Phidias' most celebrated statue (5.11.9): "I know the height and breadth of the Olympic Zeus have been measured and recorded, but I shall not praise those who made the measurements, for even their records fall short of the impression made by the sight of the image." Moreover, as we shall see in chapter 3, Pausanias' extensive exposure to ancient art of all periods and types elicits a series of connoisseurial observations hardly out of place in a traditional formalist art history.

However, my point is that beside this highly developed language of aesthetics, style, and historical evolution, is a discourse of ritual all too often suppressed in modern accounts of ancient art. As I suggested earlier, Pausanias is by no means a unique case in Second Sophistic's art appreciation of the religious. In Philostratus' *Life of Apollonius of Tyana*, for instance, the statue at Olympia of the athlete Milo clasping a pomegranate is described and explained by the sage (4.28). An art historical formulation of the image ("the antique style of the sculpture") stands side by side with both local myths ("the stories told among the people of Olympia and Arcadia") and Apollonius' own explanation, relating the iconography to ritual details in which the pomegranate is revealed to be a fruit sacred to Hera and Milo to have been her priest. This combination of art historical and ritual-centered discourses is echoed by Philostratus at the *Life of Apollonius* 6.4, where the statue of Memnon

[33] On Pausanias' interest in techniques and materials for dating objects, see Arafat (1992), 392–97, and, on Pausanias' "Plinian' view of the development of sculpture as one straightforward process punctuated by [artistic] innovators," ibid., 403–6 (quotation at 405).

[34] For example, the paintings of the Stoa Poikile at Athens (1.15.1–3), Polygnotus' murals at Delphi (10.25.1–31.12), and the architectural sculpture at the temple of Zeus in Olympia (5.10.6–9).

[35] The Chest of Cypselus: 5.17.5–19.10 (with Snodgrass, 2001); the throne at Amyclae: 3.18.10–19.1.

[36] For instance, Athena Parthenos (1.24.5–7), Hera of Argos (3.17.1–3), Asclepius at Epidaurus (2.27.2), Zeus at Olympia (5.10.2 and 5.11.1–11), Aphrodite Ourania (6.25.1).

IMAGE AND RITUAL

in Egypt is seen stylistically (as "Daedalic"),[37] as a *thauma* (in the context of the travel narrative of Apollonius visiting Egypt), and as a religious object. Apollonius and his party not only "understood that the figure was in the act of rising to make obeisance to the sun" but go so far as to emulate the image in sacrificing to the "Sun of Ethiopia" and then to Memnon himself.

IMAGE AND RITUAL

As we have seen, the ritual appreciation of an image may be seen as a kind of alternative (not necessarily an exclusive one) to what we would regard as a more straightforwardly art historical response. At Sicyon, Pausanias notes (2.10.1):

> In the gymnasium not far from the market-place is dedicated a stone Heracles made by Scopas. There is also in another place a sanctuary of Heracles. The whole of the enclosure here they name Paidize; in the middle of the enclosure is the sanctuary, and in it is an old wooden figure carved by Laphaës the Phliasian. I will now describe the ritual at the festival. The story is that on coming to the Sicyonian land Phaestus found the people giving offerings to Heracles as to a hero. Phaestus then refused to do anything of the kind, but insisted on sacrificing to him as to a god. Even at the present day the Sicyonians, after slaying the lamb and burning the thighs upon the altar, eat some of the meat as part of a victim given to a god, while the rest they offer as to a hero.[38]

Here the theme of Heracles is introduced through a stone image by a famous name, the fourth-century B.C. sculptor Scopas (another of those responsible for the Mausoleum).[39] However, although he opens in an art historical vein, Pausanias moves by association to another sanctuary of Heracles, at Sicyon but "in another place." This also has a statue, which Pausanias describes by its age and medium as "an old wooden figure" and by its artist, Laphaës the Phliasian. More interesting to him, however, or at least described at greater length, are the festival and rituals over which Laphaës' statue presides.

The rituals at the Paidize combine the kinds of offerings made to a god with those made to a hero.[40] Pausanias' account is not simply a catalogue of mythological charters given for such practice, nor a random listing of liturgical oddities (such as the details of the sacrifice) for their own sake. The ritual

[37] On the "Daedalic style" in Greco-Roman art writing, see Morris (1992), 238–56; Spivey, (1995), 446–48; and Spivey (1996), 56–63. On Pausanias and Daedalus, see Morris (1992), 246–51, and Arafat (1992), 403–4. On Daedalus and statuary in Greek writing, see Steiner (2001), 46–47, 143–44.

[38] For discussion of worship of Heracles as hero and god, see Frazer (1898), ad loc., 3:64.

[39] See Stuart Jones (1895), 168–72, 177–80. On the Heracles at Sicyon, see Stewart (1977), 90–91.

[40] On hero and divine sanctuaries in Greece, see Kearns (1992).

combination of deity and hero worship raises a theological question in material and performative terms. The myth gives two versions of Heracles—the hero whom the Sicyonians had venerated and the god whom Phaestus honored. Contemporary ritual practice resolves the theological conflict about the status of Heracles by performing both kinds of worship. In doing so, it prompts a ritual-sensitive viewer like Pausanias to question the peculiarity of this particular version of Heracles at the Paidize.

Pausanias turns to the myth to understand the ritual and the deity in the sanctuary. Art and its liturgical context have a theological resonance far beyond their formal, material, or stylistic implications. Beside the discourse of artists, which relates so alluringly to post-Renaissance art historical concerns, is a liturgical and theological discourse of art far closer to early Christian disputes about whether the Virgin was Theotokos or Christotokos (Mother of God or Mother of Christ), and to the long history of discussion about how exactly Christ could combine two natures (divine and human) in one person. For the Sicyonians, the cult of Heracles at the Paidize manages to combine two normally exclusive identities: Heracles is both a god and a hero. The difference between these roles is emphasized by the different kinds of sacrifice, but the unity of its being one and the same Heracles worshipped in this way is defined by the single statue which receives the rituals. Art and ritual are here inextricably, theologically linked.

Beside this theological quality to images in their sacral context, a quality which in some sense defines the nature of the deity,[41] is a more magical resonance. Take the strange story of the sanctuary of Artemis Orthia at Sparta (Pausanias 3.16.7–11):

> The place named Limnaeum is sacred to Artemis Orthia. The wooden image there they say is that which once Orestes and Iphigeneia stole from out of the Tauric land, and the Lacedaemonians say it was brought to their land because there also Orestes was king. . . . The Spartan Limnatians, the Kynosourians, the people of Mesoa and Pitane, while sacrificing to Artemis, fell to quarrelling, which led also to bloodshed; many were killed at the altar and the rest died of disease. Whereat an oracle was delivered to them, that they should stain the altar with human blood. A man used to be chosen by lot and sacrificed; but Lycurgus changed the custom to a scourging of youths, and so in this way the altar is stained with human blood. By them stands the priestess, holding the wooden image. Now it is small and light, but if ever the scourgers spare the lash because of a youth's beauty or high rank, then at once the priestess finds the image grows so heavy that she can hardly carry it. She lays the blame on the scourgers, and says that it is their fault that she is being weighed down. So

[41] See Beard (1985), 211.

the image ever since the sacrifices in the Tauric land keeps its fondness for human blood.[42]

This is a famous image, with an impeccable mythical pedigree. Here we are altogether outside art historical discourse and into a world where certain material objects are linked with the mythical and divine past, the sacred Greece which gives meaning to Pausanias' modern narrative.[43] The theology of this statue, unlike the Sicyonian Heracles, lies not so much in the different kinds of worship appropriate to it as in its miraculous qualities and its relentless demand for human blood. The statue of Artemis Orthia, like other sacred marvels in Pausanias' text, breaks natural laws in becoming heavy when not offered enough blood and challenges human taboos with its need for the blood of human beings.[44]

With Artemis Orthia we have no reference to an artist (the statue was a *xoanon*), although the image is quite precisely described—"small," "light," and "wooden." Instead Pausanias tells the myth of its origins. Not only is it identical with the famous Tauric statue (which had figured in Euripides' play *Iphigeneia in Tauris*), but it is linked through Orestes with the place in which it now receives worship. Pausanias reports some dispute about which of several claimants is the real Tauric goddess (statues belonging to the Lydians, the Cappadocians, and the Syrians of Laodiceia were also candidates for the honor, 3.16.7–8),[45] but he has no doubt that the authentic image is this one. His reasons are based on the image's supernatural powers as demonstrated by the ritual he describes. Ritual and magical power define authenticity. It is not custom or ritual practice which demands the shedding of human blood, it is the statue itself; this blood (for which the goddess has what is described as a "fondness" or "enjoyment," ἥδεσθαι, 3.16.11) is the link between the Orthia and its origin among the Taurians.

In the ritual of flogging with its elision of and yet allusion to human sacrifice,[46] and in the strange heaviness which overcomes the statue if her altar's intake of blood is insufficient, we are offered some sense of the danger of cult images in antiquity. Such statues are not to be profaned—as the disease and death of those who originally quarreled at her altar attest. In this sense the art

[42] On this passage see Frazer (1898), ad loc., 3:340–44; Musti and Torelli (1991), ad loc., 226–27, with archeological bibliography. Another Second Sophistic account of this image, largely in accordance with that of Pausanias, is in Philostratus, *Life of Apollonius* 6.20. On the Orthia festival generally, see Kennell (1995), 70–76.

[43] See Elsner (1995), 144–52.

[44] Compare the sanctuary of Lycaean Zeus in Arcadia (8.38.6) with Elsner (1995), 147–48.

[45] On this dispute, see Heer (1979), 228–29.

[46] On the occasional death of flogged youths, see Plutarch, *Lycurgus* 18.2, with Kennell (1995), 73–74.

object is not entirely distinct from the goddess it represents. One is reminded of the Aphrodite of Cnidos in the *Amores*, a text perhaps written not much after Pausanias in the late second or early third century A.D., quite possibly by Lucian. This Aphrodite—placed in a position so as to be as visible as possible, to be seen in her nudity from all sides—is capable of representing the ideal object of sexual desire to both a straight man and a gay man (*Amores* 13–14). But when a youth does succumb to the forbidden temptation, interacting not merely with the eyes but physically, his attempt at lovemaking is marked by a permanent blemish on the statue and he is punished by suicide (*Amores* 16–17).[47]

The Artemis Orthia belongs to a whole world of charismatic and miraculous images in Greco-Roman religion.[48] Sacred images may be magical—whether this magic belongs to myth-history, like the tale of Seleucus' sacrifice (1.16.1), when "the wood that lay on the altar advanced of its own accord to the image and caught fire," or to personal experience.[49] Pausanias himself witnessed the wood which caught light without fire following magical incantations chanted by Lydian priests at Hierocaesareia and Hypaepa (5.27.5), and the supernatural effects on the offerings made to Mycalessian Demeter (9.19.5): "Here is shown the following marvel. Before the feet of the image they place all the fruits of autumn, and these remain fresh throughout the year." Statues may be apotropaic, able to bind wandering spirits and prevent them from troubling the land.[50] Take the case of the image of Actaeon at Orchomenos (9.38.5): "A ghost, they say, carrying a rock was ravaging the land. When they inquired at Delphi, the god bade them discover the remains of Actaeon and bury them in the earth. He also bade them make a bronze likeness of the ghost and fasten it to a rock with iron. I have myself seen this image thus fastened. They also sacrifice to Actaeon as to a hero." Numinous images may have miraculous effects on their beholders—not only healing, as we have seen in the case of Aelius Aristides,[51] but also instilling remarkable qualities (10.32.6): "There is also near Magnesia on the river Lethaeus a place called Aulae where there is a cave sacred to Apollo, not very remarkable for its size, but the image of Apollo is very old indeed, and bestows strength equal to any

[47] On this text, see Foucault (1990), 212–13; R. Osborne (1994), 81–85; Goldhill (1995), 102–110 (especially 103–4); and chapter 6 below. On the statue, see for example, Havelock (1995); Stewart (1997), 97–107; and R. Osborne (1998), 230–35.

[48] An excellent modern discussion of one category of such images (apotropaic or talismanic statues) is Faraone (1992) with the review discussions in the *Cambridge Archaeological Journal* 4 (1994): 270–89.

[49] On images and magic, see Clerc (1915), 63–82.

[50] See Faraone (1991) and (1992), 74–93, 136–40; Barasch (1992), 36–39.

[51] On Aristides, see Lane Fox (1986), 160–63, and Miller (1994), 184–204; on statues and healing, see Clerc (1915), 37–45.

task. The men sacred to the god leap down from sheer precipices and high rocks, and uprooting trees of exceeding height walk with their burdens down the narrowest of paths."[52] Some images—like the horse statue dedicated by Phormis at Olympia—may affect animals as well as humans with supernatural charisma (5.27.3). Finally, as the works of Aelius Aristides and Artemidorus repeatedly emphasize, images were closely associated with dreams of a prophetic, curative, or protective nature.[53] Such dreams might occur in front of images, might include images, or might protect beholders from revealing what they have seen in a particular sanctuary, including its statues and works of art.[54] Or dreams might lead the beholder into a holy place, as at the shrine of Isis outside Tithorea and the temples of the nether gods near the Meander (10.32.13).

The range of ancient responses to art cannot be fully accommodated without giving serious consideration to the kinds of attitudes and sacredly charged images so vividly portrayed by our ancient sources and in particular by Pausanias. It is all too tempting to rely on antiquity's more philosophical and literary accounts, with their sophisticated plays on naturalism and enargeia, their polemical rhetoric and their moralizing agendas. Beside this literary world, in which art was really quite profoundly theorized (especially during the Second Sophistic) by the likes of the Philostrati, is a world of religious phenomenology, magic, and initiation, in many ways more familiar from Byzantine and medieval saints' lives than from the evolutionary art histories of naturalism reproduced by Pliny, Quintilian, and Cicero.[55]

IMAGE AS RITUAL

A particular, in some ways extreme, form of the sacred phenomenology of images can be glimpsed in those moments when Pausanias describes works of art that themselves became elements of ritual. Take the case of the offering of the Orneatai at Delphi (10.18.5):

> The men of Orneae in Argos, when hard pressed in war by the Sicyonians, vowed to Apollo that, if they should drive the host of the Sicyonians out of their native land, they would organize a daily procession in his honour at Delphi, and sacrifice victims of a certain kind and of a certain number. Well, they conquered the Sicyonians in battle. But finding the daily fulfilment of their

[52] See Frazer (1898), ad loc., 5:401.

[53] On images and dreams, see Clerc (1915), 49–54; Barasch (1992), 31–33; and Miller (1994), 28–35.

[54] For instance, the dreams Pausanias himself has at the Athenian Eleusinium (1.14.3), at Eleusis itself (1.38.7), and at the Camasian Grove outside Messene (4.33.4–5).

[55] See, for example, Pliny, *Natural History* 34.54–65, 35.1–148; Quintilian, *Inst. Or.* 12.10.1–9; Cicero, *Brutus* 70; see also Pollitt (1974), 73–84.

vow a great expense and a still greater trouble, they devised the trick of dedi-
cating to the god bronze figures representing a sacrifice and a procession.

In one sense this is a nice story and, as Pausanias concedes, a clever *sophisma*.
But that ignores the fact that the Orneatai had to find a way out of their
dilemma—a way that would not ruin them financially and would not offend
the god. It was through visual representation, through creating mimetic im-
ages, that they resolved the problem. But their imitation was more than a
mere group of images, certainly more than a "trick."[56]

Their bronze offering imitated not just particular figures and animals but
rather a process of sacrificial action. This is a different level of mimesis from
that usually discussed by ancient art theory (from Plato onward), since it im-
itates not so much a static object as a dynamic set of relations, not just some-
thing material but a performance. Moreover the offering from the Orneatai
had an identity with the ritual they had promised; not only did it represent
the sacrifice and procession they had vowed, but—so far as the god was
concerned—it *was* that sacrifice and procession. Again we find ourselves close
to the kinds of identity between image and representation theorized by
Christian theologians to justify the way Christ could be identical with his
icon in person but not in substance. The bronzes from Orneae are not the
same as a "real" procession and sacrifice in material terms, but nevertheless
are that ritual in the terms necessary to satisfy the god.

The implications of the offering from Orneae are formidable. Much an-
cient art is blandly labeled "votive" in the handbooks. But if "votive" in its
antique context should evoke anything like what the bronzes of the Orneatai
at Delphi suggest, then we must radically revise our sense of the power and
significance of such offerings. They were not simply works of art, gifts, or to-
kens of exchange with the gods;[57] they may have carried magical and dynamic
religious properties—they may also have been charged ritual objects in their
own right. Moreover, the notion of performative or ritual imitation compli-
cates the dynamics of mimesis in ways not usually suggested by those for
whom imitation implies naturalism and illusion. On the contrary, we have
here kinds of mimesis which prefigure the ways in which the emperor or the
eucharist could be seen as imitations of Christ.

One question constantly raised by these various ritual meanings and con-
texts for images is the relation of the representation to its prototype.[58] In

[56] The *sophisma* is related to what Faraone (1992) calls the "ruse of the talismanic statue," see
94–112.

[57] For a survey of these aspects of ancient votives, see Linders and Nordquist (1987).

[58] Relevant here are the reflections of Freedberg (1989), 61–81, 83–84 (mainly on ancient Classical
images).

what sense is an image identical with the deity or activity it represents? The magical and theological properties of images, as well as the way the offering of the Orneatai could actually substitute as a ritual, hint at a much more dynamic interpenetration of image and referent, representation and prototype, than we usually allow for in discussions of mimesis. As in the ancient practice of iconoclasm and *damnatio memoriae*, the elimination of memory through the demolition of images and inscriptions, where on some level the destruction of the image is the destruction of the person condemned, so here more positively the worship or context of the image asserts the actual presence of its prototype.

On the complexity of the image-referent relationship, let us look briefly at Pausanias' discussion of the statue of Theagenes of Thasos (6.11.6–9).[59] Theagenes was an extremely famous athlete who had won 1,400 crowns (6.11.5). His story is introduced with the following anecdote (6.11.2–3): "In his ninth year they say, as he was going home from school, he was attracted by a bronze image of some god or other in the market-place; so he caught up the image, placed it on one of his shoulders and carried it home. The citizens were enraged with what he had done, but one of them, a respected man of advanced years, bade them not to kill the boy, and ordered him to carry the image from his home back again to the market-place. This he did and at once became famous for his strength, his feat being celebrated throughout Greece." The supernatural strength of Theagenes and his fame are made to rest on relations with a statue.

This interplay of man and bronze image continues after Theagenes' death with the following account (6.11.6): "When he departed this life, one of those who were his enemies while he lived came every night to the statue of Theagenes and flogged the bronze as though he were ill-treating Theagenes himself. The statue put an end to the outrage by falling on him, but the sons of the dead man prosecuted the statue for murder."[60] The idea of Theagenes having "departed this life" is undercut not only by his enemy's treatment of his image as though he were alive, but more supernaturally by the statue's own response in punishing the assailant. The statue is not only prosecuted but found guilty and punished with exile by being dropped into the sea. However, when famine comes upon the Thasians, the Delphic oracle instructs them to receive back the exiles. This they do, interpreting the oracle to mean exiled people, but their action still fails to stop the famine. A second trip to Delphi yields the response (6.11.8): "But you have forgotten your great Theagenes." Pausanias continues (6.11.8–9):

[59] On this story, see Frazer (1898), ad loc., 4:38–39.

[60] This story was often repeated and referred to in antiquity, cf. Dio Chrysostom, *Oratio* 31.95–99, and Eusebius, *Praeparatio Evangelica* 5.34.

And when they could not think of a contrivance to recover the statue of Theagenes, fishermen, they say, after putting out to sea for a catch of fish caught the statue in their net and brought it back to land. The Thasians set it up in its original position, and are wont to sacrifice to him as to a god. There are many other places that I know of, both among the Greeks and among barbarians, where images of Theagenes have been set up, who cures diseases and receives honours among the natives.

The dropping of the statue into the sea was an act of legal banishment. Yet even in exile, the image was present in the city (as its prototype was present in the image)—so much so that famine ravaged the land. On its return, the image was not simply restored to its place but treated very differently. Its journey into the sea and back had become a *rite de passage* beyond heroism into divinity. The private flogging of Theagenes by an enemy was replaced by public rituals of worship; the original attraction of Theagenes as a boy to a bronze statue of a god which had pointed to his unique strength as an athlete was mirrored in his identity with a bronze statue which marked his divinity. This divinity is proved by other images of Theagenes Pausanias knows, which cure diseases.[61] The god may be present not only in one image but (simultaneously) in many. Indeed this is one way in which his divine nature is marked.

FROM POLYTHEISM TO CHRISTIANITY

No ancient writer sat back and assessed or conceptualized the relations of art and ritual—indeed such reflective thinking about the validity of art in relation to religion was a signal contribution of Christian theology. However, in his painstaking enumeration of particular instances, Pausanias certainly provided a rich evidential base for the range of practices with images which took place in Roman Greece and for the stories recounted to justify or explain such rituals. Perhaps the critical element underlying the sacred functions and supernatural qualities of art in this ritual-centered discourse is an identity (posited by worshippers) between the god and the image, or the act and its representation (as in the case of the sacrifice of the Orneatai). The represented is not just *in* the image, the represented *is* the image.

This point, of the identity of prototype and representation, is vividly emphasized in the account of the bearded, oracular Apollo in the *De Dea Syria*, probably written by Lucian in the second century A.D. (36–37):

> About his deeds I could say a great deal, but will describe only what is especially remarkable. I will first mention the oracle. There are many oracles among

[61] For the image of Theagenes as a healing statue, see also Lucian, *The Parliament of the Gods* 12.

the Greeks, many among the Egyptians, some in Libya and many in Asia. None of the others, however, speaks without priests or prophets. This god takes the initiative himself and completes the oracle of his own accord. This is his method. Whenever he wishes to deliver an oracle, he first moves on his throne, and the priests immediately lift him up. If they do not lift him up, he begins to sweat and moves still more. When they put him on their shoulders and carry him, he leads them in every direction as he spins around and leaps from one place to another. Finally the chief priest meets him face to face and asks him about all sorts of things. If the god does not want something to be done he moves backwards. If he approves of something, like a charioteer he leads forward those who are carrying him. In this manner they collect the divine utterances, and without this ritual they conduct no religious or personal business. . . . I will tell something else which he did while I was present. The priests were lifting him up and beginning to carry him, when he left them below on the ground and went off alone into the air.

About a statue like this there are no doubts: it is identical on some level with the deity, its every action pulsates with holy charisma. However cynically we may read the text to adduce the invention and manipulation of a phenomenon by a priestly class (and there is evidence in Lucian's other writings of such cynicism about religious "extremists"—for instance in his *Alexander the False Prophet* or his *Peregrinus*),[62] the many worshippers at the temple did not see it in this way. For them, this image was a god, its actions were supernatural, its utterances oracular.

It is here, in the supernatural identity of image and prototype, that the Second Sophistic's "ritual-centered" discourse of sacred art (in writers like Pausanias and the Lucian of the *De Dea Syria*, as well as in Artemidorus' dreams of statues and gods, and in the visions of Aelius Aristides) parts company with the "aestheticist" discourse of ancient art history. For the very themes of deception, absence, and illusion which characterize mimesis and which are most eloquently praised by such writers as the Philostrati (or by Lucian in ekphraseis like *Zeuxis*) are impossible to reconcile with the fact that a particular stone or wooden image may be experienced by its worshippers as a miracle-working god: in the identity of stone and deity there is no space for the imitations, deceptions, and illusions of naturalism. When the Younger Philostratus says that the deception (ἀπάτη) inherent in art is pleasurable and involves no reproach since no harm can come of it (*Imagines* proem 4), he is writing from a series of assumptions radically different from those which

[62] On these two cases, see the discussion of C. P. Jones (1986), 117–48. Generally on Lucian and religion, see ibid., 33–45, and Lightfoot (2003), 199–200.

inform the ritual discourse of the danger of images because of the presence of their supernatural prototypes.

The special interest of the Second Sophistic's writings on art lies in this unresolved conflict about the status of images: either they deceive with all the eloquence of illusionism or they are what they portray in a supernatural and potentially dangerous manner. At rare moments the two discourses may appear to fuse in a rhetorical hyperbole (as in the passage by Callistratus quoted earlier), at times they coexist in the same writer (as in the diverse works, ekphrastic and religious, by Lucian) or even in the same text (as in Pausanias). But the axioms on which these two discourses operate—deception (which is to say, difference, in that one thing pretends to be another) and identity—are mutually exclusive.

When seen in these terms, the arrival of Christianity in the fourth century would not involve a straightforward artistic shift from the naturalistic splendors of classical art to the schematic forms of religious symbolism (as has so often been asserted). Rather, there was the gradual suppression of "deceit" (images which appeared to be what they were not) coupled with a powerful affirmation of the ritual nature of art. Images as an integral element of sacred ritual would be bolstered by the force of theological justification, especially during and after the period of Byzantine Iconoclasm. The theology was precisely targeted at the issue of identity—so, for instance, the icon of Christ was identical with him in person but not in substance.[63] This distinction allowed icons to be worshipped, to cause miracles, to perform in civic and sacred ritual, while at the same time preserving them from being idols (that is, mere wood or stone worshipped as if it were divine).[64]

Because, in this sense, the Christian production and use of art was a theologically justified and adapted refinement of the practices of Greco-Roman polytheism, we can detect remarkable similarities and continuities between the classical and the Christian phenomenologies of religious image-worship. For instance, there is a striking correspondence between the account of the spinning and staggering image of Apollo in the *De Dea Syria* and Russian pilgrims' (much later) descriptions of the Hodegetria icon of the Virgin and child, the palladium of Constantinople, whose icon staggered with divine charisma

[63] For discussion of the Iconophile apology for icons, see, for example, Barasch (1992), 185–243, especially 192–98; Pelikan (1990), especially 67–98; Besançon (2000), 126–46. For a view of the arguments of Iconoclasm in an ancient intellectual context stretching back to Plato, see C. Osborne (1987).

[64] At the same time, Greek Christianity retained the language and style of ancient ekphrasis (including all the tropes of mimesis) with which to celebrate its sacred images. Likeness, however, in the Byzantine context, referred to the spiritual nature of the prototype and not to a naturalistic imitation of physical presence. See James and Webb (1991), 12–14; Nelson (2000b), 143–51; L. James (2004), 531–32.

in its weekly street processions through the city on Tuesdays.[65] Likewise, the phallus-climbers of the *De Dea Syria* have a certain affinity with Stylite saints who became a feature of the same region in the fifth century.[66] Again, the ritual precision of Pausanias' description of *Graecia religiosa* is paralleled by the wealth of liturgical detail and precision highlighted in our most important early Christian account of Jerusalem pilgrimage. Writing in the 380s, the Spanish lady Egeria devotes a large section of what survives of her description to the daily services of the holy places (*Peregrinatio Egeriae* 24.1–49.3, where the manuscript abruptly breaks off).[67] Like Pausanias, Egeria is sensitive to the visual and architectural ambience of ritual,[68] but is in the end less interested in the art per se than in its religious and liturgical uses.

The burden of my argument in this chapter has been to emphasize a ritual-centered attitude to images in antiquity, which influenced both ways of seeing and ways of thinking about art. The importance of ancient art within a religious sphere of experience is part of a deep continuity between pagan and Christian, ancient and medieval responses to images (despite the profound changes in conceptualizing and defining the icon which Christian theology introduced). Art history has tended to assume that classical art—the art of naturalism and ekphrasis—was much more like Renaissance art and art writing than it was like the arts of the Middle Ages;[69] but the evidence for image and ritual should give us pause for thought. It may in fact be that the sacred images of Byzantium and the medieval West were closer to the arts of ancient polytheism than either the church fathers or the Renaissance antiquarians would have wished or acknowledged.

[65] See the fourteenth-century description by Stephen of Novgorod in Majeska (1984), 36.

[66] See Frankfurter (1990), 184–88, on the methodological problem of generalization and "archetypalism"; also Lightfoot (2003), 418–21.

[67] On Egeria and liturgy, see J. Wilkinson (1971), 54–88, and Baldovin (1987), 55–64, 90–93.

[68] For instance 25.8–9 on the decor of the churches, 36.5–37.3 on the relics at the Holy Sepulchre.

[69] Such is the implication, for instance, of E. H. Gombrich's discussion of Classical art (1960), 99–125, and (1976), 3–18.

<div style="text-align: center; border: 1px solid black; display: inline-block; padding: 10px;">

3

</div>

DISCOURSES OF STYLE

Connoisseurship in Pausanias and Lucian

> *Sculptors and painters without long experience in training the eye by studying*
> *the works of the old masters would not be able to identify them readily, and*
> *would not be able to say with confidence that this piece of sculpture is by Poly-*
> *clitus, this by Phidias, this by Alcamenes; and this painting is by Polygnotus,*
> *this by Timanthes and this by Parrhasius.*
>
> —Dionysius of Halicarnassus, *Demosthenes* 50

WE THINK OF THE LANGUAGE of style and connoisseurship as a peculiarly characteristic discourse of twentieth-century art history—not just in the hands of professional scholars but also in the milieu of collectors, auction houses, and dealers.[1] Yet antiquity also had a language and practice of connoisseurship, as implied by the epigraph above from an essay by the Greek antiquarian and rhetorician Dionysius of Halicarnassus, who lived in Rome during the reign of Augustus.[2] Ancient connoisseurship was based on a stylistic appreciation of objects that was itself founded in a combination of aesthetic esteem and empiricism, as is that of the modern era. What the Greeks of the Roman empire, my subjects here, did with that expertise is, however, perhaps a little different from the impact of style art history in the era of positivism.

Let us begin with what constitutes a famous beginning in the writing of modern art history. That classic manual of formalist art historical analysis, *The Principles of Art History*—subtitled *The Problem of the Development of Style in Later Art*—published in 1915 by the great Swiss art historian Heinrich Wölfflin (1864–1945), opens like this: "Ludwig Richter [the Dresden painter and illustrator who lived from 1803 to 1884] relates in his reminiscences how once, when he was in Tivoli as a young man, he and three friends

[1] The literature on style is vast. Two classic pieces are Schapiro (1994), 51–102, and Gombrich (1968). See also Sauerländer (1983), Summers (1989), Davis (1990), Panofsky (1995), Elsner (2003C), also the collections of essays in Lang (1979) and Van Eck, McAllister, and Van de Vall (1995).

[2] For the standard rhetorical comparison of the styles of classic orators with the styles of canonical artists, see, for example, Cicero, *Brutus* 70 and *De Oratore* 3.26; Dion. Hal. *Isocrates* 3; Quintilian 12.10.

set out to paint part of the landscape, all four firmly resolved not to deviate from nature by one hair's-breadth; and although the subject was the same, and each quite creditably produced what his eyes had seen, the result was four totally different pictures, as different from each other as the personalities of the four painters."[3] Richter and Wölfflin would certainly agree with the greatest of all connoisseurs of antique art, Sir John Beazley, the master scholar of Attic vases, when he wrote, "I was brought up to think of 'style' as a sacred thing, as the man himself."[4] This notion—that individual artists, or the period in which they worked, or the particular place and context of that work, can somehow be inferred from looking with acute detail at the specific stylistic features of a painting or a sculpture—is the foundation of style art history. Yet if one turns to avant-garde images produced at the very time when Wölfflin was composing his *Principles of Art History*, one may wonder how easy it really is (even for a very well trained eye) to tell the Cubist Picasso from the Cubist Braque, even when they were not sharing similar subject matter, like Richter and his friends at Tivoli. Had Wölfflin looked with any care at the art of his time rather than back toward the great tradition flowing up to and through Ludwig Richter, perhaps he would not have written his masterpiece.

Given the dominance of style art history over the various methods and approaches to art historical study in the first three quarters of the twentieth century, alongside its associated techniques of connoisseurship and formal analysis, it is more than just surprising—perhaps even shocking—to find a virtually complete rejection of this method in the last quarter of that century. In 1986, the angry young men and women of the field (at least in its Anglo-American incarnation) could pen this assault on the Wölfflin tradition: "In discrediting the old art history, words like connoisseurship, quality, style and genius have become taboo, utterable by the new art historians only with scorn or mirth."[5] Only a decade later, the mockery had been replaced by silence. In the first edition of a generally excellent collection of *Critical Terms for Art History*, edited by Robert S. Nelson and Richard Shiff in 1996, hardly a single one of the traditional terms of the discipline—neither "style" nor "form," for example, nor even "the artist"—appears in the index, let alone in the table of contents.[6] I guess that after assaulting his father, Oedipus buried the corpse and forgot all about it.

This is not the place for one of those bitter methodological polemics about

[3] Wölfflin (1950, originally published in German in 1915), 1. On Wölfflin, see, for example, Gombrich (1966), 89–98; Podro (1982), 98–151; and Hart, Recht, and Warnke (1993).

[4] Beazley (1956), x, with the discussion of Neer (1997), 23–24.

[5] Rees and Borzello (1986), 4.

[6] R. S. Nelson and Shiff (1996).

how art history should be done with which my generation grew up. But at the risk of disinterring a few corpses, it may be worth going back—beyond the soon-to-be virtually forgotten art history practiced by our fathers—to its origins. Let us look back not to our fathers, but their fathers' fathers, to an antiquity which is not just before the practice of scientific art history, as we usually understand it, but even before the invention of art itself (at least in the influential formulation of Hans Belting).[7] "Style art history" is not just a modern development from the conjunction of post-Renaissance amateur connoisseurship with the combination of nineteenth-century positivism and the discovery of photographic technology. Rather, its essential intellectual moves—great and deep knowledge of objects, an interest in artists, dates and provenances, and the acute intuition that allows an art historian to place two or more objects together in a convincing way, which may never have been seen to go together before—these moves far antedate both art and art history as we know them in the post-Renaissance era. The ancient Greeks and Romans knew about artistic style and iconography, and we might learn something from their knowledge.

From Connoisseurship to Art History

Our most vivid, detailed, and accurate witness for the art and architecture of Greece in the Roman era—most of it lost now, of course—is once again Pausanias.[8] A focus on artistic style is hardly the major thrust of Pausanias' text—as it obviously is in the work of a modern art historian like Wölfflin—but he shows as acute a connoisseurial eye as anyone in a later period.

Take this passage, where he is visiting the port of Aegeira on the northern coast of the Peloponnese: "There is also a sanctuary of Apollo; the sanctuary itself, with the sculptures on the pediments, is very old; the wooden image (xoanon) of the god also is old, the figure being nude and of colossal size. None of the inhabitants could give the name of the artist, but anyone who has already seen the Heracles at Sicyon would be led to conjecture that the Apollo in Aegeira was also a work of the same artist, Laphaës the Phliasian" (7.26.6). Here we are offered a careful and precise art historical description of the image: it is made of wood, archaic, nude, colossal, a description bald and restrained enough for a museum catalog, though perhaps insufficiently vivid

[7] Belting (1994). I am thinking of Belting's strange conception that "art" only began in the Renaissance, see pp. xxi–xxii: needless to say, I disagree.

[8] Specifically on Pausanias as a traveler and travel writer, see Elsner (1992, 1994), Alcock (1996), the essays in Alcock, Cherry, and Elsner (2001), Hutton (2005b), and Akujärvi (2005). For Pausanias' interest in myths, see especially Veyne (1988), 95–102, and in oral tradition, see Prezler (2005); for Pausanias' interest in ritual, chapter 2 above.

for a modern museum label. It is enough for us to have a rough idea of its form—it was probably a kouros—though we are not told if the image was seated or standing. Then Pausanias makes one of those intuitive leaps of attribution, which have always worried those who doubt the connoisseurial eye. No one knows who made the god—not even the locals or local guides—but Pausanias, cross-referring us back to an image described much earlier in his text (2.10.1), has no hesitation in nominating Laphaës.[9]

Pausanias has none of the props of the modern art historian in making his attribution. Unlike Wölfflin, who invented the genre of the lecture with double slide projection that is still widely used today even as Powerpoint threatens to redefine the paradigm,[10] Pausanias had to rely solely on his own memory in his comparison of works of art. He could never place them side by side in photographic form, he could never refresh his memory without a long journey back to a site once visited or a statue previously seen. Nor did Pausanias have the kind of archival or documentary information which proved so significant for the founder of modern connoisseurship in making his most famous discovery. I quote from an English translation of the Italian Giovanni Morelli's great book of 1877, which he wrote in German under a Russian pseudonym:

> The picture described hastily but accurately by the Anonymous as he saw it in the year 1525 at the house of Jeronimo Marcello at Venice: a "sleeping Venus and Cupid in an open landscape." This wonderful painting is generally thought to be lost; whether correctly is another question. I believe that I can point it out, and this time I need not take my readers far. The glorious picture, hitherto veiled from the eyes of art critics, is to be found in the Dresden Gallery (number 262). To my own satisfaction I can testify that I recognized the hand and genius of Giorgione in this enchanting picture before I knew of it having been mentioned as such in the [archival] list.[11]

What Pausanias has in common with Morelli is a set of procedures which are not so much methodological as instinctive. Here is how Edgar Wind satirically described what he called the "essentials" of connoisseurship: "The first essential is to attach a painter's name to an anonymous picture. . . . The second essential is to be precise about it. . . . The next essential is to point to an obscure detail in the painting and blow it up into something important; and the final and perhaps most significant touch is to make a gesture which suggests that no reasons can be given for the judgment passed by the connoisseur,

[9] Briefly on Pausanian attribution, see Arafat (1996), 62–63.

[10] On Wölfflin and double slide projection, see Gombrich (1966), 89–98.

[11] Morelli (1883), 164. Much has been written recently on Morelli. See Panzeri and Bravi (1987); J. Anderson (1991), 491–578; and Agosti et al. (1993).

because it is all a matter of perception and hence ineffable."[12] In both Pausanias' attribution of the Aegeiran Apollo and Morelli's of the Dresden Venus all these "essentials" are apparent, except the insistence on an obscure detail. What is especially striking is the gesture which points to what Wind calls the "ineffable." In Morelli, it lies in his having "recognised the hand and genius of Giorgione" even before finding the documentary list in the archive. Effectively, the document merely proves the truth already established by the art historian's superior eye and instinct. Morelli comments—as if dismissing the hopeless eyes of all who preceded him—"How such a work, the quintessence of Venetian art could have been left unnoticed so long, would be a downright enigma to me, if long experience had not taught me that in matters of art, the most incredible things are possible."[13] In Pausanias there is a similar dismissal of basic ignorance—"none of the inhabitants could give the name of the artist"—followed by the throwaway "anyone who has already seen the Heracles at Sicyon." Since Pausanias himself must have been rare, if not unique, in his first-hand knowledge of the breadth of surviving Greek art, there can be few who might have happened to see both statues by chance (and remembered them) and none—until Pausanias himself—who would have ventured to compare them by design.

There are a number of other such attributions scattered through Pausanias' text:[14] "There is also in Erythrae, a temple of Athena Polias and a huge wooden image of her sitting on a throne; she holds a distaff in either hand and wears a polos-crown on her head. That this image is the work of Endoeus, we inferred, among other signs from the workmanship, and especially from the white marble statues of graces and seasons that stand in the open before the entrance" (7.5.9).[15] Again Pausanias is precise about the statue and her attributes. Again he implicitly refers us back to an image featured earlier in his text—the statue of Athena on the Athenian Acropolis, with an inscription saying that it was dedicated by Callias and made by Endoeus (1.26.4). This time, however, the attribution is based not on a single comparison of objects but on the way the image at Erythrae was worked (does this mean its "style"?) and

[12] Wind (1985), 31. See generally ibid., 30–46. Other interesting discussions of connoisseurship include Damisch (1970, 1971–72); Wollheim (1973), 177–201; Ginzburg (1983); Schwartz (1988); Macginnis, (1990); and most recently Neer (2005). On connoisseurship and ancient art (a subject in which the scholarship revolves almost entirely, and perhaps overly so, on the work of J. D. Beazley), see Cherry (1992), Neer (1997), and Whitley (1997). One exception, briefly treating the rise of style analysis in the German archaeological tradition, is Marchand (1996), 104–8. For treatment of personal styles in Greek art, see Pelagia and Pollitt (1996).

[13] Morelli (1883), 164.

[14] Further examples in Pausanias, not quoted in the text here, include: 2.25.10; 3.10.8; 5.25.5.

[15] On Endoeus, see Robertson (1975) 105–9, 226–27, and A. Stewart (1990), 248–49, with bibliography.

on the fact that it seems to be part of a larger program, a cycle, of other images by the same artist at the site.

When Pausanias reaches the temple of Ismenian Apollo at Thebes, he likewise comments: "The image is in size equal to that at Branchidae [another name for Didyma, in Asia Minor] and does not differ from it at all in shape. Whoever has seen one of these two images and learnt who was the artist, does not need much skill to discern, when he looks at the other, that it is the work of Canachus. The only difference is that the image at Branchidae is of bronze, while the Ismenian is of cedar-wood" (9.10.2).[16] This time he is less interested in describing the image than in displaying his knowledge not only of its artist but also of its twin brother in distant Asia Minor. In antiquity, as in modernity, style art history relies above all on a formidable firsthand acquaintance with a vast range of relevant artifacts—that is, on expert empiricism.

But the question of Pausanias' interest in style is less significant in itself than the uses to which he puts his attributions. Pausanias was not simply spotting artists but, like modern art historians, he was applying the stylistic method to a specific agenda. He was, in part, developing a history and a chronology for Greek art. Take this passage, describing Amphissa, in Locris, 120 stades to the northwest of Delphi:

> On the citadel of Amphissa is a temple of Athena, with a standing image of bronze, brought, they say, from Troy by Thoas, being part of the spoils of that city. But I cannot accept the story. For I have stated in an earlier part of my work that two Samians, Rhoecus, son of Philaeüs, and Theodorus, son of Telecles, discovered how to found bronze most perfectly, and were the first casters of that metal. I have found extant no work of Theodorus, at least no work of bronze. But in the sanctuary of Artemis at Ephesus, as you enter the building containing the pictures, there is a stone wall above the altar of Artemis called Goddess of the First Seat. Among the images that stand upon the wall is a statue of a woman at the end, a work of Rhoecus, which the Ephesians call "Night." A mere glance shows that this image is older and of rougher workmanship than the Athena in Amphissa. (10.38.6–7)[17]

Here we have something much more than straightforward attribution, although the same skills—a sharp eye, a sense of style related with period, and a phenomenal visual memory—are all in play. Pausanias is able to reject a local tradition, which sought to make a venerable image even more distinguished by adding a mythical pedigree, on the basis of his superior art historical

[16] On Canachus, see A. Stewart (1990), 248, with bibliography.

[17] On Rhoecus and Theodorus and the invention of bronze statuary, see Pliny, *Natural History* 34.83; and Robertson (1975), 180–82; Mattusch (1988), 46–50, 83–84, 213–15; A. Stewart (1990), 39, 244–46, with bibliography; and Haynes (1992), 48–49, 54–55.

knowledge. The Athena from Amphissa cannot be as old as the Trojan War, not only because bronze casting was discovered after the supposed date of the fall of Troy but also because the image exhibits later stylistic characteristics than the very earliest bronzes. As one might expect of a good art historian, Pausanias has made a careful personal study of the oldest bronzes, and despite not finding the work of Theodorus, he has seen the one extant bronze by Rhoecus.[18]

In his account of Amphissa, Pausanias refers us back to where he first mentions the history of bronze casting, at a sanctuary said to have been founded by Odysseus at Pheneüs, in Arcadia. There he reports that although he accepts most of the local myths, "I cannot believe their statement that Odysseus dedicated the bronze image. For men had not yet learnt how to make bronze images in one piece, after the manner of those weaving a garment. Their method of working bronze statues I have already described when speaking of the image of Zeus Most High in my history of Sparta. The first men to melt bronze and to cast images were the Samians Rhoecus, the son of Philaeüs, and Theodorus, the son of Telecles" (8.14.7). Here Pausanias' method is more directly chronological than art historical. Odysseus was too early for bronze casting and therefore could not be the donor.[19] But again we are referred backward through Pausanias' text, to the statue of Zeus Most High, which he calls "the oldest image that is made of bronze": "It is not wrought in one piece. Each of the limbs has been hammered separately; these are fitted together, being prevented from coming apart by nails. They say the artist was Clearchus of Rhegium, who is said by some to have been a pupil of Dipoenus and Scyllis, by others of Daedalus himself" (3.17.6).[20]

Several considerations arise from Pausanias' discussions of bronze. First, he has been careful to create a history of bronze statuary, going from the earliest methods of hammering bronze sheets onto a wooden core (known as the "sphyrelaton" technique) to the discovery of casting to modern bronzes. He does not present this narrative as a single chronology in one place within his work, but cross-refers his readers so that they can reconstruct his account if they wish. But his interest in the development of bronze sculpture is not simply anecdotal. In part, he is keen to name artists—which might be described as a shorthand way of creating a system of dating, since one artist followed

[18] On Pausanias and the history of bronze, see Arafat (1996), 71–72, and his note 68 for further bibliography.

[19] Compare also 9.41.1: "The Lycians in Patara show a bronze bowl in their temple of Apollo, saying that Telephus deidcated it and Hephaistus made it, apparently in ignorance of the fact that the first to melt bronze were Theodorus and Rhoecus." Here again the supposed antiquity of a bronze item is refuted by the art historical knowledge of the beginnning of bronze casting.

[20] On this image, see Mattusch (1988), 41, and Arafat (1996), 71–72.

another. But more significantly, he uses the history thus constructed—an art history derived from existing objects—to refute false stories and to restore a more correct dating for the images and the shrines he is discussing. This is sophisticated art historical analysis at work.

Beyond the particular realm of bronze working, Pausanias exhibits a continuous interest in relative dates, in the antiquity or archaic qualities of particular pieces, in the development of new styles or iconographies. His history of Greek art is effectively charted with as much loving care as was his slow journey through all the villages of Roman Greece, in both cases reconstructing the past as a kind of line leading down to the present. In part, he wishes to restore artists' personalities to the canon of Greek painters and sculptors. For instance, at Olympia, "There is also a Heracles fighting with the Amazon, a woman on horseback, for her girdle. It was dedicated by Evagoras, a Zanclaean by descent, and made by Aristocles of Cydonia. Aristocles should be included amongst the most ancient sculptors, and though his date is uncertain, he was clearly born before Zancle took its present name of Messene [in 494 B.C.]" (5.25.11).[21] Here an archaic sculptor is not only being restored to the list of artists, but—through a judicious reading of the inscription and its use of the word "Zancle" for the donor—a date is proposed before which Aristocles must have been born.[22]

In matters of iconography, Pausanias again shows himself acutely interested in moments of development or change:

> Who it was who first represented the Graces naked, whether in sculpture or painting, I could not discover. During the earlier period certainly, sculptors and painters alike represented them draped. At Smyrna, for instance, in the sanctuary of the Nemeses, above the images have been dedicated Graces of gold made by Bupalus; and in the Odeon in the same city there is a portrait of Grace, painted by Apelles. At Pergamon, likewise, in the chamber of Attalus, are other images of Graces made by Bupalus; and near what is called the Pythium there is a portrait of Graces, painted by Pythagoras the Parian. Socrates, too, the son of Sophoniscus, made images of Graces for the Athenians, which are before the entrance to the Acropolis. All these are alike draped; but later artists, I do not

[21] Doubt has been cast on the correctness of Pausanias' identification of this iconography as the seizure of the girdle, and on his statement that the Olympia metope (which survives in fragmentary form but appears to show Heracles fighting an Amazon) specifically represents the episode of the girdle (5.10.9). See Bothmer (1957), 121–22, and Boardman (1982), 8 and n. 24. What matters for my purposes, however, is Pausanias' concern with relative chronology, rather than his (possibly overzealous) importation of an episode familiar to him from other contexts into the interpretation of Olympian sculpture.

[22] On Pausanias' use of inscriptions, see especially Habicht (1985), 64–94; with Arafat (1996), 61 (on Aristocles) and 73–74; and Whittaker (1991).

know the reason, have changed the way of portraying them. Certainly today sculptors and painters represent the Graces naked. (9.35.6–7)

This passage is a commentary on what is in fact one of the great innovations of late Classical and Hellenistic art, namely the invention of the female nude.[23] Again, it is typical of Pausanias to have noted the development, to have placed it chronologically and correctly, and to have sought—in this case without success—for a cause.

The chronological nature of his interest in style ties Pausanias' art history into the much broader project of his travel book about Greece. His book is an attempt to find again the enchanted past of Greece—its gods, its heroes (both mythical and historical), its great works of art—as they imbue the landscape of the present. Despite, or perhaps even because of, the rather second-rate status of Achaea in the second century—economically and politically (if not culturally) a minor province in someone else's empire—Pausanias found the grandeur of the past still living in the forgotten shrines and half-ruined statues of the present.[24] His art history is about restoring the narrative of great names—a mythology of artists like Daedalus and Phidias no less heroic than the Homeric heroes or the glorious defenders of Classical Greece against the Persians. An old and nameless wooden colossus at Aegeira can, with sufficient stylistic appreciation and art historical knowledge, become the work of a named and venerable artist, such as Laphaës of Phlious. The wooden Apollo at Thebes can become the lost twin of the great bronze at Branchidae, by the famed Canachus of Sicyon, brother of Aristocles. These objects become embedded—by their locations and their artists—in a religious and cultural network of the past which gives meaning to Greece in the present.

On the specifically art historical front (not one, of course, which Pausanias would necessarily have recognized in isolation), the project represents the use of style to create, and occasionally to correct, history. Here is the greatest modern adovcate of that project, Bernard Berenson, writing in 1950:

> The business of the art historian is to rise, not above unchanging values, but above the preferences instigated by the fads, stampedes and hysterias of the moment. He must overcome private prejudice and dandaical exclusiveness, and

[23] See, for example, Spivey (1996), 173–86.

[24] On Pausanias' view of past and present, Arafat (1996), passim, is the most extensive treatment. He comes up with a broadly more pro-Roman Pausanias than, for instance, Elsner (1992), Alcock (1996), Swain (1996) or Hutton (2005b), 41–47, and I remain of the view that Pausanias is more backward looking and resistant to Rome than Arafat makes him. For a balanced view, see Bowie (1996) and now Akujärvi (2005), 181–306, for a wider view of the context of these issues in Pausanias' text. On ruins, see Porter (2001).

learn to appreciate successive styles first for their intrinsic merits, no matter how slight, and then for their living value in a humanistic scheme of life. A style, we have concluded, is a constant and unassailable way of seeing things, and the history of the arts of visual representation should be the history of successive ways of seeing the world and all that therein is—the history, in short, of styles.[25]

As in Berenson's injunctions here (though hardly like the real, phenomenally prejudiced, Berenson himself), Pausanias had a great ability to value the various arts of the past—he explicitly comments on the style of the very earliest archaic statues, said to be by Daedalus, as being "uncouth to look at," but nonetheless having "something divine about them."[26] Yet what Pausanias most strongly shares with Berenson is a deep resistance to the present—in Berenson's case to modern art and in Pausanias' case to Roman dominion over Greece.[27] For both, the reification of artistic style as meaningful and as substantive history is a way of living through the present as if one were in the company of the much greater heroes of the past. It is a backward-looking process, which constantly values the past against what might be regarded as at best the mediocrities of the present. While, methodologically and historiographically, this attitude may cast some shadows and doubts over the project of style art history in both Berenson and Pausanias, there is no doubting Pausanias' virtuoso harnessing of stylistic techniques to a profoundly nostalgic personal agenda.

From Connoisseurship to Ethnicity

I have been arguing that a close reading of Pausanias offers us a view of ancient connoisseurial art history as sophisticated as anything in the modern world. Both in his sharp eye and in his precisely defined thematic agenda, according to which Pausanias argues from his attributions and other stylistic observations, he is hardly less impressive than Wölfflin, Morelli, or Berenson. In particular, he uses the close examination of style—like many modern art historians—to construct history. In turning to another writer of the second century A.D., the Syrian-born Lucian of Samosata, I want to focus on an alternative Greco-Roman use of visual analysis—this time to explore geographic and implicitly racial differences in works of art, a strategy that can be paralleled in the world of modern art history.

[25] Berenson (1950), 202. Further on the notion of style in the same book, see 138–42.
[26] Pausanias 2.4.5. Further on this passage, see Habicht (1985), 131; Morris (1992), 248; and Arafat (1996), 68.
[27] For Berenson's antipathy to modern art, see Calo (1994), 142–67.

Lucian was a truly wonderful and versatile writer in Greek, which may well have been his second language.[28] He wrote light essays, humorous novels, biting satires against liars, frauds and religious charismatics, as well as numerous dialogues and even, as we have seen, a pilgrimage narrative. His works are highly learned and full of allusions to the canon of earlier literature, but wear their learning lightly—so that they were accessible to his audiences and did not pall. Included within his corpus are a number of essays relating to works of art—praises, descriptions, and other references—which indicate a deep acquaintance with the arts of the Greek tradition and with the rhetorical techniques used by second-century orators to discuss them.[29] Indeed, in an essay purporting to be autobiographical, Lucian even claims to have considered becoming a sculptor before deserting simply manual skills for the eloquent sophistication of high culture.[30]

Here is how Lucian opens one of his rhetorical introductions;[31] unfortunately we do not know for what occasion or audience, or how it would have been followed:

> The Celts call Heracles "Ogmios" in their native tongue, and they portray the god in a very peculiar way. To the Celts, Heracles is extremely old, bald-headed, except for a few lingering hairs which are quite grey, his skin is wrinkled, and he is burned as black as can be, like an old sea-dog. You would think him . . . anything but Heracles. Yet, in spite of his looks, he has the equipment of Heracles: He is dressed in the lion's skin, has the club in his right hand, displays the bent bow in his left, and is Heracles from head to heel as far as that goes. I thought, therefore, that the Celts had committed this offence against the good-looks of Heracles to spite the Greek gods.[32]

Lucian describes the peculiar iconography of the Celtic Heracles further. He is leading a great crowd of men tethered by the ears. They follow him joyously, their chains attached to his tongue. By the end of this description, our author stands

> for a long time, looking, wondering, puzzling and fuming, when a Celt at my elbow, not unversed in Greek lore, as he showed by his excellent use of our language, and who had, apparently, studied local traditions, said: "I will read you the riddle of the picture, stranger, as you seem very much disturbed about it.

[28] Generally, see Hall (1981); C. P. Jones (1986); and Swain (1996), 298–321.

[29] Many of his descriptions of works of art are usefully collected by S. Maffei (1994); good recent discussions include Möllendorf (2004) and Borg (2004a).

[30] See Lucian, *The Dream, or Life of Lucian* 2–14.

[31] Generally on the introductions, or *prolaliae*, see Nesselrath (1990).

[32] Lucian, *Hercules* 1, using the Loeb version of A. M. Harmon.

We Celts do not agree with you Greeks in thinking that Hermes is Eloquence: we identify Heracles with it, because he is far more powerful than Hermes. And don't be surprised that he is represented as an old man, for eloquence and eloquence alone is wont to show its full vigour in old age."[33]

Here we are given a careful iconographic account of a visual oddity by Greek standards, with an arguably even odder explanation for the picture's peculiarities from the Celtic interpreter. The description has occasioned much academic discussion, with a surprising number of scholars believing that the picture of Ogmios is more than an ironic figment of Lucian's fecund imagination.[34] What matters, from my point of view, however, is Lucian's choice of portraying a different culture by means of its espousal of an unusual iconography for a very common and familiar deity in Greco-Roman art. It is as if the style of the image comes to define the Celtic race. But we should not miss the delicate ironies of the exchange with the Celt. The Celtic interpreter takes Lucian for a Greek (when he speaks of "you Greeks"), and Lucian certainly poses as one—when he comments "our language" of the Greek used by the Celt. But in fact the Celt is virtually a reverse portrait of Lucian himself, with the Syrian mannerisms swapped for Celtic, with Lucian's eastern otherness by contrast with Greece swapped for the Celt's western otherness. Lucian (as he makes abundantly plain in other essays) was an outsider, "not unversed in Greek lore," and possessed of an excellent command of the Greek language.[35] His relations, as a Syrian, to the Greco-Roman establishment were not unlike those of the Celts.

In his partly humorous, partly pious account of pilgrimage to the temple of the Syrian Goddess in Hierapolis in Syria—not far from Lucian's birth place of Samosata, but slightly further south along the Euphrates—Lucian himself signals difference from Greco-Roman culture through non–Greco-Roman iconography. At Hierapolis, there is a miraculous oracular statue of Apollo, whose prophetic method we have already observed in chapter 2, but the statue did not look, we are told, "as it is usually made":

> For all others [by which is surely meant the Greeks and the Romans] think of Apollo as young and show him in the prime of youth. Only these people display a statue of a bearded Apollo. In acting in this way they commend

[33] Lucian, *Hercules* 4.

[34] The literature on Lucian's Ogmios-Heracles is large. It includes Koepp (1919), especially 38–43; Egger (1943), especially 117–37; Martin (1946); Grenier (1947); Benoît (1952); Hafner (1958); Roux (1960), especially 210–13; G. Anderson (1976), 31–33; Nesselrath (1990), 132–35; Maffei (1994), lxvi–lxxi; Borg (2004a), 44–48; and Balmaseda (1990), especially 256, for (doubtful) examples.

[35] On Lucian's claims to be a Syrian, see *Double Indictment* 27 and 34; *Scythian* 9; *Fisherman* 19; *Uneducated Book Collector* 19; *Syrian Goddess* 1.

themselves and accuse the Greeks and anyone else who worships Apollo as a youth. They reason like this. They think it utter stupidity to make the forms of the gods imperfect, and they consider youth an imperfect state. They make yet another innovation in their Apollo, for they alone adorn Apollo with clothing.[36]

Here iconographic divergence from Greek practice is not only emphasized, as in the case of the Celtic Heracles-Ogmios, but defended (as Ogmios was defended by the Celtic interpreter) on the grounds of its being superior to Greek habits of representation. Lucian is not perhaps as descriptively precise as Pausanias, but his account of the Hierapolitan Apollo highlights a series of key points of iconographic and hence cultural difference—age, the beard, and clothing.

The text of Lucian's *Syrian Goddess* is full of iconographic descriptions of Syrian gods and of attempts to match these with Greek verbal portaits and names of deities. As we have seen in chapter 1, despite his care in describing the deities in Hierapolis, Lucian finds it extremely difficult to pin them down. "Zeus certainly looks like Zeus in every respect . . . ," we are told, "nor will you, even if you want to, liken him to anyone else" (*De Dea Syria* 31). And yet the locals and the pilgrims (of whom the narrator is one) call him by another name. In the case of the male deity, the iconographic similarity to Zeus should be sufficient to fix his identity, but it turns out not to be entirely adequate since the Hierapolitans do not call him "Zeus" (as they call their Apollo "Apollo," despite the fact that he is iconographically dissimilar from the Greek version). Hera (of whose name Lucian reports no local version), in contrast, appears to resemble most of the female deities in the Greek pantheon. Or is it that she is made up of bits of them, as the famous courtesan Panthea in Lucian's *Essay on Images* is presented as being made up of the choicest segments of female figures in the most famous ancient statues and paintings?[37]

Earlier in the text, when attempting to decide between competing accounts of the origin of the sanctuary, Lucian uses the iconography of the cult statue within the argument: "There is another sacred account, which I heard from a wise man, that the goddess is Rhea and the sanctuary a creation of Attis. . . . Here is the proof: The goddess is similar in many ways to Rhea, for lions carry her, she holds a tympanum and wears a tower on her head, just as the Lydians depict Rhea."[38] By Rhea, Lucian means here the goddess we tend to

[36] Lucian, *Syrian Goddess* 36, Fr. H. Attridge and R. Oden. On this image see further chapters 1 and 9. For further ancient discussion of this image, see Macrobius, *Saturnalia* 1.17.66–70 and Lightfoot (2003), 456–69.

[37] See Lucian, *Essay on Images* 6–8.

[38] Lucian, *Syrian Goddess* 15, with Lightfoot (2003), 257–63.

call Magna Mater or Cybele, whose lover Attis castrated himself in her honor. His description of the iconography of Cybele is rather accurate,[39] although how the Syrian Goddess can hold a tympanum as well as a scepter and a spindle (as we are told later) is difficult to see.

What these discussions of the statues of Hierapolis show, however, is a tremendous sensitivity to the iconography of divine images in relation to racial and cultural difference. Unlike Pausanias—who was by his commitment to seeing everything to be seen in Greece, virtually a professional or academic expert in art historical matters—Lucian is more of a cultured amateur. But what is striking is that the direction he takes his viewing is very different from that of Pausanias. Instead of focussing on chronological development and hence issues of history, Lucian—the Syrian outsider who writes such scintillating Greek—is interested in themes of peripherality and ethnic difference. Like Pausanias, he too uses stylistic and iconographic evidence to test stories reported as true—but he is more interested in the question of "where" than that of "when" or "who." His difficulties in marrying the visual style of Syrian deities with their representation in Greek nomenclature are themselves a symptom of the problems of acculturation and ethnic diversity within the Roman east.[40] In his playful account of Heracles-Ogmios, Lucian shows himself aware of similar problems of cultural encounter in the Roman west.[41] The fact that all these issues are represented in his writings in terms of problematic, misrepresented, or misunderstood iconographies wonderfully captures—in highly sophisticated written prose—a cultural context in which for most (illiterate) inhabitants of the empire the style and iconography of such images were indeed a prime means of representing identity—whether parochial, peripheral or, indeed, mainstream.

RHETORICS OF CONNOISSEURSHIP

Lucian's interest in art as a marker of cultural difference is easy to understand from his biography as a Syrian outsider assimilated within Greco-Roman culture. But it has striking parallels with, or perhaps descendants in, modern art history. Consider the wonderful icon of St. Peter from the collection in the Monastery of St. Catherine at Mount Sinai (figure 3.1). Since the discovery of this panel of wax-encaustic pigments on wood in the 1950s, it has been convincingly dated to the pre-Iconoclastic period, probably to the sixth century A.D.

[39] For the corpus of Cybele images, see Vermaseren (1977–89).

[40] For an excellent account of the near east, see Millar (1993). For a variety of recent papers on the Roman east in general, see Alcock (1997b).

[41] On the west, see, for instance, Blagg and Millett (1990).

FIGURE 3.1. Icon of St. Peter in wax-encaustic pigments on wooden panel from the Monastery of St. Catherine at Mount Sinai. In the roundels above are figures of Christ and possibly the Virgin and St. John to the right and left, respectively. Probably sixth century A.D. (Photo: Studio Kontos.)

But its provenance—which depends on the stylistic parallels adduced and the relative importance given to its appearance, its medium, and its final resting place at Sinai—has been variously placed in Alexandria, Constantinople, and even aligned with Rome.[42] In modern art history, this structure of argument—that is, the analysis of style in relation to geographic provenance rather than the specific hands of artists—goes back to the fierce polemic between Alois Riegl and Josef Strzygowski after 1901 about whether the arts of late antiquity and the early Middle Ages adopted their characteristically antinaturalistic forms as a result of eastern influence or from a development inherent in and integral to Roman culture.[43]

The burden of my argument has been to suggest that many key characteristics of nineteenth- and twentieth-century style art history have parallels with and arguably may trace their origins to ancient viewing and ancient uses of stylistic or iconographic analysis. Whether one takes the chronological line of attribution and the spotting of artists' hands, like Pausanias, or the geographical line of emphasizing cultural and racial difference through differentiated iconography, like Lucian, art history is in its essential premises no more expert or scientific today than it was in the second century A.D.[44] A useful question in consequence may be to ask what we may learn from the ways that the ancients did it. Do they simply anticipate modern developments by an interesting and quirky happenstance? Or is their attitude to the fraught questions of attribution, style, and form different from ours? Let us return to Lucian's *Heracles*.

We have already seen that the Celtic interpreter turns out to be a kind of Celtic Lucian—a sophisticated Greek-speaking foreigner, like Lucian, but from the empire's western rather than its eastern fringe. The situation becomes more complicated, however, after the Celt has finished his explanation. The whole passage is an introduction to a lost speech. At the end, after the

[42] On the provenance of the Sinai St. Peter, for Alexandria, see Sotiriou and Sotiriou (1956–58), 2:19–21; for an alignment with Rome (and a dating in line with the Roman material), see Kitzinger (1976), 239; for Constantinople, see Weitzmann (1976), 23–26, followed by Galavaris (1990), 94.

[43] See Riegl (1985, first published 1901) and Strzygowski (1901). The polemic surfaced after each had read the other's seminal publication, see especially Riegl (1988, first published in 1902) and Strzygowski (1905). Further on Strzygowski's approach, see Brendel (1979), 41–47, and (on his Orientalism), see Wharton (1995) 3–12, and on the debate, see Elsner (2002). The particular synthesis of this debate, which allowed multiple geographical centers for the creation of late antique art (each more or less "Roman," more or less "eastern") came in Morey (1942), and it is later versions of Morey's position which govern the various geographical attributions of icons like the St. Peter panel from Sinai.

[44] Of course, it would overstate the case to imply that every ancient writer on art was as visually aware as Lucian or as connoisseurially acute as Pausanias. In fact there is very little by way of stylistic expertise evident in the rhetorical tradition of describing paintings exemplified by the Philostrati or Callistratus, or in our most extensive ancient history of art, preserved in Books 34, 35, and 36 of the Elder Pliny's *Natural History*.

Celt has finished speaking, Lucian turns to his audience in autobiographical mode (7). He is now an old man, with infirm feet, no longer suited—he feels—to addressing "so large a jury" as that gathered to hear him now. He thinks he should withdraw—when "it chanced that in the nick of time I remembered the picture." "When I remember that old Heracles," he says, "I am moved to undertake anything, and am not ashamed to be so bold, since I am no older than the picture. Goodbye, then, to strength, speed, beauty and all manner of physical excellence. . . . Now should certainly be the time for eloquence to flourish and flower and reach its fulness, and drag as many as it can by the ears and let fly its arrows" (7–8).

The elegance and the irony of the piece is that the image of the aged Ogmios leading a crowd tethered by the ears, which had Lucian so incomprehending and furious at the opening of his speech, turns out to be his own self-portrait as divine master of eloquence.[45] It is a telling irony that it requires a foreign image of the great god of labors to represent the foreign Lucian, and it needs a Celtic version of Lucian the interpreter to make the image plain to him in the first place. Yet all these genuflections to the periphery revolve around the imagery of Heracles, an absolutely mainstream god, and reflect upon the art of eloquence in Greek, the mainstream language of the intellectual elite of the Roman empire.

What we have here, I would contest, is an elegant and sophisticated use of the notions of style and iconography, which is very different from anything on offer in style art history since the Renaissance. Neither Lucian nor Pausanias is hung up on, or obsessed by, a sense of the weighty truth-value resting on the problems of style—as were such as Wölfflin, Berenson, Morelli, and Riegl. For Lucian, visual iconography (including its style) is a sophisticated form of expertise with which to play—self-consciously and intelligently, to be sure—in making a rhetorical statement about himself which is brilliantly self-deprecating and self-aggrandizing at the same time. He is not only as old, bald, lame and wrinkled as Ogmios, but he is the master of Heraclean heights of eloquence.[46] In Pausanias, style and attribution feature as just one of the rhetorical and literary means for evoking the glories of the Greek past—along with history, myth, and ritual detail. For both, the expert language of art history is one rhetorical discourse available, amid a plethora of other weapons in

[45] See Nesselrath (1990), 132–33, 135.

[46] I have not explored the physiognomic angle of Lucian's account of himself-Heracles-Ogmios as not strictly relevant to the issue of style or iconography. However, the style and form of representing people or deities clearly was related to the ancient science of physiognomics (as is revealed in at least one anecdote in Pliny's *Natural History* 35.88). Further on physiognomic art, see L'Orange (1947), 22–23, 110–12. On physiognomics in the Roman empire, see Barton (1994), 95–132, and Gleason (1995), both with further bibliography.

the armory of persuasive eloquence, to make a point or correct an error. For the ancients, style was a genuine form of knowledge and expertise, but no less or more so than any other. Style art history was to be exercised not for its own sake, but whenever it served the purpose of the writer or speaker.

Unlike the pseudoscientism of modern scholarship (and Morelli's attributions, let us never forget, arise out of his anatomical studies as a doctor), the ancients attached no ultimate truth-value to the findings of connoisseurship. It is we who want style to tell us too much and too securely (to give us a certain date, the fingerprint of an actual artist's hand, the local geography of a specific city). Or, when we reject style completely, it is we who too strongly deny any value to art history's most affectionately knowledgeable and most strikingly intuitive of techniques. We can learn something from antiquity's openness to a plurality of methods, techniques, and discursive models—each of which was valid only insofar as it could persuade.[47] What Pausanias and Lucian offer is a light touch on matters of method and approach which would be wonderfully welcome in the context of the polemics and insistent certainties which have afflicted the discipline of art history over the last century.[48]

[47] On the theme of rhetorical discourse in the Roman world, I follow the synopsis offered by Barton (1994), especially 1–25.

[48] My call might be said to echo a remark of Gombrich's, when he commented that "to escape from the physiognomic fallacy [by which he means an essentialist construction of social holism from stylistic evidence], the student of style might do worse than to return to the lessons of ancient rhetoric." See Gombrich (1968), 359.

<div style="text-align: center;">

4

</div>

EKPHRASIS AND THE GAZE

From Roman Poetry to Domestic Wall Painting

IT WAS ONLY IN THE TWENTIETH CENTURY that the term "ekphrasis" came to be applied exclusively to the description of works of art.[1] But while in antiquity that term had a much broader meaning (it was used as a technical definition for all kinds of vivid description in the *progymnasmata* or rhetorical handbooks),[2] there is nonetheless a classic trajectory of interreferential—and indisputably purple—passages in Greek and Roman poetry that focused on the description of a work of art to offer a metatextual reflection on the poem as a whole.[3] Going back to the Shield of Achilles in the *Iliad* (18.578–608) and leading via Apollonius Rhodius to Catullus, Virgil, Ovid, and Silius Italicus (to cite only extant poems), this trope of epic may be considered a genre in its own right. My concern here is not with ekphrasis as such—either as description or as the description of art—but with the specific and repeated feature of the ekphrasis of art that turns on viewing. The theme of the gaze is significantly embedded not only in pre-Roman epic,[4] but also in the Hellenistic genre of so-called ekphrastic epigram (that is, epigrams which play with works of art)[5] and comes to be a powerful element of prose

[1] See Webb (1999), 7–11, 15–18.

[2] See ibid., 11–15. On the vividness, see Graf (1995), Dubel (1997), and Webb (1997a). On the *progymnasmata*, see, for instance, Webb (2001).

[3] Friedländer (1912), 1–132, is the classic discussion of the ancient passages, with 1–23 on epic and other sections devoted to drama, history, the novel, epigram, rhetoric, and so forth. Other accounts of ekphrasis in antiquity include G. Downey (1959), Pernice and Gross (1969), Ravenna (1974), and Bartsch (1989).

[4] So the great cloak of Jason in the *Argonautica* 1.721–67 is framed by images of gazing (vv. 725–26, 765–67)—called by Hunter (1993), 53, "two addresses to the reader."

[5] See Goldhill (1994) and Gutzwiller (2002, 2004). Generally now on the gaze in Hellenistic poetry, see G. Zanker (2004).

ekphraseis both in the rhetorical tradition that culminated in Philostratus and in the novels.[6]

The wonderfully complex self-reflection on the gaze (itself a potential literary metaphor for reading) in poets like Catullus and Virgil and in Philostratus' *Imagines* can be read against the parallel as well as equally intense and complex visual exploration of the gaze in contemporary Roman painting. For, within what has been described as a remarkably ocular culture,[7] these two forms of artistic commentary (painterly and literary) provide evidence of the intense attention paid to the gaze by the Roman world. If it is difficult, under the regime of naturalism, to be sure that the viewing subject has correctly understood and related to the viewed object, then the examination of that difficulty in Roman writers and painters demonstrates an acute self-awareness about the gaze's potential for failure, error, and deception. Ekphrasis itself, insofar as it provides a pedagogic model for the gaze, may be seen as both its enabler (in helping the viewers it is training to see) and its occluder (in the veil of words with which it screens and obscures the purported visual object). But when, in its own performance, ekphrasis demonstrates a clear self-awareness of both these qualities (enabling and occluding), then one might say that its true subject is not the verbal depiction of a visual object but, rather, the verbal enactment of the gaze that tries to relate with and penetrate the object.

The Gaze in Ekphrasis

Catullus 64

The first great surviving poetic ekphrasis in the Roman tradition appears in Catullus' sixty-fourth poem—a short hexameter epic (epyllion) of 408 lines written in the fourth or fifth decade of the first century B.C.[8] A celebration of the marriage of Peleus and Thetis in the mythological golden age, written in an elaborate and highly wrought style,[9] Catullus 64 opens in genuflection to the *Argonautica* of Apollonius with an image of Jason's ship, the

[6] See especially Goldhill (2001a). For ekphrasis in the novels, see Zeitlin (1990) on Longus; Bartsch (1989) on Achilles Tatius and Heliodorus, especially 109–43 on spectacle; Whitmarsh (2002) on Heliodorus. On the gaze in Tatius, see Morales (1996b, 2004) and Goldhill (2001a), 167–72, 178–79; on the gaze in Chariton, see B. Egger (1994) and now Zeitlin (2003).

[7] See, for example, Coleman (1990); Segal (1994), 257–58; Bergmann and Kondoleon (1999); and Goldhill (2001a).

[8] The classic discussion is Klingner (1956). I am particularly indebted to the outstanding reading of Fitzgerald (1995), 140–68. For a rich account of the complexity of the narrative line in this ekphrasis and its interrelations with other texts, see Theodorakopoulos (2000). For the intriguing possibility that Catullus 64 dates to after the Civil War (that is, to the 40s B.C.), see Hutchinson (2003), 210n17.

[9] Jenkyns (1982), 105, calls it "with some hesitation" "rococo."

Argo.[10] The poem finds its way relatively swiftly to the couple's wedding bed in the middle of things (*in mediis*, v. 48) and lingers there over its embroidered coverlet to such an extent that the ekphrasis threatens to take over the poem (vv. 50–264), so that by the time it ends we are well beyond the middle of this miniature epic. As has been comprehensively discussed by William Fitzgerald, the entire poem is infused with the imagery of gazing, which is most strongly focused around the ekphrasis itself. From the opening lines with the Nereids gazing in wonder at the *Argo* (v. 15) and the ship's crew gazing back at the naked nymphs who rise up to their breasts in the foam (v. 16), a thematic is established of watching and wonder—at naked natural beauty tending to succumb to voyeurism and at the artifice of creation tending to an unnatural excess (so that the *Argo*—literally a ship woven (*texta* v. 10) by Athena—is a *monstrum* at v. 15). The tapestry itself (another piece of weaving like the *Argo*, but woven by human hands, one presumes) reflects and intensifies these themes with a deep focus on gazes and desire—mainly unfulfilled or denied.

The ekphrasis opens with Ariadne in misery on Naxos, gazing out, watching Theseus sail away (vv. 52–53) and unable to believe that she sees what she sees (v. 55):

> Saxea ut effigies bacchantis, prospicit, eheu,
> prospicit . . . (vv. 61–62)

> Like some Bacchante's stone statue, she watches, ah,
> watches . . . (after Lee's version)[11]

Disheveled and near-naked—with her "milky breasts" specifically undraped (vv. 63–67)—Ariadne is both a visual parallel to the naked nymphs glimpsed from the *Argo*,[12] and is objectified by Catullus as the subject of a gaze from outside the image (like Achilles Tatius' Andromeda in chapter 1 above), whether this be his own gaze and ours as his readers or that of the young men of Thessaly within his narrative.[13] As Bacchante, she looks forward both to her final fate as bride of Bacchus, whose approach (but not the consummation of his love with her) is described at the end of the ekphrasis (vv. 251–64) where the Bacchantes' twice-repeated "euhoe" (v. 255) replaces the "eheu" of her looking out to sea (v. 61),[14] and also to the dance of Bacchus on Parnassus

[10] On the poem's Hellenistic qualities and especially in the opening, see, for example, R. Thomas (1982).

[11] On this simile and the way a textual tapestry appeals to sculptural imagery, see Laird (1993), 20–21, also Fitzgerald (1995), 154–55. On Ariadne as Maenad, see Panoussi (2003), 114–21.

[12] Fitzgerald (1995), 150–51.

[13] Cf. Griffin (1985), 98, and Fitzgerald (1995), 147–49.

[14] With Fitzgerald (1995), 154–56.

in the times of Peleus at the end of the poem (vv. 390–93). The object of Ari-
adne's gaze here is not just the receding Theseus but also the memory (*com-
memorem*, v. 117)[15] of his arrival at Crete and his incursion into her story (or
her entrapment in his), as Catullus shifts to recounting the earlier part of the
myth. That too turns out to be a drama of gazes—especially the striking
memory of first love in the moment that the virgin princess caught sight of
Theseus with a longing look (*cupido conspexit lumine* v. 86):[16]

> Non prius ex illo flagrantia declinavit
> lumina, quam cuncto concepit corpore flammam
> funditus atque imis exarsit tota medullis. (vv. 91–93)

> She did not turn away from him her smouldering
> eye-beams until throughout her frame she had caught fire
> deep down, and in her inmost marrow was all ablaze. (Lee)

Gazing on the memory of her first gaze at Jason, which is a throwback to
an earlier section of the myth within the narrative structure of the ekphrasis,
Ariadne serves as a figure for the intratextual viewers of the coverlet, ob-
serving the bed-cover with its complex of gazes. These are not only the
youth of Thessaly (explicitly cited at v. 267),[17] but perhaps also the lovers on
the point of marriage and the gods who come to celebrate the wedding feast
in the latter part of the poem. Ariadne may also figure the extratextual view-
ers of the ekphrasis—Catullus himself and his readers, whose access to this
picture is always vicariously through its description, and whose response to
the subject of this description is continuously focalized through Ariadne's
gaze.[18] The subject matter of the coverlet juxtaposes the failed marriage of
Ariadne and Theseus against that of Peleus and Thetis in an ekphrastic pause
that intervenes one mythical narrative into the unfolding of another.[19] In
an extraordinarily self-referential moment within the ekphrasis, Catullus'
account of the tapestry posits another purple coverlet which the loving Ariadne

[15] Catullus' memory of the story, but implicitly Ariadne's too, I take it—a memory specifically
counterpointed against Theseus' lack of memory of Ariadne in his departure (*immemori*, v. 123; *im-
memor*, v. 135; *dicta nihil meminere*, v. 148 accepting Czwalina's conjecture for *metuere*).

[16] See Fitzgerald (1995), 161–62.

[17] Fitzerald (1995), 140, 141, 153, makes much of the gaze of these Thessalian countrymen, but in
fact Catullus only refers to the Thessalians' gazing after the ekphrasis is finished at v. 267 (*spectando*).
The intimacy of our private view of the spectacle of the tapestry alongside the poet is only broken af-
ter its images have been described by the reminder that we are looking at it in the company of a crowd
of spectators within the poem.

[18] On focalization, see Fowler (2000), 37–107, especially 40–41, and on ekphrasis 72–73, 99.

[19] Further on the implications of this for the poem, see, for example, Kinsey (1965), Bramble
(1970), and Clare (1996).

might have spread over the bed of her beloved Theseus, had he not deserted her (*purpurea . . . veste*, v. 163).[20] Later in the poem, as the Fates sing their prophecies to the company assembled at the wedding of Peleus and Thetis, their robes are described as white with a purple fringe (*purpurea . . . ora*, v. 308). It is as if the poem's logic of purple fabrics (in every case set off against white)[21]—two coverlets (the real one of Peleus and Thetis bearing a picture of Ariadne and Ariadne's imagined one for herself and Theseus within the picture) and the robes of the Fates—culminates in a third textile associated with destiny itself.[22] One might argue that the vagaries of fate in its variety and ambiguities—are to be summed up in the intimations of Catullus' purple textiles.

This shift between different registers of storytelling is itself mirrored in the move from present to past in the recounting of Ariadne's distress, from a narrative of loss to a narrative memory of love. While the love of Peleus and Thetis is not directly evoked through the gaze, it too is described in the language of burning (*incensus*, v. 19)—this time of the male Peleus inflamed with love for the goddess Thetis, reversing the inflammation of gender between Ariadne and Theseus. The brief account of Peleus' and Thetis' falling-in-love—the former on board the *Argo* (vv. 19–21)—immediately follows that of the Nereids gazing at the ship and the ship's crew ogling the Nymphs (vv. 14–18), with Thetis described as the fairest of the Nereids (v. 28). So Ariadne's gaze into the memory of her falling-in-love evokes and replays the further memory of the love of Peleus and Thetis, already recounted in the poem, with Ariadne's explicitly described gazes and ardent burning (vv. 86 and 91–93) reflecting the implied gazes and less intensely emphasized flames of Peleus and Thetis (vv. 14–21).

The narrative—or memory—of Ariadne's elopement with Theseus is conducted by means of abandoning her father's sight (*vultum*, v. 117) and herself being abandoned when her eyes were closed in sleep (v. 122).[23] These memories, continually reinforced by Ariadne's gaze out over the sea (vv. 52–53, 61–62, 127, 249–50) lead to her speech (vv. 132–201) in which she curses Theseus and calls down ruin upon him as he has ruined her. Whether the narrative

[20] Cf. vv. 49–50, *tincta tegit roseo conchyli purpura fuco / haec vestis,* and again v. 265, *vestis.* See Hurley (2004), 107.

[21] The purple tapestry of v. 49 by contrast with the ivory of the couch at v. 48; the purple coverlet of v. 163 by contrast with the white feet of Theseus at v. 162; the white robes of the Fates by contrast with their purple borders at 64.308. See J. Clarke (2003), 57, 126–27, 129, and 131.

[22] Of course, purple tapestries have a deep Homeric resonance hardly unrelated to issues of fate and destiny: when we first meet Helen in the *Iliad,* she is weaving a purple cloth with images of the Trojan War on it (*Il.* 3.126) and likewise Andromache is weaving a purple tapestry when she receives news of Hector's death (*Il.* 22.441).

[23] Further on memory and oblivion, see Hurley (2004), 108–9.

EKPHRASIS AND THE GAZE

of Theseus' return is to be imagined as a further scene on the tapestry,[24] or as the fulfillment of Ariadne's curse—a proleptic extension of her gaze into the future that balances the recollective gaze into her past, Catullus tells the story, again in terms of gazing. The deal between Theseus and his father, Aegeus, is that when Theseus' eyes see the hills of Attica from the ship (v. 233), he must hang white sails in place of black. Unmindful (and accursed), Theseus forgets:

at pater, ut summa prospectum ex arce petebat,
anxia in assiduos absumens lumina fletus,
cum primum infecti conspexit lintea veli,
praecipitem sese scopulorum e vertice iecit . . . (vv. 241–44)

But his father, as he scanned the view from the top of the
citadel, wasting his anxious eyes in endless weeping,
the moment he saw the canvas of the darkened sail
hurled himself headlong from the summit of the rocks (Goold, adapted)

Aegeus' gaze of desire for Theseus is ironically doomed as the object of his affection approaches, while Ariadne's gaze is stricken as Theseus recedes. Theseus himself, we are told, arrives home to grief as great as he had imposed upon Ariadne, returning to the news of his father's death (vv. 246–48), at which point the ekphrasis pointedly returns to Ariadne, still looking out at the receding ship and turning her griefs over in her heart:

. . . prospectans cedentem maesta carinam
multiplices animo volvebat saucia curas (vv. 249–50)

. . . gazing where his hull had dwindled,
Stricken, her thoughts a whirl of love and pain (Mitchie)

Arguably, the only images on the coverlet are that of Ariadne gazing out to sea and of Bacchus coming to find her (vv. 251–64). In the unfulfillment of Ariadne's gaze, Catullus creates a whole past and future of gazes reverberating between love and despair, like so many cares in Ariadne's heart. What matters here, for my purposes, is an insistent emphasis on the gaze in which the principal figure within the tapestry's picture is portrayed as the paradigm for a process of looking that refers implicitly to the poem's characters outside the ekphrasis (the lovers Peleus and Thetis, the Thessalian youths) and to the extrapoetic viewers of Catullus' masterly word-painting (that is, his readers). After the description of the coverlet, we are told that the youth of Thessaly

[24] Contra Fitzgerald (1995), 153; see, for example, Hurley (2004), 100.

gazed eagerly upon it until they were sated, as Catullus has his readers dwell on it for more than two hundred lines:

> quae postquam cupide spectando Thessala pubes
> expleta est . . . (vv. 267–68)

> . . . When the young Thessalians
> had glutted avid eyes on this rare work (Mitchie)

Ironically, the only gaze that is satisfied in Catullus 64 is that of the Thessalian youths come to celebrate the wedding of Peleus and Thetis and looking at the coverlet. Their visual satisfaction lies in a lengthy observation of unfulfilled gazes; and the challenge to the reader is whether the unfulfilled gazes inside the tapestry (all of various forms of mythic disaster) or the sated gaze at the coverlet are the more appropriate models for our response to the poem as a whole.

The Emulators of Catullus

The gaze remains central to a number of the refractions of Catullus 64 in later Roman, especially Augustan, poetry. Propertius 1.3, published in 29 or 28 B.C., opens with the image of the poet's sleeping mistress, Cynthia, lying like Ariadne abandoned on the shore:[25]

> Qualis Thesea iacuit cedente carina
> languida desertis Cnosia litoribus . . . (Propertius 1.3.1–2)

> Like the maid of Cnossos as in a swoon she lay
> on the deserted shore when Theseus sailed away . . . (Goold, adapted)

Compared also with Andromeda's first sleep after being rescued from the sea monster and with a Maenad exhausted after Bacchic dancing (vv. 3–6)—the former another highly sexualized image as we saw in chapter 1 and the latter borrowed, like the Ariadne theme itself, from Catullus 64[26]—Cynthia here emulates and reverses a series of elements from Catullus. She lies asleep in the love bed she and Propertius share—not, however, a marriage bed as in Catullus 64—and Ariadne figures as simile, not as ekphrasis or explicit work of art (the image on Catullus' coverlet). Ariadne-Cynthia is approached by Propertius, comically emulating Bacchus (*multo . . . Baccho*, 1.3.9 cf. 1.3.14),

[25] For some of the debts of Prop. 1.3 to Cat. 64, see L. Curran (1966), 196–97, 207; Harmon (1974), 153–54, 162; Harrison (1994), 19; and Zetzel (1996), 84–88.

[26] Cat. 64.61 has Ariadne as an *effigies . . . bacchantis*, while 251–64 has Maenads in their ecstasy (Propertius' *assiduis . . . choreis* at 1.3.5). On the bacchic elements of Cat. 64, see Panoussi (2003), 114–21.

as intimated in Catullus 64.251–64, but this time Bacchus in the sense of being inebriated with wine. The gaze in Propertius is not of Ariadne looking persistently out to sea, but of Propertius as (anti-)Bacchus looking uncertainly at his mistress—bashful at being late and drunk, afraid of waking her and afraid of her dreams:[27]

> sed sic intentis haerebam fixus ocellis
>> Argus ut ignotis cornibus Inachidos. (1.3.19–20)

> But I remained rooted with eyes intent upon her
>> like those of Argus upon the strange horns of Inachus' child. (Goold)

In this gaze at Ariadne-Cynthia (the eyes evoking the *ocellis* of the first line of the opening poem of Propertius I, where Cynthia's eyes take Propertius prisoner and capture his gaze), Propertius-Bacchus finds himself transformed into the many-eyed monster Argus, employed in myth by Hera to guard Io, Inachus' daughter.[28] When the moon's beams, peeping through the shutters, open Cynthia's eyes (1.3.31–33), she wakes and berates her lover with a lament about abandonment, unfaithfulness, and her loneliness—which again plays with variations on the model of Ariadne's lament in Catullus 64. Particularly striking is the image of Cynthia resisting sleep by "spinning in purple" (*purpureo . . . stamine*, 1.3.41), which evokes the purple coverlet of Catullus' ekphrasis (*purpura*, Cat. 64.49), the purple coverings which Catullus' Ariadne imagines she might have spread on her bed with Theseus (*purpurea . . . veste*, Cat. 64.163), and especially the spinning of Catullus' Fates in their white and purple robes (Cat. 64.303–22), suggesting perhaps that Cynthia is spinning out Propertius' fate.[29]

Propertius' play with the gaze in 1.3 brilliantly reverses Catullus by placing the poem's gaze in the first person singular of the poet's own eyes as he looks at Cynthia-Ariadne. This gaze is not within an ekphrasis nor at a work of art (as are the various gazes in Catullus) but self-confessedly the poet's gaze not at his woman, Cynthia, but at his woman reduced to a simile (Cynthia as Ariadne). This sets up the objectification of the female as the viewed, only to surprise us when the poem ends with the objectified Cynthia emulating Ariadne's

[27] On the objectification of Cynthia in Propertius' gaze ("without any resistance or interference from reality"), see Greene (1995), 307–8 (= Greene, 1998, 56–57); Sharrock (2000), 272–75; O'Neill (2000), 271–72; Wyke (2002), 162. More broadly on Propertius' Cynthia in relation to the gaze, see O'Neill (2005).

[28] On Prop. 1.3.19–20, see Lyne (1970), 70–71; Harmon (1974), 159–60; Harrison (1994), 22; and Valladares (2005), 224–28.

[29] For other intimations of spinning in purple, see Harrison (1994), 23, and J. Clarke (2003), 129–30.

curse and berating Propertius in her (at least partly justified) rage.[30] In transferring the gaze to the male, Propertius hugely complicates the first-person persona of his viewer.[31] Is Propertius Theseus, the faithless deserter returned after failing to penetrate another girl's door (1.3.35–36)? Is he a comic Bacchus—drunk rather than divine (as at 1.3.9–10)? Is he one of the Thessalian youths—less a participant than an observer, watching impotently and afraid to disturb the repose of the lady, self-absorbed in her dreams (1.3.17–18)? Or has he become the monster Argus, watching the girl with the paranoia of a hundred eyes as she dreams of other men (1.3.19–20)? The gaze of Catullus 64, beautifully orchestrated as a coordinating meditation on the poem's own structure as ekphrasis, becomes in Propertius 1.3 a far less certain assertion of the ambivalences of subjectivity in the lover's relations (real, projected, and imagined) in relation to his beloved. The Catullan choice between unfulfilled gazes within an image and the external viewer's voyeuristic satiation is replayed as the ambivalent, multifaceted, and confused authorial gaze of a lover who cannot be fulfilled and cannot find satisfaction even in just watching (since his jealousy of Cynthia's dreams causes him to want to wake her up).

Catullus' Ariadne emerges twice in Ovid, both times with memorable intertextual allusion.[32] Specifically in the *Heroides*, a collection of poems written as letters (many of them from famed mythical women to their lovers), probably composed in the penultimate or last decade B.C. and much concerned with the gaze,[33] Ovid's Ariadne addresses Theseus in a text that reworks Catullus' poem at length and in particular his motif of looking out over the sea at her vanished lover.[34] Instead of being an ekphrasis of a pictorial figure on a bedspread, Ovid's Ariadne is all voice—the poem being in her words, picking up Cynthia's diatribe at the ending of Propertius 1.3.[35] Where Propertius refocalizes the Catullan motif of the gaze through himself in the first person (and hence problematizes it with all the roles he may

[30] On Cynthia as Ariadne cursing, see Valladares (2005), 234–35.

[31] See, for example, Wlosok (1967), 352.

[32] On Fasti 3.469–75 and Cat. 64, see Conte (1986), 60–63; Barchiesi (1997b), 243, 245; Barchiesi (2001), 18–19; though in these accounts the gaze is not significant.

[33] See Spentzou (2003), 91–93.

[34] On the play of *Her.* 10 with Cat. 64, see Verducci (1985), 246, 256–62, 284–85; Barchiesi (2001), 20–25, 114–17; Lindheim (2003), 92–93, 96–97; and Fulkerson (2005), 32, 137–40.

[35] There are various echoes of Propertius 1.3, from the moonlit time of night (Prop. 1.3.30–33, Ovid, *Her.* 10.17) to the uncertain groping of hands—Propertius desirous but afraid of touching Cynthia (1.3.13–18), Ovid's Ariadne stretching between sleep and fear for the vanished Theseus by her side (*Her.* 10.9–16). Critics have tended to neglect the Propertian intertext between Catullus and Ovid.

play), Ovid keeps the Propertian first person but in the Catullan form of Ariadne's own gaze and voice. Her letter explicitly casts the poem's reader as Theseus:

> quae legis ... Theseu ...

> What you are reading, Theseus ... (*Her.* 10.3)

Either the reader *is* Theseus, or the reader is eavesdropping on a private communication—playing the voyeur, but always in danger of identification with the second-person addressee, with Theseus as privileged *reader* of Ariadne's letter.[36] Like the spectator of a picture of Ariadne (the Thessalian youths of Catullus) or an onlooker figure within a painting (as in several of the Pompeian versions of the scene, which I shall discuss below), the reader is cast in a similar range of potential roles and uncertainties as Propertius' 1.3 casts its narrator. Is the reader Theseus, or Bacchus (observing the action prior to his entry into the narrative), or an innocent and impotent onlooker whose gaze happens simply to be caught in the drama? In relation to all these potential addressees, Ovid's Ariadne and, indeed, all the mythical heroines of the *Heroides* allow the poet to give a voice and a gaze to the usually objectified female beloved of Roman (and especially Ovidian) amatory poetry.[37] But the effect of returning the gaze to Ariadne and turning all his readers into voyeurs is that Ovid undermines any potential fulfillment or satiation for his external viewers: the satisfaction of the Thessalian youths is revealed as wish-fulfillment fantasy.

In relation to the ekphrastic structure of his Catullan ur-text, Ovid performs a remarkable game of giving life to what in Catullus were figures on a coverlet. Not only does Ariadne speak, but her bed (the bed on whose bedspread she appeared as a picture in Catullus, and also the bed on which Propertius' Cynthia lay as an imagined Ariadne) turns into a lavish and potent object spread on the beach at Naxos and evoked at length (*Her.* 10.11–14, 51–58).[38] This may hardly resonate with a sense of mythical realism in picturing a seashore abandonment,[39] but it works to emphasize Ovid's debt to his precursors and his poem's relation to the elegiac tradition of lovers, beds, and mistresses, while at the same time genuflecting to (or perhaps inspiring) the Roman visual tradition of this imagery with its elaborate cushions and

[36] For some general issues of epistolarity in the *Heroides,* see Farrell (1998) and Kennedy (2002).

[37] See the discussion of Spentzou (2003), 24–42. On elegiac objectification (what Sharrock calls "womanufacture"), see Sharrock (1991a, b) and Wyke (1987a, b, 1995). For further general interrelations of the *Heroides* with Roman elegy, see, for example, Barchiesi (2001), 29–47; Hardie (2002b), 121–28.

[38] On the bed, see Verducci (1985), 262–67; Lindheim (2003), 110.

[39] As remarked by Barchiesi (2001), 114.

couches on the sand (see e.g. figure 4.3). Where Catullus figuratively described his woven Ariadne as a stone statue of a Bacchante (v. 61: *saxea . . . effigies bacchantis*), Ovid has his real Ariadne running about as an excited Bacchante, sitting frozen on the rocks, "as much a stone myself as was the stone I sat upon" (*Her.* 10.48–50: *concita Baccha . . . in saxo frigida sedi / quamque lapis sedes, tam lapis ipsa fui*).[40] This not only has the effect of virtuosic play with Catullus's original, but also performs the classic Ovidian strategy in relation to art of avoiding ekphrasis as such and bringing art to life in the text (a technique especially perfected in his *Metamorphoses*).[41]

In all this the gaze remains central to the Ovidian conceit—with Ariadne constantly looking out (*Her.* 10.17–18, 27–31, 49), her eyes pouring tears when they fail to see Theseus' sails (*Her.* 10. 43–46), able to see no trace of human habitation (60), unable to see her own mother's tears as she succumbs to death in her abandonment (119), with no one there even to close her eyes in death (120). In an interesting projection, and an affirmation of the reciprocity of gazes in Roman culture, part of Ariadne's purpose is to attract Theseus' gaze at her as his ship recedes (39) and ultimately to see her in her misery, with his mind if not with his eyes:[42]

> Di facerent, ut me summa de puppe videres;
> > movisset vultus maesta figura tuos!
> nunc quoque non oculis, sed, qua potes, adspice mente
> > haerentem scopulo, quem vaga pulsat aqua.
> adspice demissos lugentis more capillos
> > et tunicas lacrimis sicut ab imbre gravis.

> I would pray the gods that you had seen me from the high stern;
> > that my sad figure had moved your heart.
> Yet gaze at me now, not with eyes, for with them you cannot, but with your mind,
> > clinging to a rock all beaten by the wandering wave.
> Gaze at my locks, loosened like one grieving for the dead,
> > and at my robes, heavy with tears as if with rain. (*Her.* 10. 133–38)

Effectively, some of the bite of Ovid's transposition of the theme from Catullus' ekphrastic coverlet and Propertius' extended mythical simile to an impassioned letter is the transference by which Ariadne's gaze projects itself in her imagination into that of Theseus, so that in the last section of the poem he sees her suffering and, in seeing it, feels it.

[40] See ibid.

[41] See especially Hardie (2002b) 177–93.

[42] On Ovid's Ariadne constructing herself as object of Theseus' absent male gaze, see Lindheim (2003), 111–14, 164–65, 167.

The Catullan thematics of desire, loss, huge emotion, and the making present of past and future by means of a picture are all borrowed, developed, and transformed in Virgil's *Aeneid*, written in the last third of the first century B.C.[43] Where Catullus' emulators of the Ariadne theme move the narrative out of ekphrasis proper, Virgil chooses to avoid Ariadne but to conduct a profound and fundamental reworking of the nature of ekphrasis. Supremely, where Virgil differs from Catullus is that his use of ekphrasis and viewing in the *Aeneid* focuses not on a depicted character within the picture described, but on various viewers (and especially on Aeneas himself) within the poem represented as looking at and reacting to works of art. For Virgil the gaze becomes a remarkable means to figure the process of reading (his own text) and of moving from erroneous reactions and interpretations to ones more in keeping with Aeneas' poetic fate. More radically, Catullus' Ariadne destabilizes the (apparent) narrative frame of poem 64 by using the ekphrasis to cast doubt (in the marriage bed's very space of consummation) on the happiness of any marriage in the context of a poem that presents itself as the celebration of the golden age's archetypal wedding feast.

While Catullus 64 is a miniature epic, its main narrative sandwiching a gigantic ekphrasis, Virgil's *Aeneid* is an epic on the grand scale, with aspects of its poetic argument structured (I shall argue) as a sequence of ekphraseis that unfold as the narrative progresses.[44] There are several descriptions of works of art within the epic which in each case extend beyond the object into a narrative account of what its decoration depicts.[45] These include the murals of Dido's temple in Carthage (1.453–93),[46] the silver-gilt dishes chased with the deeds of Dido's ancestors (1.640–42), the cloak with the story of Ganymede given to the victor of the ship race (5.250–57), the bronze doors made by Daedalus for the temple at Cumae (6.20–37), the cedar statues of the ancestors of king Latinus (7.177–91), the shield of Turnus (7.789–92), the shield of Aeneas (8.626–728), the sword-belt of Pallas (10.495–505).

[43] For some thoughts on Virgil's debts to Cat. 64 in the *Aeneid*, see Putnam (1998), 13–15.

[44] The literature is vast. Most fundamentally on Virgilian ekphrastic strategies in the *Aeneid*, see now Putnam (1998). I have also found very useful Dubois (1982), 28–51; R. Thomas (1983); Ravenna (1985); and Heffernan (1993), 22–36.

[45] I find Putnam's insistence, on only 6 ekphraseis (for example, 1998, 23), followed, for instance, by Leach (1999), 116, or Hardie (2002b), 177, and (2002a), 335, somewhat artificial. Friedländer (1912), 18, sees 5. But like the subject matter of Virgilian ekphraseis, their number too lies in the interpretative eye of the beholder; see Boyd (1995), 173 and n. 8.

[46] Virgil is in fact ambiguous as to what material the images in this ekphrasis are made of, although "pictura" tends to suggest painting. See Leach (1988), 81–82; Boyd (1995), 81–83.

It is worth noting that Virgil is careful to select different material forms and types for the (imaginary) objects he chooses to describe, creating a deliberate variation except in the case of the two shields of the opposed heroes Aeneas and Turnus, which are paired in counterpoint.[47] The actual description is in several cases the result of a deliberate buildup in which the narrative pace has been slowed—so that in Book 1, Aeneas and Achates survey the great prospect of Dido's new Carthage under construction (1.418–52) before focusing on the temple paintings, while in Book 8, Venus brings her son his new arms (8.608–25) before the narrator turns the textual gaze onto the shield itself. The pause in the pace of epic narrative follows the Catullan model in allowing a description which is at the same time the insertion of different narratives—the Trojan War and Aeneas' past in Book 1, the tragedies of Crete and especially of Daedalus in Book 6, the future history of Rome culminating in Augustus himself on the shield in Book 8, the crimes of the Danaids on the baldric of Pallas in Book 10. The presentation of these new narratives differs from the strategy in Catullus 64 in that the epic actors of the *Aeneid*—especially Aeneas—are portrayed as themselves responding to art.[48] As a result the reader is provided with an admittedly highly complex not to say ambiguous paradigm of the range and multiplicity of responses he or she is potentially to feel.[49] At the same time, by being the account of the *Aeneid*'s narrator and not of any particular internal actor (like Aeneas himself), the ekphraseis allow the reader to learn what the epic's protagonists cannot know themselves and thus to be aware both of the subjectivity of responses within the poem and of the likely subjectivity of the reader's own reactions to the poem.[50]

The first of the ekphraseis poses the problem of emotional response, something emphasized by the rhetorical handbooks,[51] with eloquent reiteration.[52] Looking at the frescoes of the Trojan War, Aeneas weeps (*lacrimans*, 1.459) and pronounces some famous lines on the sorrows evoked by deeds (*rerum*, 1.462)—whether these be actual (the "real" history of Troy and Aeneas' part in that war), literary (effectively the passage is a summary of the *Iliad*'s narrative), or painted (paintings being the immediate cause for Aeneas' wonder (*miratur*, 1.456) and for his tears):

[47] On the range of materials, see Simon (1982); on Aeneas and the arts, see Hine (1982).

[48] For the intrusion and layering of narratives in the ekphrastic interruption to epic, see Boyd (1995), 73—though she sees this as especially Virgilian (even as "the narrative ambiguity of the *Aeneid*") rather than as generally characteristic of ekphrasis.

[49] See Leach (1988), 311–19; Barchiesi (1997a), 275–78; and Bartsch (1998), 335–37.

[50] See Boyd (1995), 78–80.

[51] See Webb (1997b).

[52] See, for example, Williams (1960); Clay (1988); Barchiesi (1994), 114–24; and Putnam (1998), 23–54.

sunt lacrimae rerum et mentem mortalia tangunt.
solve metus; feret haec aliquam tibi fama salutem (1.462–63)

And our misfortunes human pity breed.
This fame may help produce; suppress thy dread. (Sandys)

One wonders whether this meditation on human cares touching the heart is not in direct response to Catullus' Ariadne, who turned so many woes over in her heart (*multiplices animo volvebat saucia curas*, v. 250) as she gazed out at Theseus' escape. But here the stricken viewer is not in the picture as such, but observed by us as he looks at the pictures. Of course Aeneas is hardly an ordinary viewer and is explicitly described as within the murals too (1.488), insofar as they depict his personal heroic past as well as the *Iliad*'s narrative. In this sense Aeneas stands for Odysseus in Book 8 of the *Odyssey* when he weeps at the narrative of the Trojan War told by the poet Demodocus to the Phaeacian court (8.83–92, 521–30), and the paintings of Dido's temple are a transposition to visual form of Demodocus' oral recitation of the *Iliad*.[53] But Virgil, using the special device of Aeneas as a former actor in the depicted narrative (like Odysseus in the face of Demodocus' tale at *Od.* 8.75, 502, 517, and 521), contrives to keep the complexity of Ariadne's self-immersement in the themes that so affect her while transposing that complexity outside the image onto an external viewer (like the Thessalian youths in Catullus 64, but of course one infinitely more invested and identified in the described images). Aeneas' misery as viewer is a repeated theme:

multa gemens, largoque umectat flumine vultum (1.465, cf. 470, 485)

His heart with sighs, his face with rivers fraught . . . (Sandys)

Yet the flood of emotion goes side by side with the theme of wonder at the handicraft of the artist (1.455–56, 494) and a gaze concentrated on the object (which contrasts explicitly with the averted gaze of Athena as she looks away from the supplications of the Trojan women within the description itself at 1.482):

dum stupet obtutuque haeret defixus in uno (1.495)

. . . while yet amaz'd,
Dardan Aeneas on each object gaz'd . . . (Sandys)

[53] On Odysseus' tears and Demodocus' song, see G. Walsh (1984), 3–21; Goldhill (1991), 58–59.

The wonder of this wonder—and what might be called the great aesthetic problem raised by this ekphrasis about art in general (and about responding to epic narrative like the *Aeneid* itself in particular)—is that:

> . . . atque animum pictura pascit inani
> multa gemens (1.464–65)

> . . . his Tears a ready Passage find,
> Devouring what he saw so well design'd
> And with an empty Picture fed his Mind. (Dryden)

That emptiness recurs within the described images too where Troilus' chariot is presented as a *curru . . . inani* (1.476, "an empty car")—empty because its charioteer is slain by Achilles and empty too because art is simply a poor imitation of what were to Aeneas real events. The gaze, which in Catullus is so powerfully focused on the lookers within the tapestry (especially Ariadne, but also Theseus looking at the cliffs of Attica and Aegeus looking out to sea), is largely removed from within the images (except for Athena turning her eyes from her Trojan worshippers in a line powerfully repeated to describe Dido when the Carthaginian queen refuses to respond to Aeneas in the Under-world).[54] Instead the gaze is vested in the complexity of Aeneas' reactions to the images' emptiness. One difference from Catullus' Ariadne is that she looked backward into her own past and forward into her curse on Theseus, in each case with an absolute conviction born of her own experience or of our knowledge of the mythical narratives of Theseus' return. Aeneas has the same conviction, based on personal involvement with the depicted narrative, but the material object he looks at is the creation of the Carthaginians on the temple of their great goddess (and the Trojans' enemy) Juno. What he sees is the emotion-filled narrative of his own tragedy—especially Priam (men-tioned three times) alongside Troilus, Hector, himself, Memnon, and Penthe-sileia. But it has rather convincingly been argued that what Virgil implies was actually depicted was a visual narrative of the Greek triumph over Troy (from the conquerors' point of view and not from that of the Trojans), with Achilles mentioned more than any other character (four times).[55] The focalization of viewing through Aeneas stages a gaze in which not only can the viewer get it wrong, but arguably the more invested he is, the greater his chances of seeing not what is there, but what he wishes to see.[56] Our ability, as constructed by

[54] *Aen.* 6.469. Cf. 4.362–63, with Putnam (1998), 43–45.

[55] See Dubois (1982), 32–35; Leach (1988), 317–18; Boyd (1995), 76–79; and Perkell (1999a), 45–46.

[56] The complexity is worthy of Lacan (1979) 102 (his italics): "*You never look at me from the place from which I see you. Conversely, what I look at is never what I wish to see.*"

Virgil, both to share Aeneas' responses (to view with him) and also to watch him viewing and to stand back from his engagement signals a significantly more complex take on visuality than even the subtleties of Catullus 64.[57]

The opening ekphrasis of Book 6 reconfigures the dual thematics of sorrow (*dolor*, 6.31) and absence already rehearsed at the paintings of Dido's temple to Juno and effectively inherited from Catullus 64.[58] Here

> . . . tu quoque magnam
> partem opere in tanto, sineret dolor, Icare, haberes.
> bis conatus erat casus effingere in auro,
> bis patriae cecidere manus. (6.30–33)

> Here hapless Icarus had found his part;
> Had not the Father's Grief restrained his Art.
> He twice assay'd to cast his Son in Gold;
> Twice from his hands he drop'd the forming Mold. (Dryden)

This time it is the artist who weeps and the images' emptiness (of Icarus) is testament to that sorrow, while Virgil's own intervention as descriptive artist makes present (as text rather than as gilded bronze or personal feeling) both Daedalus' pain and Icarus' fall. Viewing here is *reading*, with Aeneas and his companions famously "reading through with their eyes" (*perlegerent oculis*, 6.34) until the priestess calls them away from the spectacle (*spectacula*, 6.37).[59] This is a relatively passive absorption in art (by contrast with Aeneas' emotion at the frescoes in Carthage), and it stands against Daedalus' passion in making the tale of his own life on the temple doors and his inability to complete it. The Daedalus episode might be said to be Virgil's own take on Catullus' ekphrasis in poem 64—returning to the same complex of myths, quoting directly,[60] and staging as the invested viewer tortured by emotion not just a character within the story (Catullus' Ariadne) but one who is both its protagonist as told here and its artist in Daedalus.[61] At Cumae, Virgil adds yet

[57] Again one thinks of Lacan and the paranoia of a panoptic gaze in which the viewer is always being looked at—see, for instance, Bryson (1988), 88–94. For further Lacanian reflections, especially on the emptiness of the pictures in the ekphrasis of Book 1, see Porter (2004), 143–44, and Kennedy (2004), 253–54.

[58] See, for example, Dubois (1982), 35–41; Fitzgerald (1984); Paschalis (1986); Leach (1988), 353–60; Sharrock (1994), 103–11; Casali (1995); and Putnam (1995), 73–99, and (1998), 75–96.

[59] The use of "reading" for "seeing" is odd enough for Servius to need to explain it by reference to the Greek *grapsai* (meaning "drawing" and "writing") in his fourth century A.D. commentary. See, for example, Elsner (1996b), 1; Bartsch (1998), 327; and Leach (1999), 119–20.

[60] Compare Cat. 64.115 and *Aen.* 6.27; Cat. 64.113 and *Aen.* 6.30, with Paschalis (1986), 34–36; Casali (1995), 5; Putnam (1998), 13–15; and Theodorakopoulos (2000), 130–31.

[61] For an acute discussion of the visuality of the ekphrasis in Book 6 within the logic of the *Aeneid*'s other ekphraseis, see especially Leach (1999), 116–19.

another level of complexity to his account of ekphrastic visuality. Aeneas is presented as looking at (or reading about) Daedalus' creations, whose agonies Daedalus seems to live through and witness as Aeneas watches. But we watch (or read about) Aeneas watching.

While the ekphraseis of Books 1 and 6 take us back to viewing the past—Aeneas' personal past at Dido's temple and a mythical past which is also a literary genuflection to the Catullan ancestry of Virgil at Cumae—the proleptic theme (as already witnessed in Ariadne's gaze into the future through her curse in Catullus 64) reaches new, perhaps unique heights in the "fabric of the shield beyond all words to describe" (*clipei non enarrabile textum*, 8.625).[62] This unnarratable visual text is what Virgil spends the next hundred-odd lines describing—at great length for an ekphrasis but with great brevity for the great history of Rome from Romulus to Augustus.[63] As with the temples at Carthage and Cumae, Virgil is careful to mark out not only that Aeneas gazes at the shield and the other weapons but that he is absorbed:[64]

> expleri nequit atque oculos per singula volvit
> miraturque (8.618–19)

> . . . he rolled his greedy sight
> around the work, and gazed with vast delight. (Dryden)

This time, by contrast with the personal emotions and disturbance of Book 1 and the readerly witnessing of someone else's tragedy in Book 6, Aeneas' gaze combines wonder and incomprehension. This time Aeneas marvels at a future not understood rather than a past which one might prefer to forget, and his emotion is of joy rather than of sorrow:

> miratur rerumque ignarus imagine gaudet
> attollens umeroque famamque et fata nepotum (8.730–31)

> Unknown the Names, he yet admires the Grace;
> And bears aloft the Fame and Fortune of his Race. (Dryden)

Even this brief account has shown that the *Aeneid*'s ekphraseis link together powerfully. As a group they offer a metareflection on art and its responses, on the difficulties of writing epic and its emotive challenges. But within the fabric of Virgil's text as a whole they build a progressive argument.

[62] On proleptic ekphrasis generally, see Harrison (2001), with 89–90 specifically on the Shield of Aeneas.

[63] See Dubois (1982), 41–48; Hardie (1986), 97–109, 120–24, 336–76; Putnam (1998), 119–88; and Boyle (1999), 153–61.

[64] See, for example, Laird (1996), 77–78.

The first two—the confrontation with the Trojan War at Carthage and the silver dishes with Dido's ancestors—render the genealogies of the epic's opening protagonists. Yet the prehistory of Dido is merely referred to and dismissed in a couple of lines—an ekphrastic signal that her narrative is but a stage on Aeneas' long journey beyond Carthage and Dido's love to Italy. The third—the cloak with the tale of Ganymede—returns to the theme of Aeneas' Trojan past,[65] some of which had been portrayed on Dido's temple paintings. The first ekphrasis, as we have seen, is replete with emotion (Aeneas' at his own history, the reader's through Aeneas at Homer's great poem retold by Virgil). The narrative on the cloak, by contrast—half-remembered, as it were, so that Ganymede is not mentioned by name—renders the distance Aeneas has come from that past as his epic moves into its Italian future; indeed Aeneas gives the cloak away as a prize to Cloanthus. In Book 6 (where Icarus is not depicted but is named), Aeneas and his companions are explicitly called away from their absorption in art by the priestess:

> non hoc ista sibi tempus spectacula poscit (6.37)

> Time suffers not, she said, to feed your Eyes
> With empty Pleasures. (Dryden)

As the time for action comes, the lures of art (and its descriptions) are to be resisted.

The cedar statues at Latinus' palace give a narrative of ancestry to the Latins at the opening of the epic's second half—longer than that accorded to Dido and announcing the past that Aeneas would acquire for his people through his marriage to Latinus' daughter Lavinia. The two shields placed at the ends of Books 7 and 8 pit Turnus against Aeneas, the former bearing a motif of his own ancestral mythology (Io, Argus, and Inachus) immured in the past,[66] the latter carrying the future of Rome and interjecting the climactic rhetoric of its ekphrasis into the Augustan present and the time of the poem's composition. While the emblem on Turnus's shield looks back genealogically, that of Aeneas carries the epic action of the poem as a whole onward into its Augustan future—a future that is not part of the epic's own narrative but is nonetheless incorporated as the decoration of a work of art and thus included within the *Aeneid*'s own art. Apart from this motif of panegyric through prophecy and teleology culminating in Augustus through the apparent description of art, the accounts of the shields have the effect of moving the *Aeneid*'s ekphrastic pattern from a materializing of genealogy (that is at the

[65] See Boyd (1995), 84–88; Putnam (1998), 55–74; and Hardie (2002a).
[66] See Breen (1986) and Gale (1997).

same time an allegory in the figure of Io of Turnus' own fate at the hands of Juno) and an aesthetics of response to a direct involvement in epic action. The shields become—in different ways—emblems for the two protagonists, like the shields of the heroes in Aeschylus' *Seven against Thebes*.[67]

It is the last of the ekphraseis, that of Pallas' baldric,[68] that fully unites the description of art with epic action, the thematics of aesthetic response and emotion with the dynamic of a narrative plot. The image—an "abominable crime" (*impressum nefas*, 10.497)—is sketchily described, its protagonists (like Ganymede) never named, but its artist (like Daedalus) firmly announced as (the unknown) Clonus Eutychides, whose name, meaning "Din-of-Battle, Son-of-Success," seems like a joke at the expense of the Homeric epithet (10.499). Turnus wrests the sword-belt from the dead body of Pallas, and Virgil warns us that Turnus will rue the act (10.500–505). That time comes at the very end of the entire poem, when Turnus pleads for his life before the triumphant Aeneas. Aeneas wavers—his eyes rolling (*volvens oculos*, 12.939)[69]— and then he sees the sword-belt of Pallas which Turnus is wearing. In the poem's last moment of the viewing of art, Aeneas "feasted his eyes on the sight of this spoil, this reminder of his own wild grief":

> ille, oculis postquam saevi monimenta doloris
> exuviasque hausit . . . (12.945–46).

Again the thematics of personal suffering (cf. *dolor* at 6.31), identification, and memory (cf. 6.26 for *monimenta*) arise in the face of a work of art, this time with the response postponed for two books from the initial description and its impact altered by the epic's intervening action—notably the death of Pallas and the defeat of Turnus. Where Aeneas had stood transfixed and tearful before Dido's paintings, and transfixed until the priestess called him away at Cumae, where Daedalus had been so moved by *dolor* that he could not complete the images planned for the temple door, now grief gives way to vengeful fury and Aeneas strikes. That mindful anger in Aeneas' response to the sword-belt is effectively an echo of Juno's anger at the opening of the epic, which initiated its action (1.11). But it is also, one might say, the "ira" and the "furor" (against Aeneas and the Trojans) which Juno has put aside in the scene immediately before the killing of Turnus (12.831–32)[70] and which in the epic's very last words

[67] See Zeitlin (1982).

[68] See, for example, Breen (1986); Conte (1986), 185–95; Putnam (1998), 119–88; and Harrison (1998).

[69] A grim echo of Dido at 4.363, unable to look at and unable to look away from the man about to desert her.

[70] On the reconciliation of Juno and Jupiter in *Aen.* 12.791–842, see Johnson (1976), 123–27; Feeney (1990); and Most (2001), 161–62.

Aeneas takes on in order to strike (12.946). As *monimentum*, and especially a *monimentum* that is active in stirring its audience to emotive response, the artwork of the sword-belt merges with the artwork that is the poem as a whole.[71]

The moment of the poem's ending has long struck readers as abrupt and inconclusive—a strange form of closure.[72] In terms of the *Aeneid*'s narrative of ekphrastic viewing, the reader is faced with an incremental simplification in which by the end Aeneas no longer stands back to view art and to feel its multiple—even contradictory—effects but stabs home in rage. Is this Virgil's argument, we may ask? Is it to this that Aeneas' passage of development has led through the poem, and does the author applaud? Or does the last act of the epic's drama not challenge the reader to confront the whole narrative of the *Aeneid*, as Aeneas himself had confronted the narrative of the *Iliad* in the first ekphrasis of Book 1? Indeed, Turnus' request to Aeneas to return him or his lifeless body (*corpus spoliatum lumine*, 12.935) to his father, specifically recalls the Iliadic scene in the first ekphrasis, where Achilles returned the lifeless body of Hector (*exanimum . . . corpus*, 1.484; *ipsum corpus*, 1.486) to Priam—a scene that invokes a groan from the breast of the watching Aeneas at Carthage (*vero ingentem gemitum dat pectore ab imo*, 1.485) that is ironically echoed by the burying of Aeneas' sword in Turnus' breast (*sub pectore*, 12.950) and the groan that Turnus' life gives out (*cum gemitu*, 12.952) as it leaves the world of the living in the poem's very last line. In a masterly allusion, Virgil appears to place his reader in Book 12 in the place of Aeneas, his viewer within the text in the first ekphrasis of Book 1. The reader is left with all the unresolved but potent ironies of that ekphrasis as his or her final problem of response to the poem: at the end of a great epic narrative, do we weep, as Aeneas did, even if to weep is to get it wrong (as Aeneas did in relation to the paintings of Book 1)? Is it for the audiences of great art to let their tears flow, but for epic actors to harden their hearts? Is it right to read with the thrust of Aeneas' action, from his point of view, or to read with a kind of pathos for Turnus quite at odds with the hero's burning rage, but utterly dependent on his viewing in Book 1? The recurrence of the sword-belt of Pallas at the poem's last gasp is effectively the re-opening of its spectacular ekphrastic *mise-en-abime* of viewing as a paradigm for reading, which puts into question the epic's entire meaning.[73]

[71] For a vivid reflection on memory in the *Aeneid* and especially in relation to the poem's last lines, see Most (2001), 149–55.

[72] See, for example, Johnson (1976), 115–16; and Putnam (1999), 224–30, for instance, 224: "the calculated dissatisfaction of the ending."

[73] Cf. Perkell (1999a), 46 (on the first ekphrasis): "The interpretative question here is precisely the one that confronts critics of the *Aeneid*'s ending as well: what is the authorially endorsed reading of the violence depicted there?"

Quite apart from the extraordinary uses to which Virgil's narrative puts the narrative pause of ekphrasis and its theme of the gaze in the *Aeneid*, I stress here the complex range of viewings that Virgil stages. These go beyond "a multiplicity of interpretative responses,"[74] to a pattern of different kinds of visual engagement (intensely moved, "readerly," uncomprehending) focused around a series of emotional responses (wonder, sorrow, joy, fury) and all characterized by visual absorption in the object. Aeneas' movement through the epic's ekphraseis is one of spectatorship—from getting what might have been the objective significance of the images at Carthage wrong via a variety of other responses to that final recognition of the baldric and the fury (his last response to art in the poem) which unites viewing with action in the epic's last scene. The gaze, in Virgil's account, is hardly within the picture (as it was in Catullus 64) but is a structured series of responses by a privileged viewer (the main protagonist) with a significantly sited series of fictive works of art. But in addition to portraying the act of spectating art, rather than the gaze within art, Vergil adds a double complexity. First, his spectator is always within art (that is, within his own verbal work of art). Second, there is always the awareness of the viewing of a viewing in which the reader, knowing what Aeneas does not know (in the case of the shield) or sensing a meaning that Aeneas does not want to see (in the case of Dido's temple), both participates in the act of viewing and observes it askance. In the case of the doors at Cumae, the reader watches Aeneas himself watching images whose meanings are focalized by Virgil through the experience of their creator, Daedalus. We are effectively in the mightily complex world of a Roman visuality in which the act of spectatorship is defined as being on stage and observed as one looks.[75]

This thematic structure of the gaze as the subject of ekphrasis is in different ways explored in later Latin poetry—notably in the art-centered and ekphrastic passages of Ovid's *Metamorphoses*, some of which I shall discuss later.[76] But my concern here is to turn to the exploration of the gaze in Roman painting, to examine a parallel development there to the move discernible from Catullus to Virgil, from a focus on the gaze *in* the picture to a focus on the gaze observing the picture and observing the act of gazing.

[74] Putnam (1998), 209.

[75] On this in relation to rhetoric, see Gunderson (1998); on the theatricality of Roman culture, see especially C. P. Jones (1991); Bartsch (1994); C. Edwards (1994); Koloski-Ostrow (1997); and the essays in Bergmann and Kondoleon (1999).

[76] On Ovid, see especially Leach (1974); Solodow (1988), 203–31; and Hardie (2002b), 173–93. On Silius Italicus, see Fowler (2000), 93–106.

The Gaze in Campanian Painting

The Gaze in Pompeii

It is well known that the structure of the Roman domestic house—the kind of dwelling whose imagery I now turn to—was in part articulated through a complex orchestration of the view.[77] This architectural sensitivity to viewing had implications in respect both of social status and of areas within the house of relatively greater public access or privacy.[78] It also related to the arts of memory in Roman intellectual culture whereby orators were trained to memorize their speeches by means of remembered views within houses (among other things).[79] And the view across rooms and through specifically designed vistas was related to the gaze not only as depicted within specific rooms or pictures but also as demanded from the visitors to the house by those pictures.[80] Indeed within individual rooms, it is clear that the decorators often envisaged particular viewing positions and vistas.[81]

Although most surviving Roman mythological paintings are panel-type inserts within the wall decoration from the so-called Third and Fourth styles (mid-Augustan to Vespasianic, with most examples clustering in the Neronian and Flavian periods), one of the earliest and most famous surviving figural cycles is that of the Villa of the Mysteries at Pompeii—dated to between 60 and 50 B.C., exactly when Catullus was writing in Rome.[82] Painted on a grand scale but within the miniature setting of a single enclosed room, oecus 5, and genuflecting significantly in style and subject matter to Hellenistic precedents (like Poem 64), the Mysteries frieze has a specific thematic alignment with Catullus' mini-epic. If we accept the majority view that the frescoes' subject matter has something to do with a bridal initiation into marriage (by no means a wholly certain interpretation, it must be said), then the main action of the room's décor (apparently consisting of various ritual acts including women and mythical beings from the Dionysiac sphere) is interrupted by a scene of Dionysus and Ariadne enthroned together at the center of the east wall.[83] As Catullus breaks his narrative of the marriage of Peleus

[77] See, for example, Drerup (1959), 155–59; Bek (1980), 181–203; and Jung (1984).

[78] The classic discussion is Wallace-Hadrill (1994), 3–61, 143–74, with some discussion of vistas at 44–45, 82–83. See also Hales (2003), 97–163; Leach (2004), 3–7, 18–54.

[79] See especially Bergmann (1994), also Elsner (1995), 74–85.

[80] For interesting accounts of the gaze in relation to some Roman paintings, see Fredrick (1995) and Platt (2002a).

[81] For example, Corlàita Scagliarini (1974–76).

[82] The literature is vast. The standard publication is Maiuri (1931), 121–74; recent accounts with bibliography include Veyne (1997) and Sauron (1998).

and Thetis with an ekphrastic inset telling the tale of Ariadne, so the villa's paintings insert the epiphany of Dionysus and Ariadne at the heart of their visual argument on the theme of marital initiation. By contrast with Catullus, the Ariadne theme in the villa seems one of divine fulfillment—a kind of serene plenitude amid scenes of ritual whipping and reading the future. Recent discussion has stressed the significance of the gaze within the painted figures of the room, prompting and challenging viewers to respond to the ambivalences and uncertainties elicited by such groups as the "bride" who looks at us, while her maid looks down at a mirror held by an Amor to the left that reflects the "bride" as if she were looking at it (figure 4.1).[84] On some level, as in Catullus' contemporary poem and as in the architectural orchestration of the house's structure along various visually constructed axes and vistas, the question of the gaze is at stake within the (admittedly exceptional and still mysterious) visual decoration of this single room with its relatively early surviving paintings.

This model of a room-sized interrogation of the gaze (in only very rarely attested so-called megalographic friezes) gives way in Campanian and Roman frescoes to panel pictures on mythological subjects inserted into the architectural arrangement of the room's décor. By the last two decades of the first century B.C. (just after Virgil's death in 19 B.C.) such panels begin to appear in surviving houses—such as the Farnesina villa in Rome or the villa from Boscotrecase (see figure 1.1).[85] In these panels, as we shall see, some of the most popular subjects (Ariadne gazing out to sea, Narcissus gazing into the pool) explicitly evoke the questions of looking, focalizing and responding to what is seen in ways that intersect interestingly with the tradition of literary ekphrasis. But the juxtapositions of themes in particular rooms often adds a resonance to how any individual picture might be viewed, by creating a cross-mythological program (which was occasionally repeated in different houses, as in the example from chapter 1 of the villa at Boscotrecase and the Casa di Sacerdos Amandus). The particularly theatrical fetish of including what have been called "supernumerary" figures within a picture to render a scene as if it were staged and watched, adds an extra frisson to the gaze—questioning the

<hr/>

[83] Note that a closely related composition of Dionysus and Ariadne—now lost—appears to have figured in the slightly later (c. 50–40 B.C.) frescoes of room H from the villa at Boscoreale. See Little (1964) and Andreae (1975).

[84] On the gaze in the Villa of the Mysteries, see Henderson (1996), especially 243 and 260 on the "bride," also 245–47, 252–53, 257–58 (on Dionysus), 260–63 (on the "domina"), 272–76 (on problems of unification in the visual field). On the "bride" and the mirror, see Balensiefen (1990), 48–50.

[85] For a brief account of panel painting, see Ling (1991), 112–41, and on the picture-gallery setting of such panels, Leach (2004), 132–55.

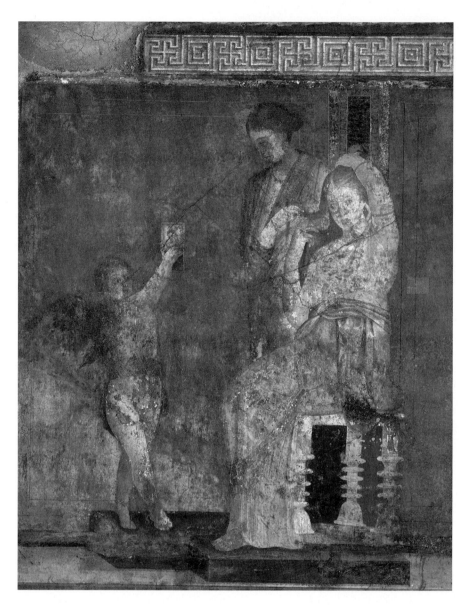

FIGURE 4.1. Fresco of the "Bride" from the south wall of oecus 5 in the Villa of Mysteries, Pompeii. Second quarter of the first century B.C. (© Photo Scala, Florence)

viewer's own spectatorship by offering him or her some pictorial models of the act of viewing within the picture.[86] So, for example, the image of Theseus triumphant after slaying the Minotaur from the Casa di Gavius Rufus (VII.2.16–17) has the nude hero spotlit before a white column with a crowd of

[86] See Klein (1912), Michel (1982), and J. R. Clarke (1997).

FIGURE 4.2. Fresco of Theseus, from Casa di Gavius Rufus, Pompeii (VII.2.16). Third quarter of the first century A.D. Now in the Naples Museum (MN 9043). (Photo: Ward-Perkins Collection, by courtesy of Roger Ling.)

onlookers to the right, one gazing up at him and several looking toward (even pointing at) the dead monster to the lower left (figure 4.2).[87] This spotlighting of a protagonist within a theater of gazes within the picture is not confined to Pompeii; there are several parallels in Philostratus' descriptions of (purportedly real) pictures in his third-century *Imagines*.[88]

Ariadne in Pompeii

Following the lead of Catullus, let us turn to the gaze in one of the most popular mythological subjects from Campania, namely the image of Ariadne gazing out at Theseus' ship as it sails away.[89] Our surviving examples are mostly from the so-called Fourth style, dating to Neronian and Flavian times, relatively soon before the eruption of Vesuvius in A.D. 79.[90] In the context of the

[87] See PPM VI.563, Bianchi Bandinelli (1970), 110–14; Ling (1991), 138; J. R. Clarke (1997), 43.

[88] For example, for figures in the centre of crowds: *Imagines* 1.3.1, 1.28.8, 2.31.2; for youths spotlit in the center of action: 1.30.4, 2.4.4, 2.7.5.

[89] On the popularity of the theme, see Fredrick (1995), 271–73.

[90] See the catalog by Gallo (1988), also Parise Badoni (1990), 83–87, and LIMC III.1.1058–60, nos. 75–90.

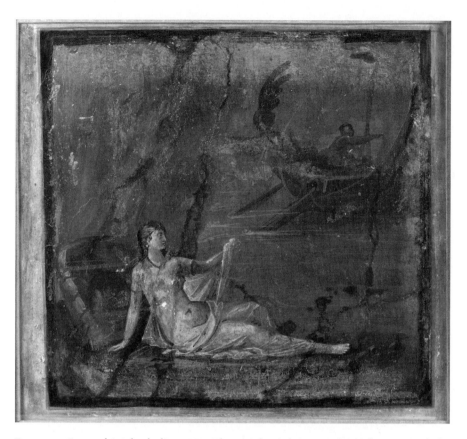

FIGURE 4.3. Fresco of Ariadne looking out at Theseus' ship sailing away, from a house in Hercula-
neum. Third quarter of the first century A.D. Now in the British Museum. (Photo: British Museum.)

single panel (occasionally presented as a prize piece in a complex trompe l'oeil
niche or frame), the isolation of Ariadne in her abandonment, which is im-
plicit in Catullus' literary treatment of the theme, is occasionally stressed, as
in a painting from Herculaneum now in the British Museum (figure 4.3).[91]
But more common is what has been called the "strangely sociable" depiction
of Ariadne at her moment of desertion—accompanied by one or more winged
figures, often with one weeping and a second pointing to the receding ship.[92]
The privacy and desolation of the moment is staged as a group with the point-
ing figure making visually explicit Ariadne's gaze at the ship while the
lamenting Eros externalizes her state of mind and tears (for example, figures
4.4–4.7). The fact that in many of the extant examples the weeping Eros
covers his eyes only heightens the scheme's emphasis on gazes and visual

[91] Gallo (1988), 68–70, no. 15.
[92] See McNally (1985), 178.

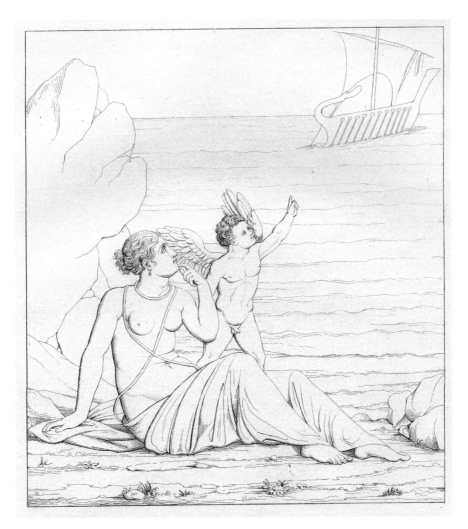

FIGURE 4.4. Fresco of Aridane looking out at Theseus' ship in the company of a pointing cupid, from Pompeii (IX.5.11). Third quarter of the first century A.D. (Photo: From Roux-Ainé and Barré, 1861, vol. 3, tav.106.)

emotion.[93] In most examples, the figure of Ariadne herself gazes out at the ship, emulating the pointing figure. However, in the interesting example from the peristyle of the Casa di Meleagro (VI.9.2/13), now in the Naples

[93] Ariadne accompanied by a single weeping eros: for example, Naples Museum 9046 and Pompeii V.3.4, with Gallo (1988), nos. 10 and 8; accompanied by a single winged figure pointing: for example, VI.8.3 and VIII.5.5, with Gallo (1988), nos. 12 and 14; accompanied by a weeping eros covering its eyes and a pointing figure: for example, Naples Museum 9047, VI.9.2, VII.12.26, V.1.18, with Gallo (1988), nos. 1–4. The weeping figure (nude, male, youthful, often with a bow) is clearly an eros. The female figure pointing has been identified as Eos by Scherf (1967), 22–26, and as Nemesis by Parise Badoni (1990), 83, and by Bragantini in PPM VII.572, for no very good reason in either case so far as I can see.

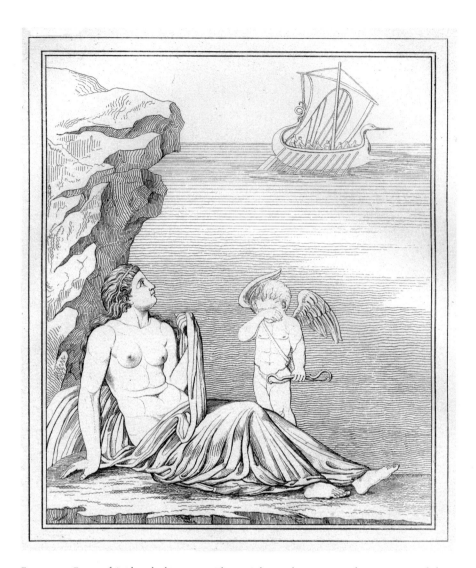

FIGURE 4.5. Fresco of Aridane looking out at Theseus' ship in the company of a weeping cupid, from an unidentified building in Pompeii. Third quarter of the first century A.D. Now in the National Museum in Naples (no. 9046). (Photo: From Roux-Ainé and Barré, 1861, vol. 2, tav. 35.)

Museum,[94] Ariadne looks away from Theseus' ship, putting her right hand to her right eye to brush away the tears—a gesture echoed by the Eros to the left. Behind her, the winged figure points to the ship (figure 4.8). Here, one might argue that Ariadne's internal division of ocularity between gazing and weeping, emphasized by all these renditions of the theme, shifts the weight of the pictorial interpretation away from the gaze as such and toward the misery

[94] Naples Museum 9051: see Gallo (1988), 57–63, no. 1, and PPM IV.719.

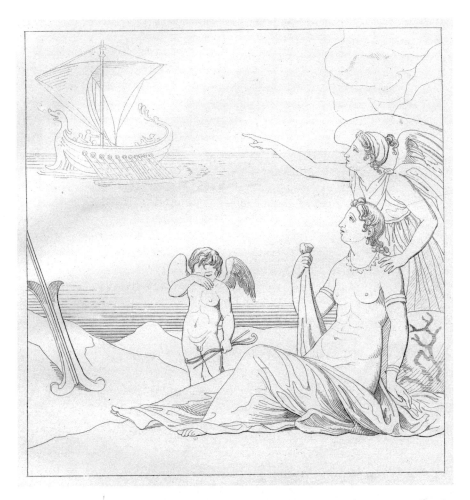

FIGURE 4.6. Fresco of Ariadne looking out at Theseus' ship in the company of a weeping cupid and a pointing female winged figure, from an unidentified house in Pompeii. Third quarter of the first century A.D. Now in the Naples Museum (MN 9047). (Photo: From Roux-Ainé and Barré, 1861, vol. 2, tav.32.)

that is its result.[95] Effectively, this version of the subject stresses the "sad eyes" (*maestis . . . occellis*, Cat. 64.60) and "waves of emotion" (*magnis curarum fluctuat undis*, Cat. 64.62) of Ariadne's dilemma, as opposed to her gaze as such.

This exteriorization or visual dramatization of the image of Ariadne's grief is extended further by an iconography of additional figures that intrude into the scene. In a painting from the Casa della Soffitta (V.3.4), the painter adds to

[95] There is an oddity or incongruity of gender in that Ariadne's weeping gesture is echoed by that of the *male* weeping eros, whereas the pointing figure is female. In other examples Ariadne looks out following the pointing figure, whose gender is female like hers.

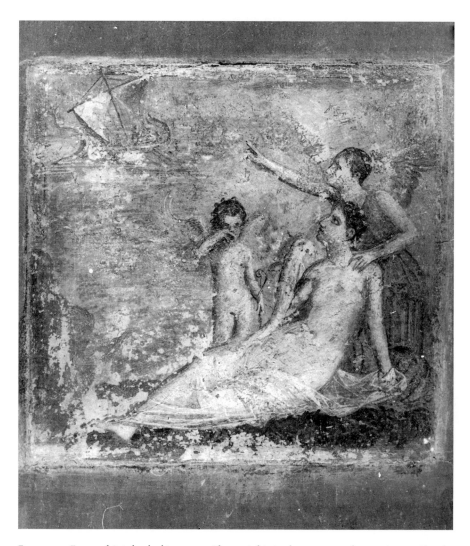

FIGURE 4.7. Fresco of Ariadne looking out at Theseus' ship in the company of a weeping cupid and a pointing female winged figure, from Pompeii (IX.2.5, room c, north wall). Third quarter of the first century A.D. This picture, taken in 1931, is all that remains of this wall painting, which has now completely faded from sight. An 1870 drawing by La Volpe appears in PPM VIII.1057 and PPM Documentazione 748, which differs from the photograph in the absence of wings on the pointing female personification. (Photo: DAI Inst. Neg. 1931.1744.)

the basic configuration of Ariadne, weeping Amor, and Theseus' ship an additional semi-nude, bearded male figure on the lower right, apparently holding an oar and looking at Ariadne, who herself looks out beyond the lamenting Amor to the departing ship (figure 4.9).[96] Not only is there a play of gazes within the picture (the onlooker at Ariadne, Ariadne at the ship, the Eros with

[96] See Gallo (1988), 65, no. 9; Guzzo (1997), 120, no. 70; and PPM III.899.

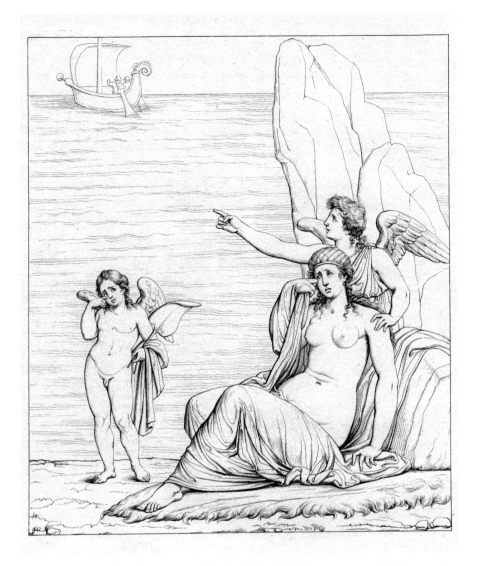

FIGURE 4.8. Fresco of Ariadne weeping while Theseus's ship sails away, accompanied by a weeping cupid and a pointing female winged figure, from the Casa di Meleagro (VI.9.2/13, peristyle). Third quarter of the first century A.D. Now in the Naples Museum (MN 9051). (Photo: From *Real Museo Borbonico* vol. 8, tav. 4.)

his hand over his eyes), but insofar as the male onlooker figures a viewer external to the main mythical narrative (like the Roman viewer within the house where this picture was displayed, for instance), Ariadne's grief is framed as itself a spectacle to be observed—as the Thessalian youths observe the coverlet in Catullus or as Aeneas responds to the various works of art in the *Aeneid*. The fact that the figure with the oar is hard to explain within the logic

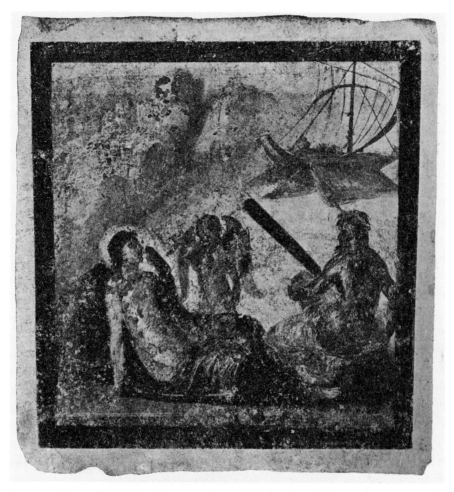

FIGURE 4.9. Fresco of Ariadne looking out at Theseus' ship, accompanied by a weeping cupid and a male onlooker figure with an oar, from the Casa della Soffitta (Pompeii V.3.4). Third quarter of the first century A.D. (Photo: From *Scavi di Pompeii*, 1905.)

of the mythical narrative (some kind of marine personification perhaps?) only adds to the sense of rupture.[97]

In the triclinium of the Casa di Cornelius Diadumenus (VII.12.26), within a wonderful trompe l'oeil niche with an illusionary coffered ceiling that presents itself as a kind of window onto a wider world outside the house, the painter adds still greater complexity (figure 4.10).[98] This time Ariadne on the left gazes at the departing ship with the aid of a winged female figure, while the Eros covers his eyes in weeping. To the right of this group is a semi-nude

[97] Not to speak of the phallic intervention of the oar whose tip reaches up to the line of Ariadne's gaze between her eyes and Theseus' ship.

[98] See Gallo (1988), 63, no. 3; Bragantini (2004), 142–44; and PPM VII.571–72.

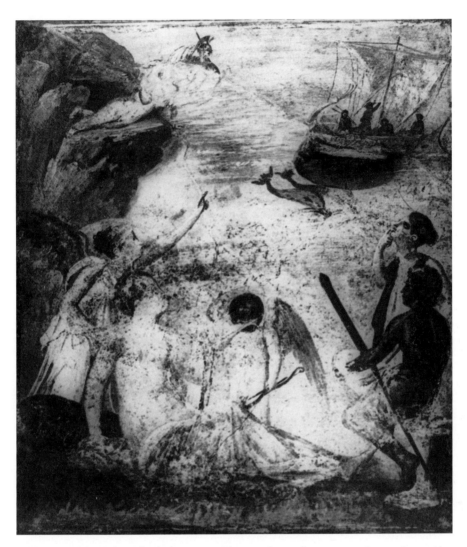

FIGURE 4.10. Fresco of Ariadne looking out at Theseus' ship in the company of a weeping cupid, a pointing female winged figure, and two onlooker figures, from the Casa di Cornelius Diadumenus, Pompeii (VII.12.26/7). Third quarter of the first century A.D. (Photo: DAI Inst. Neg. 32.1700.)

male figure with an oar (as in the Casa della Soffitta),[99] who may be observing them or may be looking up.[100] Behind him is a second, clothed, female onlooker whose gaze is focused above Ariadne at two figures on the top left. These are the goddess Athena (Theseus' protectress), apparently flying out over the rocks toward the ship, and what is probably a nude winged Amor

[99] And this oar is no less ithyphallic.
[100] If we follow La Volpe's nineteenth-century drawing of the scene, he is looking up: PPM documentazione 715–17.

reclining on the rocks.[101] This group—and certainly Athena on the rocks—which appears in no other extant version of the scene, is an import from the "Theseus escaping while Ariadne sleeps" iconographic topos.[102]

However one stretches the mythical narrative to explain the accumulation of figures on the upper left (Athena and the reclining nude) no interpretation that seeks a coherent pictorial unity within the image can surely make sense of the two onlookers to the right (one might be justified as a personification, I suppose, but two—as Oscar Wilde might have had it—implies carelessness!). Instead we have a staging not only of viewers observing a scene of gazing but of one of these interlopers looking up and seeing in the picture something which never was there (in any of the other examples of Ariadne gazing) but comes to be so, here—the epiphany of Athena and the vision of the reclining winged nude. Since the primary object of Ariadne's gaze in all these versions is a vanishing ship, more or less sketchy in the distance, the actual object of the painting as it stages the scene is the gaze itself (as in the ekphrastic strategies of both Catullus and Virgil, as I have argued). But what the mural from the Casa di Cornelius Diadumenus adds to this subject is a deliberate problematization of the observing focalizer. In multiplying its onlooker figures and staging the potential difference of their gazes (both in direction and in object), the painting throws back at its viewers a question about what point of view, what hierarchy of significance, what object of the gaze they themselves will apply to this (or any) painting. The visual challenge is not so radically different from those of the different perspectives Virgil stages at the images in the temples of Juno at Carthage and Apollo at Cumae.

With a number of these Campanian paintings it is possible to embark on a contextual interpretation in the light of other pictorial themes with which they were connected.[103] The number of visual juxtapositions is large and their potential meanings are not always obvious. But twice, for instance, Ariadne gazing at Theseus' receding ship is paired with a pendant showing Leander swimming across the Hellespont to Hero, who gazes upon him from the other bank.[104] Here there is a play of desire defeated and desire fulfilled. In each case the lovers are separated by water, with the female looking out at the male in action, who sails away from his lover in the case of Theseus or swims toward her in the case of Leander. In the Casa dei Vettii, the watery nature of the

[101] Again, given the current state of the image, the best guide is La Volpe's drawing. But we do have to trust it! See PPM documentazione 715–17 and PPM VII.572.

[102] On the sleeping Ariadne abandoned by Theseus, see McNally (1985), 177–91; Parise Badoni (1990), 73–82; and LIMC III.1.1057–58, nos. 55–66.

[103] See Parise Badoni (1990), 88—appendices 1 and 2 for lists of the surviving cases.

[104] In room z of the Casa del Gallo, VIII.5.2/5 (PPM VIII.563–65 with PPM documentazione 282 and 839) and in cubiculum (d) of the Casa dei Vettii, VI.15.1 (PPM V.482–85).

CHAPTER FOUR

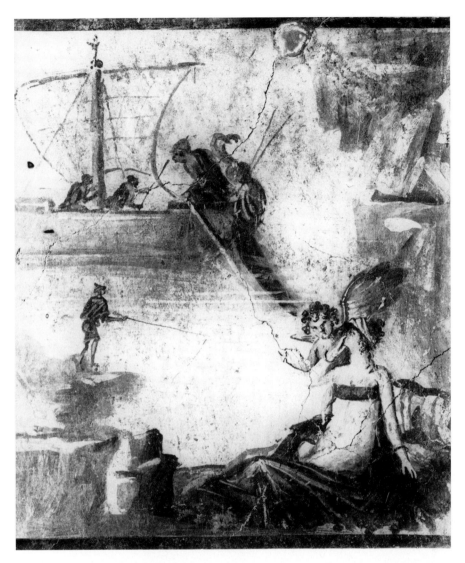

FIGURE 4.11. Fresco of Ariadne looking out at Theseus' ship accompanied by a pointing cupid, with a fisherman in the middle distance, from the north wall of cubiculum D of the Casa dei Vettii, Pompeii (VI.15.1/2). Third quarter of the first century A.D. (Photo: DAI Inst. Neg. 53.635.)

space over which desire and separation are enacted in these stories is emphasized by a remarkable frieze of swimming fishes in the upper part of the room above the panels with mythological scenes (figures 4.11–4.13).[105] In the Casa

[105] See PPM V.483. Note that not all the mythological images from the walls of cubiculum d have survived and that the original scheme would therefore have been more complex. The Ariadne theme may be completed in the nearby oecus e, whose south wall has Dionysus and Ariadne (?) enthroned together in its main image: see PPM V.488–91.

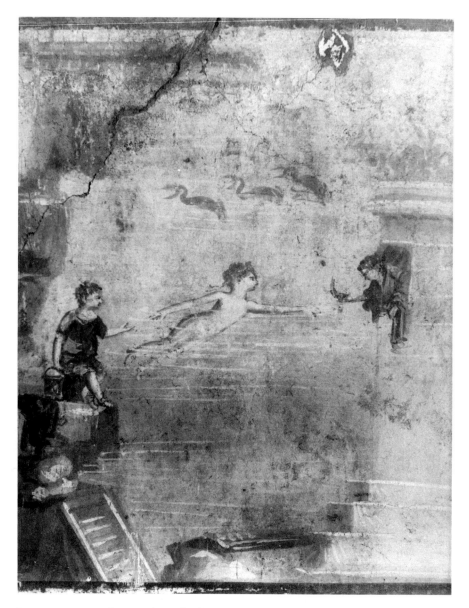

FIGURE 4.12. Fresco of Hero and Leander, from the south wall of cubiculum D of the Casa dei Vettii, Pompeii (VI.15.1/2). Third quarter of the first century A.D. (Photo: Fototeca Unione—AAR, neg. 2574.)

di Poeta Tragico (VI.8.3/5), the Ariadne theme cuts across more than one room. In room 14 (sometimes numbered 14a), off the peristyle, was an image of Ariadne looking out to sea with an Eros pointing to Theseus' ship.[106] Across the peristyle, in triclinium 15, was a panel of Theseus deserting Ariadne

[106] Gallo (1988), 68, no. 12; PPM IV.562–3.

FIGURE 4.13. General view of cubiculum D in the Casa dei Vettii, Pompeii (VI.15.1/2), looking east, showing the frieze of fishes and the Ariadne panel (fig. 4.17) to the left. Third quarter of the first century A.D. (Photo: Courtesy of Katherina Lorenz.)

(probably asleep, though this section of the picture hardly survives).[107] Here the pictorial décor of the house offers not only what could be seen as a temporal progression of the subject, with the gazing scene following the abandonment, but also effectively two renderings of the same theme from the (very different) points of view of Theseus and Ariadne. In cubiculum 14, the story is focalized through Ariadne's gaze—it is a narrative of her loss and the bereavement of her love (as thematized by the Amor). In room 15, we are offered Theseus boarding ship with Athena hovering over the rocks to the upper left. The desertion is focalised through the sharp glance of Theseus looking back for a last time at his sleeping lover as he leaves, and justified by the presence of Athena, urging him on to his mythic destiny. Again, as in Virgil's staging of more than one view of a work of art (Daedalus' view and Aeneas' at Cumae, for instance, or Aeneas' "misreading" of the Trojan cycle at Carthage, not to speak of Aeneas' and Dido's mutually exclusive opinions of his departure), the paintings perform the diversity of potential focalization around a single event or sequence of events and the complexity of clashing subjectivities in response.

[107] Parise Badoni (1990), 74–76; PPM IV.573–76. A good black-and-white photograph of the much damaged Ariadne is in Rizzo (1929), tav. 39.

EKPHRASIS AND THE GAZE

Two final treatments add a further frisson to the complex by throwing Dionysus into the pictorial melting pot (as does Catullus). In the Casa dei Capitelli Colorati (VII.4.31/51), there are two views of the encounter of Dionysus and Ariadne, both in rooms off the peristyle in the middle of the house. In oecus 24, in an image largely lost but well preserved in nineteenth-century drawings, Dionysus and his entourage come upon Ariadne asleep (figure 4.14).[108] In oecus 28 was an image (now wholly preserved only in somewhat contradictory nineteenth-century versions) showing Ariadne weeping and gazing *away* from the sea out of the picture's space to the left. Behind her to the left, Theseus' ship sails away into the distance, while to the right stand Dionysus, Silenus, and two bacchantes (figure 4.15).[109] Here we have a single subject—the discovery of Ariadne by Dionysus—staged in radically different ways with very different emotive connotations. In neither case does Ariadne know her fate as divine bride, but in one she sleeps through both abandonment and epiphany, while in the other she stares away from her fate—both past and future, both loss and imminent bliss. The viewer focuses no longer on Ariadne, whose ignorance in different ways might be seen as the subject of both images, but on the dramatization of that ignorance in which we (like Virgil's extratextual readers) know something that the protagonist of the visual narrative does not.

Finally, in two rooms off the peristyle of the Casa della Fortuna (IX.7.20), the same play of different Dionysiac discoveries is enacted. In one room (i) Dionysus and his entourage come across the sleeping Ariadne in an iconography related to the scene in oecus 24 of the Casa dei Capitelli Colorati (figure 4.16).[110] In room (l), however, at least two images of Ariadne were juxtaposed. One showed her seated in a chair to the left giving the thread of wool to Theseus at the inception of their love;[111] the second had her seated on the ground at the lower right and pointing. It is ambiguous from Discannio's nineteenth-century drawing whether she points at the ship, receding into the distance, or at Dionysus himself who stands before her (figure 4.17).[112] Here Ariadne appears to confront both her fates (directly reversing the effects of the image in oecus 28 of the Casa dei Capitelli Colorati)—both the loss of her human lover (emphasized by the image of her meeting with Theseus in the same room)

[108] See PPM VI.1072–73, PPM documentazione 833.

[109] See Gallo (1988), 73–75, no. 19; PPM VI.1046–47 and PPM documentazione 205. Rizzo (1929), tav. 109, gives as good a picture as one can find of the mural's state a hundred years ago.

[110] See PPM IX.848.

[111] See PPM IX.860.

[112] See PPM IX.862, and Gallo (1988), 71–73, no. 18, but beware the reproduction here (no. 16), which is wrongly reversed right to left.

FIGURE 4.14. Fresco of Dionysus and his entourage discovering the sleeping Ariadne, from oecus 24 of the Casa dei Capitelli Colorati, Pompeii (VII.4.31/51). Transferred to the Naples Museum (MN 9278) and now almost wholly lost. Third quarter of the first century A.D. (Photo: From Raoul-Rochette, 1867, pl.5.)

and the arrival of her divine lover. This image offers a wakeful resistance to the Ariadne of room (i) and a deliberate swapping of Theseus for Dionysus in that the two images are in parallel with Ariadne seated in both, to the left with Theseus and to the right with Dionysus. In the visual narratives of rooms (i) and (l), the stories seem incompatible—either Ariadne was asleep or

FIGURE 4.15. Fresco of Ariadne abandoned, with Theseus' ship in the distance and Dionysus with his entourage approaching behind her, from oecus 28 of the Casa dei Capitelli Colorati, Pompeii (VII.4.31/51). Third quarter of the first century A.D. (Photo: From Raoul-Rochette, 1867, pl.6.)

FIGURE 4.16. Fresco of Dionysus and his entourage discovering the sleeping Ariadne, from room (i) of the Casa delle Fortuna, Pompeii (IX.7.20). Third quarter of the first century A.D. Now wholly lost and surviving only in a nineteenth-century sketch by Discannio. (Photo: Guidotti, DAI 53.559.)

awake when Dionysus came upon her, either the god arrived with a large retinue or their meeting was in intimate isolation.[113] It is as if the refractions of the gaze which we have been exploring are themselves versions of the refracted mythological matrix which allowed stories to be told in such substantially divergent ways by the same patrons and artists for the same groups of viewers.

[113] For another image of just Dionysus and Ariadne alone together from VI.11.4, but with Ariadne asleep, see PPM documentazione 283.

FIGURE 4.17. Fresco of Ariadne face to face with Dionysus, pointing to him or to Theseus' receding ship, from room (1) of the Casa delle Fortuna, Pompeii (IX.7.20). Third quarter of the first century A.D. Now wholly lost and surviving only in a nineteenth-century sketch by Discannio. (Photo: Guidotti, DAI 53.561.)

Much might be said about the multiple thematic reverberations of meaning and response generated by the variations on mythical themes perpetuated by Campanian painters. Those variations are exactly parallel to the creativity with myth offered both by such oral traditions as those reported by Pausanias and by much more high-flown literary versions in poets like Virgil and Ovid.[114]

[114] The outstanding account of Greco-Roman myth, its relations to truth and belief, and its pluralism is Veyne (1988).

My point here is that the *gaze* (different characters' gazing, the different potential objects upon which the gaze may be focalized, the self-consciousness of representing the gaze itself being gazed at) is a central weapon in the visual mythographers' pictorial argument. This is repeatedly emphasized by Philostratus in his elegant early-third-century ekphraseis of what are allegedly real panel paintings and can be generically taken to have some intended resemblance to the kinds of murals we find in Pompeii. While Philostratus' Ariadne (1.15) belongs to the sleeping topos (alongside a series of other often eroticized sleepers),[115] the painting described immediately afterward—of Pasiphaë—turns pointedly on a play of frustrated gazes. While Daedalus makes the cow whose form will allow the queen to experience sexual satisfaction, "Pasiphaë outside the workshop in the cattle-fold gazes on the bull. . . . She has a helpless look—for she knows what the creature is that she loves—and she is eager to embrace it, but it takes no notice of her and gazes at its own cow. . . . It gazes fondly at the cow, but the cow in the herd, ranging free and all white but for a black head, disdains the bull. For its pose suggests a leap, as of a girl who avoids the importunity of a lover" (1.16.4).[116] This complex of desires frustrated is enacted by the same means—the gaze—as the exchange of looks that generates falling-in-love in the Perseus description (I.29) explored in chapter 1, or the self-absorbed petrification in his own reflected gaze played out by Narcissus in *Imagines* 1.23 (on which see chapter 6 below). Repeatedly in Philostratus the gaze is articulated as a key mechanism for the emotional impact and hence meaning of paintings.[117]

Within painting, then, as well as within the writing about painting, the gaze takes up a crucial role as focalizer of the subject's position, director of the subjectivity of a viewer to a chosen object, projector of desire, framer of interpretative direction. It is some of the manifold ramifications of this mechanism of the Roman gaze as unifier but also as divider of self and the world that Part II will explore.

[115] For eroticized sleepers, cf. Comus at 1.2, Olympus at 1.20 and Midas' satyr at 1.22. Other sleepers include Pan at 2.11 and Heracles at 2.22.

[116] See on 1.16 Beall (1993), 359–63.

[117] Particularly interesting are those moments when the gaze appears to become the subject of Philostratus' account of a picture—for instance at 1.13.9, 1.16.4, 1.21, 1.23 as well as the *Imagines* 5 of the Younger Philostratus. See on this Elsner (2004), 164–71; also Leach (2000).

PLATE I. Wax-encaustic icon of St. Peter, from Sinai (see also figure 3.1).

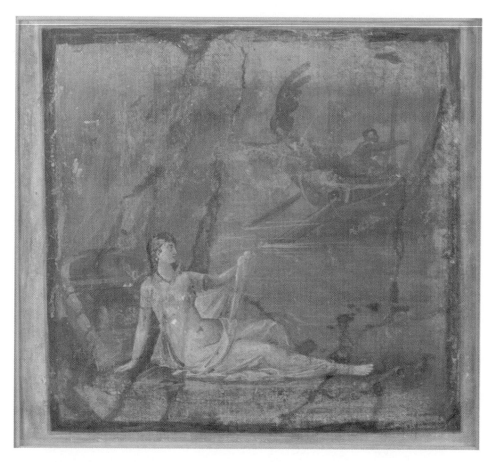

PLATE II. Fresco of Ariadne abandoned by Theseus, from Herculaneum (see also figure 4.3).

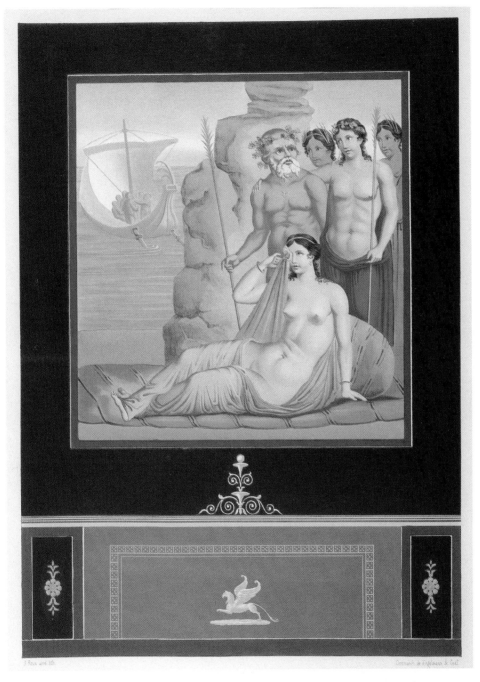

PLATE III. Print after a lost fresco of Ariadne abandoned, with Theseus' ship in the distance and Dionysus approaching, from Pompeii (see also figure 4.15).

PLATE IV. Fresco of Narcissus, from Pompeii (see also figure 6.6).

PLATE V. The atrium of the Casa dell' Ara Massima, Pompeii (see also figure 6.7).

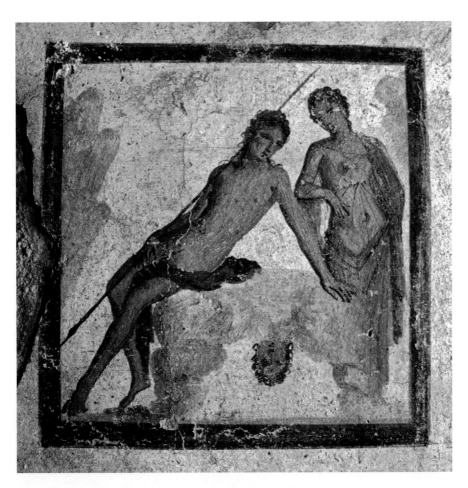

PLATE VI. Fresco of Narcissus, Eros, and Echo, Pompeii (see also figure 6.17).

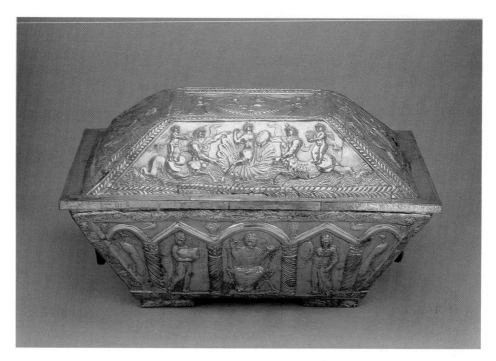

PLATE VII. The Projecta casket, silver with gilding (see also figure 8.6).

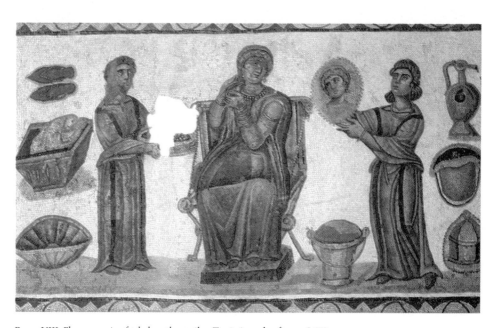

PLATE VIII. Floor mosaic of a lady at her toilet, Tunis (see also figure 8.11).

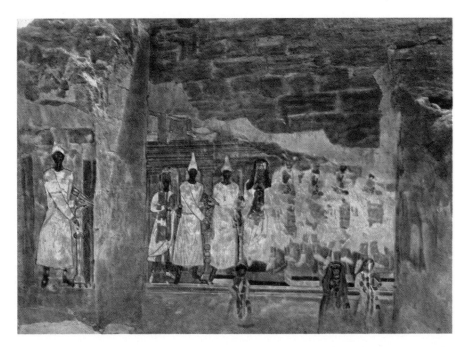

PLATE IX. Print after the fresco of Conon and his family making sacrifice, Dura Europos (see also figure 10.1).

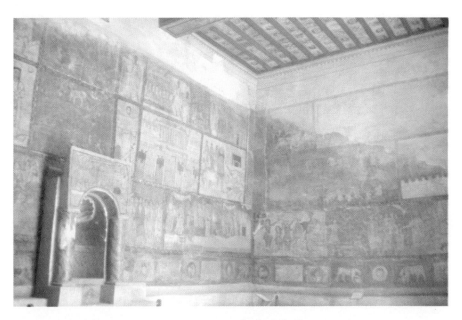

PLATE X. View of the synagogue, Dura Europos (see also figure10.11).

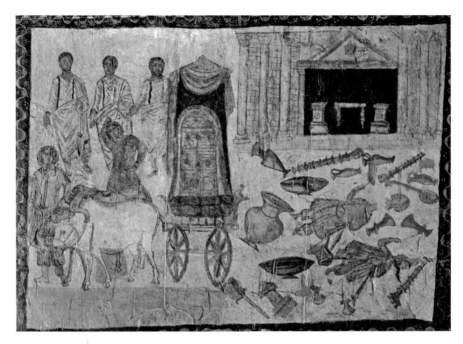

PLATE XI. Fresco of the Ark of the Covenant in the land of the Philistines, Dura Europos synagogue (see also figure 10.16).

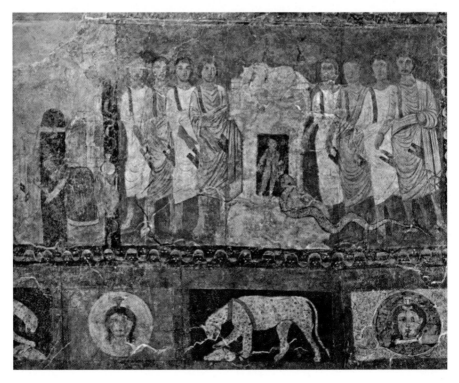

PLATE XII. Fresco of the prophets of Baal making sacrifice, Dura Europos synagogue (see also figure 10.17).

WAYS OF VIEWING

<div style="text-align: center">

┌─────┐
│ 5 │
└─────┘

</div>

VIEWING AND CREATIVITY

Ovid's Pygmalion as Viewer

> *The art of sculpture flourished in Greece and was practised by many splendid artists, notably Phidias of Athens, with Praxiteles and Polyclitus, who did excellent work in intaglio, and Pygmalion, who produced relief sculpture in ivory. It was Pygmalion of whom the story goes that, in answer to his prayers, the girl he had carved in stone was brought to life.*
>
> —Giorgio Vasari

OVID'S PYGMALION HAS USUALLY been read as a myth of the artist.[1] So successful a story was it, that the Renaissance art historian Vasari, writing in the sixteenth century, places Pygmalion in his list of great ancient artists, and concludes his catalog with what had already become the supreme paradigm of realist art—the myth of the artist whose sculpture not only was like flesh but became flesh.[2] Modern literary critics have tended to agree with the judgment of Vasari. "Pygmalion is the creative artist *par excellence*,"[3] to be associated directly with Ovid himself as a symbol of the "artist's 'boundless liberty' to represent such perfections as nature could never produce."[4] He is seen in parallel with Orpheus, the poet in whose song (within Book 10 of the *Metamorphoses*, vv. 148–739) the Pygmalion episode appears.[5] Through this parallel of sculptor and poet, "Ovid provides a metaphorical reflection of the creative and restorative power of his own art."[6] In all these versions there is a "figurative equation between the sculpture of Pygmalion and the art of the poet," in which the statue serves as a "most celebrated exemplar of the potentialities

[1] This is despite the strictures of Wilkinson (1955), 212, who believed that "we must not force such interpretations on stories which, whatever their mythological origin, were surely told by Ovid for their own sake."

[2] The epigraph is taken from Vasari (1550), preface, trans. George Bull.

[3] W. S. Anderson (1963), 25; cf. Solodow (1988), 215. For Pygmalion as creator of *woman*, as an analogue for Ovid, creator of elegiac women, see Sharrock (1991b).

[4] Fränkel (1945), 96.

[5] Viarre (1968).

[6] Segal (1972), 491.

belonging to the fine arts."[7] As one commentator has written, "what more could Ovid do to establish the priority of art over nature? The story of Pygmalion is crucial to the *Metamorphoses*, for here . . . the poet demonstrates most vividly the power of the artist."[8] The tenor of all these readings is that Ovid presents Pygmalion as a success story, an artist so superb and a lover so intense that his art does indeed begin to breathe.

Others, however, have seen Pygmalion the artist as a model of "artistic failure."[9] For them, Pygmalion's art is a narcissistic self-absorption;[10] he "has created a private love object and realized a private love wholly isolated from reality."[11] Pygmalion uses "art in the service of his own apostasy" and "carves a material monument to his artistry in the form of a statue."[12] His love, itself a "self-love of astounding intensity,"[13] is also a loss—it causes him to lose "the identity whose reflection he welcomed so avidly in his object."[14] This loss is, in part, of his identity *as* artist, since "once the statue *is* a 'true maiden,' it is no longer artistically marvelous: the gap between appearance and reality that made its mimesis an artistic *tour de force* disappears."[15] "In the end, the former stone has no autonomy or identity beyond that of Pygmalion, her creator and her husband who is her whole world. . . . Pygmalion can regard the woman as his possession, as much as the initial block of stone was."[16]

All these versions of Ovid's myth focus on different facets of the theme of the artist. But an alternative reading of Ovid's Pygmalion, as a lover and one who responds to his object of love,[17] suggests that the story might also be taken as a representation of how art was viewed in antiquity.[18] It is notable that Ovid in fact gives only two and half lines to describing Pygmalion's act of creation (*Metamorphoses* 10.247–49). The rest of the story (some fifty lines) dwells in exquisite detail on the viewing, which sees the ivory statue as a real

[7] Bauer (1962), 13.

[8] Solodow (1988), 219.

[9] Leach (1974), 127.

[10] Leach (1974), 123–25; Janan (1988), 119, 124–26.

[11] Leach (1974), 125.

[12] Janan (1988), 124.

[13] Ahl (1985), 246.

[14] Janan (1988), 124; cf. Leach (1974), 124.

[15] Janan (1988) 125; cf. Freedberg (1989), 343–44: "The great paradox and the great tragedy that lies in making the protagonist an artist is that the object he made was only beautiful because of his skills, because it was art; but as soon as it came alive, it was no longer a piece of art at all. It was indeed, and no less, the body itself."

[16] Hershkowitz (1999), 189. Note that "stone" must be a slip, since ivory is a kind of bone. See also Hershkowitz (1998), 187–89.

[17] See Bettini (1999), 66–73, on Pygmalion as a "paranoid lover," and Lively (1999), 212–13, on Pygmalion's transformation from artist to lover.

[18] With, for example, Hardie (2002b), 189.

woman, and on Pygmalion's desire and its fulfillment. The Pygmalion I evoke below is an account of the sculptor as viewer. This perspective has important repercussions for reading the *Metamorphoses*. If Pygmalion the creator is inevitably suggestive of the writer (whether this be Ovid or Orpheus or both), then Pygmalion as a viewer appears as a myth of the reader. The ivory statue (which we may view as a figure for the poem) may have been created by Pygmalion the sculptor, but it generates him as a viewer-lover,[19] just as the *Metamorphoses* generates us as its readers.

REALISTIC SCULPTURE AND MYTHS OF THE REAL

Before plunging into Ovid's version of viewing realistic sculpture, let us explore some of the problems of realistic art by looking at a Roman statue of roughly Ovid's time. The celebrated Venus dei Medici, discovered in the early Renaissance in Rome, is now in the Uffizi Gallery at Florence (figure 5.1). It is thought to be a Roman marble copy of a Hellenistic bronze original, which was in its turn a copy or variant of Praxiteles' famous Aphrodite of Cnidos.[20]

Beside this image place the remarkable description of the Venus dei Medici by the French sculptor Auguste Rodin: "Is it not marvellous? Confess that you did not expect to discover so much detail. Just look at the numberless undulations of the hollow which unites the body and the thighs. . . . Notice all the voluptuous curvings of the hip. . . . And now, here, the adorable dimples along the loins. . . . It is truly flesh. . . . You would think it moulded by caresses! You almost expect, when you touch the body, to find it warm."[21] Of course, Rodin is wrong. He doesn't have the benefit of knowing that his exalted Roman marble is, to quote Martin Robertson, a mere "dull copy, restored and worked over of a statue adapted by conventional minds from a creation of great originality."[22] Furthermore, he misconceives his object. The

[19] Ovid's persistent presentation of Pygmalion in terms of the tropes usual of an elegiac lover (on which see Knox 1986, 52–54; Sharrock 1991b, 43–46; and Holzberg 2002, 136–37) is one highly literary device for evoking Pygmalion as viewer-lover. But ironically this is also a way of assimilating Pygmalion to Ovid himself (the elegiac lover par excellence) as well as of romanizing the originally Greek context of the myth with a series of contemporary Roman customs and idioms, on which see Wheeler (1999), 202.

[20] On the origins of the Venus dei Medici, see Mansuelli (1958–61), 71–73. For a discussion of this image (a "dull copy," a "charmless remnant of antiquity", see Robertson (1975), 1:549. For her later history, see Haskell and Penny (1981), 325–28; Didi-Huberman (1999), 11–25. On the Aphrodite of Cnidos, see, for example, Havelock (1995); Stewart (1997), 97–107; Salomon (1997); R. Osborne (1998), 230–35; and G. Zanker (2004), 42–44, 144–46.

[21] Quoted by Berger (1980), 182.

[22] Robertson (1975), 1:549.

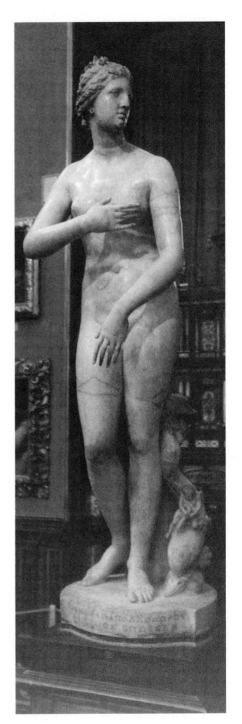

FIGURE 5.1. Venus dei Medici. Roman period version of a Greek Aphrodite type deriving from Praxiteles' Aphrodite of Cnidos. Marble, signed in Greek on the base, "Cleomenes, son of Apollodorus, the Athenian, made [me]." Usually dated to the first century B.C. (on the basis of the letter forms of the inscription), but perhaps later. Found in Rome in the sixteenth century and sent to Florence in 1677. Uffizi Museum. (Photo: Nicholas Penny; Conway Library, Courtauld Institute of Art.)

Venus dei Medici is a *goddess*, not a woman. It specifically can never be what Rodin wants it and imagines it to be, what the eroticism of his language constantly suggests it to be—namely, a woman available to the full play of erotic suggestion occasioned by male desire.

But conceptually speaking, Rodin's jump is interesting. He takes the image to refer not to a more original original (a Greek bronze rather than a Roman stone) but to a still more original original—a "real" woman. Realistic art, like the Venus dei Medici, seems to have built into it the search for and desire for a prior reality, a referent more real and other than the statue itself. This is the inevitable effect of carving stone perfectly so as to resemble flesh. The supreme achievement of the "voluptuous curvings of the hip," the "adorable dimples along the loins," would be for these to become real curvings, real dimples, in a real woman.

"Realism" in art necessarily evokes a myth of "reality." Perfectly sculpted flesh evokes the real thing; the perfect sculpted body evokes a real body. The "real" object, in this case a woman, is the goal to which realist art constantly aspires, and yet this reality is precisely the limit it can never reach, the boundary it cannot transgress. It is not only the famous sculptor who moves from the work of art in the direction of a "real" referent outside the world of art. In fact art history itself follows Rodin down this path of the real. But what the scholars evoke is not their own myth of a real woman; it is someone else's story (the classic story) of a statue that becomes a woman—the myth of Ovid's Pygmalion. John Berger, in his discussion of Rodin's sculpture, jumps from statues like the Venus dei Medici to the ur-myth par excellence of a statue that becomes "real"—namely, the myth of Pygmalion.[23] For David Freedberg, Pygmalion's "act of re-creation by love becomes the hallmark of the powers of creation itself."[24] The third chapter of Ernst Gombrich's book *Art and Illusion*—still perhaps the most influential discussion of "realism" in the history of art—is revealingly entitled "Pygmalion's Power." Gombrich says of Pygmalion: "Ovid turned it into an erotic novelette, but even in his perfumed version we can feel something of the thrill which the artist's mysterious powers once gave to man."[25]

Before we move to Ovid's myth of realism and art in his "perfumed version" of Pygmalion, it is worth reassuring ourselves that Rodin's fantasies of Classical statues are not gratuitously irrelevant to how such realist images were seen in antiquity. In the *Amores* attributed to Lucian, the author describes a visit to Praxiteles' statue of Aphrodite at Cnidos (figure 5.2 shows

[23] Berger (1980), 181.
[24] Freedberg (1989), 340–44, quotation at 342.
[25] Gombrich (1960), 80–98, quotation at 80.

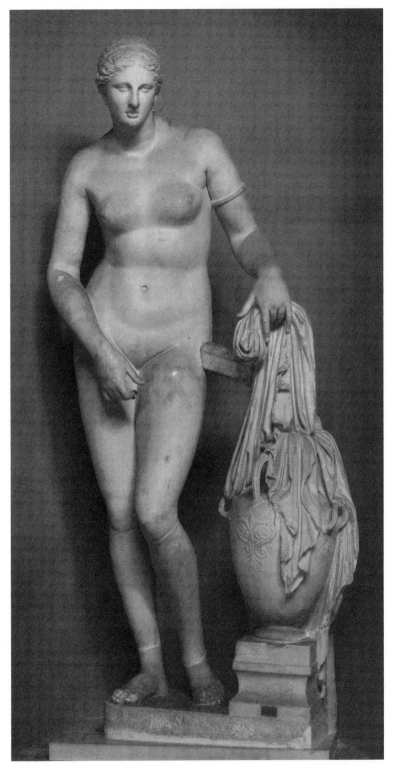

FIGURE 5.2. Aphrodite of Cnidos. Roman version (the so-called Colonna Venus) of Praxiteles' statue of the mid-fourth century B.C. Marble. First or second century A.D. Vatican Museum (Photo: Felbermeyer, DAI 68.3650.)

our most accurate surviving copy).[26] This statue, of course, was the model that inspired the copy of which the Venus dei Medici is a later version. The sketch takes the form of a dialogue in which one of the participants recounts his trip to the temple with two friends—Charicles, a heterosexual, and Callicratidas, who is gay. Initially Callicratidas is not keen to visit a famously erotic female image, and his embarassment is increased when Charicles—viewing the statue from the front, immediately enamored and distracted by the image of his desire—flings himself upon the marble and starts to kiss the goddess with importunate lips (*Amores* 13.6–10).

When the visitors view the image from behind, however, the embarassment is reversed. Callicratidas, "who had been so impassive an observer a minute before, upon inspecting those parts of the goddess which recommend a boy, suddenly raised a shout far more frenzied than that of Charicles" (*Am.* 14.17–19). The reader is then treated to the disturbing spectacle of the most celebrated statue of Aphrodite, goddess of feminine sexuality, being praised for the delights of her rear in a speech as hyperbolic as Rodin's by a homosexual man (*Am.* 14.19–28). In Lucian's account, the play of fantasy and desire is as pronounced as in Rodin. The brilliance, and strangeness, of this ancient image-panegyric is that the same female statue can function simultaneously as the object of male homo- and heterosexual desire. This is a spectacular example of the transgressive nature of an ancient god. But it is also a succinct demonstration of the way desire is generated by the beholder for an object essentially in his or her *own* imagination, an object which has little to do with the actual material work that sparked off the fantasy. Charicles fell for an ideal woman, Callicratidas for a boy; but the actual object around which these fantasies were played is the statue of a goddess.

The visitors to Cnidos also notice that the statue has a blemish on one thigh "like a stain on a dress" (*Am.* 15.1–2). As they speculate about its causes and unexpectedness in a work of such perfect finish, the attendant tells them a "strange, incredible story" (*Am.* 15.10–11). A young man had fallen passionately in love with the statue and eventually engineered to spend the night locked in the sanctuary. The woman concludes, "These marks of his amorous

[26] See Foucault (1990), 212–13; R. Osborne (1994), 81–85; Goldhill (1995), 102–111; McGlathery (1998), 220–23; and Borg (2004a), 52–57. Although this text is always considered pseudo-Lucianic and probably third century A.D., I have seen no substantive argument making the case. The dialogue is elegant, well written, and clever enough to be characteristic of Lucian, and its apparent divergences of style from other works in a heterogeneous corpus cannot be considered clinching when other stylistically and thematically exceptional works (like the *De Dea Syria*) have come to be accepted as Lucianic. Effectively it is its subject matter (distasteful in the eyes of an earlier era because apologetic for homosexuality) that has warranted the dismissal of the *Amores* from the Lucianic corpus where the manuscripts have consistently placed it. For some discussion of issues of authorship and bibliography, see C. P. Jones (1984).

embraces were seen after day came and the goddess had that blemish to prove what she had suffered" (*Am.* 16.10–11). The passionate sexual actions of the unnamed youth and his consequent suicide mark limits that are distinctly extreme in the history of the appreciation of art.[27] To add to the sense of extremity, the homosexual Callicratidas rounds off this tale of heterosexual desire by speculating on just how the "love-struck youth" enjoyed his "complete liberty to glut his passion": "he made love to the marble as though to a boy, because, I'm sure, he didn't want to be confronted by the female parts . . ." (*Am.* 17.24–27).

One source of this tale of a young man's passion for a statue turns out to have been a source for Ovid's Pygmalion. Like its rough contemporary the Venus dei Medici, Pygmalion's story is the descendant of a long tradition of lost originals. Although we have no access to these, there do survive accounts (all later than Ovid) of the earlier myth. We learn from Clement of Alexandria and Arnobius, both Christian apologists, that the story of Pygmalion was recounted by the third-century B.C. writer Philostephanus in his *Cypriaca*.[28] In this early version of the myth, Pygmalion, king of Cyprus, falls in love with a statue of Aphrodite—just like the unfortunate Cnidian in Lucian. In the words of Arnobius, exploiting for his Christian purposes the depths to which pagan idolatry could descend, "Pygmalion used in his madness, just as if he were dealing with his wife, to raise the deity to his couch and be joined with it in embraces and kisses, and to do other vain things, carried away by an imagination of empty lust" (*Adversus Gentes* 6.22).

Commenting on this story, Clement of Alexandria is particularly sensitive to the dangers of art in "beguiling man by pretending to be truth" (*Protrepticus* 4.51), and to the fact that these dangers are especially present in erotic images. He is aware of the problem of realism as we observed it in Lucian and Rodin—the temptation of taking stone for flesh and the function of desire in directing the beholder from the actual statue or painting to an *imagined* object. But Clement also notes a second problem posed by the myth as related by Philostephanus: "If one sees a woman represented naked, he understands it is 'golden' Aphrodite. So the well-known Pygmalion of Cyprus fell in love with an ivory statue; it was of Aphrodite and it was naked" (*Protrepticus* 4.50–51). Clement's comment raises two issues: How can you tell if a female nude is a goddess or a woman? And if she is a goddess, what is the status of the dangerously transgressive desire that takes the sacred image to be available as a

[27] For a history of such responses from sexual arousal to witchcraft, from idolatry to iconoclasm, see Freedberg (1989).

[28] Clement of Alexandria, *Protrepticus* 4.50f.; Arnobius, *Adversus Gentes* 6.22. On Philostephanus, see Muller (1841–70), 3:28ff. Generally on the sources for Ovid's Pygmalion, see Otis (1970), app. 14, 418–19; Bömer (1980), 93–97; Rosati (1983), 54–57; and Miller (1988), 205–8.

human sex object? Clement's Pygmalion, like the love-struck young man in Lucian, imagines the occupant of the Other World to play by the rules of this one. But the goddess is not a woman—and in Lucian, at least, the crime is punished by suicide. Although a momentary action in time, the rape of the goddess is marked by the blemish on the stone for all time.

Both Clement and Arnobius mention a second myth in connection with Philostephanus' Pygmalion. This is said to have been recounted by the writer Posidippus in his works on Cnidos.[29] It is precisely the story of the youth who fell for Praxiteles' Aphrodite, which we met with some elaborations in Lucian's *Amores*. In all these cases the core narrative is the same: a young man falls madly in love with a statue of Aphrodite, takes it to bed with him, and makes love to it. Clearly the theme was popular in antiquity.[30]

These accounts of the myth differ in two essential respects from Ovid's version. First, Ovid's Pygmalion is in love with a sculpture of a *woman*.[31] The Roman poet abandons the theme of the beholder's love being for the statue of a *goddess* imagined as a woman, although his Venus (who enables the consummation of Pygmalion's desire, 10.277–94) is described in terms that suggest a chryselephantine statue animated through sacred ritual.[32] Ovid concentrates the story around the problem of realism, which, while it is transgressive in making the marble or ivory flesh, is precisely *not* a problem of the human transgressing the divine. Ovid dramatizes what is to him the important transgression (that of realism, and hence of art) by eliminating the religious one.[33]

Ovid's second innovation is a correlate of the first. Given Clement's dictum that statues of nude women are goddesses, the only way to ensure the humanity of Pygmalion's ideal woman is to indulge the fantasy of authorial intention and make Pygmalion artist as well as lover. Pygmalion is unique. He is the ideal beholder who sees neither more nor less than the artist saw; he is the ideal artist whose creation will never be subject to the misinterpretations of viewers. It is only because Pygmalion was sole creator and sole observer that his statue could remain forever a human woman. Any other viewer might have followed Clement in taking a "woman represented naked" to be golden Aphrodite. Ovid's "perfumed version" turns Pygmalion into the supreme myth of the artist. He is the artist who makes his image so like life that in the end art becomes life. He is the artist—the one and only artist—to preserve his

[29] On Posidippus, who may or may not be the same person as the third century B.C. poet of the same name, see Muller (1841–70), 4:482.

[30] See chapter 1, note 3.

[31] As is noted in passing by Fränkel (1945), 96.

[32] Hardie (2002b), 190.

[33] This is not to say that the divine element of the entire narrative—inherited by Ovid from earlier versions—is suppressed: see Sharrock (1991a), 171, and Hardie (2002b), 190.

VIEWING AND CREATIVITY

work in its pristine integrity of meaning, since he never lets go of it, never lets it into anyone else's sight.[34] It is precisely as a myth of the "power of art to create rather than to portray" that Gombrich takes the story of Pygmalion in Ovid.[35]

Ovid's text (*Metamorphoses* 10.243–97), however, allows little space to the act of creation:

> interea niveum mira feliciter arte
> sculpsit ebur formamque dedit, qua femina nasci
> nulla potest . . . (vv. 247–49)

> Meanwhile with wondrous art he skilfully carved
> snowy ivory and gave it form lovelier
> than any woman ever born . . .

The rest of the discussion is taken up with Pygmalion's desire (vv. 249–69, twenty-one lines), with the feast of Venus and the lover's prayer (vv. 270–79, ten lines), and with the statue's metamorphosis (vv. 280–94, fifteen lines). The poet concludes with a brief reference to the marriage and its issue (vv. 295–97, three lines). This suggests that Ovid's focus is not on the myth of the creative artist as such (as critics have invariably assumed), but on the role of Pygmalion as author of his own love, creator of his own desire. In other words, Ovid's picture of Pygmalion as artist-sculptor is itself a metaphor for Pygmalion as artist-viewer—the creator of something real and alive to him out of a mere statue, just as he was sculptor of a realistic statue out of mere ivory. This theme of Pygmalion as viewer is itself a metaphor for the reader as creator of his own narrative, his own reality, out of the text of the *Metamorphoses*.

The position of the Pygmalion episode within the *Metamorphoses* frames it in an erotic context. The story is part of Orpheus' song to the wild beasts—a song grounded in the failure of the singer's desire for Euridice through the very excess of his love.[36] More immediately the Pygmalion passage is

[34] Critics, emphasizing the theme of Pygmalion the supreme artist, fail to notice that this is the correlate of Pygmalion the viewer. The supremacy of his artistry lies in the fact that only he sees what he has made, and because of this the statue's meanings can be constrained. Had his *eburnea virgo* ("ivory maiden") been an image of a goddess (as it would have been in any other viewing but his own, according to Clement of Alexandria), could it have been a perfect likeness, so perfect a work of art? The point is that for Pygmalion, it was perfect. If Pygmalion the artist is a figure for Ovid the writer, then the myth as a whole undermines the integrity of Ovid's writing; since he is not its only reader, he cannot control its meanings as Pygmalion does those of the statue. On the other hand, Ovid can write the Pygmalion myth as a symbol of how ideally the *Metamorphoses* should be read—as if by a lover.

[35] Gombrich (1960), 80.

[36] On Orpheus and Augustan ideology, see Segal (1972), 473–94; on Orpheus and failure, see Leach (1974), 119–22; on Orpheus and transgression, see Janan (1988), 111–14.

preceded in Book 10 by the story of the Propoetides, who are presented by Orpheus as the first to turn to prostitution (v. 240) and who were consequently turned to stone.[37] Pygmalion's project of turning ivory to woman is directly motivated by his disgust for these women in particular and by his general hatred for the *vitia* ("crimes," v. 244) of the *mens feminea* ("female mind," v. 244–45). *Sine coniuge caelebs* ("a bachelor without a wife," v. 245), he is intent on fashioning his own fantasy woman, a work of art, instead of living with a real one.[38]

Ovid's Pygmalion actually falls in love not with a work of art (an object in the external world) but with his own creation, his own fantasy:

operisque sui concepit amorem (v. 249)

And he conceived a love *of his own work*.

Ovid's word for falling in love (*concepit*) is, of course, the supreme authorial verb—the parental verb of paternity. But the paternity here is in the sense not of the artist (since Pygmalion has done the sculpting already) but of the beholder's desire. Pygmalion is conceiving *amor* for his sculpture. But the effect is to conceive, which is to say refashion, his own work as an object (and an objective genitive) of his *amor*. The ambiguity of *operis sui* is that it can stand both for the object (the *niveum ebur*, "snowy ivory," vv. 247–48) and for the beholder's egotistic appropriation and transformation of the object through his own desire. We can never know if it is the object or himself (as creator of the *operis sui*) with whom Pygmalion is in fact in love.[39]

The *amor* is not in the ivory statue; it is in the lover's mind. And yet the lover must always believe his object to be in some sense "real," in some sense capable of response. In the next couplet (vv. 250–51) Ovid dramatizes the beholder's need to believe in the possibility of the real. The maiden's face is real (*verae*); one can believe that she is alive, that she wishes to move. But all this is dependent on *credas* ("you might believe," v. 250), on the fact that it happens in the viewer's mind. The second person of *credas* addresses the reader directly as a viewer of the statue and equates the reader with Pygmalion as one who might also believe.[40] This *credas*, immediately following the lines which describe Pygmalion's act of creation and his act of falling in love (vv. 247–49), is what establishes his viewing as something not entirely differentiated from our act of reading. As we read on and Pygmalion looks, we discover

[37] See Lively (1999), 201–3, on the way the Propoetides are focalized via Orpheus from Pygmalion's point of view.

[38] For some remarks on the psychopathology of this project, see Freedberg (1989), 343–44.

[39] For the sexual connotations of *opus* here, see Sharrock (1991a), 169.

[40] On the second person in Ovidian discussions of art, see Wheeler (1999), 154–55.

the lovesick sculptor sublimating his own desire onto the image. His (and our) desire for it becomes its desire to move, its desire to be moved by him (both these meanings—active and passive—being implied by *velle moveri*, v. 251).[41] Only *reverentia* (v. 251), the sexual restraint and modesty of which this wish-fulfillment fantasy is rapidly robbing the lover, stands between him and his desire. Yet *reverentia* means more than modesty. It punningly inscribes the term *re vere* ("in reality") and thus asserts the whole problematic of the "real" woman which the image cannot be. What stands between Pygmalion and the object of his desire is the very reality which the fantasy of his desire has been constantly appropriating to the mere semblance of reality, the statue. These lines are crowded, overdetermined by puns on the "real"—*verae, (vi)vere, re-vere(ntia), (mo)veri*.[42]

Ovid is exploring the essential psychological problem of all realist art. The essential transgression of realism is that desire is generated by the beholder as lover, by the beholder as artist for something which he himself makes out of what is there.[43] As Pygmalion in the Philostephanus version implicitly played the artist in his own imagination by creating from a statue of Aphrodite the fantasy of a desirable and available woman, so Ovid dramatizes this transgression by making his Pygmalion an artist—the creator of a woman out of ivory. The desire of the beholder-lover is explicitly not for what was originally there (an ivory tusk) but for what the beholder-lover as artist has created out of what was there, namely a woman. The genius of Ovid's account of the viewer as artist is that it becomes the supreme myth of realist viewing. For in realism all viewers are invited to become creators—to create in their own imagination the fantasy of the real.

Miratur (v. 252): the lover "admires" and his image *is* a wonder because it was created *mira arte* ("by wondrous art," v. 247) and because it is *simulati corporis* (a "simulated body," v. 253)—real but not real. The myth of the artist was a myth of *mira feliciter arte* ("wondrous art and fertile skill," v. 247), of the triumph of art over nature so that the statue's beauty was such as no woman could ever have been born with (vv. 248–49). But the transgressive problem of *ars* as realism is that its very nature as art must be disguised in order for it to be imagined and desired as real—*ars adeo latet arte sua* ("so far is art hidden in its own art," v. 252). Since nature, the real, is the definition of what *mira ars* ("wondrous art") should be like, it follows that only

[41] On the sexual significance of *moveri*, see Sharrock (1991a), 172–73.

[42] On these puns, see Ahl (1985), 248. I should add here that *reverentia*, as a quality specific for the relations of humans to gods, reminds us of the original story in which Pygmalion loved a statue of Aphrodite. In a sense his *reverentia* proves that he has fallen in love with a (love) goddess after all.

[43] For this as "fetishization," see Ahl (1985), 248, and Freedberg (1989), 344, 352.

when art has so vanished that there is nothing but nature left (the *virginis . . . verae facies*, the "appearance of a true virgin," v. 250) can art really be art. But the art which imitates nature is itself a fiction: something which "you *might believe* to be alive" (knowing it not to be so), *quam vivere credas* (v. 250). And so the disguise of art by art is a double deceit: not only is the viewer deceived by the work of art in thinking *ars* to be *natura*, but moreover he deceives himself in accepting the fiction of realistic mimesis. In order for naturalistic art to deceive a viewer, that viewer must first deceive himself by suspending the possibility of disbelief. The famous epigram *ars adeo latet arte sua* shows the extent of Pygmalion's derangement in the fantasy of his desire. For as artist, he of all viewers should still be aware of the status as ivory of the *ebur* which he sculpted and which the text never ceases to remind us is what Pygmalion's beloved "really" is (vv. 248, 255, 275, 276, 283).

Pygmalion's derangement is itself a symbol of the deception which lies at the heart of realism. Pliny records in his *Natural History* 35.65 that

> Parrhasius and Zeuxis entered into competition. Zeuxis exhibited a picture of some grapes so true to nature that birds flew up to the wall of the stage. Parrhasius exhibited a linen curtain which was painted with such realism that Zeuxis, swelling with pride over the verdict of the birds, demanded that his rival remove the curtain and show the picture. When he realised his error, he yielded the victory, frankly admitting that whereas he had deceived the birds, Parrhasius had deceived Zeuxis himself, a painter.

As has been remarked, "Ovid in his account has gone this one better. Pygmalion's representation is so persuasive that it deceives not the birds, not a fellow artist, but the maker himself!"[44] In effect, realism is founded on its ability to deceive. Ironically Pygmalion's derangement is itself proof of the realist perfection of his statue. In realism the viewer must fashion a deceptive or false vision of the artwork (one whose object is not the actuality of the artwork, the fact that it is ivory or pigment on canvas, but the fantasy desire of the onlooker—real grapes or curtains or a woman). In other words, for the realism of a statue to be true, that realism must always be based on the falseness of the viewing it evokes: *ars adeo latet arte sua* ("so far is art hidden in its own art," v. 252).

In this theme of the deceptivity of realism, Ovid is aided by the fact that *ivory* was the material in which Pygmalion's beloved statue was made.[45] In

[44] Solodow (1988), 217.

[45] As Clement of Alexandria explicitly tells us (*Protrepticus* 4.51): "The well-known Pygmalion fell in love with an ivory statue . . . [he] is captivated by its shapeliness and makes love with the statue."

Greek and Roman literary tradition, ivory had strong associations with deception. Originally this connection was rooted in a pun, famously made by Homer (*Odyssey* 19.562–65) between the Greek for "ivory" (*elephas*) and for "to deceive" (*elephairomai*). In *Odyssey* 19.562–67, Penelope says:[46] "Two gates there are for unsubstantial dreams, one made of horn and one of ivory (*elephanti*). The dreams that pass through the carved ivory (*elephantos*) delude (*elephairontai*) and bring us tales that turn to naught. Those that come forth through polished horn accomplish real things, whenever seen." This passage bred many later imitations or allusions,[47] none more significant than Virgil's version at the end of Aeneas' trip to the Underworld in the sixth book of the *Aeneid* (6.893–98).[48]

> sunt geminae Somni portae; quarum altera fertur
> cornea, qua veris facilis datur exitus umbris;
> altera candenti perfecta nitens elephanto,
> sed falsa ad caelum mittunt insomnia Manes.
> his ibi tum natum Anchises unaque Sibyllam
> prosequitur dictis portaque emittit eburna.

> Two gates the silent house of Sleep adorn
> of polished ivory this, that of transparent horn.
> True visions through transparent horn arise,
> through polished ivory pass deluding lies.
> Of various things discoursing as he passed,
> Anchises hither bears his steps at last;
> then, through the gate of ivory, he dismissed
> his valiant offspring and divining guest. (Dryden)

Virgil follows Homer in associating the ivory gate with falsehood, but impossibly complicates the matter by making Aeneas himself and the Sibyl also pass through the ivory gate. This twist to the tale has caused scholars all kinds of problems.[49] But it plays beautifully into Ovid's hands. In this Homeric-Virgilian tradition, ivory is liminal—the material for a gate between worlds— just as the *eburnea virgo* ("ivory maiden," v. 275) is a liminal woman, a woman who makes the transition from falsehood (*simulati corporis*, "a simulated body," v. 253; *simulacra . . . puellae*, "the simulacrum of a girl," v. 280)

[46] On *Od.* 19.562f., see Russo (1985), ad loc., 255–57, and Amory (1966).

[47] For lists of such allusions, see Amory (1966), 3, and Austin (1977), 275.

[48] On *Aeneid* 6.893–98, see Boyle (1986), 142–46; Austin (1977), ad loc., 274–76; and Nolan (1990), 15–34.

[49] See Boyle (1986), 142n21, and Austin (1977), 276, for bibliography.

to real flesh (*corpus erat*; "she was flesh!" v. 289).[50] Moreover, ivory is the gate of the *falsa . . . insomnia*—dreams which appear to be real but (like the ivory woman in Pygmalion's imagination, before Venus miraculously transforms her) are in fact false. And yet in the Virgilian twist the ivory gate offers passage to one who represents a reality greater than any dreams (whether false or true)—Aeneas himself. Likewise in the Pygmalion story, the ivory woman transcends her reality as ivory and becomes flesh.

Greco-Roman mythical tradition also offered a further, more corporeal, theme to the deceptivity of ivory. In the myth of Pelops, to which Pindar refers in his First Olympian Ode (vv. 26–27), the hero was dismembered, cooked, and served at a feast of the gods by his father, Tantalus.[51] In the course of the feast, his shoulder was eaten before the gods realized what meat they had been served. They restored Pelops to life and replaced the lost shoulder with an ivory substitute—*elephanti phaidimon omon* ("a shoulder shining with ivory," v. 27). In *Georgic* 3.7 this passage is echoed by Virgil (*umeroque Pelops insignis eburno*, "Pelops famed for his ivory shoulder"), but it finds its longest Roman commentary in Ovid's *Metamorphoses* (6.401–11).[52] The ivory shoulder is not merely an artificial substitute for the real thing: it is also, in the complex context of Pindar's narrative (which rejects the story of the dismemberment but preserves the ivory shoulder), a symbol for the problematics of true and false stories.[53] Again the theme of ivory as the material of artifice, six times repeated in the fifty-two lines of the Pygmalion story,[54] plays upon and points to the poetics of deception.

The deceptivity of ivory is complex—like Pygmalion's own self-deception. Pygmalion is deluded not only by a work of art which appears to be real but also, more deeply, by himself in consistently suspending his disbelief and allowing himself to believe in the suggestions of art. Likewise ivory is not simply a material of artifice—the stuff of which Pygmalion's deceptive woman and Pelops's deceptive shoulder are made. It is also an entirely natural material, like stone, wood, or horn. In effect, ivory is *natura*'s own material of *ars*, the natural material implicated, since Homer, with falsehood. As such, ivory,

[50] Other ivory gates include that of Apollo's temple in Virgil's *Georgics* 3.26 and the doors of the room in which Vulcan catches Mars and Venus *in flagrante delicto* in Ovid's *Metamorphoses* 4.185. Another highly transgressive passage emphasizing ivory in the *Metamorphoses* is the repetition at 4.332, 335, and 354 to describe the body of Hermaphroditus. Ivory, along with Parian marble, is evoked also in the Narcissus story, describing the reflection with which the unfortunate youth falls in love (3.422).

[51] On the myth of Pelops and Pindar's Olympian I, see Gerber (1982), ad loc., 55–59, and Nagy (1986).

[52] On Ovid's Pelops, see Bömer (1976), ad loc., 112–15.

[53] Nagy (1986), 86–88.

[54] Ivory words appear at vv. 248, 255 (twice), 275, 276, and 283.

just like the very theme of realism itself, suggests a transgression of *natura* by *ars* and vice versa. Ivory, according to its associations in Roman culture, is most wonderfully suited as the material for Pygmalion's realist sculpture because it evokes precisely the same set of transgressive associations as realism itself.

To return to Ovid's text and the psychology of deception: the movement from *reverentia* ("modesty," v. 251), itself a significant shift in desire from *offensus vitiis* ("offended by crimes," v. 244), toward *ignes pectore* ("fires in the breast," v. 253) is a progress in desire but simultaneously in transgression— for this is still only a *simulati corporis* (a "simulated body," v. 253). Every verse now adds a further step in the process of transgression, the fantasy of desire for the real. Pygmalion touches the ivory; he can no longer be sure whether it is bone or flesh (vv. 254–55). He kisses it and believes his kisses returned (v. 256); he speaks to it, fondles it, fears lest it bruise (vv. 256–58). All of this is in his mind (*putat*, "he thinks," v. 256) and yet has entirely taken over his life in the obsessional offering of lovers' gifts (vv. 259–66). The movement of transgression and desire inherent in illusionism and realist art, inherent in the theme of ivory, inherent in the invitation to the viewer to become his own artist and create his own wish-fulfillment fantasy out of art, is both parodied and yet engaged in. Pygmalion lays the statue in his bed (vv. 267–69), implying that he will soon reach the culmination of his desire in real lovemaking.

The wish-fulfillment is wonderfully enacted by Hermann Fränkel: "Whoever happens to be in love with an ivory woman may take these words to heart and try out Ovid's directions. The artist's hands molded the statue into life. The warm sunshine of his affection and the deft touch of his hands melted down the frigidity, and while he was acting upon her as if she would respond, she did finally respond.[55] The critic, transformed by Ovid's *Metamorphoses* into a reader-lover, is transported by the Pygmalion passage into the wish-fulfillment fantasy of realism. As Pygmalion loves and desires, so the reader loves and desires—dramatizing and enacting the poem he quotes. The "warm sunshine" of Pygmalion's affection has the power to stir "the pulse of warm blood in those ivory statues"—not only in Pygmalion's mind but in that of one distinguished reader at least.[56] In effect, in Fränkel's case, the invitation to the viewer in realistic art to become his own artist has been transformed by Ovid's text into an invitation to the reader to write his own version—his own fantasy—of the transgressive passion so effectively captured in the Pygmalion episode.

[55] Fränkel (1945), 95.
[56] Ibid., 96.

The supreme moment of transgression, and one of the best jokes on the lovesick viewer, is Pygmalion's prayer to Venus. He asks (vv. 274–76) not for the statue to be his wife, but for a wife like his statue.[57] This request outrageously reverses the logic of likeness—the logic on which the whole project of realist art is built. Illusionism is gone mad in the deluded viewer's attempt to map life onto art, to make the real like that which imitated the real, like that which was imagined as real. And yet language itself betrays him. For Pygmalion to be making his prayer at all, for him to be using terms like *eburnea virgo* ("ivory maiden," v. 275) for his statue, shows that the whole fantasy of transgression (the fantasy of kisses and bruises and presents) is no more than a fantasy and is known by the lover even in his delirium to be no more.

It is here that Ovid pulls off the third and most brilliant of his divergences from the earlier versions of the myth. Even as he demonstrates the hopeless contradictions of a subjective desire for a reality which cannot exist (for no ivory statue ever became a woman), the poet departs from his models by offering us the ultimate wish-fulfillment fantasy—where the statue does indeed come to life. In Philostephanus, Pygmalion went to bed with ivory; in Ovid, he goes to bed with ivory only to find it flesh. The genius of this is more than to turn a story of obscene infatuation into one of wholesome piety and auspicious marriage.[58] The earlier versions of the Pygmalion myth merely described the problem of realism by representing men making love to statues. But Ovid dramatizes the issue at the heart of realism by for once allowing the subjectivist dream to come true. The essential problem of realism is its generation of a wish-fulfillment fantasy which needs only a miracle to make it real. It is only through the miracle of metamorphosis that realism can achieve the end implicit in the desire which it generates. But miracles are precisely what realism denies (except of course in Ovid) by its necessary concentration on the imitation of real things in the natural world.

Recent readings have attempted to attribute some agency to the statue-woman, as she receives Pygmalion's kisses:[59]

> dataque oscula virgo
> sensit et erubuit timidumque ad lumina lumen
> attolens pariter cum caelo vidit amantem. (vv. 292–94)

[57] On vv. 275–76, see also Leach (1988), 125, "*similis* suggests not merely the likeness of a woman, but her likeness to Pygmalion himself. The love for a self-reflecting image recalls the passion of Narcissus," and especially Ahl (1985), 248, "what he *says* he desires is thus a living being that looks like a work of art. What he really desires, however, is the work of art, his own art. Venus understands."

[58] Otis (1970), 189–92, 418–19; cf. A.H.F. Griffin (1977), 65–68.

[59] See especially Lively (1999), 206–8, and Bettini (1999), 147, on the statue-woman's gaze.

And the girl felt the kisses given to her
and blushed, and raising her timid eyes to the light
saw the sky and her lover at the same time.

But the question of her gaze, returned to the lover, leads to the direct parallel of Pygmalion here with Narcissus in Book 3 (on whom see the next chapter).[60] Is the maiden's response real, or imputed by the lover in his delirium? Are her gaze and blush objective or are they a heterosexual version of the boy in the pool who looks back with such love at Narcissus as Narcissus looks to him, in a crescendo of reciprocation with every further investment from the gazing lover? The imputation of agency to the beloved in the image is realism's supreme trap for the wish-fulfillment desires of the viewer, for it verifies the image as objectively independent and hence valorizes the viewer's gush of subjective fantasy as valid. In the moment that he sees the statue-woman actually respond, we might say that Pygmalion is either the recipient of a divine miracle or finally and certifiably mad.

Where Ovid's predecessors described a problem (how realist art makes men think images are real), Ovid has enacted it. The reader is enticed by the movement of the text toward the possibility of metamorphosis, the possibility of the statue's becoming real. The reader's desire for a happy ending through the transformation of ivory to flesh is generated in the same way as Pygmalion's *amor* for an ivory statue, which he sees as if it were a real woman. In the achievement of Pygmalion's desire, in the poet's articulation—through his myth of miracle and metamorphosis—of the wish-fulfillment fantasy of the real, Ovid suddenly brings the reader up against the boundaries of his own desire as generated by the text. What can happen in a story cannot happen in life. The erotic myth of Pygmalion's statue turned to flesh is as much an assertion of absence as it is of fulfillment. In the moment of miracle, Ovid turns the viewer-reader (until then the participant of Pygmalion's desire) into a voyeur—the excluded observer of an imagined world which can never be anything but fantasy. The *amor*, the desire, of Pygmalion's viewing (and our reading of his viewing) was always for the real which might possibly be there; our voyeurism of the metamorphosis is for something we can never share— the purely imagined, the wholly unreal. The miracle puts an irreparable distance between us and Pygmalion, as there was (except in his mental fantasy) between Pygmalion and the image untransformed.

The meaning of Ovid's text is intimately bound up with the act of reading it. Only at the moment of metamorphosis can we know how far we are from Pygmalion, can we reread the basic self-deception of our desire as generated

[60] On Narcissus and Pygmalion, see Rosati (1983), 58–67.

by the text and the viewer's desire as generated by a realist image. We can never achieve what Pygmalion achieved. As all viewers (except Pygmalion) stand to the promise of realism, so the reader stands to the promise of Ovid's myth about the miracle of art. The miracle (unachievable except in a myth of wish-fulfillment) is Ovid's reminder of the limits of fantasy and the unfulfillability of desire.

If Ovid's Pygmalion as artist can be taken for a symbol of the writer, then the beholder-lover in Pygmalion may be read as a myth of the reader.[61] This is a story of how you can view, of how you can read, a metamorphosis. This is a story about reading the text of which it is part. But the very failure of the reader of the *Metamorphoses* to satisfy his desire as Pygmalion can is a sign of his or her difference from Pygmalion the ideal reader, the reader who is unique in being also the author, unique in being fulfilled in his desire. Perhaps the most effective metamorphosis in this text about statues coming to life is that of the reader. Ovid begins by constructing his reader as a participant in Pymalion's desire for something which in fantasy one might hope to achieve. But in the miracle of transformation which is the very achievement of the reader's desire, the reader is metamorphosed to become an excluded voyeur. The miracle of transformation in its very enactment spells the reader's exclusion and the end of the fantasy of achievable desire.

[61] For example, Solodow (1988), 215–19, and Hardie (2002b), 189. Wheeler (1999), 156, argues that the Pygmalion episode is not about the reader in general but about "one sort of reader—one who loses his wits and believes too much in what he reads." But this is too fine a point: surely Pygmalion (like Narcissus) is about that part in any reader which risks too much absorption until only a miracle can save him or her from the delirium of being lost in the object.

VIEWER AS IMAGE

Intimations of Narcissus

By the river
His eyes were aware of the pointed corners of his eyes
And his hands aware of the pointed tips of his fingers.

—T. S. Eliot

The body of Narcissus flows out and loses itself
In the abyss of his reflection,
Like the sand glass that will not be turned again.

—Salvador Dalí

Narcissus, who was changed into a flower according to the poets, was the inven-
tor of painting. Since painting is already the flower of every art, the story of
Narcissus is most to the point. What else can you call painting but a similar em-
bracing with art of what is presented on the surface of the water in the fountain.

—Leon Battista Alberti

THE STORY OF NARCISSUS HAS PROVED a deep pool, reflecting multiple interpre-
tations.[1] Every reading, every retelling, every reworking—whether visual or
verbal—is a new eddy in the waters of hermeneutic possibility, mirrored by
the image of the boy who dies entranced by his own reflection.[2] One of the
special qualities of the story is the fact that its manifold readings are mutually
supportive in their highlighting of different—sometimes complementary and
sometimes contradictory—facets of the problem of subjectivity, rather than
being in conflict. The myth is a fundamental paradigm for the inseparability
of self from representation, and for the inextricability of desire from either.
Whether one emphasizes issues of reflection (as did Eliot in an early poem
which conflated the adolescent youth of ancient mythology with a Christian

[1] The first epigraph is from "The Death of Saint Narcissus" (ll. 13–15) in Eliot (1969), 605; the sec-
ond, from "Metamorphosis of Narcissus" (ll. 75–77), originally published in Dalí (1937); the third,
from *De Pictura* 2.26, in Alberti (1977), 64 (originally published in 1435). On this last text, see Bann
(1989), 105–6.
[2] A good basic guide, at least to the textual reworkings, is Vinge (1967).

martyr) or focuses on the ebb of a self-absorbed inertia leading to death and metamorphosis (as did Dalí in a fascinating poem written to accompany his great 1937 painting of Narcissus, which now hangs in the Tate Gallery), the problems of the theme turn on the question of self and its objectification. Narcissus sees himself as an other person sufficiently outside his own subjectivity for his subjective self then to fall in love with that fantasy. Effectively, as Alberti so rivetingly put it, Narcissus is indeed the inventor of painting, not only because Narcissus became a flower and painting is the flower of the arts but, more significantly, because however one defines painting, it involves "embracing with art" that objectified reflection called representation. To rephrase Alberti's specifically art-centered formulation of the myth, painting is not just the result of the artist's desire to make objective an internal vision (to embrace an object with art) but is also the focus for the viewer's desire to possess as if it were real what is no more than pigment, to embrace what is no more than a reflection writ on water. Narcissus invented painting because he is both the paradigmatic artist in that he saw his own image and mentally turned it into an objective being and, at the same time, the ideal viewer, whom all artists would wish for—the viewer who believes the depicted image is so real that he falls in love with it.

A youth sits alone in a landscape, leaning on his left arm and looking down into a pool of water beneath him. He is virtually nude but wreathed with flowers, resting a staff—perhaps a hunter's spear—over his right shoulder, and with his cloak fallen so as to drape his legs. He gazes into the pool, and his reflection gazes back at him. I describe one of a number of Roman paintings surviving from Campania which represent Narcissus (figure 6.1).[3] It depicts not only a famous myth, celebrated in a famous and popular poem by Ovid (*Metamorphoses* 3.339–510), but also an image of someone looking at an image. The motif of Narcissus has a particular art historical resonance, because it represents art reflecting on the theme of spectatorship. Moreover, as any ancient viewer familiar with the myth of Narcissus would have known, this was a story with erotic implications. The enraptured gaze of Narcissus is a lover's gaze. In antiquity, the myth of Narcissus—perhaps like all the classic myths—was possessed of a rich, suggestive, and varied polysemy. I focus here on one strand of the interpretations of Narcissus—those by the writers on art the Elder Philostratus and Callistratus, which focus on the theme of viewing a perfectly rendered naturalistic image, and use the viewing of art to reflect on the

[3] For Roman images of Narcissus, see Rafn (1992); P. Zanker (1966); and Balensiefen (1990), 130–66. For discussion of the theme of Narcissus in antiquity, see Eitrem (1935); Pellizer (1987); Bettini (1999), 94–99, 230–31; Bartsch (2000); Hardie (2002b), 143–72, and—for the standard work on antiquity and the classical tradition—especially Vinge (1967). Any discussion of the art history of Narcissus owes a deep debt to the pioneering exploration of Bann (1989), 105–201.

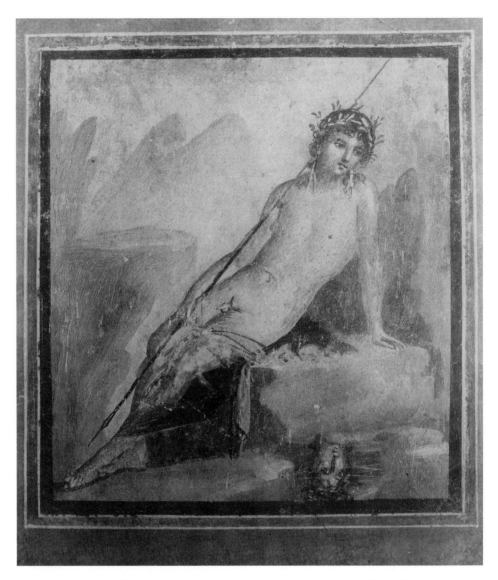

FIGURE 6.1. Fresco of Narcissus from the Casa di M. Lucretius Fronto (Pompeii V.4.a). Third quarter of the first century A.D. (Photo: DAI 72.3597.)

erotics of naturalism.[4] My question is how the viewer's desire is articulated in relation to the object of the gaze—art, beloved, self—by commentators whose own relations to works of art, to rhetoric, and to the past are rendered as complex, self-aware, even erotically charged.

Callistratus and Philostratus occupy a fascinating place in ancient writing

[4] On viewing and eroticism in antiquity see, for example, Walker (1992); Henderson (1991), 60, 81–86; and Frontisi-Ducroux (1996). On vision and sexuality, see, for example, Rose (1986, 1988).

on images. Their works are late products of the Second Sophistic, the remarkable flowering of (mainly) Greek literature and scholarship which developed in the Roman empire from the second to the fourth centuries A.D.[5] Their collections of ekphrases, or descriptions of art, have the interest of being not only contemporary comments on images from the period of the Second Sophistic but also highly learned assimilations of and commentaries on the entire classical tradition of thinking about representation.[6] Their historical and political environment was quite different from that of the classical Greek writers with whom they engage: their readers were inhabitants of the multicultural Roman empire and not of an autonomous, xenophobic Greece made up of small, independent, and usually belligerent city-states. The Second Sophistic's encounter with ancient Greece involved the paradox of appropriating a world which was apparently familiar through its canonical cultural heritage and through being possessed as imperial property, but was at the same time deeply alien in its political and historical distance and in the magnitude of a cultural achievement which was forever held in awe. Yet although Callistratus and Philostratus come from the end of classical antiquity, their works exhibit a desire to belong to and recapitulate the literary and artistic canon of the past.[7] The artistic and cultural world which their ekphrases evoke is an imagined version of contemporary reality *as* that of the classical canon (with all its norms reduced to literary tropes).[8] So the subjects of paintings invoked by Philostratus and even his very style of writing often refer back to a mythic-literary dreamworld of Homer, Pindar, and Tragedy, while many of the statues described by Callistratus are the purported works of great sculptors from the fourth century B.C.[9]

[5] On the Second Sophistic in general, see Bowersock (1969), Reardon (1971), G. Anderson (1993), and Swain (1996).

[6] For reflections on the Second Sophistic and art, see G. Anderson (1993), 144–55.

[7] Unlike those other period labels which modern scholarship has invented and imposed onto the past (such as "Classical," "Hellenistic," or "Byzantine"), the "Second Sophistic" is a term created by its principal contemporary historian, Philostratus (very likely the same Philostratus as the art critic who features in this chapter), as a *self*-definition by at least one of those actively involved in the movement. In his *Lives of the Sophists* 481 (at the beginning of the first book) Philostratus claims that the activity of sophists in Roman times is not new but old—a "second sophistic," a revival of that first sophistic whose geniuses included Pericles and Demosthenes. In other words, even in its very title and self-image, the Second Sophistic was concerned with the desires of reviving and reenacting the Greek cultural canon. For an attempt to define the Second Sophistic, see G. Anderson (1993), 13–21, 243–44.

[8] On the complex relations between Greek literature of the Second Sophistic and the Greek past, see Reardon (1971), 3–11, 17–20 (on ignoring the contemporary Roman context), and G. Anderson (1993), 69–85, 101–32.

[9] In the Elder Philostratus, take, for example, 1.1 (a virtuosic competition with Homer's narrative of the river Scamander in *Iliad* 21, with Blanchard, 1978), 1.4 (an episode from the seige of Thebes), 1.7 (an episode from the Trojan War), and so on. In Book 2, he has a description of a painting of Pindar, the lyric poet (12), while his nephew, the Younger Philostratus, describes a painting of Sophocles (in his *Imagines* 13). Among the artists evoked by Callistratus are Scopas (2), Praxiteles (3, 8, 11), and Lysippus (6).

Alongside the literary discussions of art that I explore in this part of the book, the accounts of Narcissus have in common an alignment of sexuality and imitation. They examine the interesting theme, important both for naturalism and for erotics, of how there may be a difference between the actual object or person in the world at whom desire is directed and the object as it is imagined in the lover's (or beholder's) mind. This difference, and the frisson as well as the danger of imagining that one might elide the difference (that the "real" object could become entirely assimilated to the object in the lover's mind), is eloquently explored by ancient thinkers about art through the theme of Narcissus. For Narcissus raises not only the problem of conflating ideal with actual (the imagined with the object) but also the issue of how much of viewing is in the beholder's eye—of how much the beholder imposes onto the autonomy of the viewed.

Additionally, these ancient discussions of erotic viewing are concerned with objectification.[10] That is, viewers like Charicles and Callicratidas in Lucian's *Amores*, or like Pygmalion, objectify the image they see by imagining it as (transforming it into) something else. Theirs is an aggressive gaze—a violation of the image's integrity as stone or pigment, in no case more so than that of Callicratidas, who sees the nude buttocks of a divine female as if they were those of a boy. Narcissus takes the problem of objectification much further, for his tragedy directly addresses the place of the subject in objectifying the seen. What happens when you objectify yourself? While the reification of a female image—or that of a boy—may be acceptable in an ancient male-dominated culture, could it ever be other than dangerously transgressive to love a male of the same age, to objectify a full-grown man, to reify an image of *oneself*? Of course the dynamics and mores of sexuality were hardly seamless and unchanging between the established homoerotic attitudes of fifth-century B.C. Athens (when it was the norm for male lovers to be of different ages—an older *erastēs* and a younger *erōmenos*)[11] and those of the Second Sophistic. But whatever the actual modes of later Roman sexual *practice*, in terms of the ideal literary world imagined by Philostratus and Callistratus and shared by their readers, the assumptions of the classical canon as betrayed by classical texts were certainly incorporated in the imaginary world of pastoral desire within which the tragedy of Narcissus was performed.

The story of Narcissus combines two self-deceptions crucial to the dynamics of naturalism and, at the same time, suggestive for the problematics of erotic love: first, Narcissus believes absolutely that the image he loves is *real*, and second, he fails to see that the image reflected in the pool, which he takes

[10] For objectification in ancient reflections and images of sexual intercourse, see Myerowitz (1992), 149–55. More broadly on objectification and pornography, see Stoltenberg (1992), 153–54.

[11] The classic discussion of Athenian homosexuality is Dover (1978), especially 16–17.

to be real, is in fact himself. Believing that the image one sees is a real object, a real person, is, of course, one of the most potent desires of illusionism. But in erotic terms, too, Narcissus struggles with the notion of the image's status as real object when he maps onto the beloved (who is, after all, the product of his own subjective fantasy, his own interpretation of a reflection in a pool) the subjective image he has fashioned of the beloved. Here the reification of a fantasy image is made hauntingly and hopelessly potent by the fact that it is a mere reflection, an image writ on water, which Narcissus takes to be real. His dilemma is that he imagines a beloved, imposes the imagined beloved onto the watery image he looks at, but this "real" beloved turns out to be only an image.

Narcissus' remarkable inability to see that he himself is the object reflected in the pool of water seems a striking example of the fact that, for the deceptions of naturalism to work, one must blind oneself to one's own collusion with them. In blinding himself in this way with such success, Narcissus shows himself to be a perfect viewer of art in the mode of naturalism—or at least to be disastrously unselfconscious in his collusion with naturalism's deceptions. The erotic connotations of such blindness (self-absorption to the point of self-forgetting) are powerful: for the lover to believe fully in his or her subjective image of the beloved, the lover must suppress fully the worrying possibility that the subjective image may always be a self-image—a narcissistic self-love sublimated as the desire for another, a Narcissus-like self-objectification posing as love.

The interest of the theme of Narcissus for Greco-Roman theorists of art is pointedly motivated by the dynamics of the myth which reflect with such acuteness on the desires of naturalism. One might say, from the point of view of the exploration of naturalism, that the Narcissus myth exploits some deep compexities of erotics to explore the problematics of naturalism (and vice versa), for in both cases the myth reflects upon the extent to which subjectivity may attempt to override the constraints of actuality.[12]

NARCISSUS DESCRIBED

The accounts of Narcissus from the collections of ekphraseis written in Greek by the sophists Philostratus and Callistratus around the third and fourth centuries A.D. are explicit descriptions of art. Although the particular art objects

[12] I do not focus here on Ovid's Narcissus, which is never overtly a discussion of art; but on that text see, for instance, Fränkel (1945), 82–85; Galinsky (1974), 114–22; Stirrup (1976), 97–103; Brenkman (1976); Rosati (1976); Rosati (1983), 1–50; Frontisi-Ducroux and Vernant (1997), 210–17; and Hardie (2002b), 143–72.

they describe, a statue and a painting, may never have existed (although others like them certainly did exist and still survive), both discussions frame the myth of Narcissus (essentially a narrative) around its key moment so far as the issue of representation is concerned—namely, the youth's fascination with his image in the pool. Unlike Ovid (whose *Metamorphoses* preceded both these descriptions and may well have been known to their authors), both the sophists ignore the story of Narcissus and Echo (the nymph who loved Narcissus, was rejected by him, and could only repeat the last part of his words to her, as the pool reflects back his image to him). While Ovid's Narcissus is a complex consideration of the theme of reflection in auditory as well as in visual terms,[13] the ekphrasists are interested much more specifically in issues of visual representation. Both texts are keenly aware of their own status as descriptions of a work of art—as imagined viewings of an image whose key theme is the act of viewing and as representations of a visual representation whose subject is in fact representation itself.

Perhaps writing around the fourth century A.D., Callistratus described a statue of Narcissus (*Descriptiones* 5):[14] "There was a grove, and in it an exceedingly beautiful spring of very pure clear water, and by this stood Narcissus made of marble" (5.1).[15] The opening of the passage, initially ambivalent about whether it is an ekphrasis of a landscape or of a work of art,[16] immediately foregrounds a desire for the art object to be its prototype: "by the spring stood Narcissus," we are told, and only then are we informed that this Narcissus is made of stone (εἱστήκει δὲ ἐπ᾽ αὐτῆι Νάρκισσος ἐκ λίθου πεποιημένος). In his first sentence the writer dramatizes the power of ekphrasis to elide the work of art with its subject matter, the image with its model, beneath the glittering but deceptive surface of his descriptive prose. That elision of image and prototype, which the artist of a naturalistic object may only hope for in his wildest imaginings,[17] is promised here in the rhetorical performance of the ekphrasist. By hinting at the desire for the carved marble to be a real boy, Callistratus also suggests his own power, the power of ekphrasis, to take the viewer into a visionary world beyond objects, where the marble statue may be imagined as the real Narcissus.

The statue is remarkable: "He gave out, as it were, a radiance of lightning

[13] Cf., for example, Vinge (1967), 11.

[14] On Callistratus' Narcissus, see Vinge (1967), 32–33, and Frontisi-Ducroux and Vernant (1997), 231–34.

[15] Ἄλσος ἦν καὶ ἐν αὐτῶι κρήνη πάγκαλος ἐκ μάλα καθαροῦ τε καὶ διαυγοῦς ὕδατος, εἱστήκει δὲ ἐπ᾽ αὐτῆι Νάρκισσος ἐκ λίθου πεποιημένος. I use A. Fairbanks's Loeb version.

[16] Cf. Virgil, *Aen.* 1.441f., where the celebrated description of Dido's temple in Carthage and its murals is embedded in the ekphrasis of a *lucus*, a grove (1.441 and 450).

[17] Cf. Gombrich (1960), 80–83.

from the very beauty of his body. . . . It was shining with gilded hair" (5.1).[18] The expression of this sculpture went beyond naturalism, hinting at an ideal foreknowledge—a proleptic glance at its subject's sorry fate as well as at his present beauty: "In the nature of the eyes art had put an indication of grief, that the image might represent not only Narcissus but also his fate" (5.1).[19] Throughout this description the sophist evokes the tactile qualities of the statue—emphasizing not just the visual but other senses too. It is important, in the verbal conjuring of the visual just as in naturalism's visual emulation of the real, that representation use every means available to create a "virtual reality":[20] "A white mantle, of the same colour as the marble of which he was made, encircled him . . . it was so delicate and imitated a mantle so closely that the colour of his body shone through, the whiteness of the drapery permitting the gleam of the limbs to come out" (5.2).[21]

As the description develops, Callistratus orchestrates a parallelism, even a competition, between the desire of naturalism, that of marble to imitate real flesh or drapery, and the erotics of his subject—the desire of Narcissus for his own reflection in the pool. The orator's desire for the image to be real, itself perhaps a sublimation of his desire for the boy in the image or maybe a metaphor of the viewer's desire for the ekphrasist to engineer the transformation of art into nature, finds itself reflected in the image's desire for its own image, for its reflection in the spring: "He stood using the spring as a mirror and pouring into it the beauty of his face, and the spring, receiving the lineaments which came from him, reproduced so perfectly the same image, that the two beings seemed to emulate each other" (5.3).[22] The desire of these images, each reflecting the other, each striving for the other, becomes a kind of competition. The highly artificial conceit of competing representations is itself a figure for (a sublimation of) the other conflicts which ripple through the prose even as Callistratus expands on his theme: the competition between ekphrasis and artwork (between verbal and visual representation), the competition between marble and "reality" to create the perfect living ideal.

[18] . . . ἀστραπὴν οἷον ἐξ αὐτοῦ τοῦ σώματος ἀπολάμπων κάλλους . . . κόμαις ἐπιχρύσοις ἤστραπτεν . . .

[19] ἐπιπεφύκει γὰρ ἐν τοῖς ὄμμασιν ἐκ τῆς τέχνης καὶ λύπη, ἵνα μετὰ τοῦ Ναρκίσσου καὶ τὴν τύχην ἡ εἰκὼν μιμῆται.

[20] I owe the inspired phrase "virtual reality" in the context of ekphrasis to Andrew Laird. See further on the use of other senses than the visual (sound, speech) in Laird (1993).

[21] πέπλος λευκανθὴς ὁμόχρως τῶι σώματι τοῦ λίθου περιθέων εἰς κύκλον . . . οὕτω δὲ ἦν ἁπαλὸς καὶ πρὸς πέπλου γεγονὼς μίμησιν, ὡς καὶ τὴν τοῦ σώματος διαλάμπειν χρόαν τῆς ἐν τῆι περιβολῆι λευκότητος τὴν ἐν τοῖς μέλεσιν αὐγὴν ἐξιέναι συγχωρούσης.

[22] Ἔστη δὲ καθάπερ κατόπτρωι τῆι πηγῆι χρώμενος καὶ εἰς αὐτὴν περιχέων τοῦ προσώπου τὸ εἶδος, ἡ δὲ τοὺς ἀπ᾽ αὐτοῦ δεχομένη χαρακτῆρας τὴν αὐτὴν εἰδωλοποιίαν ἤνυεν, ὡς δοκεῖν ἀλλήλαις ἀντιφιλοτιμεῖσθαι τὰς φύσεις.

"For whereas the marble was in every part trying to change the real boy (*ton ontōs paida*) so as to match the one in the water,[23] the spring was struggling to match the skilful efforts of art in the marble, reproducing in an incorporeal medium the likeness of a corporeal model and enveloping the reflection which came from the statue with the substance of water as though it were the substance of flesh" (5.3).[24] Who is the "real boy"? If not the statue's reflection in the pool, then the statue itself? or the mythical prototype to which both statue and reflection, competing, aspire (the "real" Narcissus)? The reflection in the water effaces the ontological difference between "boy" and "statue of a boy" in a way startlingly analogous to that in which ekphrasis in general (and this one in particular) effaces the ontological difference between artists' imitations and their objects. In effect Callistratus' ekphrasis, capable of encompassing all these images (whether reflection or statue), aspires to control the levels of reality they imply, even if it, being only a rhetorical description, is not the "real" Narcissus itself.

The conflict of marble and water, of images in three and two dimensions, becomes aligned to the competition of image with prototype, of marble imitating flesh and flesh itself. It is not entirely clear whether the pool's attempt to reflect the statue is in competition with the statue's achievement as a "skilful effort of art" or in emulation of the statue's desire to become the real boy. And these suggestive desires are themselves elided as the water itself is presented as bursting into life: "And indeed the form in the water was so instinct with life and breath that it seemed to be Narcissus himself, who, as the story goes, came to the spring, and when his form was seen by him in the water he died among the water nymphs, because he desired to make love to his own image" (5.4).[25] That Narcissus alive and breathing should be represented (in

[23] This is a very odd half-sentence. I have given the Loeb translation by A. Fairbanks. The Greek reads: ἡ μὲν γὰρ λίθος ὅλη πρὸς ἐκεῖνον μετηλλάττετο τὸν ὄντως παῖδα which literally means "for the stone altogether tried to change the real boy toward that one." If the text is not corrupt, this could well mean what Fairbanks made of it. Vinge (1967), 32, says the Loeb is wrong and renders "for whereas the marble was in every part trying to change *into* the real boy. . . ." This makes more conventional sense of Callistratus' expression, but must take πρὸς ἐκεῖνον . . . τὸν ὄντως παῖδα as a single (very emphatic) phrase meaning something like "tried to change itself toward that one, the real boy." In my view the Greek is deliberately difficult—to mirror the difficulty of the spectator in tackling this very issue, namely what is real. Vinge's version oversimplifies.

[24] ἡ μὲν γὰρ λίθος ὅλη πρὸς ἐκεῖνον μετηλλάττετο τὸν ὄντως παῖδα, ἡ δὲ πηγὴ πρὸς τὰ ἐν τῆι λίθωι μηχανήματα τῆς τέχνης ἀντηγωνίζετο ἐν ἀσωμάτωι σχήματι τὴν ἐκ σώματος ἀπεργαζομένη τοῦ παραδείγματος ὁμοιότητα, καὶ τῶι ἐκ τῆς εἰκόνος κατερχομένωι σκιάσματι οἷον τινα σάρκα τὴν τοῦ ὕδατος φύσιν περιθεῖσα.

[25] Οὕτω δὲ ἦν ζωτικὸν καὶ ἔμπνουν τὸ καθ' ὑδάτων σχῆμα, ὡς αὐτὸν εἶναι δοξάσαι τὸν Νάρκισσον, ὃν ἐπὶ πηγὴν ἐλθόντα τῆς μορφῆς αὐτῶι καθ' ὑδάτων ὀφθείσης παρὰ Νύμφαις τελευτῆσαι λέγουσι ἐρασθέντα τῶι εἰδώλωι συμμῖξαι . . .

this text) by the spring—the cause of his death—is ironic.[26] But the rhetoric of the description dangerously elides the fact that the spring is not a work of art like the statue; it is just a real spring which happens to be reflecting a sculpture nearby. Here Callistratus elegantly subverts the distinction between ekphrasis as description of landscape and ekphrasis as evocation of art. Yet in presenting the water's reflection as a struggle to emulate the statue's artistry, Callistratus performs a version of the same error as Narcissus himself. The mythical lover thought there was a real boy in the image in the water: Callistratus pretends there is a real work of art, "instinct with life and breath" (ζωτικὸν καὶ ἔμπνουν), in the reflection.

The rhetorical allusion to the desires inherent in naturalism is deliberately focused on the subject of Narcissus as one who desired himself, whose erotic delirium was to confuse not only image with prototype (he imagined it was not merely a reflection he embraced) but his *own* image with the prototype of an *other* whom he could love. Callistratus presents the desires of naturalism as themselves confusing. The image yearns to be its prototype: so the spring's reflection rivals the statue until the "water was instinct with life" (no longer the image of the statue, but a reflection of the *life* of the statue's mythical, that is, nonexistent, prototype) and the statue struggles to be more than marble, to be real flesh: "Indeed, words cannot describe how the marble softened into suppleness and provided a body at variance with its own essence; for though its own nature is very hard, it yielded a sensation of softness" (5.5).[27] The sculpture, figured as a living and desiring lover—to such an extent that Callistratus describes it in terms of "the expression of his eyes, . . . the record of his character, . . . the perception of his senses, . . . his emotions" (5.4)[28]—and even its reflection in water ("instinct with life") are projected as being *alive* and thus as being analogous to, even confusable with, the boy himself. The description, as it rises to its hyper-real crescendo, desires inanimate art and even natural reflection of art to be real and living. And this confusion is mapped onto the sexual desire of Narcissus, which is both a desire for an inanimate reflection to be alive and a confusion of the image (of another beautiful boy) in his own head, in his mind's eye, with the actual image in the water of himself.

[26] Callistratus may here be alluding to a different version of Narcissus' death from the mainstream myth reported by Ovid (*Met.* 3.407–510). In the latter, as in Pausanias 9.31.7, Narcissus died of love at the edge of the spring; by having his Narcissus "perish among the water nymphs," Callistratus may imply that his protagonist plunged into the water and drowned—a version of the myth used also by Plotinus (*Enn.* 1.6.8). On Plotinus' treatment, see Hadot (1976) and Mortley (1998), 17–21.

[27] Τὸ δὲ οὐδὲ λόγωι ῥητὸν λίθος εἰς ὑγρότητα κεχαλασμένος καὶ ἐναντίον σῶμα τῆι οὐσίαι παρεχόμενος · στερεωτέρας γὰρ τετυχηκὼς φύσεως τρυφερότητος ἀπέστελλεν αἴσθησιν . . .

[28] . . . ὀμμάτων κατασκευὴν . . . ἠθῶν ἱστορίαν . . . αἰσθήσεις . . . πάθη . . .

The orator concludes his bravura display with a masterly turn, by claiming: "In admiration of this Narcissus, O youths, I have fashioned an image of him (ἀποτυπωσάμενος) and brought it before you in the halls of the Muses" (5.5).[29] The sophist's image, conjured by description in the mind's eye (of the reader and the "youths" he pretends to address), is itself a reflection of the statue. The ekphrasis at last articulates its rivalry with the pool and the statue *as images,* and like the pool it too flirts with the opportunity to be imagined not only as a reflection of an image but as a presentation of the real Narcissus. But even as the process of *describing art* is upheld as a worthy means of imitation, so it is challenged: first, because words could not describe how the marble softened into suppleness (5.5—that is, Callistratus' words failed the image at its moment of transfiguration); and second, because the image conjured in the mind's eye (the image conjured by ekphrasis) is precisely that which led to Narcissus' undoing. It was Narcissus' inability to distinguish between the referent of an actual image (himself) and the referent of an image in the mind's eye (his desire that the image in the pool be of another whom he could love) which caused his tragedy. Callistratus thus draws attention to the fact that the image *can* never be visualized except in the subjective arena of the mind's eye. The very conflation the ekphrasis enacts when it presents the "real" Narcissus, the image of Narcissus and the image's reflection in the spring as in some sense elided, or at least only ambivalently distinct, is itself a dramatization of the Narcissian confusion in the face of naturalism.

Callistratus' Narcissus is an assured exposé of the complex dynamics of desire entangling ekphrasis and naturalism. A naturalistic image not only is a sign for its prototype, but imitates the original object and—in naturalism's ideal case—would wish to be not only a perfect copy but the original itself. Of course, the desire is not in the image itself but in its beholders; yet naturalism frames the beholder as one in whom such desire is generated. As a Lacanian reading of the nude in Renaissance art might put it, the more perfect the erotic object exposed on the canvas, the more perfect the artistry in disguising the fact that the nude is mere pigment. The more successful the naturalism becomes, the greater the gap between the image on the canvas and the image imagined in the beholder/desirer's mind.[30] Narcissus is well chosen to expose this problem, for he is naturalism's limit-case: the viewer whose success in believing that the imitation is real (that a reflection is its prototype) is tragically engulfed by his failure to see that the prototype he loved was not an other but himself. As he tries to elide the gap between prototype and reflection, a nonexistent gap since both in fact are himself, he wastes away (or possibly plunges) to death.

[29] τοῦτον θαυμάσας, ὦ νέοι, τὸν Νάρκισσον καὶ εἰς ὑμᾶς παρήγαγον εἰς Μουσῶν αὐλὴν ἀποτυπωσάμενος.

[30] Cf. Lacan (1979), 103.

As the spellbound exemplum of an extreme kind of naturalist desire, Narcissus figures again in an ekphrasis from the remarkable group of descriptions collected in the *Imagines* of the Elder Philostratus (1.23).[31] Written in the early to mid-third century A.D. and purporting to describe the paintings displayed in a gallery at Naples,[32] the two books of the *Imagines* explore with dazzling virtuosity many of the problems of naturalism.[33] Philostratus opens his ekphrasis of Narcissus with a cool self-reflection, instantly pivoting the whole discussion around the way the theme of Narcissus addresses a key issue within representation itself: "The pool paints Narcissus, and the painting represents both the pool and the whole story of Narcissus" (1.23.1).[34] If the painting depicts the pool and the whole story, then our relation to it as real viewers (were we by chance to be among Philostratus' addressees in the gallery) or imaginary viewers (seeing the subject in our mind's eye) is problematized by our looking at an image of Narcissus looking at an image. The picture before us celebrates a very strange relationship between a viewer and an image. Can we be sure that we are not subject to the seduction and the desire which cost Narcissus his life? If the pool paints Narcissus, its beholder, does the painting paint us as well as (perhaps even in the form of) its mythical subject? To add to these already disconcerting questions, there is an allusive edge to the word Philostratus chooses for "paints" and "painting." The terms *graphei* and *graphē* also mean "writes" and "writing"—and this ekphrasis is, of course, a writing. So, as with Callistratus, the image we behold as readers is not free from implication in the perilous dynamics of Narcissian viewing.

"A youth just returned from the hunt stands over a pool, drawing from within himself a kind of yearning (ἵμερον) and falling in love (ἐρῶν) with his own beauty; and, as you see, he sheds a radiance into the water" (1.23.1).[35] Narcissus has been hunting—an activity which was itself a figure for sexual desire in antiquity.[36] Captivated by his own beauty, which draws from him not only a yearning (*himeron*—a yearning for the lost self?)[37] but also erotic

<hr />

[31] For discussion of the *Imagines* of the Elder Philostratus, see, for example, G. Anderson (1986), 259–68; M. E. Blanchard (1986); Conan (1987); Beall (1993); and Elsner (2000).

[32] On the gallery see Lehmann-Hartleben (1941) and Bryson (1994).

[33] See on this issue Elsner (1995), 28–39.

[34] Ἡ μὲν πηγὴ γράφει τὸν Νάρκισσον, ἡ δὲ γραφὴ τὴν πηγὴν καὶ τοῦ Ναρκίσσου πάντα. On Philostratus' Narcissus, see Vinge (1967), 29–32; Kalinka and Schönberger (1968), 348–51; Rosati (1983), 46–47; Bann (1989), 108–13; and Frontisi-Ducroux and Vernant (1997), 225–30.

[35] μειράκιον ἄρτι θήρας ἀπηλλαγμένον πηγῆι ἐφέστηκεν ἕλκον τινὰ ἐξ αὑτοῦ ἵμερον καὶ ἐρῶν τῆς ἑαυτοῦ ὥρας, ἀστράπτει δέ, ὡς ὁρᾶις, ἐς τὸ ὕδωρ.

[36] For hunting and eroticism in Classical Greece, see Schnapp (1989) and (1997), 318–54, on eroticism and desire, and for the image in Philostratus himself, see *Imagines* 1.28.1 and in the Narcissus ekphrasis: "Whether the panting of his breast remains from his hunting or is already the panting of love I do not know" (1.23.4).

love (*erōs*), the hunter sheds a radiance which, one presumes, his image reflects to haunt and to foster his desire (cf. 1.23.3). The setting here is a sacred one (1.23.2) with allusions to Bacchic rites, a cave holy to the river god Achelöus and the Nymphs, and idyllic blooms "springing up in honour of the youth." But Philostratus, like Callistratus, is at pains to assert the realism of the image.

We are told that "the scene is painted realistically (*ta eikota*)" (1.23.2).[38] Very realistically, it turns out: "The painting has such regard for truthfulness (*alētheian*) that it even shows drops of dew dripping from the flowers and a bee settling on the flowers—whether a real bee has been deceived by the painted flowers or whether we are to be deceived into thinking that a painted bee is real, I do not know. But let that pass" (1.23.2).[39] Plunging into this address to the beholder, and beset by the *aporia* of trompe l'oeil,[40] Philostratus takes us directly back to the parallelism of painting and subject matter with which he began. If it is a real bee deceived by the flowers, like Pliny's birds deceived by the grapes in the famous anecdote of Zeuxis and Parrhasius quoted in chapter 5 (*Natural History* 35.65), then the bee is caught in the Narcissian delirium whereby disbelief is sufficiently suspended for the image to be successfully imagined as real. If we are deceived by a painted bee, then our desire as beholders is, like that of Narcissus, sufficient to make the reflection seem real (note the repetition of the verb ἐξαπατᾶν for the deceiving of the bee, us, and Narcissus in 1.23.2–3). As it is, the sophist does not even know whether or not the bee is real. He (and we, his addressees) are caught in a version of the spellbound fascination which grips Narcissus gazing into the pool.[41] The dynamics of desire between the painted viewer Narcissus and the pool have transcended the painting's frame and rest firmly in us as we attempt to relate with the painting.[42] If Philostratus is serious in his "I do not know," then he articulates the terror of

[37] This is elegantly suggested by the juxtaposition of ἕλκον τινὰ ἐξ αὐτοῦ ἵμερον (1.23.1): literally "drawing a certain yearning from himself" but αὐτοῦ ἵμερον implying a yearning for himself.

[38] γέγραπται δὲ τὰ εἰκότα.

[39] τιμῶσα δὲ ἡ γραφὴ τὴν ἀλήθειαν καὶ δρόσου τι λείβει ἀπὸ τῶν ἀνθέων, οἷς καὶ μέλιττα ἐφιζάνει τις, οὐκ οἶδα εἴτ' ἐξαπατηθεῖσα ὑπὸ τῆς γραφῆς, εἴτε ἡμᾶς ἐξαπατῆσθαι χρὴ εἶναι αὐτήν.

[40] This passage is an instance of what Bryson terms "the Philostratian 'Look!'"—what he describes as "the moment of lift-off," when "words and pictures collaborate to produce a hyper-real, sensuously intense experience that goes beyond the limits of both pictures and words." See Bryson (1994), 266–73 (quotes at 266 and 273; on Narcissus, see 273).

[41] This is made explicit in the following sentence: "As for you, however, Narcissus, it is no painting that has deceived you" (1.23.3). Narcissus is deceived as we are, but not by a painting.

[42] Vinge (1967), 30–31, emphasizes the parallels of deception between "the observer's or listener's attitude to the illusion [of the bee] and Narcissus' [to the illusion of his reflection]" and notes a hierarchy of self-consciousness in which Narcissus is unaware of his delusion while we are aware of the problem. However, self-consciousness, far from rescuing the viewer from the complexities of naturalist desire, only adds a further entanglement to the web (see below on Pausanias' Narcissus).

CHAPTER SIX

naturalist art when we cannot tell whether the deception is the prototype or, in the case of multiple deceptions, which one is more true. The writer's "I do not know" functions in more than one way: it may insist on his comparative safety from the dangers of Narcissistic viewing, since his disclaimer gives him distance by implying that however sure we may feel we are about the reality of these images, his skepticism in not being sure offers a certain separation from the cycle of entrancement. But it may also imply his potential for being seduced by the image, since he is himself not sure about what is real.

Narcissus, however, is one stage beyond this:

> As for you, however, Narcissus, it is no painting that has deceived you, nor are you engrossed in a thing of pigments and wax; but you do not realize that the water represents you exactly as you are when you gaze upon it, nor do you see through the artifice of the pool, though to do so you have only to nod your head or change your expression or slightly move your hand, instead of standing in the same attitude; but acting as though you had met a companion, you wait for some move on his part. Do you then expect the pool to enter into conversation with you? Nay, this youth does not hear anything we say, but he is immersed, eyes and ears alike, in the water and we must interpret the painting for ourselves. (1.23.3)[43]

The viewer is entranced with his two crucial senses ("eyes and ears alike") in the pool of his deception, in the reflection of his desire. And the reflection desires back with the intensity of passion which Narcissus directs toward it. Ironically, while so many ekphraseis give an impression of movement (with the text transforming the static image it describes into a narrative),[44] here this is reversed to poignant effect. By artifice and by desire, Narcissus is frozen as if he were a work of art (a petrification nicely realized in Callistratus' marble statue, which enacts the myth as well as representing it).[45] But ironically,

[43] Σὲ μέντοι, μειράκιον, οὐ γραφή τις ἐξηπάτησεν, οὐδὲ χρώμασιν ἢ κηρῷ προστέτηκας, ἀλλ᾽ ἐκτυπῶσαν σὲ τὸ ὕδωρ, οἷον εἶδες αὐτό, οὐκ οἶσθα οὔτε τὸ τῆς πηγῆς ἐλέγχεις σόφισμα, νεῦσαι δεῖν καὶ παρατρέψαι τοῦ εἴδους καὶ τὴν χεῖρα ὑποκινῆσαι καὶ μὴ ἐπὶ ταὐτοῦ ἑστάναι, σὺ δ᾽ ὥσπερ ἑταίρῳ ἐντυχὼν τἀκεῖθεν περιμένεις. εἶτά σοι ἡ πηγὴ μύθωι χρήσεται; οὗτος μὲν οὖν οὐδ᾽ ἐπαίει τι ἡμῶν, ἀλλ᾽ ἐμπέπτωκεν ἐπὶ τὸ ὕδωρ αὐτοῖς ὠσὶ καὶ αὐτοῖς ὄμμασιν, αὐτοὶ δὲ ἡμεῖς, ὥσπερ γέγραπται, λέγωμεν.

[44] Examples of narrativized movement abound in the literature of ekphrasis: in Philostratus alone, see, for example, 1.1, 2, 4, 6, and so on. For ekphrasis "intuiting the complex narrative sequences that are implied in frozen images," see, for example, Barkan (1993), 135 and 159n10, whence the quote. The refusal of Narcissus to reply in this passage is, however, typical of ekphrasis; see Laird (1993), 20, 21–24.

[45] This irony of Narcissus turned into a work of art by his rapt gazing at an image is much exploited by Ovid in his version of the Narcissus story at *Metamorphoses* 3.419 and 422, where Narcissus is compared to a statue carved in Parian marble and his neck is ivory. In Ovid, there is a parallel between Narcissus (the man who gazes at a reflection, loves the image, and "becomes" a work of sculpture) and Pygmalion, who creates a statue, falls in love with it, and finds that it eventually becomes a "real" woman. On this see chapter 5 above.

when Narcissus finally makes his move, it will not be to disabuse himself, but to imagine that his beloved is fleeing from him (at least in Ovid's version, *Met.* 3.428–32, 454–55). In that sense, he is already so deranged that Philostratus is right to describe him as "immersed (*empeptōken*: literally "fallen") in the water"; his fall is accomplished even in the initial enchantment of his gaze and its desire.

The failure to see through artifice, however, is not only that of Narcissus. The description is so written that we, as participants of Philostratus' imaginary conversation with the picture, attempt to address Narcissus, just as he seems to expect the pool to respond to his adoring gaze with conversation.[46] The worrying first and second persons ("I do not know," "you, however, Narcissus," "we must interpret the painting for ourselves") weave the reader/viewer into the nexus of Narcissian desire, where we are so entranced by the fantasy of naturalism that we can imagine he is impervious to "anything we say" since "he is immersed" in desire for another.

The self-absorption of Narcissus, with its constant intimations of a similar absorption in the viewer, is wonderfully caught at the end of the description as Philostratus pretends to be straightforwardly and analytically describing a painting: "Both the Narcissi are exactly alike in form and each repeats the traits of the other, except that one stands out in the open air while the other is immersed in the pool. For the youth stands over the youth who stands in the water, or rather who gazes intently at him and seems to be athirst for his beauty" (1.23.5).[47] The viewer's desire, sublimated onto the naturalist image, allows the image to appear to desire back, to desire on its own terms. As Philostratus puts it earlier, Narcissus "perhaps thinks he is loved in return, since the reflection gazes at him in just the way that he looks at it" (1.23.4). For this imagined lover to be seen as athirst for Narcissus is of course heavily ironic.[48]

RATIONALIZING NARCISSUS

These descriptions by Philostratus and Callistratus focus the interpretation of Narcissus not on the myth as such, nor on its moralistic or rationalizing

[46] Here Philostratus emulates the narrator's apostrophe in Ovid, *Met.* 3.432–36, on which see Brenkman (1976), 322–24. As in Ovid, not only does Narcissus fail to hear but the narrator's unsuccessful intrusion into the world of the image abolishes the secure authority which his own voice is supposed to establish. Again Philostratus' (and our) failure in viewing the image (in falsely imagining the image can respond) only mirrors that of Narcissus in viewing the pool.

[47] ἴσοι τε ἄμφω οἱ Νάρκισσοι τὸ εἶδος ἴσα ἐμφαίνοντες ἀλλήλων, πλὴν ὅσον ὁ μὲν ἔκκειται τοῦ ἀέρος, ὁ δὲ τὴν πηγὴν ὑποδέδυκεν. ἐφέστηκε γὰρ τὸ μειράκιον τῶι ἐν ὕδατι ἑστῶτι, μᾶλλον δὲ ἀτενίζοντι ἐς αὐτὸ καὶ οἷον διψῶντι τοῦ κάλλους.

[48] And a reversal of the thirst in Ovid, *Met.* 3.415, where Narcissus' thirst to drink gives rise to his thirst as a lover when he sees the image in the pool.

implications, but on its representation in art and as art. The two sophists' accounts remake the myth of Narcissus rhetorically into a meditation on viewing, naturalism, and erotic desire—which is to say, on subjectivity. They emphasize the pivotal moment of the myth's narrative pattern: the tale whereby a vigorous hunter was transformed into a flower turns on the moment of self-absorption when the lover's gaze meets that of his own image. From being a paradigm of the chase (Philostratus, 1.23.1, 4), Narcissus becomes frozen and passive, not only in his self-immersion (Philostratus 1.23.1, 3, 5) but also in the hints that he has become petrified, work-of-art-like, the statue in Callistratus. While Ovid's Pygmalion objectified a statue into a woman until it became "real," Narcissus objectifies himself as another until he resembles a statue. The passivity of Narcissus, suggested in the very etymology of his name (*narkē* means "numbness," "deadening"), elides into a feminization implied by the language of softening, suppleness, and dissolution (Callistratus 5.5), by the flowers springing up in his honor (Philostratus 1.23.2), and by the flower into which he is eventually transformed (Callistratus 5.4).[49]

The dynamic of this metamorphosis is effected by the self-objectifying gaze which alters Narcissus' image from being his own reflection to becoming a loved one of his own sex transgressively like himself, transgressively his own age.[50] Erotic desire operating through the power of mimesis creates an object who is ambiguously both lover (*erastēs*) and beloved (*erōmenos*), an impossible and transgressive combination in terms of the ideals of Athenian homosexual culture implicit in Second Sophistic recapitulations of the classical canon.[51] By altering his image into something else, Narcissus alters himself into something else—becoming not only the lover of the *erōmenos* in the image but also the beloved object of the lover in the pool. In Callistratus (5.3), this splitting of the subject is figured as the conflict in which the statue competes with its image in the water. The terrifying confrontation with the self's gaze as if it were other causes a psychic move whereby Narcissus looks at himself as another would look at him (since he sees his own gaze gazing at himself but imagines it to be his lover/beloved gazing at him, or as Philostratus more elegantly enacts it—"do you then expect the pool to enter into conversation with you?" 1.23.3).[52] He looks at himself as a man would look at his

[49] On flowers as symbols of virginity and vulnerability, see Segal (1969), 33–38.

[50] Transgressive because "reciprocal desire of partners belonging to the same age-category is virtually unknown in Greek homosexuality," Dover (1978), 16, cf. 85f.

[51] On the distinction between these roles—between "'active' (or 'assertive,' or 'dominant') and 'passive' (or 'receptive,' or 'subordinate') partners"—see Dover (1978), 16–17.

[52] Here the Narcissus narrative not only anticipates some of the more "catastrophic" themes in Western visuality as elucidated by Sartre and Lacan, but in fact goes further in defining an isolated subject subjected to an other's alienating gaze which is fact not an other's but his own. On these themes in modern visuality (by contrast with a non-Western model), see Bryson (1988).

VIEWER AS IMAGE

erōmenos or at a woman; but he also looks at himself as a woman in a male-dominated society (ever aware of the male social context governing her self-image) would look at herself, or as a boy in a homosexual culture which adored prepubertal boys would look at himself: that is, he looks at himself as one who is being looked at.[53] In effect he has become both himself and a (kind of) woman or the kind of boy which he no longer is: one might say that he has become a kind of hermaphrodite.[54] Since his beloved is an *object* to be penetrated by the active *erastēs*, Narcissus has turned himself as *subject* into a kind of object. But one might argue that the man in Narcissus (the viewer crouching by the pool) had fallen in love with the boy in him (the reflection). The ambivalence of Narcissus—and of adolescence generally, poised between boyhood and manhood—is here used to confuse not just those who might normally desire boys, but specifically the adolescent hunter whose own subjectivity is split between man- and boyhood and who enacts that split by objectifying one half of it. Part of the paralysis at the pool depends on the fact that Narcissus does not know whether he is the lover (of the boy in the water) or the beloved (of the man in the water)—as implied by Ovid's "what shall I do? Shall I woo or be wooed?" (*Met.* 3.465). His subjectivity objectivized, Narcissus as subject loses all capacity for action, becomes feminized, infantalized, passive. His objectification of self turns the subject into an object and results in an absorbed paralysis of self, a self-absorption whose only end is death.

The ekphrasists' Narcissus becomes a myth of the fallibilities of the gaze and of the subject as viewer. Their theme is not so much the perils of mirroring as those of deception, artifice, and viewing in Philostratus and competing imitations in Callistratus. Here they elide the philosophical implications of the story as presented in Ovid's earlier version[55] with the bewitching powers suggested by reflection in water,[56] and instead focus the myth around the

[53] The classic art historical formulation of this theme (in relation to women) is Berger (1972), 45–64. His position has been much criticized, of course: see, for example, Pointon (1990), 15–17, and Nead (1992), 15.

[54] For parallels between Ovid's Narcissus and Hermaphroditus, see Stirrup (1976) and Segal (1969), 24, 52–53.

[55] For the philosophical implications of mirroring (as knowing oneself and yet being separate or alientated from the self one knows), see Myerowitz (1992), 149–52, and especially McCarty (1989), 164–84; on Narcissus and the mirror, see ibid., 162–63, and V. Skinner (1965). On Ovid's Narcissus and Epicurean psychology, see Hardie (2002b), 150–65, and for Narcissus as seduced from the philosopher's path into a world of sensory delusions, cf. Plotinus, *Enn.* 1.6.8.8. See further on mirrors, philosophy, and self-fashioning, Too (1996) and Bartsch (2000).

[56] Take for instance Plutarch's story of Eutelidas, *Quaestiones Convivales* 5.7.682B:
> Fair once were, fair indeed the tresses of Eutelidas;
> But he cast an evil spell on himself, that baneful man,
> Beholding self in river's eddy; and straight fell disease . . .

erotics of naturalistic imitation. The amatory conundrum found in these descriptions of a painting and a sculpture turns out to be *the* problematic of naturalism. The image is imagined as real and the imaginer so forgets his own input into this subjective fantasy that (in his imagination) the image becomes real. Here both sophists eschew the outburst of self-consciousness at the heart of Ovid's narrative.[57] In Ovid, Narcissus memorably cries out:

> iste ego sum: sensi, nec me mea fallit imago;
> uror amore mei. (*Met.* 3.463–64).

> I am he: I know it, and my image does not deceive me;
> I am on fire with love for myself.

But in Callistratus and Philostratus, Narcissus is entirely wrapped up in his fascination for the reflection in the pool, without any hint of awareness that it is himself he loves. Instead the dangers of such viewing, which is presented as a paradigm for the viewing of mimetic images, are made potent and palpable as nowhere else in ancient discussion. For the self-forgetting of Narcissus becomes not the apparent achievement of a Pygmalion or the imagined sexual ecstasy of Lucian's Charicles and Callicratidas or even the comparison of presumed homosexual success with the viewer's sense of sexual failure as in Encolpius' lament in the Petronian art gallery which is the subject of chapter 7 below, but the paralysis, loss, and ultimate effacement of self.

This danger is extended to the imagined viewer of these Narcissian images. The aim of ekphrastic rhetoric in antiquity was to evoke the image described in the mind's eye of the listener.[58] To hear or read Philostratus or Callistratus was to have painted an image of Narcissus in one's own fantasy and thus to be embroiled in the disturbing subjectivism of projected images and desires which both ekphraseis take to be a crucial aspect of Narcissus' own plight. If, to paraphrase Philostratus, the pool paints Narcissus and the painting represents both the pool and the tragedy of Narcissus' viewing, then the description repaints the painting, the pool, and the tragedy as a vision in the listener's or reader's mind. All the myth's complex psychodynamics of eroticism, naturalism, and desire are evoked by the descriptions to be replayed in

The legend is that Eutelidas, beautiful in his own estimation, being affected by what he saw, fell sick and lost his beauty with his health.

On the implications of water and sexuality, see Segal (1969), 23–33, 45–49.

[57] On the self-aware Narcissus of Ovid, see P. Zanker (1966), 152; Rosati (1976), 98; and Hardie (2002b), 147.

[58] On this aspect of ekphrasis (its creation of what the Greeks called *phantasia*), see Imbert (1980); G. Watson (1988), 59–95; and Webb (1997b).

the listener's mind before an imagined painting or statue whose supremely perfect naturalism is limited by nothing except the failings of a viewer's imagination.

The myth and its representations were terrifying; one strategy of defense was to follow the hint in Ovid and to disbelieve that anyone (Narcissus included) could sufficiently suspend his or her disbelief. In his discussion of the Narcissus myth, the second-century A.D. traveler Pausanias could not accept that a grown man failed to differentiate between reality and illusion:

> In the territory of the Thespians is a place called Donacon. Here is the spring of Narcissus. They say that Narcissus looked into this water, and not understanding that he saw his own reflection, unconsciously fell in love with himself, and died of love at the spring. But it is utter stupidity to imagine that a man old enough to fall in love was incapable of distinguishing a man from a man's reflection. (9.31.7)[59]

Pausanias' commonsense rationalization of the tale attempts to strip Narcissus of the self-deceptions central to the ekphrasists' version of the myth's theme. It is simply not credible to imagine Narcissus unable to distinguish reality from reflection. Pausanias begins not with an image or the myth, but by coming across the actual spring in his travels where the myth was said to have happened. His insistence on actuality—perhaps itself a result of the genre (the myth-and-history-collecting, rationalizing yet religious travelogue) in which he writes—seems to guide his reading of the myth (which it should be said he does not doubt) toward what is to him a more plausible version:[60]

> There is another story about Narcissus, less popular indeed than the other, but not without some support. It is said that Narcissus had a twin sister; they were exactly alike in appearance, their hair was the same, they wore similar clothes, and went hunting together. The story goes on that Narcissus fell in love with his sister, and when the girl died, would go to the spring, knowing that it was his reflection that he saw, but in spite of this knowledge finding some relief for

[59] Θεσπιέων δὲ ἐν τῆι γῆι Δονακῶν ἐστιν ὀνομαζόμενος· ἐνταῦθά ἐστι Ναρκίσσου πηγή, καὶ τὸν Νάρκισσον ἰδεῖν ἐς τοῦτο τὸ ὕδωρ φασίν, οὐ συνέντα δὲ ὅτι ἑώρα σκιὰν τὴν ἑαυτοῦ λαθεῖν τε αὐτὸν ἐρασθέντα αὑτοῦ καὶ ὑπὸ τοῦ ἔρωτος ἐπὶ τῆι πηγῆι οἱ συμβῆναι τὴν τελευτήν. τοῦτο μὲν δὴ παντάπασιν εὔηθες, ἡλικίας ἤδη τινὰ ἐς τοσοῦτο ἥκοντα ὡς ὑπὸ ἔρωτος ἁλίσκεσθαι μηδὲ ὁποῖόν τι ἄνθρωπος καὶ ὁποῖόν τι ἀνθρώπου σκία διαγνῶναι.

On Pausanias' Narcissus, see Frazer (1898), 5:159; Vinge (1967), 21–22; Heer (1979), 199; Rosati (1983), 12; Pellizer (1987), 112; Frontisi-Ducroux and Vernant (1997), 217–21; and Bettini (1999), 98–99.

[60] For Pausanias' rationalism in the face of myth, see Veyne (1988), 95–102 (Narcissus, 97).

his love in imagining that he saw, not his own reflection, but the likeness of his sister. (9.31.7–8)[61]

Having abandoned the first self-deception of the myth (that Narcissus could not tell reflection from reality), Pausanias goes on to reject the second (that Narcissus confuses an image of himself with that of another). Yet, having emptied the tale of the perilous but entrancing self-deceptions so fascinating to most retellers of the myth (not to mention a whole host of painters from Pompeii's muralists to Caravaggio and Dalí), Pausanias offers an alternative version perhaps as interesting and certainly as troubling.

In place of the dynamics of self-desire (and carefully eliding the homo-eroticism of the myth in choosing a sister and not a brother for his Narcissus), Pausanias creates a remarkable and complex psychopathology of the lost, the desired, and the imagined. Instead of self, his Narcissus loves a heterosexual sublimation of self—a "twin sister" (*adelphēn . . . didymon*), "exactly alike in appearance" (*hapan homoion to eidos*), whose hair, clothes, and activities exactly mirror her brother's. In turning the reflected boy into a reflected girl, Pausanias comes up with a formulation which is both a more and a less socially "normal" sexual relationship. Instead of breaking the taboo of homosexual love for a youth of the same age, Pausanias' Narcissus stumbles into incest—incest with an other so exactly like him as almost to be him. Yet this transgression is itself subsidiary to the fundamental taboo underlying all versions of the myth. Like those Roman paintings of Narcissus which show him *alone* with his reflection by the pool (sometimes accompanied by Eros),[62] the key dynamic which Pausanias' Narcissus shares with those of Philostratus and Callistratus (as well as Ovid) is autoeroticism. In the end, there is no other—no beloved, no sister. There is only the lonely subject transforming the image of self through erotic fantasy.

While the ekphrasists' Narcissus was wholly entangled in the deceitful web of naturalism, Pausanias' Narcissus is caught in the still more psychologically complex predicament of Philostratus and his audience. He *knows* the image is a mere reflection (as Philostratus knows that the painting is just a painting), but nevertheless he *imagines* that it is more (as Philostratus speculates on the reality of the bee, and on whether it is he or the bee which is deluded). Deprived by rationalization of all the excuses and the fantastical strategies of

[61] ἔχει δὲ καὶ ἕτερος ἐς αὐτὸν λόγος, ἧσσον μὲν τοῦ προτέρου γνώριμος, λεγόμενος δὲ καὶ οὗτος, ἀδελφὴν γενέσθαι Ναρκίσσωι δίδυμον, τά τε ἄλλα ἐς ἅπαν ὅμοιον τὸ εἶδος καὶ ἀμφοτέροις ὡσαύτως κόμην εἶναι καὶ ἐσθῆτα ἐοικυῖαν αὐτοὺς ἐνδύεσθαι καὶ δὴ καὶ ἐπὶ θήραν ἰέναι μετὰ ἀλλήλων· Νάρκισσον δὲ ἐρασθῆναι τῆς ἀδελφῆς, καὶ ὡς ἀπέθανεν ἡ παῖς, φοιτῶντα ἐπὶ τὴν πηγὴν συνιέναι μὲν ὅτι τὴν ἑαυτοῦ σκιὰν ἑώρα, εἶναι δέ οἱ καὶ συνιέντι ῥαϊστώνην τοῦ ἔρωτος ἅτε οὐχ ἑαυτοῦ σκιὰν δοξάζοντι ἀλλὰ εἰκόνα ὁρᾶν τῆς ἀδελφῆς.

[62] Rafn (1992), 709; on the isolation of Ovid's Narcissus and the pool, see Brenkman (1976), 304–5.

VIEWER AS IMAGE

myth, Pausanias' Narcissus finds himself in the voyeur's tragedy of knowing consciously that what he is doing is only self-indulgence and wish-fulfillment but being unable to do anything else. In effect, Pausanias takes the dynamics of the story out of the realm of artistic paradigms and mythical archetypes into the still more disturbing world of psychological plausibility.

No less than in the ekphraseis, Pausanias' Narcissus imagines the other in the image of self. But while the descriptive Narcissi of Callistratus and Philostratus were evocations of works of art (admittedly art which was highly self-referential in the way it addressed the theme of representation), this Narcissus (unlike Ovid's highly literary creation) is the figure for a rational human being (like you and me). He is a grown person who can tell the difference between real things and the illusions which pretend to be like them, a real person whom we meet through arriving at a place associated with him presented in the factual discourse of the travelogue. It is worth remarking that the genres of the different accounts of Narcissus, as well as their different historical contexts, modulate the kinds of retellings we have been exploring. The ekphrasists' Narcissus represented works of art figuring an ideal (and ultimately catastrophic) position in the dialectics of the viewing of naturalism, and they presented their Narcissus in the context of the Second Sophistic as a variant and indeed commentary on other previous positions in the same ancient debate. Pausanias' Narcissus figures a still more tragic, because perhaps ultimately more realistic, situation. He is not the emblematic case of a spectator so sympathetic to the wiles of naturalism as to be destroyed by them, but the much more familiar instance of the voyeur reduced to a world of autoerotic fantasy as a desperate attempt to evoke the nonexistent.

Depicting Narcissus

Let us turn to the myth of Narcissus as conceived and portrayed by artists in the Roman empire. No less than Alberti, or than the modern painters of the theme from Poussin and Caravaggio to Salvador Dalí,[63] Roman artists (and I shall here mainly concentrate on mostly anonymous fresco painters from the region around Pompeii, working in roughly the second and third quarters of the first century A.D.) were interpreters. The pictorial tradition of Narcissus in antiquity is as varied as the literary interpretations of the myth. Not surprisingly, this tradition focuses above all on the theme of reflection—both on the image wrought by the water and on Narcissus' fascination with it. Implicitly, then, the ancient visualization of the myth focuses on the art historically interesting problem of *viewing*, as emphasized by Philostratus. The surviving

[63] For a discussion of some modern visual versions, see Bann (1989), 127–56.

images comprise wall paintings and a stucco from the region around Vesuvius, floor mosaics from both the east and the west of the Roman empire, as well as a few statuettes, gems, terracottas, and textiles.[64] Most belong to the Roman period—to the same time, roughly, which separates Ovid's retelling of the myth in the early first century A.D. from Callistratus' description, which most likely dates from the late third or early fourth century. The images come from the private sphere and decorated the houses and persons of the wealthy elite—though not (in the case of any surviving examples) of the most elevated aristocracy. Although Narcissus occasionally appears as a hunter (sometimes in the company of nymphs or of Artemis, the goddess of the hunt), the majority of the surviving images focus—like Caravaggio's painting—on the boy rapt in intense visual dialogue with his image in the pool.[65]

The "reflective Narcissus" seated by the pool appears under what may be divided into three principal headings:[66] alone by the pool (for instance, figures 6.1, 6.6, 6.8, 6.10, 6.11, and 6.12),[67] by the pool in the company of Eros (figures 6.2, 6.4, 6.5, and 6.13),[68] and by the pool accompanied by Echo as well as Eros (for example, figures 6.14, 6.15, and 6.16).[69] In every case, Narcissus is semi-nude, his cloak having fallen about his legs, usually to reveal his genitals as well as his torso. Normally he carries a spear—the mark of his huntsman's profession (as in Philostratus 1.23.4). This signals more than a mere attribute. In being a hunter, Narcissus is aligned (like Hippolytus in Euripides' play) with the world of Artemis and hence with chastity, as is implied by his rejection of Echo in Ovid's version (*Met.* 3.352–55, 389–92). But as a hunter, he was also implicitly a figure of erotic desire—his game always potentially a sexual pursuit.[70] This role is suggested visually by the way Eros holds Narcissus' spear for him, just as Narcissus himself cradles Eros in figure 6.2.[71] In all the images, therefore, there is an ambivalence between eroticism and chastity which reflects the

[64] On the images, the most comprehensive catalogue is Rafn (1992). Discussions include P. Zanker (1966); Balensiefen (1990), 130–66; and Prehn (1997).

[65] This theme is the specific focus of Balensiefen (1990), 130–66, and (from a more textual angle) of Frontisi-Ducroux and Vernant (1997), 200–41.

[66] There is also a parallel if less common iconography of the standing Narcissus (both alone with erotes—for example, from IX.3.5/24, with PPM IX.205 and PPM documentazione 461–64 and 823–26—and with Echo and erotes—for example, Naples Museum 9385, from Torre Anunziata, with Rafn (1992), 707 no. 49), but I shall not focus on this iconography here.

[67] See Rafn (1992), 704 A(a) 1–8.

[68] See ibid., 705–6 B 27–36.

[69] See ibid., 707 C 45–50, and Bazant and Simon (1986), 681–82 C 9–12.

[70] On the meanings of hunting in Greek culture, see Schnapp (1997), especially 318–54 on eroticism and desire.

[71] On this image, originally from the Casa di Marinaio (VII.15.2), see PPM VII.736 and Guzzo (1997), 124, no. 75. In one of the second-century A.D. mosaic versions from Antioch (now in Baltimore: BMA 1938.710), the spear glides down along Narcissus' arm to penetrate the pool and his reflected image beneath. See figure 6.10.

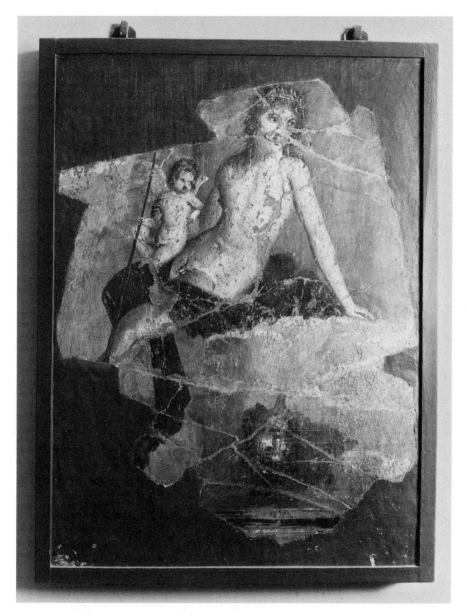

FIGURE 6.2. Fragment of a fresco of Narcissus by the pool with Eros, from the Casa del Marinaio, Pompeii (VII.15.2). Third quarter of the first century A.D. Now in the Antiquarium, Pompeii. (Photo: Rossa, DAI 77.2283.)

myth's double focus between one who rejects the passion of Echo and yet who falls passionately in love with himself. This ambivalence is itself aligned with the age at which Narcissus is represented—in Ovid's words, "when he might seem either a boy or a man" and at a moment when "many youths and many girls desired him" (*Met.* 3.352–53).[72] Like the texts, the images all

cast the subject within what was in antiquity the charged erotic landscape of the pastoral.[73]

Before we examine the images, it is worth remarking on their context. None would have been displayed in isolation in antiquity—though many have been removed from their archeological find-spot (and from the other images with which they were originally connected) in the wake of modern excavation (for example, figures 6.2 and 6.15). In the case of those which survive in situ, some come from interiors and some from garden settings. Figure 6.1, the image from the Casa di M. Lucretius Fronto (Pompeii V.4.a) comes from the north wall of what was probably a groundfloor bedroom, cubiculum 6. The wall is divided into three equal panels with a yellow background. The Narcissus image is presented as if it were a framed painting placed on the central panel within the wall beneath a trompe l'oeil niche. In each of the side panels are small vignettes painted directly onto the yellow ground showing amorini carrying a cornucopia (on the left) and a drinking cup (on the right). The opposite wall is divided in the same way, with an illustration of the story of Pero and Micon (told in the *Memorable Deeds and Sayings* 5.4.7 of Valerius Maximus, a younger contemporary of Ovid), which is identified by a poem in elegiac couplets painted on the left of the picture (figure 6.3).[74] The context isolates the painting of Narcissus (though the amorini on either side might be said to provide the company of Eros offered in other pictures, such as figures 6.4 and 6.5) and the image seems resolutely focused on its subject's fixation with his reflection. The highly literary (and rather obscure) subject matter of the painting of Pero giving the breast to her father Micon as if he were her baby, while they are both in prison,[75] may suggest that the Narcissus image is specifically alluding to the literary context of Ovid's poem. Certainly, there is a parallelism of different kinds of imprisonment and the reversal of the natural order in both themes, while the maturity of Pero combined with the simultaneous old age and babyhood of Micon throw a particular emphasis on the adolescence of Narcissus on the opposite wall. Likewise, the very close human interaction of Pero and Micon—highlighted by the emphasis in the last line of the inscribed poem on "sad modesty together with daughterly love" (*tristi inest cum pietate pudor*)—contrasts with the solipsism of Narcissus, who has no other company in this image than his own reflection.

[72] Cf. Callistratus 5.1: "He was a boy, or rather a youth, of the same age as the Erotes."

[73] For landscape in the texts, see Ovid, *Met.* 3.356, 407–12; Philostratus, 1.23.1–2; and Callistratus, 5.1.

[74] On all this see PPM III, 1000–1008, and Peters and Moormann (1993), 332–39; also J. R. Clarke (2003b), 257–59, and Milnor (2005), 98–102. For a close iconographic parallel to this Narcissus in a lost image from regio III, see PPM documentazione 295. On the poem, see Courtney (1995), 76–77, no. 56), with 277–78 for commentary.

[75] On this strange myth and its representations, see Berger-Doer (1994), with bibliography.

VIEWER AS IMAGE

———

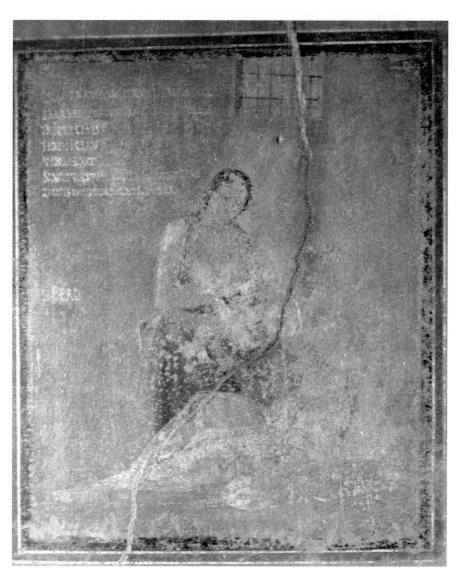

FIGURE 6.3. Fresco of Pero and Micon from the Casa di M Lucretius Fronto (Pompeii, V.4.a). Third quarter of the first century A.D. (Photo: Fuhrmann, DAI 39.368.)

The isolated Narcissus (figure 6.6) from the Casa dell' Ara Massima (Pompeii, VI.16.15.17) is also from an interior setting. It comes from the alcove (described as a "pseudotablinum") off the west wall of the house's main groundfloor atrium, facing the entrance (figure 6.7). Again the image is presented as if it were a framed panel painting, this time rendered as if it were propped on two wooden supports with trompe-l'oeil shutters depicted as if they had been left open. The white wall around the picture is embellished with elaborate fantasy architecture and playful vine-scrolls with birds, animals, and

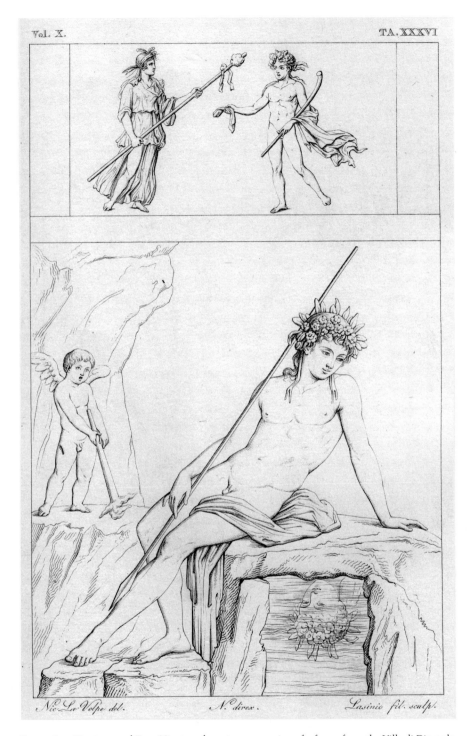

Nic. La Volpe del. N.e direx. Lasinio fil. sculp.

FIGURE 6.4. Narcissus and Eros. Nineteenth-century engraving of a fresco from the Villa di Diomede, Pompeii. Third quarter of the first century A.D. Now in Naples Museum (MN 9383). (Photo: From *Real Museo Borbonico*, vol. 10, tav. 36.)

VIEWER AS IMAGE

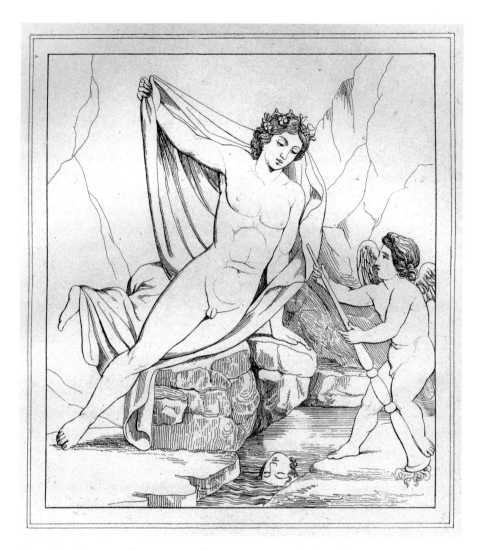

FIGURE 6.5. Narcissus and Eros. Nineteenth-century engraving of a fresco from the Casa delle Vestali, Pompeii (VI.1.7/25). Third quarter of the first century A.D. Now in Naples Museum (MN 9701). (Photo: From Roux-Aîné and Barré, 1861, vol. 2, tav. 41.)

winged figures.[76] On the ground below the image, there may have been a basin on a high stand containing water, in which have been reflected not only this painted Narcissus but also anyone who paused to look at the fresco with any care.[77] While Narcissus is the only image in this alcove, the painting looks into the extensively decorated main room, with what appears to be an elaborate theater set with statues, masks, standing figures, and a central landscape

[76] See Stemmer (1992), 31–33, figs. 188–204, and PPM V.850–58.
[77] See the photographs in PPM V.854 and Stemmer (1992), 78.

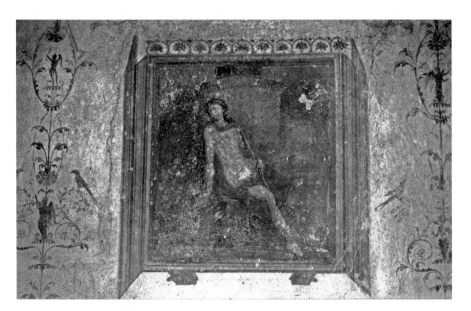

FIGURE 6.6. Fresco of Narcissus from the Casa dell' Ara Massima, Pompeii (VI.16.15). Third quarter of the first century A.D. (Photo: Courtesy of Katherina Lorenz.)

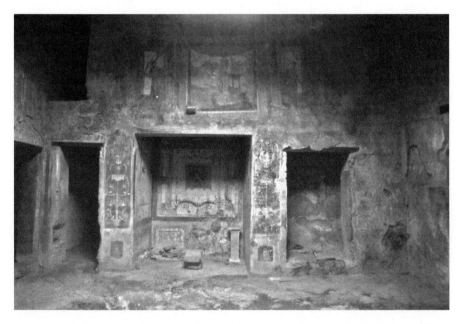

FIGURE 6.7. General view of the context of figure 6.6, the atrium of the Casa dell' Ara Massima, Pompeii (VI.16.15). Third quarter of the first century A.D. (Photo: Courtesy of Katherina Lorenz.)

on the wall directly above and to either side of the alcove.[78] This time the Narcissus theme seems staged within a theater—a kind of mythical performance of isolated individualism within one of the house's more public rooms, directly visible in a view across the atrium as one entered from the street.

By contrast, the Narcissus (by a painter who signs himself "Lucius," figure 6.8)[79] from the Casa dei M. Loreius Tiburtinus (Pompeii, II.2.2–5) comes from a much less public spot within the orchestration of the Roman house—a terrace with a pool overlooking the house's long back garden with a nymphaeum, fountains, and vine-covered pergola.[80] The northeast corner of the terrace consisted of two masonry couches (a "biclinium") on either side of the pool, beneath an aedicula niche framed with two columns (figure 6.9). On the walls behind the couches, on either side of the niche, are the paintings of Narcissus (on the viewer's left) and Pyramus and Thisbe (on the right).[81] Here there is a clear parallelism intended between the diner reclining on the couch overlooking the pool, and the image of Narcissus behind him.[82] The painting has an ironic relationship with its viewer—looking askance at the role of the diner, reclining over the pool and his own reflection in the water. Even the rock on which Narcissus sits is not unlike the form of the masonry couch on which the diner beneath Narcissus would recline (immediately behind the protective modern wooden fence which disfigures figure 6.9). The tragic deaths of Pyramus and Thisbe over the other couch may mean that both images were understood to refer specifically to Ovid (the Pyramus and Thisbe narrative follows that of Narcissus in *Met.* 4.55–166). Certainly the figure of Pyramus—with his flowing cloak and spear—looks like a fallen Narcissus, while Thisbe might be said to echo Echo.

The emphasis on the viewing context is significant, because the Narcissus images foreground the theme of viewing in what might seem the artificial ambience of an idyllic pastoral setting. The images can be viewed as one visual narrative within a whole pattern of connected stories (as in Ovid's *Metamorphoses*), where it is up to the viewer to construct his or her own meanings in relation to Narcissus' juxtaposition with Pyramus and Thisbe or with Pero and Micon.[83] Alternatively they may be seen as isolated scenes, set individually within the visual space defined by their painted frames (like the paintings

[78] Stemmer (1992), 17–21, figs. 70–93.

[79] On Lucius and his works, see L. Richardson (2000), 147–53.

[80] On issues of public and private in the Roman house, see Wallace-Hadrill (1994), 3–61.

[81] See PPM III.102–5; Jashemski (1993), 78–82; and P. Zanker (1998), 145–56, for context. For this image in relation to other images of viewing and epiphany in the same house, see Platt (2002a).

[82] For a wonderfully detailed and visually sensitive account of Roman dining, see Dunbabin (2003), especially 38–40, on couches, and 144–50, on picnics; also J. R. Clarke (2003b), 223–45.

[83] For some thoughts on this kind of process, see Brilliant (1984), 53–89.

CHAPTER SIX

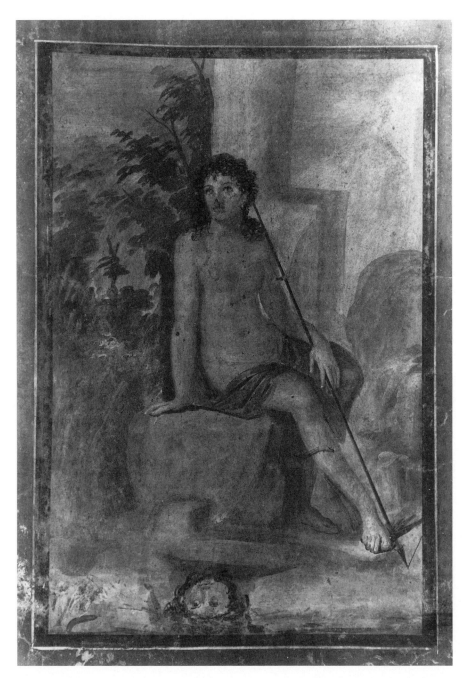

FIGURE 6.8. Fresco of Narcissus from the Casa di M. Loreius Tiburtinus, sometimes given as D. Octavius Quarto, Pompeii (II.2.2). Third quarter of the first century A.D. The companion picture of Pyramus and Thisbe is signed by the painter Lucius. (Photo: Bartl, DAI 57.872.)

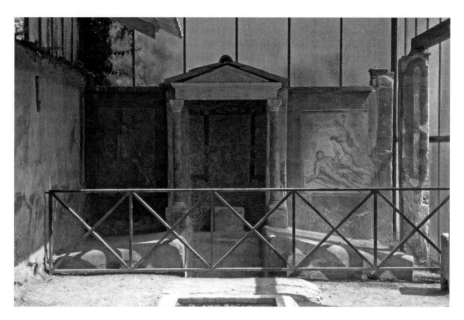

FIGURE 6.9. Aedicula and biclinium from the Casa di M. Loreius Tiburtinus or D. Octavius Quarto, Pompeii (II.2.2), showing the Narcissus fresco (figure 6.8) and its companion image of Pyramus and Thisbe in context. (Photo: Courtesy of Katherina Lorenz.)

individually described and never overtly compared in the text of Philostratus). A viewer may not directly relate them to the images nearby, and yet there may be certain tantalizing parallels. In the case of Philostratus' gallery, the image of Olympus (1.21), described before that of Narcissus (1.23) and with only one painting intervening, anticipates many of the Narcissian themes: "I do not understand why you take delight in the pool of water by the rock and gaze into it. What interest have you in it? . . . As far as the breast the water pictures you, as you bend down over it from the rock; but if it pictured you full length, it would not have shown you as comely from the breast down; for reflections in the water are but on the surface, imperfect because stature is foreshortened in them."[84]

This pattern, whereby the image is presented to be viewed either as an isolated narrative in its own right or as an item within the broader interconnections of mythological subject matter, is repeated in the surviving floor mosaics. Those from the east—including four examples from Antioch on the Orontes (the main metropolis in Roman Syria) and one from Paphos in Cyprus—have a single square or oblong panel depicting the scene by the pool, set within a design of geometrical ornament which covers the rest of the floor

[84] Philostratus, *Imagines* 1.21.1 and 3. On the parallelism of this and the Narcissus ekphrasis, see Bann (1989), 108–9.

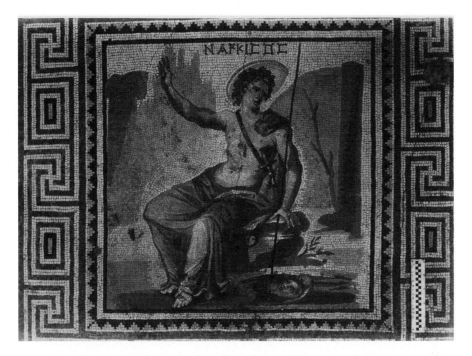

FIGURE 6.10. Floor mosaic of Narcissus from the triclinium of the House of Narcissus, Antioch in Syria. Second quarter of the second century A.D. Now in the Baltimore Museum of Art. (Photo: Antioch Expedition Archives, Research Photographs, Department of Art and Archaeology, Princeton University, no. 2987.)

(figure 6.10).[85] Of course we cannot know how this floor decoration married with any images painted on the walls of the rooms concerned. By contrast, the impressive octagonal medallion from Orbe in Switzerland figured as one of thirteen mythological or religious scenes set in an elaborate floor (figure 6.11). Other subjects depicted include Ganymede, Venus, Mercury, Mars, Saturn, Jupiter, and various sea deities.[86] Moreover, the formal type used to depict Narcissus in the Pompeian images (as a youth slouching diagonally and holding a spear) is one which appears in other mythological subjects—for example, to render Ganymede, Cyparissus, or Endymion.[87] Again, this subject might spark the viewer to relate Narcissus to visually parallel images, even if nothing in their subject matter immediately suggested this.

[85] The Antioch mosaics are illustrated and discussed by Levi (1947), 60–66, pl. 10b (House of Narcissus); 89, pl. 14b (House of the Red Pavement); 136–37, pl. 23c (House of the Buffet Supper); 200–201, pl. 45a (House of Menander). The Paphos image, from the House of Dionysos, is discussed by Kondoleon (1995), 30–40, figs. 10–12.

[86] On the Orbe image, see von Gonzenbach (1961), 184–92 (especially 189–90), pl. 60–67.

[87] See the examples illustrated by Rizzo (1929), pl. 105a (Ganymede), pl. 107b (Cyparissus), pl. 125 (Endymion), with relevant detailed accounts in LIMC.

VIEWER AS IMAGE

FIGURE 6.11. Floor mosaic of Narcissus. Detail from the Mosaic of the Planetary Deities, Orbe, Switzerland. First quarter of the third century A.D. (Photo: Institute of Archaeology, Oxford.)

FIGURE 6.12. Fresco of Narcissus from triclinium 8 of the Temple of Isis at Pompeii (VIII.7.28). Third quarter of the first century A.D. Now in the Naples Museum (MN 9379). The current state of this image is very poor, and the identification of the subject as Narcissus rests on nineteenth-century versions like this. Were there to have been no head in the pool, the figure would have to be identified as Endymion. (Photo: From *Real Museo Borbonico*, vol. 12, tav. 7.)

Yet the focus on the viewing context is complicated. Is Narcissus alone, self-immersed in his own reflection (as in figure 6.12, for instance), or is he accompanied—alone, as it were, with Eros (figure 6.13), as Ariadne so often is, and with the reflected self whom Eros is seducing him into loving? The boy in the pool looks back at Narcissus and casts him within the same entrancing gaze as he himself directs to the water (Ovid, *Met.* 3.450–62; Philostratus, 1.23.3). Effectively this poses a crisis of visuality: Narcissus perishes in part

FIGURE 6.13. Stucco bas-relief of Narcissus by the pool with Eros, from the baths in a villa in Stabiae. Roughly 60 A.D. Now in the Antiquarium, Castellamare di Stabia. (Photo: DAI 71.494.)

because the sovereignty of subjecthood in looking out and controlling the world of the seen becomes inverted in a kind of paranoiac catastrophe in which the seen looks back at and controls as an object the viewer who looks out at it. Inevitably this subject has relevance for viewers looking at works of art—especially at works depicting the tragedy of Narcissus.

Interestingly this scenario, where the viewer finds himself watched (which has been called the "paranoid or terrorist coloration [. . . of] the Gaze" in association with "menace" and "persecution"), is at the center of Jacques Lacan's influential formulation of the psychological dynamics of the gaze.[88] In *The*

[88] The key text is Lacan (1977), 67–122. A useful discussion (comparing Lacan and Sartre with Oriental notions of the gaze) is Bryson (1988), especially 87–94, 104–8 (quotations at 107).

Four Fundamental Concepts of Psycho-Analysis, Lacan tells the story of the sardine can. As a young man he went sailing, and one day a fisherman, Petit-Jean, pointed out a sardine can floating in the water and glittering in the sun. The fisherman tells Lacan: "You see that can? Do you see it? Well it doesn't see you!" This appears to be an ironic joke, yet for Lacan, the affirmation that the can could not see him was deeply disquieting: "To begin with, if what Petit-Jean said to me, namely that the can did not see me, had any meaning, it was because, in a sense, it was looking at me, all the same. It was looking at me at the level of the point of light, the point at which everything that looks at me is situated."[89] Unlike the can in Petit-Jean's formulation, but very like Lacan's own fears, Narcissus' reflection *does* look back at its viewer out of the waters. Whether Lacan was deliberately alluding to the tale of Narcissus in setting his story (which he claims to be true) in the dangerous context of the reflective waters, its point about the destabilizing of the subject's sense of autonomy and of his reversal into an object under the gaze of an inanimate other is strikingly parallel to the dynamic of Narcissus at the pool.

But in looking at the paintings of Narcissus, the problem of viewing is more complex still. For how can we know that our observation of his tragedy is always preserved within the safety of voyeurism, within that inalienable line which demarcates the represented as utterly separate from its viewer? What if the viewer's presence, intruding on the peculiar privacy of Narcissus' self-obsession, raises the specter of a response from the painting, just as the pool responds to Narcissus in the myth—whereby we who watch may ourselves be observed by him? This is, in fact, precisely the problem suggested in Philostratus' account, which opens, "The pool paints Narcissus, and the painting represents both the pool and the whole story of Narcissus" (1.23.1). If the painting within the painting (the painted pool which is Narcissus' portrait) has the effects on Narcissus described in the story, then what guarantee have we that the image described by Philostratus (or the frescoes from Pompeii) will not have similarly entrancing effects on us? Unlike the reader of Lacan's sardine story, who is safely excluded from the potential gaze of the can because he or she is only reading about it, viewers of a painting of Narcissus are exposed both to the gaze of the reflection in the pool and to the possible gaze of the figure of Narcissus himself.

In figure 6.8, is Narcissus glancing up so as to see if we are watching him? Or are his upturned eyes simply dazed with the engrossing power of his own self-love? Another Pompeian Narcissus in the same pose, now preserved in the Naples Museum (no. 9388), does appear to gaze straight out at the viewer, challenging us with the thought that Narcissus (and his story) may be our

[89] See Lacan (1977), 95–96, with Bryson's commentary—Bryson (1988), 91.

own self-reflection, and turning our environment (in the context of the Roman house) into an extension of the mythical world of the pastoral, where metamorphic tragedies, like that of Narcissus, can take place (figure 6.14).[90] The context of some of the Pompeian paintings, in relation to water and reflections (for instance, figures 6.6 and 6.8) hardly makes it easier for the viewer. In effect, these paintings set up visually the pattern so consummately elaborated by Philostratus, where the subject matter of the work of art becomes a sign for the viewer's own relationship with the image he is looking at.

But the paintings take the challenge to the viewer further than this. They propose a triangulation of viewing which breaks out, beyond the engrossment of Narcissus in his own reflection, to the viewer outside the painting. If the painting reflects us, as the pool reflects Narcissus, then in what sense does it do this? Are we reflected in the painted pool? Or in the image of Narcissus? Or is our visual relationship with the painting mirrored in his relationship with the reflection in the pool? Is it our viewing or, perhaps more disturbingly, our desire which the paintings mirror? Is our relation with what we look at, what we think about, what we may engage in narrative fantasies about, always a version of narcissistic self-absorption, such as these images represent?

Philostratus, in particular, is aware of the problem of triangulation. He plunges into an imagined discussion with Narcissus about the image in the pool, as we have seen (1.23.3). By stepping so boldly over the boundary which separates viewer from image, Philostratus immediately casts the spectator within the net of Narcissian desire—and includes not only himself (the speaker who addresses Narcissus as "you") but also his readers (the "we" of the imagined dialogue between Philostratus and us). The result is that Narcissus is only self-absorbed in his reflection (whether in a text or in an image) *because* we are there to witness it. His tragic self-engrossment cannot be separated from its triangulation with our voyeuristic desire to observe his predicament, just as Lacan's story about the sardine can would have no point if there were no one to listen to it or read it.

Figure 6.8 adds a particular frisson to these issues, for the reflected face of Narcissus, upside down at the bottom-center of the visual field, seems to resemble not so much the slender youth as a Gorgon's head.[91] Since the Gorgon's head turned anyone who looked at it into stone, this is a particularly

[90] The painting is Naples, Museo Nazionale 9388, illustrated in Balensiefen (1990), taf. 34.2, and LIMC III.2 (1986), 534, Echo 9. If we believe La Volpe's drawing of the very damaged Casa dell' Orso Narcissus (PPM documentazione 721–22) as opposed to Ala's version (PPM documentazione 570–71)—both from 1865—then he too looked out at the viewer. See also PPM VI.727–64 and Ehrhardt (1988), 25–31, 72–73.

[91] Cf L. Richardson (2000), 147.

FIGURE 6.14. Fresco of Narcissus with Eros and Echo from the Casa dell' Argenteria, Pompeii (VI.7,20/22). Third quarter of the first century A.D. Now in Naples Museum (NM 9388). (Photo: Anger, DAI 89.84.)

appropriate characterization of the reflection which petrified Narcissus. But does its power extend outside the fresco to its nonpainted viewers? Certainly the suggestion of turning Narcissus to stone picks up a series of images in the texts—from Ovid's reference to the youth "motionless, like a statue carved from Parian marble" (*Met.* 3.418–19) to the motionlessness of Philostratus'

painted addressee to the marble statue described by Callistratus, which is so lifelike as to be almost real. Philostratus indeed deliberately uses the word *gorgon* of Narcissus' gaze (at 1.23.4), meaning "spirited" or "fierce" but effectively articulating the Gorgon's presence in the image.[92] In Dalí's painting of 1937, the Surrealist does in fact have his Narcissus turned into a vast stone hand (complete with ancient cracks) that holds an egg from which the narcissus flower emerges.

These consummate visual interrogations of viewing and voyeurism become more complex as more figures intrude into the scene. In the images where Narcissus is accompanied by Eros, both he and his reflection are themselves being observed by an other (6.2, 6.4, 6.5).[93] In the case of the stucco from Stabiae (figure 6.13),[94] where Eros holds a flaming torch (as in a number of painted examples such as figures 6.4 and 6.5), the iconography may well relate the representation back to Ovid's text. In Ovid there is not only much discussion of burning (ironic in the context of Narcissus' watery passion), but Echo is compared with the "quick-burning" sulphur smeared on a flaming torch (*Met.* 3.371–74).[95] Yet when Echo herself intrudes into Narcissus' seclusion by the pool, for example in an image from the Naples Museum (figure 6.15),[96] as she does toward the end of Ovid's account (*Met.* 3.494–510), the viewer's difficulties simply amass. Echo is Narcissus' double—repeating his every word, wasting away as he will, loving in vain as he does.[97] Cast in the visual form of one who watches him, she stands for the viewer who watches the image. She adds a dimension of female viewing which breaks across the insistent homosexuality of Narcissus' self-absorption, to incorporate the female spectator in the Roman house as well as the male. And yet her watching is—emphatically in Ovid's account—a version of Narcissus' own desire. Instead of being confronted with just the reflection and its hopeless spectator (Narcissus), the viewer of the painting is offered another hopeless spectator of the tragic event, whose every feeling (and every word) echoes Narcissus. Instead of just the reflection in the pool, the Echo and Narcissus paintings stage a hall of mirrors in which the viewer is challenged as the final reflection of the myth's narrative of endlessly hopeless visual desires.

The surviving Pompeian paintings in which Echo intrudes upon Narcissus' seclusion offer a range of potential voyeurisms through which the nymph may echo Narcissus. Echo may observe the self-absorption of her beloved

[92] I am grateful to Sandrine Dubel for pointing this out to me. See Platt (2002a), 92–94 and n. 28.

[93] In addition to the examples illustrated here, see those in Balensiefen (1990), taf. 26–27, 32–33.

[94] Further on this relief, see Mielsch (1975), 45–46, 129.

[95] See further Stirrup (1976), 100.

[96] On this image (Naples, Museo Nazionale 9380), see Michel (1982), 567–71.

[97] See especially Stirrup (1976), 97–103; Rosati (1983), 20–41; and Hardie (2002b), 165.

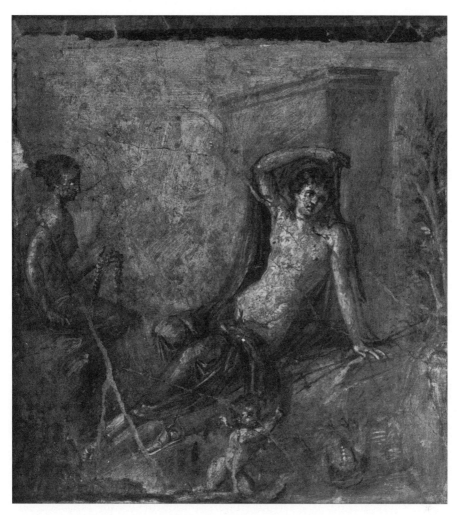

FIGURE 6.15. Fresco of Narcissus by the pool accompanied by Eros and Echo, from Pompeii (provenance unknown). Now in Naples, Museo Nazionale (9380). (Photo: Cremer, DAI 86.420.)

from a distance and to the side, as in Naples Museum 9380 (figure 6.15).[98] She may engage with the main action, as in Naples Museum 9388 (figure 6.14), where she pours water into the pool in which Narcissus' face is reflected and looks at him while he looks frontally out at the viewer with an Eros floating above his head. Here the painting stages a recession of gazes—Echo at Narcissus, Narcissus at us—that specifically incorporates the viewer in its vortex, not just by the analogy of an image representing the act of looking at an object but by a direct visual address. In two lost pictures known only from

[98] Cf. also the image from triclinium d of IX.2.10 with PPM VIII.1098 and PPM documentazione 408.

nineteenth-century watercolors and engravings from the Casa dei Dioscuri (VI.9.6/7), Narcissus appears accompanied by Echo and other figures.[99] In the painting from room 38, Narcissus is absorbed by his reflection in the pool with an Eros embracing his shoulder, perhaps asleep, while Echo looks at him from the right embraced by another Eros gesturing at Narcissus (figure 6.16). It is as if the Erotes externalize the dynamics of the narrative, with Narcissus turning to a self-absorbed slumber while Echo looks out with love at a love which she can never reach and which will not reciprocate. In the second painting (not illustrated here), from room 49, Narcissus looks down at a bowl into which a Cupid is pouring water. Above and to the left, Echo looks down at the Cupid—explicitly away from Narcissus (if we believe the surviving reproductions), while to the right another figure, a fully draped female (perhaps Aphrodite, perhaps Narcissus' mother, Leirope) looks away again, perhaps in despair at all these loves gone awry. Here none of the gazes focalizes on a major figure in the narrative, with the result that there seems a strongly disruptive effect of a series of gazes askance within the picture's visual field. On the north wall of cubiculum 12 of the Casa dell' Efebo, as one of three panel pictures beneath trompe l'oeil columnar niches on a yellow background, Narcissus and Echo appear together again (figure 6.17).[100] Here Narcissus sits on the left leaning to the right and looking down to the pool, in a familiar posture (see, for instance, figure 6.1). Echo stands on the right, looking down at him and leaning on a pillar to the left, her elbow all but touching his arm. The figures make a kind of triangle of Narcissus and Echo leaning in toward each other and the reflected head central below. The head in the pool, looking out frontally despite the three-quarter turn of both Narcissus and Echo, could in fact reflect either of them, since their faces are strikingly similar: only the viewer's importation of a narrative interpretation makes the reflection certainly that of Narcissus.[101] The arrangement makes them virtually a couple, despite their differently directed gazes, opposite Apollo and Daphne (another not wholly successful couple) on the south wall and with a rather damaged image of nude Venus—the divine figure responsible for these various amatory disasters—on the west wall opposite the door.

[99] See P. Zanker (1966), 156–58; PPM IV.896–97 (room 38) and 952–53 (room 49), PPM documentazione 166–67.

[100] See PPM I.658–65, especially 663. For a good photograph, see Franciscis et al. (1991), plate 17.

[101] Interestingly, this iconography is a variant of the relatively popular Pompeian scene of Perseus and Andromeda sitting together, even embracing, in a triangular composition over a pool in which the Gorgon's head (held aloft by Perseus over the couple) is reflected: see, for example, Balensiefen (1990), 54–56, and Roccos (1994) 344–45 and 347. In the case of Perseus and Andromeda, what identifies the embracing couple is the addition of the Gorgon's head; in the Casa dell' Efebo scene, what makes this image a Narcissus is the exclusion of the Gorgon coupled with the reflected head in the pool. But it is striking that the Gorgon theme again intrudes.

FIGURE 6.16. Narcissus and Echo, each accompanied by Eros. Nineteenth-century engraving of a now lost fresco from the Casa dei Dioscuri, Pompeii (VI.9.6.7). Third quarter of the first century A.D. (Photo: From *Real Museo Borbonico*, vol. 1, tav. 4.)

For both female and male viewer outside these pictures (as well as for Echo within the image—except perhaps for the example from the Casa dell' Efebo, figure 6.17), Narcissus is an inaccessible object of desire. He is incapable of reciprocating, because his love is always wrapped up in a mirror from which he has no escape. Yet the love for him, the attraction to looking at him, is itself bound up with a version of his own failure. To what extent is it the self-

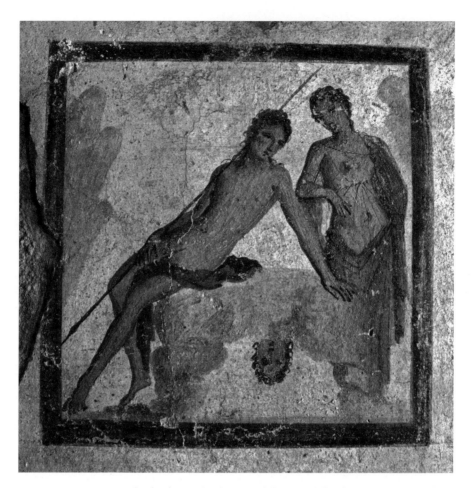

FIGURE 6.17. Narcissus and Echo from cubiculum 12 of the Casa dell' Efebo, Pompeii (I.7.10–12). Third quarter of the first century A.D. (Photo: Courtesy of Katherina Lorenz.)

absorption of Echo—her own set of purely self-generated fantasies—which cause her to imagine that she could ever get a response from Narcissus? To what extent is the fantasy of reciprocation in a lover not always a version of Narcissus' deranged obsession that the image in the pool is reaching out to touch him? And in the spectacle of the Roman house's range of mythical imagery (not to speak, more generally, of any viewer's relation with any work of art), to what extent is our expectation that a picture relates back to us, may speak to us, not in fact simply a version of Narcissistic delusion or of Echo's desire?[102]

[102] The exploration of this theme is, I believe, at the heart of Philostratus' enterprise in the *Imagines* as a whole; see Elsner (1995), 23–39.

We know that Roman public culture was highly ocular—given to a complex of voyeuristic, violent, and extravagant visual relationships.[103] In the domestic world, the context for all our images of Narcissus, this ocular culture was extended into the private sphere in several ways. First, the Roman house was itself open to a series of views and viewpoints cutting across sequences of rooms, which have been shown to form a remarkable architectonics for orchestrating the passage through the building, and which helped to define relationships between those who lived in the house and those who came to visit.[104] Second, mythological and other scenes painted onto the walls of the house as trompe-l'oeil panel paintings have a tendency to be dramatized both by being set in a highly theatrical staging (as in the case of figure 6.6 from the Casa dell' Ara Massima) and by including what have been called "supernumerary" figures who observe the main action, as does Echo in figures 6.15 and 6.16.[105] Effectively, both within the space of specific paintings and within the living space of the house itself which those paintings adorned, there was an intense visual awareness of events existing above all in the ocular dispensation of their being witnessed, of things happening always in a panopticon of spectatorship (both real and imagined).

Within this broad cultural context where the view was staged, made self-reflexive and self-conscious, both in the public and in the private domain, the subject of Narcissus had a particular bite. It challenged the culture in two ways. In one sense, Narcissus is the ultimate example of individual solipsism—someone who is always alone and enamored of himself, even in the company of others who love him or may at least wish to observe him. The challenge and ambivalence of the viewer's triangulation with Narcissus' reflection is that he may look back, but he may not: it is perhaps for the viewer's own fantasy to decide. Yet that aloneness is always within the presence of others—it is constituted by (or against) the intrusive or voyeuristic gaze not only of Echo and of Eros but also of viewers as they wander through the house and its gardens. At the same time, Narcissus challenges the myth of a public or shared world in which we may all participate. For he represents the extreme position that nothing can ever be seen beyond what the subject fantasizes, imposes on, or appropriates from the world he occupies. Despite the presence of Echo, of Eros, of other potential supernumerary figures, and of the Roman viewer in the house, Narcissus resolutely ignores all socialization, all the claims of reality on his attention, and plunges ever deeper into self-absorption.

[103] For a brief summary, with some bibliography, see Segal (1994), 257–58; also Coleman (1990) and C. Barton (1993).

[104] See, for instance, Drerup (1959), 155–59; Bek (1980), 181–203; Jung (1984); and Elsner (1995), 74–85.

[105] On these figures, see Klein (1912) and Michel (1982).

VIEWER AS IMAGE

Is this the fate of his spectators, whether they watch images of him, whether they watch each other, whether they watch theatrical reenactments of myths such as his in real theaters, where real convicts in mythological garb were made to die on stage?[106] Is this the ultimate tragedy of "Narcissism," as conceived by antiquity and handed down in so many recensions to the modern world?

[106] See Coleman (1990) on the latter.

VIEWING AND DECADENCE

Petronius' Picture Gallery

ROMAN SATIRE ARCHETYPALLY TAKES the faults of the present and performs them with a mixture of disgust and fascination, condemnation and envy.[1] The satirical poem as exemplified by Horace, Persius, and Juvenal, in the verse tradition of Ennius and Lucilius,[2] is not the only form of this peculiarly Roman take on contemporary culture. We find it equally in so-called Menippean satire of mixed prose and verse, whose surviving apogees are the *Apocolocyntosis* of Seneca and the *Satyrica* of Petronius, in a tradition reaching back to Varro.[3] A similar pose characterizes the iambic and epigrammatic tradition of Catullus, Horace's *epodes*, the pseudo-Virgilian *catalepton*, and Martial's epigrams.[4] All these media, in different ways, enable the obscene to be articulated in all the rich enjoyment of its extremity while at the same time framed by a distancing condemnation which cannot of course wholly spare either author or reader from a vicarious involvement in the decadent activities described.[5]

[1] It is striking that contemporary theorists of decadence turn to Rome instinctively for a historical ur-moment: for example, Gilman (1979), 36–56; Paglia (1990), 130–39; and Bernheimer (2002), 4.

[2] For example, Coffey (1989), 3–62, for the genre with good recent discussion by Freudenburg (2001).

[3] See Coffey (1989), 149–64, and especially Connors (1998), 1–19, on *Satyrica*.

[4] On the "great streak of mockery" that "runs through the mighty chain of Latin classics," see Henderson (1999).

[5] See especially Henderson (1999), 93–113, on fellatio in Horace *ep.* 8, and Rimell (2002), 200, on the "series of double-binds" that entangle the reader of the *Satyrica*. All this cannot be separated from the theatricality of the writing (and art) of this period in which writers, performers, and audience are all implicated—see Bartsch (1994), 10–12, 23–24; also C. Edwards (1993), 98–136, and (1994) for the normative Roman response to the theater (disapproval). For the development of Nero as a character in post-Neronian historical drama (that is, in the *Octavia*) in relation to the emperor's own stage appearances, see Flower (2002).

In this world, the most flamboyant moral speeches against degeneracy are issued from the mouths of those who most purely embody decadence—like Eumolpus in the *Satyricon* (83–84),[6] or Naevolus, Juvenal's male prostitute, in Satire 9.[7] Effectively, not only is decadence most perfectly embodied by those who most articulately condemn it, but the audience of that act of condemnation is implicated in the perversions performed before it through the voyeuristic act of listening, reading, or viewing. In the context of visuality, this is a world of spectacular voyeurism. Take, for instance, the Younger Seneca's tale of the debaucheries of Hostius Quadra, which forms the culmination of the first book of his *Natural Questions* (*Naturales Quaestiones* 1.16).[8] This gentleman's depth of perversion is defined less by what he does in bed than by the fact that "mirrors faced him on all sides in order that he might be a spectator of his own shame" (1.16.3). His decadence is a matter of voyeurism as much as of performance. The mirrors, moreover, are not ordinary mirrors but magnifying ones, so that his sexual gratification is not merely obscene in its own right but is distorted by a kind of instant visual anamorphosis to become even more excessive. His delight lies not only in the visual feast but especially in the delusion of the reflection—"he took pleasure in the misleading size of his partner's member as if it were really so big" (1.16.2). Quadra's voyeurism as a kind of essential signifier of decadence is inevitably transferred to the writer and to the reader, to whom Seneca retells these actions. That retelling at second hand (and hence, if we follow the Elder Seneca, still further degraded)[9] cannot be wholly free from a contagion of decadence that infests all these mirrored gazes, and it is not clear that Seneca's account has not enlarged all these activities rhetorically in a way that reflects Quadra's magnifying mirrors.

What is significant here for my purposes is that decadence inheres not just in the debauched act or, in the case of Hostius Quadra, numerous "unheard of—even unknown—acts" (1.16.4), but in the simultaneous fact of their being consumed through voyeurism by the actor at the moment of their production and of that voyeurism's being an aggrandizing distortion of the already obscene reality. The passage reverberates with a relentless insistence on the gaze,[10] but that gaze is associated in the speech Seneca writes for Quadra with

[6] See Courtney (2001), 135.

[7] See Braund (1988), 130–77; Henderson (1997), 96, and (1999), 199–200.

[8] For discussion, see Frontisi-Ducroux and Vernant (1997), 177–81; Leitao (1998), 135–36, 140–46; and Bartsch (2000), 82–86. On prodigal pleasures and decline, see C. Edwards (1993), 173–206.

[9] Seneca the Elder, *Controversiae* 1.praef.6: "An imitator never comes up to the level of his model. This is the way it is; the copy always falls short of the reality."

[10] 1.16.2 ("when he was offering himself to a man *he might see* in a mirror all the movements of his stallion behind him"); 1.16.3 ("he might be a *spectator* of his own shame"; "secret acts . . . he not

a decadent self-knowledge: "Let those acts be seen which the position of our bodies removes from sight, so that no one may think I do not know what I do" (1.16.7). And what Quadra knows is a self-consciously false knowledge, a crudely magnified version of his actual acts:

> To what purpose my depravity, if I sin only to the limit of nature? I will sur-
> round myself with mirrors, the type which render the size of objects incredi-
> ble. If it were possible, I would make those sizes real; because it is not possible,
> I will feast myself on the illusion. (1.16.8–9)

This discourse ties into a profound seam of Roman moral rhetoric in favor of the real and against debased imitations.[11] But here the reality of debauched sex (itself the extreme polemical target of moral rhetoric) is itself instanta- neously degraded into delusion by its initiator, whose main interest is to con- sume visually (which is to say, voyeuristically) the falsehood of his every anamorphosed gratification, even as the act is being performed.

Decadence in the ocular regime of Roman culture is inextricably linked to voyeurism—a chain of voyeurism that extends to the audience of the texts that seek to condemn it. The chain of voyeurism is encapsulated by Petronius' episode in Quartilla's brothel, where Giton's deflowering of the seven-year-old Pannychis is observed through a keyhole by Quartilla and Encolpius, cheek to cheek, while Petronius contrives that we, his readers, vicariously watch them through the keyhole of his prose.[12] This episode, early in the surviving text, is the mirror to a second scene of voyeurism at the end, where the antics of a threesome involving Eumolpus, his male slave Corax, and a young girl en- trusted to his tutelage are observed through the keyhole by the girl's brother and Encolpius. Voyeurism in this case proves the spur to Encolpius to make an attempt on the boy, but his customary impotence lets him down.[13] This pair of pornographic peep shows frames the *Cena Trimalchionis*, itself a supremely theatrical performance within Petronius' text in which the narrator and other

only presented to his mouth but to *his eyes*"); 1.16.4 ("he summoned *his eyes* to witness them"); "be- cause he could not *watch* so attentively when his head dipped in and clung to his partner's private parts, *he displayed his own doings to himself* through reflections"); 1.16.5 ("he used to *look at* that obscene lusting of the mouth"; "he used to *watch* men"; "he used to *watch* the unspeakable acts"; "he even *showed himself* monstrous coitions"); 1.16.6 ("the monster made a *spectacle* of his own obscen- ity"); 1.16.7 ("let *my eyes* too receive their share").

[11] See Elsner (1995), 51–58 (mainly on Vitruvius 7.5) and 85–86 (on Papirius Fabianus in the Elder Seneca *Contr.* 2.1.13).

[12] *Sat.* 25–26, with Sullivan (1968), 238–40; Panayotakis (1994a); Courtney (2001), 70–71; and Rimell (2002), 54.

[13] See *Sat.* 140, with Panayotakis (1994b), Courtney (2001), 208–9 and Rimell (2002), 171–75, for much more on the context.

guests are the audience for Trimalchio's self-display within the dining room, and we—the readers—are constructed as voyeurs of the whole event.[14]

Such voyeurism certainly remains a significant element in the later Roman novel, to judge at least by Apuleius' *Metamorphoses* or *The Golden Ass* (written in the second half of the second century A.D.), on which see the epilogue at greater length. In the key ekphrasis of 2.4, Lucius—the novel's hero who is shortly to be turned into a donkey—enters the atrium of Byrrhena's house in Hypata in Thessaly to be confronted by a statue group of Diana and Actaeon:[15]

> In the middle of the marble foliage, the image of Actaeon could be seen (*visitur*), both in stone and in the spring's reflection, leaning towards the goddess with an inquisitive gaze (*curioso optutu*), in the very act of changing into a stag and waiting for Diana to step into the bath. I was staring again and again (*identidem rimabundus*) at the statuary enjoying myself, when Byrrhena spoke. "Everything you see (*cuncta quae vides*)," she said, "belongs to you." (2.4–5)

The complex of visualities here has the already transforming Actaeon gazing curiously and voyeuristically at the goddess as she prepares to bathe, while Lucius—soon to be transformed himself as a result of his own curiosity about magic (and directly after watching the witch Pamphile through a keyhole as she strips naked and turns herself into an owl, 3.21)—is transfixed, gazing repeatedly at Actaeon's gaze. As Byrrhena ironically comments, everything he sees will indeed be his, since these statues are effectively predictive of the novel's unfolding plot. Interestingly, voyeurism becomes the mark of supreme decadence when Lucius the ass feels shame (*pudor*) at the prospect of being made to perform bestial sexual intercourse with a condemned criminal before a large paying public (10.23, 29 and 34). His resistance to this fate, to decadence itself, is what prompts his escape at 10.34–35, immediately before his vision of Isis and salvation in Book 11. In a still later (but highly classicizing) text, the extreme depravity of the empress Theodora, as polemicized in Procopius' *Secret History* 9.10–26, reaches its apogee not in all the degrading sexual acts at which she is so inventive but in the fact that she performs these in public in the theater. The interest in this kind of voyeurism, far from being limited to texts, appears frequently in the art of the period, from the Warren cup to Pompeian wall painting, as we have already seen in relation to the figures surrounding images of Narcissus and Ariadne.[16] The current view of

[14] On the theatricality of *Satyrica*, see, for example, Bartsch (1994), 197–99, and Rosati (1999).

[15] See, for example, Winkler (1985), 168–70; Slater (1998), 26–37; Merlier-Espenel (2001); and further below in the epilogue.

[16] On voyeur figures in Roman art, see Klein (1912), Michel (1982), J. R. Clarke (1997); also Platt (2002a), 87, 99–101. On sex, see especially J. R. Clarke (1998), 61–78, and Pollini (1999), 39.

Roman sexual imagery (whether with voyeurs depicted or just constructing its viewers as voyeurs) is that it was largely celebratory,[17] but given the loud disapproval of our texts, it may well be that this is a misguided idealization.

One interesting feature of the texts on contemporary depravity which simultaneously enjoy and disapprove, or rather parade the act disapproved of in affectionate detail before condemning it, is that so many cluster in Neronian and Flavian Rome.[18] I will focus here on a passage of Petronius where a Neronian writer (whose transgressive excesses are often seen as paradigmatic of his debauched historical context) not only explicitly discusses the "decadence of the age" (*desidia praesentis, Satyrica* 88.1) but dramatizes that decadence in the fictional characters he chooses as his discussants. In the *Satyrica* Petronius not only parades all the vices for which the Neronian era would later stand accused, but attacks them from an assumed high point of moral authority and at the same time frames that moral polemic against decline within the ironic assault of his own satire. Petronius builds both a highly self-aware picture of the susceptibility of Neronian culture to condemnation by the standards of Roman moral rhetorizing and a penetrating critique of the limits and contradictions of such condemnatory rhetoric.

As is appropriate to the voyeuristic Roman frame for decadence, the Petronian critique of *desidia* takes place in an art gallery and is constantly played off against the problems of ancient art criticism and imitation itself. The art gallery episode (83–90) serves to introduce the reader to Eumolpus, the *Satyrica's* disreputable poet. Its dynamics involve attempts by both Eumolpus and Encolpius to find satisfactory ways of viewing the images they see. Both fail—Encolpius because he reduces the paintings ultimately to being simply reflections of his own state of mind, and Eumolpus because he attempts too ambitiously to assimilate his own and his listeners' sense of identity into the imaginary world of the painting he views. Both attempts raise questions about the difficulties of viewing art and the nature of ekphrasis as a verbal celebration of viewing. I shall explore the episode by looking at each attempt in turn.

[17] See, for example, J. R. Clarke (1998), 275–79 (his conclusion) with repeated references to "fun and enjoyment" as opposed to "our Western prudery"; also Clarke (2002), where the images are celebrated as the nonelite's enjoyment while the texts are dismissed as elite and hence nonrepresentative, and Clarke (2003a), which asserts the need to emphasize "ancient *Roman* attitudes" (11) but concludes by insistently arguing for enjoyment in a "world where sexual pleasure and its representation stood for social and cultural values" (158) by (polemical) contrast with modern notions of pornography and prudery: cf. 159–62 with a good deal of explicitly modern investment (for example, "women's liberation" in ancient Rome, 39, 43–45, 161).

[18] For the systematic (and hardly coincidental) parallels in the literary denigrations of Nero and Domitian, see Charles (2002). On the use of decadence as a playful self-image in this period, see, for example, the essays in Elsner and Masters (1994), especially Gowers (1994); Rudich (1997); Schubert (1998), 15–253; Freudenburg (2001), 125–34; and Croisille and Perrin (2002), 143–228.

ENCOLPIUS

The section of the *Satyrica* with which we are concerned takes place after En-
colpius and his boyfriend, Giton, have left Trimalchio's feast.[19] Encolpius is
jilted by Giton, who has been seduced by Ascyltus. To console himself, our
hero visits a picture gallery (*pinacotheca*) hung with a wonderful (*mirabilis*)
collection of paintings.[20] Such galleries with remarkable paintings are, of course,
a rhetorical trope of ekphrasis. Whether the gallery described is fictional or
actual, it represents a necessary setting for a writer who wants to present
ekphraseis of a series of pictures. The most famous example of such a gallery
is that evoked by the Elder Philostratus as the setting for the paintings
(*pinakes*) he describes in his two books of *Imagines*.[21] Likewise in Lucian's
De Domo, an extensive ekphrasis in praise of an ideal house (*oikos*), the grand
finale is a series of descriptions of mythological paintings hanging in the
gallery.[22] Such galleries, particularly in Rome, containing pictures or sculp-
ture are frequently mentioned by the Elder Pliny (a contemporary of Petron-
ius) in books 35 and 36 of his *Natural History*.[23] Art galleries in ancient
Rome (indeed in most contexts and periods) were complex spaces, susceptible
to the paranoid visuality of one's looking at art being in itself looked at by
others, one's gaze being on display (as indeed is the case in the Petronian art
gallery, when Eumolpus observes Encolpius looking at a picture of the Trojan
horse).[24] Moreover, they were transgressive spaces where more than the
simple looking-at-art could take place, for example the act of seduction mas-
querading as cultural or pedagogic exchange (again a theme with which
Petronius flirts).[25]

[19] On Petronius and the *Satyrica* generally, see Sullivan (1968), Zeitlin (1971a), Slater (1990),
Panayotakis (1995), Conte (1996), McMahon (1998), Plaza (2000), Courtney (2001), and Rimell (2002).
On the *Satyrica* specifically as a parody of the ancient novel, see especially Heinze (1899) and Court-
ney (1962), 92–100.

[20] On the art gallery episode of the *Satyrica* as a parody of themes in the romances, see Walsh
(1970), 93–97; Slater (1987), 169; Conte (1996), 18–20; and Courtney (2001), 134.

[21] This description has sufficiently convinced art historians that many regard the gallery as having
existed, see especially Lehmann-Hartleben (1941), with the discussion of Bryson (1994). Further on
some of those pictures, see chapters 1, 4, and 6.

[22] On *De Domo*, see E. Thomas (1994), 162–82; Maffei (1994), xxxviii–xl; Boeder (1996), 117–37;
Goldhill (2001b), 160–67; and Newby (2002b).

[23] See Gualandi (1982); Rouveret (1987); Isager (1991), 157–59; and Carey (2003), 79–84.

[24] Generally on Roman displays, see Strong (1973). On the issue of gazes in the domestic context
of the house, see Platt (2002a).

[25] On monuments as a context for seduction, see Ovid, *Amores* 2.2.3–4 and *Ars Amatoria* 1.49–50
and 67–88, 1.491–504, 3.387–98, with C. Edwards (1996), 23–25, and Boyle (2003), 176–77, 178–79.
For museums as ritual structures whose narratives are constantly susceptible to "misreading" or in-
terpretation against the grain of the dominant narrative, see, for example, Duncan (1995), 13, and
Gaskell (2003).

By any standards, Encolpius' gallery is outstanding in its collection of famous names:

> I saw the works of Zeuxis still unaffected by the ravages of time. And I examined, not without a certain thrill, some sketches by Protogenes (*rudimenta*), so life-like they were a challenge to nature herself. I practically worshipped the masterpiece of Apelles that the Greeks call the Goddess on One Knee. The lines of the paintings were so subtle and clear-cut that you could see them as expressing the subjects' very souls. (83.1–2)

Here Encolpius betrays the taste of his time. His list of artists represents the highlights from any educated Roman's catalog of the great and the good. In Pliny's *Natural History*, Zeuxis "gave to the painter's brush . . . the full glory to which it aspired" (35.61); Apelles "excelled all painters who came before or after him" (35.79); Protogenes was Apelles' "equal or superior in everything" except in knowing when to finish working on a painting (35.80). Likewise the orator Quintilian informs us that "[Zeuxis] seems to have discovered the method of representing light and shade. . . . For Zeuxis emphasised the limbs of the human body, thinking thereby to add dignity and grandeur to his style. . . . Protogenes was renowned for accuracy. . . . Apelles for genius and grace, in the latter of which qualities he took especial pride" (*Institutio oratoria* 12.10.3–6). Even Encolpius' *reasons* for liking the paintings are matched by Pliny: the perfect emulation of nature is indeed the Plinian criterion for artistic excellence, and in Pliny too such naturalism does not exclude insights into the sitter's "soul." Apelles' portraits were such perfect likenesses that a physiognomist could tell from the paintings alone how long the sitter had lived or had to live (*Natural History* 35.88).

Our worry as readers about Encolpius' being such a perfect exemplar of the taste of his time is that he exists in a literary genre which aspires not to realistic likeness but to satiric distortion. If ekphrasis is a mode for introducing the romantic novel in antiquity,[26] in Petronius' novel the art gallery as a setting for ekphrasis is itself framed by the transgressive expectations of satire. We should be alerted to the possibility that all may not be as it seems by the way the famous works in the Petronian gallery are (rather terrible) puns on their artists' names. The *rudimenta* of Protogenes are not only "rough sketches" but a literal Latin translation of his Greek name (an unexpected "rivaling of the truth of nature"). The painting of Apelles which Encolpius adores may well be by Apelles only because they call it so (*apellant*, a dreadful

[26] On the device of the introductory painting, see especially Schissel von Fleschenberg (1913) and Bartsch (1989), 40–79 (principally on Achilles Tatius and Heliodorus' *Aethiopica*) . On Longus, see Hunter (1983), 38–51, and Zeitlin (1990) on the prologue.

joke). Indeed in this case even the image's name (*monoknemon*, "one-kneed") may be a reflection of Encolpius' own act of adoring it (if *adoravi* implies sinking to one knee).[27] In the light of all this, the text describing the products of Zeuxis (whose name in Greek means literally "yoking" or "putting together") as *nondum . . . victas* (not yet conquered) seems weak. Perhaps it should be emended to *nondum . . . vinctas* ("not yet bound together") or *nondum . . . iunctas* ("not yet yoked") to sharpen the pun.[28]

Sure enough, it is little surprise when Encolpius' Plinian assumptions are instantly colored by and subverted in the paintings he describes:

> In one the eagle [Jupiter], way up on high, was carrying off the Idaean youth [Ganymede], and in another a dazzling white Hylas repulsed the lascivious Naiad. Apollo cursed his murderous hands and decorated his unstrung lyre with a new flower [a hyacinth, sprung from the blood of his dead lover]. Surrounded by these faces of painted lovers, I cried out as if in a desert, "So love affects the gods too.[29] Jupiter can't find anything to love in heaven, but at least when going to sin on earth [with Ganymede] he injured no one.[30] The nymph that snatched Hylas away would have controlled her passion if she had thought that Hercules [Hylas' lover] would come to restrain her. Apollo called back the boy's soul into a flower—all of them enjoyed embraces free from rivalry. But I took to my heart a crueller friend than Lycurgus . . ." (83.2–3)

What Encolpius actually sees in the gallery is what his immediate personal circumstances have conditioned him to see—homosexual love and its distress. Jupiter fails to find satisfaction in heaven, Hercules loses Hylas to the seduction of a nymph, and Apollo loses Hyacinthus through a mistaken throw of the discus. These painted versions of love's misfortunes are idealized by contrast with Encolpius' own sufferings: "they all enjoyed embraces free from rivalry; but I . . ." The praised psychological penetration of naturalism and the exalted adherence of art to an external and objective criterion (namely "the truth of nature," *naturae veritas*, 83.1), which a straightforward reading of Encolpius' version of the Plinian account appeared to offer, turns out to be a bathetic subjectivism in which the viewer sees only himself reflected in the

[27] My thanks to J. Henderson, N. Hopkinson, and M. Reeve for their interest in these awful puns.

[28] I am grateful to Neil Hopkinson for proposing *vinctas* for *victas* and to John Henderson for suggesting *iunctas*.

[29] *Ergo amor etiam deos tangit*, a parody of Virgil's *et mentem mortalia tangunt* (*Aeneid* 1.462) also from an ekphrastic passage as we saw in chapter 4, which will be evoked again later in Eumolpus' poem the *Troiae Halosis*, on which see below. On the many relations of the gallery episode to Virgil, see Zeitlin (1971b) and Connors (1998), 84–99.

[30] Not quite the story given by the Homeric Hymn to Aphrodite 202–17. On the theme of Ganymede, with a number of parallel "transumptions" of homoeroticism as art and art as homoeroticism in humanist writing and painting, see Barkan (1991), 48–74.

paintings he views.[31] From the ekphraseis of Encolpius, despite the high claims about art's rendering the sitter's very soul, we learn nothing more than Encolpius's own subjective misery in being jilted by Giton.[32]

At the very least, Encolpius is being highly *selective* about the paintings on which he fastens. These mythological evocations of love's distress are presumably not the naturalistic masterpieces of Zeuxis, Protogenes, and Apelles which Encolpius just praised for their rivalry of nature rather than for their seductive subject matter. Later we will find a picture of the fall of Troy (89.1) in the same gallery. What Encolpius selects, appropriately for a jilted lover in an ancient novel, are erotic images which mirror his own plight. This erotic pattern whereby art imitates or prefigures the viewer's experience is a classic use of the figure of ekphrasis in the novels. In addition to the *Satyrica*, we find this romance pattern of the lover as viewer of erotic art in *Daphnis and Chloe* and in Achilles Tatius' *Adventures of Leucippe and Clitophon*.[33] In the novels, however, it is heterosexual lovers who are confronted with images of heterosexual love—for instance (in *Leucippe and Clitophon*) paintings of Europa and the bull (1.1–2) and Perseus with Andromeda (3.6–7).[34] The *Satyrica* reverses, satirizes, and parodies the whole structure of erotic attachment which comes from romance by its constant theme of homoerotic rather than heterosexual love.[35]

To be sure, erotic paintings with homosexual themes did exist in the Roman world;[36] and Petronius is using these paintings as a paradigm for the viewer's plight. This use is consonant with the erotics of ancient ekphrasis. But it is also entirely in keeping with a nonerotic, what one might broadly call "philosophical" usage of ekphrasis, in other first-century A.D. writers like Cebes. In the *Tabula* of Cebes, a philosophic allegory of a picture drawing on

[31] For an earlier *reductio ad absurdum* of naturalism, compare Trimalchio's comments at 52.1: "Myself, I have a great passion for silver. I own about a hundred four-gallon cups engraved with Cassandra killing her sons [Trimalchio has of course confused Cassandra with Medea], and the boys lying there dead—but you would think they were alive!"

[32] On Encolpius' reactions to the paintings, see especially Slater (1990), 220–30; Conte (1996), 14–15, 184; Connors (1998), 84–85; and Rimell (2002), 62–63.

[33] *Daphnis and Chloe* proem 1–2, with the discussions of Zeitlin (1990), 430–36 on "art and eros," and Hunter (1983), 38–51; Achilles Tatius 1.1–2, 3.6–7, 5.3, with Bartsch (1989), 40–79, and Morales (1996b)—see also chapter 1 above.

[34] However, on the theme of homosexuality in the novels, see Effe (1987).

[35] Cf. Heinze (1899).

[36] See, for example, J. R. Clarke (1998), 59–90, for sexually explicit material. For imagery on the themes that Encolpius looks at, see Sichtermann (1988); Villard and Villard (1990); and Oakley (1990). Note that in these cases the homoerotics inhere less in the imagery depicted than in the broader remit of the mythological narrative illustrated—so that Hylas, for instance, is a subject of heterosexual rape (by female nymphs of a male youth) where the homosexual theme inheres in knowing of the relationship between Hylas and Hercules, which is generally not referred to in these pictures.

eclectic sources and purporting to offer salvation both to the viewers of the image and to the readers of the text,[37] the viewers' initial *aporia* before the subject matter of a picture is presented as a reflection of their *aporia* before the problem of life itself (from which a correct understanding of the image is going to save them).[38] While, on an erotic reading, Encolpius' response to the paintings is a normal self-reflexive vision of his own personal dilemmas, on a "philosophic" reading his is a highly selective reaction indicative of *aporia*, confusion, and the need for salvation. As usual in the *Satyrica*, Petronius marshals a literary cliché (with different uses in different discourses within the culture), in this case the ekphrastic context of an art gallery, and will employ all its contradictory suggestive associations to devastating satiric effect.

Moreover, the indulgent subjectivism of Encolpius attacks a deep philosophical objectivism which underlies the very practice not only of ekphrasis (at any rate, in the Roman period) but also of rhetorical theory itself. In Stoic philosophy, by contrast with earlier Platonic theory, truth itself (and not merely a relativistic impression) could be derived from sense perception. For the Stoics, external objects imprinted themselves upon the mind by means of *phantasia*, or "presentation."[39] The mind was conceived as being like a wax tablet upon which an impression of an external object was, in Cicero's words, "stamped and reproduced and impressed."[40] In ancient literary and aesthetic theory, the concept of *phantasia* was seized upon, by extension from this Stoic doctrine, to define the "visualization" in the artist's mind, which gives rise to his creative act of producing plastic art or writing a speech.[41] This is how "Longinus" and Quintilian describe *phantasia* in oratory in the first century A.D.,[42] and how Cicero in the preceding century presents its opera-

[37] On the *Tabula*, see Praechter (1885); Joly (1968); J. T. Fitzgerald and White (1983); and Trapp (1997).

[38] For a discussion of this issue, see Elsner (1995), 40–46.

[39] On *phantasia* as the criterion for truth in Stoic thought, see Diogenes Laertius, *Lives of Eminent Philosophers* 7.49 on the Stoic Zeno, with Rist (1969), 133–55; Annas (1980); Taylor (1980); and G. Watson (1988), 38–58. On earlier Greek views of *phantasia*, see G. Watson (1988), 1–37; A. Silverman (1991); and Schofield (1978).

[40] Cicero, *Lucullus* 77, with Ioppolo (1990), 433–41; also Long (1974), 121–31; Imbert (1980); and Pollitt (1974), 52–55, 61–63, 293–97.

[41] On "the transformation of *phantasia*," see especially G. Watson (1988), 59–95; also Goldhill (2001b), 168–70, 175–79; and Platt (2006), 247–53.

[42] Longinus, *De Sublimitate* 15.1: "Another thing which is very productive of grandeur, magnificence and urgency, my young friend, is visualization (*phantasia*). I use this word for what some people call image production. The term *phantasia* is used generally for any thing which in any way suggests a thought productive of speech; but the word has also come into fashion for the situation in which enthusiasm and emotion make the speaker *see* what he is saying and bring it *visually* before his audience."

Quintilian, *Inst. Or.* 6.2.29: "There are certain experiences which the Greeks call *phantasiai* and the Romans *visiones*, whereby things absent are presented to our imagination with such extreme vividness that they seem actually to be before our very eyes."

tion on the mind of the sculptor Phidias.[43] The creative act of the artist and the speech of the orator, including ekphrasis itself, were seen as rooted in a vision, a *phantasia*, which was itself objectively tied to truth according to Stoic theory. As "Longinus" tells us, *phantasia* means "the situation in which enthusiasm and emotion make the speaker *see* what he is saying and bring it *visually* before his audience" (15.1). What the listener "sees" in ekphrasis is the vision which the orator himself "sees," the vision communicated to him by the work of art. Despite the fact that this vision was subjective (it appeared only in the *mind* of speaker, listener, and artist), it was nevertheless objective in that it bore the stamp of truth: it was (in each case) the same vision.

In other words, the key concept around which Roman ideas of artistic creativity, rhetorical theory, ekphrasis, and even truth itself all intersected was *phantasia*. The word trips to Quintilian's pen not only in contexts explicitly dedicated to rhetoric (for example, 6.2.29 and 10.7.15) but also in those related to the plastic arts (for example, 12.10.6). In setting Encolpius up in an art gallery, in referring to the theme of truth (*naturae veritas*), and in causing Encolpius to deliver an ekphrasis about his own hapless situation as a jilted lover, Petronius is alluding to—among other cultural tropes—the theory of *phantasia*. Although the theory of *phantasia* is not strictly necessary to the text's jokes, it is a target that Petronius implicitly subverts in the subjectivism of Encolpius' response to the paintings. Whatever visions of surpassing beauty Zeuxis, Protogenes, and Apelles may have seen to inspire their creativity (visions which according to Stoic theory their masterly art should inspire in the mind of the beholder), what Encolpius actually sees is not the objective vision of a higher *phantasia*, but the sordid reflection of his own disastrous love

Quintilian, *Inst. Or.* 10.7.15: "Those vivid conceptions of which I spoke and which, as I remarked, are called *phantasiai*, . . . must be kept clearly before our eyes and admitted into our hearts: for it is feeling and force of imagination that makes us eloquent."

Not only do these passages emphasize the creative importance of *phantasia* in inspiring the orator's eloquence, but that of Longinus also hints at a *shift* in meaning of the word in precisely the century when Petronius too was writing. The implication is that once *phantasia* moved from being a precise term in Stoic epistemology, it gradually became a concept for creative imagination, generally applicable to a large number of creative activities.

[43] Cicero, *Orator* 2.9: "Surely the great sculptor [Phidias], while making the image of Jupiter or Minerva, did not look at any person he was using as a model, but in his own mind there dwelt a surpassing vision of beauty; at this he gazed and all intent on this he guided his artist's hand to produce the likeness of the god. Accordingly . . . there is something perfect and surpassing in the case of sculpture and painting—an intellectual ideal by reference to which the artist represents those objects which do not themselves appear to the eye." Cf. The Elder Seneca, *Contr.* 8.2 and 10.5.8; Quintilian, *Inst. Or.* 12.10.9; Dio Chrysostom, *The Olympic Discourse* (*Oratio* 12) 70–71; Philostratus, *Vit. Apoll.* 6.13; and Plotinus, *Enneads* 5.8.1. On the theme of *phantasia* and the artist, see Pollitt (1974), 52–55, 203–5; Zeitlin (2001), 220–24.

life.[44] While the erotic and "philosophic" frames of ekphrasis allow the painting to prefigure (and in Encolpius' case to reflect) its spectator's personal situation, Petronius here uses the device to undercut the more high-falluting claims of *phantasia* that it communicates the artist's higher vision to the viewer.

EUMOLPUS

It is at this point that Eumolpus, described as a "white-haired old man," enters the art gallery:[45] "His face was troubled, but there seemed to be the promise of some great thing about him; though he was shabby in appearance, so that it was quite plain by this characteristic that he was a man of letters, of the kind that rich men hate" (83.7). Eumolpus (whose name means roughly "Good Singer") shares his name with the famous Eleusinian priest Eumolpus, the eponymous ancestor of the Eumolpid clan of priests, who appears to have enunciated the sacred words and in some myths even to have founded the rites of the Eleusinian mysteries.[46] Petronius' Eumolpus, whom we initially meet anonymously (like the other exegetes of art in the novels, in Lucian, and in the *Tabula* of Cebes),[47] is as much a philosopher, salvation-promising exegete, and interpreter of art as he is a poet. What he has to offer Encolpius is a solution to his immediate problem of "striving with the empty air" (*cum ventis litigo*, 83.7) in attempting to understand the paintings. Eumolpus presents his credentials not only as a poet but also as a moralist and pedagogue. Although the story he tells to support these credentials (the Pergamene boy) ruthlessly satirizes and undermines all his claims to being an ethically minded educator of the young, Encolpius immediately accepts him as an expert on art (88.1)—a role to which Eumolpus responds not only with some potted philosophy and art history but also with his grand ekphrasis, the *Troiae Halosis* (88–89). In using this frame for his introduction of Eumolpus, Petronius plunges us here directly into one of the dominant tropes of ancient ekphrasis. Eumolpus' entry is immediately presaged by the words "I strove thus with the empty air" (*cum ventis litigo*). On an erotic reading, Encolpius

[44] Contra Slater (1990), 228–30, who suggests that Petronius may have held the Stoic doctrine of *phantasia*, or at least used it to attack simple views of mimesis. While I agree that mimesis is being "systematically satirized," I suggest that Stoic doctrines are no less immune from satiric undermining. In general, Petronius is as happy to take up a Platonic position for satiric purposes, such as attacking the Stoics, as he is to adopt any other position—including ones which attack Platonic views. On the Stoicism present in Petronius' rhetoric, see Barnes (1973).

[45] On Eumolpus, see particularly P. G. Walsh (1968); Zeitlin (1971b); Beck (1979); and Connors (1998), 62–86.

[46] On the Eleusinian Eumolpus, see N. J. Richardson (1974), 197–98.

[47] Cf. Conte (1996), 18–19, and Courtney (2001), 139.

is here telling his troubles to the winds, troubles represented on the paintings and evoked by them. On such a reading, like the interpreter of the painting sought out in the prologue to *Daphnis and Chloe* (2: *exegeten tes eikonos*), Eumolpus appears as a kind of savior who will rescue the lovelorn Encolpius with some advice from an old hand. On a more directly art historical reading, the viewer has a try at understanding the picture and fails—"I strove thus with the empty air," as Encolpius says. Then a wise man appears who explains the real meaning of the image in the form of an ekphrasis. This pattern appears in the *Tabula* of Cebes (probably roughly contemporary with Petronius, where the interpreter is also an old man, 1.3), in Lucian's *Hercules* (4) and *Amores* (8 and 15), in Callistratus' *Descriptions* (6.4), and in a Christian context in Prudentius, *Peristephanon* 9. It is also the pattern of which the Elder Philostratus, as a sophist describing pictures to a group of young men, takes advantage in the *Imagines* (1 proem 4).[48] The interpreter's description is thus much more than simply an account of the painting he describes—it is also an interpretation. In the case of some texts like the *Tabula* of Cebes it is even a mystical initiation, and certainly it is always an enlightenment. When ekphrasis appears in an erotic context, the speaker (usually an older man) is one who offers to satisfy the viewer's desire, or to train the viewer in the interpretative skills whereby he may satisfy his own desire. The power dynamics of such descriptions bring the allure of satisfaction; and the speaker acquires the potent authority of problem solver and wise man.[49]

In the case of Eumolpus, this trope works to set up and satirize claims to philosophical, moral, and even religious initiation (presented in the *Tabula* of Cebes explicitly in terms of salvation, *Tabula* 3.3–4). In the *Satyrica*, the *pinacotheca* (83.1) is set in a *templum* (90.1), like the sacred settings of the pictures in the *Tabula* (1.1), Achilles Tatius (1.2), and Longus (proem). Like the old man in the *Tabula*,[50] Eumolpus indulges in a good deal of eclectic philosophy. Like Philostratus in the *Imagines* (1 proem 4) and the old man in the *Tabula* (32), who both offer education through exegesis, Eumolpus' tale of the Pergamene boy (85–86) is explicitly the biography of a pedagogue (albeit a pedagogue in satire). In effect, Eumolpus is the *Satyrica*'s satiric version of the philosophical and mystical exegete (so often in ancient literature presented as the exegete of art). He is *vates* not only in the poetic sense but in the prophetic sense as well. He is also, like the rhetorician Agamemnon from an earlier part of the *Satyrica*, a "corrupt" scholar.

[48] On this context for Eumolpus, see the brief accounts of Schissel von Fleschenberg (1913), 103–5, and Courtney (1962), 97. On Prudentius, see Kässer (2002).

[49] For more on the pedagogic/pederastic dynamics of this situation, see Elsner (2004).

[50] See J. T. Fitzgerald and White (1983), 20–27, and Trapp (1997), 168–71, for the eclectic philosophizing presented there.

In the context of all the literary genres with which Petronius is playing here, Eumolpus indeed offers "the promise of something great." He is a poet (which explains his poverty—"the worship of genius never made a man rich"). Moreover he begins his display of credentials to Encolpius with a true philosopher's parade of morality: "If a man dislikes all vices, and begins to tread a straight path in life, he is hated first of all because his character is superior; for who is able to like what differs from himself?" (84.1). Like the exegete in the *Tabula* of Cebes, Eumolpus (admittedly with a transparent vanity possible only in satire) presents the stakes involved in an association with himself as being of the highest moral import. His shabby appearance becomes proof of his persecution by the idle rich—for "poverty is the twin sister of good sense."

After this thoroughly (indeed overly) worthy introduction, Eumolpus treats his listener to an account of how he came to be where he is today. But this is an outrageous story by any standards. The philosopher-poet and moralist proves his credentials to teaching authority (at least to the exegesis of paintings) by describing how he presented himself as "a philosopher above the sensual pleasures of the world" to the parents of a pretty boy he fancied (85.1–3).[51] The parents, as deluded by his claims as Encolpius is to be,[52] find him convincing: "Soon I began to escort the boy to the gymnasium, to arrange his studies, to be his teacher, and to warn his parents to admit no corrupter into the house." The bulk of the narrative describes in vivid (some have said frankly pornographic) detail his seduction of the boy through gifts of doves, fighting cocks, and the promise of a thoroughbred horse, which (like most of Eumolpus' promises) he fails to fulfill (85.1–87.10). Finally, in an elegant reversal, the boy is so keen on the sexual pleasures Eumolpus supplies that the old pedagogue has to threaten him with betrayal to his father in order to snatch any sleep at night.

The tale of the Pergamene boy undermines the erotic pattern with a presentation of the sophos as homosexual adventurer. While we might have expected the wise man to put Encolpius straight (as it were) on matters of love, we find him only outdoing Encolpius in the skills of gay seduction. But the story also undermines any credentials Eumolpus might have claimed as an interpreter of art, since his expertise is spectacularly irrelevant to describing pictures, although it demonstrates formidable abilities in the arts of deception.[53]

[51] On the tale of the Pergamene boy, see Slater (1990), 92–95; McGlathery (1998), 209–17; and Courtney (2001), 136–39.

[52] Indeed, Eumolpus will later try to seduce Giton from Encolpius, just as he seduced the Pergamene boy (92–100).

[53] Contrast for instance the Elder Philostratus, whose self-accreditations include four years of study with the painter and writer Aristodemus of Caria (*Imagines* 1.proem.3), and the Younger Philostratus, who explicitly writes in the tradition of his uncle (*Imagines* proem.1–2).

Encolpius' response to this extraordinary speech of self-accreditation is a prize moment of high comedy: "Encouraged by his conversation, I began to draw on his knowledge about the age of the pictures and about some of the stories which puzzled me" (88.1). How Encolpius imagines that this kind of encouragement will teach him anything about paintings is left to the reader to work out. Petronius is explicitly satirizing the erotics of ekphrasis (both in its association with literature like the erotic novels and in its evocation of desire for further knowledge or satisfaction in the viewer). The desire of Encolpius to understand art is in Petronius a sublimation of his desire to learn more about the techniques of homosexual seduction from a self-proclaimed expert. Eumolpus' speech of accreditation, while admittedly couched in terms of a career as a pedagogue, is entirely directed at appealing to Enclopius' desire for a very different kind of education from what one would more usually expect in art and the art historian.[54]

In effect, what guarantees Eumolpus' authority as interpreter to Encolpius is the theme of homosexual seduction which obsesses Encolpius throughout the plot of the *Satyrica* and determines his own reading of the pictures. But, while this may do for Encolpius, it undermines Eumolpus in the eyes of the reader—for the exegete is seen to be no better than his audience (on the very moral high ground which he claimed).[55] The wisdom of this wise man lies in his greater cynicism by contrast with Encolpius and in his truly outstanding talent for lies and dissimulation. And yet ironically, this talent for deception is indeed a quality specifically suited to understanding the deceptive modes of the naturalistic art which is displayed in the gallery. Earlier in the *Satyrica*, it is the deceptivity of realism which is explicitly highlighted when Encolpius falls over at the terrifying sight of Trimalchio's painted dog (29.1).[56] Likewise deception is one of the key themes of naturalism in Pliny's famous anecdotes of the artistic duel between Zeuxis and Parrhasius (35.65–66) or his story of the horse painted by Apelles which caused other horses to neigh (35.95).[57] Like naturalistic paintings themselves, Eumolpus not only lies extravagantly (in appearing to be what he is not) but positively rejoices in parading his

[54] Cf. Zeitlin (1971b), 61: "The Milesian tale of the Pergamene boy . . . provides a relevant contrast to Encolpius in that it takes up the story of a successful and clever seduction of a young boy."

[55] Cf. Slater (1990), 95: "The message thus far is clear: Eumolpus is just as much of an intellectual fraud as Encolpius."

[56] For a discussion of "Realism in Petronius," see F. M. Jones (1991), especially 110–12 on "visualism," 112–14 on *decorum* and its inversions, and 118–19 on the disruptions of verisimilitude. For the problems of realism and symbolism in the *Satyrica*, in connection with an account of the paintings of Trimalchio's life (29.3–6), see Bodel (1993). For Trimalchio's dog, see Veyne (1963); Slater (1987), 167, 169–70; Plaza (2000), 95–97; Courtney (2001), 75–76; and Hales (2003), 142–43.

[57] On Zeuxis and Parrhasius, see Bann (1989), 27–40; Bryson (1990), 30–32; Elsner (1995), 15–17, 89–90; Morales (1996a), 184–88; and Carey (2003), 109–11. See further chapter 5 above.

deceptions and strategies for dissimulation as transparently as possible. At stake here is the whole claim of ekphrasis to be providing any kind of greater insight into art. What the old man of Cebes' *Tabula*, Philostratus in the *Imagines*, and the numerous other exegetes of art in the ancient literature of ekphrasis have in common is their offer of having something more, something better, "something great," as Petronius puts it, with which to enlighten their listeners. This offer is usually couched in moral or philosophical terms. Eumolpus' authority, by contrast, lies in his ability to corrupt the young while pretending to educate them. But such duplicity is entirely appropriate to the nature of illusionistic art, and such corruption is of course precisely the function of mimesis in Platonic theory. So Eumolpus the exegete is simultaneously undermined as being merely a duplicitous pederast and yet upheld as a perfect living exemplar of the deceptive nature of the kinds of images he is being asked to interpret.

Hence there is a fine irony about Encolpius' desire not only to learn about the pictures but "to discuss the decadence of the age (*causam desidiae praesentis*), since the fine arts had died, not least painting which had vanished without the slightest trace" (88.1). Since the theme of the present decadence of the arts was a cliché in Roman art historical writing (cf. *Satyrica* 2.9; Vitruvius, *De architectura* 7.5; Pliny, *Natural History* 35.2 and 28), Petronius is again subverting and satirizing the pretensions of contemporary aesthetics. More forcefully still, he is also exploiting the jargon and tropes of art history to make from them a pervasive moral metaphor for the decline of the age. This metaphor of decline—embodied in the figures of Eumolpus and Encolpius in the picture gallery, sublimating their sexual fantasies in talk about art and its decadence—is itself subject to the ironizing context of satire. Not only do these Petronian heroes represent the sad reduction of the appreciation of the fine arts to the level of what Eumolpus later describes as "wine and whores" (88.6), but also, paradoxically, the figure of Eumolpus as dissimulator is the perfect paradigm of the deceptive art he attempts to explain. Of course, in a Platonic discourse—which is one of the philosophical tropes Petronius at the same time upholds and attacks—mimesis and all the arts which embody it are themselves decadent. Ekphrasis is an ideal means for presenting this theme of decadence because of its traditional associations with mimetic images, its inevitable implication with pedagogy of a salvific and moralistic sort (above all in the frequently read *Tabula* of Cebes, to which several ancient writers including Lucian refer),[58] and its deeper roots in Stoic epistemology. But the genius of Petronius here is that a text which satirizes and yet embodies decadence in the figures of Eumolpus and Encolpius, which ruthlessly

[58] See J. T. Fitzgerald and White (1983), 7–8.

attacks decline and yet luxuriously indulges in a parade of all the features it attacks, should actually turn to discuss the theme explicitly.

Eumolpus' response to Encolpius' request for enlightenment is, like Trimalchio's expertise on history and myth, a wonderful mixture of philosophical and art historical gobbledygook.[59] Returning to his role as moralizing philosopher, Eumolpus pronounces that "love of money began this revolution. In former ages virtue was still loved for her own sake, the noble arts flourished, and there were the keenest struggles among mankind to prevent anything being long undiscovered which might benefit posterity" (88.2). He illustrates this (entirely trite) theme of a former golden age with some garbled references to the philosophers Democritus, Eudoxus, and Chrysippus the Stoic (88.3–4). Again the philosophical eclecticism of doctrines on which he draws is directly paralleled by the eclecticism of the doctrine expounded in the *Tabula* of Cebes. To these philosophical sages Eumolpus appends a number of artists, implicitly attributing to them the same status, inspiration, and depth. Presumably the very juxtaposition of artists and philosophers (given, for instance, Plato's radically different attitudes to these two groups) is itself satirical—although the author may be satirizing what had become a commonplace in an age when the emperor Nero styled himself a great poet and his chief minister Seneca claimed to be a philosopher.

Eumolpus continues:

> If you turn to sculptors, Lysippus died of starvation as he brooded over the lines of a single statue, and Myron, who almost caught the very soul of men and beasts in bronze, left no heir behind him. But *we* are besotted with wine and whores and cannot rise to understand even the arts that are developed; we slander the past, and learn and teach nothing but vices. (88.5–6)

The initial joke, of course, is that Eumolpus has got his facts about these artists exactly the reverse of how they are reported by ancient art history. Lysippus died rich after producing hundreds of statues, according to Pliny (34.37), and Myron's major weakness was not giving enough "expression to the feelings of the soul" (34.58).[60] More deeply, however, one wonders what actually recommends the lost golden age in Eumolpus' account when one of its chief geniuses is so abstracted that he starves, while the other is not competent enough to train an heir. They at least devoted themselves body and soul to art: such devotion could hardly be attributed to the exponent of this past, Eumolpus, whose later conduct in the novel will prove a truly wholehearted

[59] On "this comically inaccurate survey of the philosophical and artistic geniuses of the past," see P. G. Walsh (1970), 96–97.

[60] See P. G. Walsh (1970), 96, and Slater (1990), 171.

VIEWING AND DECADENCE

commitment to wine and whoring, and whose student (for whom all this is an education) is of course Encolpius. In the light of this, the reader must ask whether Eumolpus' accusation against modern decadents as "slandering the past" does not directly apply to himself and to this very speech. Certainly no one is a better exemplar of "learning and teaching nothing but vices." The speech rises to a climax with a grand denigration of the lust for money and ends on the somewhat peculiar artistic coda: "So don't be surprised in the decline of painting, when a lump of gold seems more beautiful to everyone, gods and men, than anything those poor crazy Greeks (*Graeculi delirantes*), Apelles and Phidias, ever did" (88.10). Of course there were few greater insults in Roman invective than being called a "crazy little Greek." Even as he concludes his speech, however, Eumolpus notices that Encolpius' interest is riveted on the picture which represents the fall of Troy. "Well, I shall try and explain the work (*opus*) in verse," he begins (89.1).

Instead of finishing, Eumolpus now concludes his diatribe with a truly grandiose peroration, the *Troiae Halosis*—an ekphrastic poem of sixty-five lines, a pastiche both of Virgil's *Aeneid*, Book 2, and of the style of Seneca (89).[61] One of the jokes of this poem is that its inspiration appears to be entirely textual—it tells a long narrative and seems to ignore any relation to the narrative that the picture might have had.[62] This is unlike the norms of ekphrasis as exemplified in, say, the Elder Philostratus, who usually remarks in what ways his pictures depart from the texts which may have inspired them. Here Petronius puts an extreme position on the relation of words to pictures. This "description" may be a tour de force in bathos but it is impossible to tell what contact it makes with the work of art it purports to describe.

The response to Eumolpus' poem is another wonderful moment: "Some of the people who were walking in the colonnades threw stones at Eumolpus as he recited. But he recognized this tribute to his genius, covered his head and fled out of the temple" (90.1). Whether the much lamented decadence of the arts is here embodied in Eumolpus' dreadful poem (which Encolpius ascribes to his "disease," *morbo*, in being a poet—90.3) or in the reaction of his listeners (to which Eumolpus is well used) or in both is not made explicit.[63]

[61] On the *Troiae Halosis* and its introduction in Eumolpus' discourse, see Sullivan (1968), 165–89; Zeitlin (1971b), 58–67; Slater (1990), 95–101, 186–90; Connors (1998), 84–99; and Rimell (2002), 65–81.

[62] Slater (1987), 172, and (1990), 244. But see Rimell (2002), 66–67, who correctly remarks that is impossible to tell what, if any, relations the picture and the poem may have had; she argues that the inability to perceive the relationship between images and the reading of images is thematically central to Petronius' project.

[63] On the stoning of Eumolpus and Petronius' presentation of an audience potentially misreading an author (as the Trojans misread the meaning of the Trojan horse, and as we ourselves may be in danger of misreading the *Satyrica*), see Rimell (2002), 73–75.

In its literary reference to the *Aeneid*, however, the *Troiae Halosis* recalls not only Aeneas' account of the fall of Troy in Book 2 but also his confrontation with the pictures of the Trojan War on the walls of Dido's temple in Carthage (Book 1, vv. 450–93). In effect, the *Troiae Halosis* recapitulates not just the theme of the capture of Troy but, more significantly, the problematic of response to that theme. Whereas Aeneas was an involved witness—a participator—who could rightfully frame his account (in *Aeneid* 2) in the first person and who sees *himself* depicted among the images of the temple (1.438: *se quoque*), Eumolpus' use of the first person (as if he were a Trojan) is much more complex. For Eumolpus to say "we thought the thousand ships were beaten off" (v. 11) or "we look back [at the death of Laocoon and his sons]" (v. 35) presupposes a kind of viewing very different from that of Aeneas. While Virgil's hero weeps at the *phantasia* of his own past, Eumolpus' first person is a classic and multilayered ekphrastic deception (encountered frequently, for instance, in the Elder Philostratus)[64]—an attempt to introduce vividness, to produce *phantasia* on the listeners' part. The response the poem receives implies that Eumolpus fails. His strategy of using the enargeia of the first-person plural, a "we" which encompasses both himself and his listeners, does not succeed in taking Encolpius and the others in the gallery "into the picture."

In this sense, the poem's inscription of the first person as both eyewitness and participant replays the difficulties of Encolpius at the beginning of the passage, when he first entered the gallery. Encolpius was unsure where he stood *as viewer* in relation to the paintings, so that initially, despite his conventional Plinian taste, the pictures were puns on their artists' names and in the end the paintings came to imitate Encolpius' plight as lover rather than evoking in his mind any naturalistic or visionary truths they might have promised. In the *Troiae Halosis*, by contrast, Eumolpus attempts to evoke a much more heightened, epic theme for the painting than any so far suggested by his personal history or predilections. He assimilates his and Encolpius' subjectivity to the picture's visual and poetic narrative rather than turning its imagery to his own subjective interests as Encolpius did. While Encolpius had found the paintings merely to reflect his own experience, Eumolpus attempts a visionary transformation of his own and his listeners' experience into the high mythic world of the image's epic drama. But this attempt to parade his own ekphrastic authority and to save the dignity of ekphrasis from being merely an Encolpian self-identification fails all the more grandly than did

[64] See, for example, *Imagines* 1.4 (4), "Let us catch the blood, my boy . . ."; I.6 (5), "Let not yonder hare escape us . . ."; 1.28 (1), "Do not rush past us, ye hunters. . . ." For some reflections on this ekphrastic strategy, particularly its involvement of the viewer in a voyeuristic fantasy of engagement, see Elsner (1995), 23–39.

VIEWING AND DECADENCE

Encolpius' initial mutterings to the empty air. Not only does his audience not listen, they pelt him with stones into the bargain.

In the *Satyrica* the attempt at a high-flown ekphrasis, instead of the self-image projected on the paintings by Encolpius, came to grief. This failure is acknowledged as such both by Encolpius and by Eumolpus, who promises to keep off poetry for the day and is in return rewarded by dinner. So the rewards for ekphrasis in Petronius lie in its failure and in the shutting up of its authoritative figure. That failure in this passage consists of a repeated inability for the viewer meaningfully to confront the paintings, for subject to relate with object. Either the pictures are assimilated into the identity of the subject to the extent that one doubts whether the viewer sees anything but himself (in the case of Encolpius), or the subjectivity of the viewer is so assimilated to the paintings that the gap between himself (the old pederast Eumolpus) and himself-imagined (the heroic Trojan witnessing the tragic fall of his city) is untenable and bathetic. But ironically this failure has now united the exegete and his listener in a relationship which will produce numerous initiations (of a largely sexual kind) in which Eumolpus will mostly have the upper hand. So the failure of ekphrasis in describing art and the self-acclaimed failure of the exegete in living up to his own moral code form the foundation for a friendship of the old man and the young which runs through the rest of the novel.

Deception and Decadence

As in any satire, the positive point being made by the *Satyrica* in its systematic undercutting of the literary and philosophical presuppositions of ekphrasis is less clear than the ironic light which it casts on its theme.[65] But this irony, in that it reflects upon Stoicism, upon Platonic theory, and upon the arts in the Neronian age, has the potential for a social and political effect. Not only is culture itself seen through the distorting mirror of satire, but also all the standard responses to culture. Since the *Satyrica* is perhaps the supreme response to culture to survive from the reign of Nero, it may be that one element of the text's strategy is a deliberate satire on itself (and other writings somewhat like it, such as moralizing satires) as a moral commentary on the age. In this sense, its persistent attack on the philosophical and pedagogic frame in which ancient ekphrasis is so often presented becomes a self-reflexive satire of the *Satyrica* (indeed of satire in general) as a frame for the exposure of the Neronian era. Like Eumolpus' speech in which he laments

[65] Cf. F. M. Jones (1991), 118–19, especially 119: "It is hard to believe there is a centre beneath the masks, and beyond this level, in the narrative itself there is no accessible reality, only layers of imitation, and only relative criteria to judge between different genres."

how "we slander the past, and learn and teach nothing but vices," the *Satyrica* is a classic example of a text which indulges lavishly and self-consciously in all the crimes of which it accuses its age. One thing we learn from the ekphrastic episode in the art gallery is how clear Petronius is about exactly what he is doing—since he satirizes the process with ruthless and pointed elegance. Yet if the *Satyrica* is in any sense reflective of its age in terms of its persistent urge to ironize, then we might perhaps expect Neronian and Flavian responses to sexual imagery in painting or sculpture to have been at least susceptible to some of the richness of the satirical gaze.

The naturalistic qualities of Roman painting are useful to Petronius because their measure of success lies precisely in their ability to deceive.[66] Here again the *Satyrica*'s paintings fit into the normal criteria of taste displayed by the art criticism of Petronius' time (for instance in Pliny's famous anecdotes of Zeuxis and Parrhasius). Indeed deception (*apate*) was to be a quality of paintings explicitly recommended by ancient critics of art from Gorgias (*Encomium of Helen* 18–19) to the Younger Philostratus, who wrote:

> The deception inherent in a work [of art] is pleasurable and involves no reproach; for to confront objects which do not exist as though they existed and to be influenced by them, to believe that they do exist—is not this, since no harm can come of it, a suitable and irreproachable means of providing entertainment? (*Imagines*, proem 4)

But for Petronius the success not only of the image but of the exegete himself, of Eumolpus, is measured in terms of *his* ability to deceive—in lying to the parents of the Pergamene boy and in cheating the boy of the "Macedonian thoroughbred" he offered as the price of his desire. Just as Encolpius (like Pliny and the rest of Neronian taste) is taken in by the naturalism of painting so that he imports into the paintings of the gallery a whole range of (his own frustrated) emotions,[67] so he is also taken in by the transparent dissimulations of Eumolpus—who is truly an expert in the art of deception.[68]

Indeed, it is in this respect especially that Eumolpus' ekphrasis related to the painting it purports to describe: the *Troiae Halosis* is all about the Greek deception of the Trojans by means of the Trojan horse. The poem is, in a sense, an epic paradigm both for the triumph of deception (showing how people

[66] As Slater points out (1987), 167, and (1990), 216.

[67] This strategy of reading an emotional interpretation into art is specifically what a sophist like the Elder Philostratus aims to teach; see Elsner (1995), 23–39.

[68] If one sees illusionism and deception as central themes of the *Satyrica*, then Eumolpus as priest, poet, and paradigm of Petronian deception becomes the embodiment of the strains and contradictions of the *Satyrica* as a whole. Cf. Rimell (2002), 75. For another angle on the deceptions of Eumolpus—as the victim of false deaths—see Connors (1994).

"trust a fraud"—*dolis addit fidem*, v. 22) and for the tragic price of deception in the destruction of Troy. In the poem these themes are interwoven with a moralizing motif of sacrilege (vv. 52–53), which is itself connected with the theme of misplaced worship as a sign of decadence in the speech which served as a preface for the poem (88). In effect, Petronius' play with art and art criticism in the age of naturalism makes a wonderful summary (just as so many pictures do in the ancient novels) of one of the main themes of the plot. But it is the constant deceits and dissimulations which constitute the essence of naturalism (rather than the content of any one painting, as in Longus or Achilles Tatius) that come to form the ekphrastic summary of Petronius' theme as well as the butt of his satire. The text's pungent irony is that Petronius' characters (and indeed his culture) present the decline of art as being a decadence from the peaks of mimetic illusionism—an illusionism which, according to the *Satyrica*'s presentation of it, was already rotten to the core. The very theme of decline is itself undermined in the notion that the high point (the naturalistic—and hence deceptive—art of the famous Greek painters in the gallery and the Homeric narrative of the *Troiae Halosis*) is itself a paradigm of decadence, through the motif of its inherent deceit.

Since the whole passage is explicitly cast as a reflection on the degeneracy of the age, we are entitled to ask what its themes of decadence and decline may tell us about the Neronian era and its own self-fashioning. Deception—whether as destructive trickery in the story of the Trojan horse, as illusionistic art, or as seductive action—is clearly a central motif, as it is throughout the *Satyrica*. Clearly too the problems of deception and dissimulation were topical in the reign of an emperor who appeared on the stage and who would later be roundly condemned for the transgressive excesses of his obsession with acting.[69] To some extent the complexity of Neronian culture is like that of the *Satyrica*. It indulged to the full in a parade of activities highly questionable by the standards of Roman moral rhetoric, and at the same time reveled in rhetorical and satiric condemnation or moral polemic, whose target was so often precisely those actions which the period both engaged in and celebrated.

The key moment is perhaps that following the end of the *Troiae Halosis*, when those in the gallery stoned Eumolpus as he recited, but the poet recognized this as a tribute to his genius (*plausum ingenii sui*) and fled (90.1). The age is decadent, so stoning the artist is proof of his genius (like his poverty and shabbiness at 83.7–9). Indeed the quality of his verse is unjudgable, since a decadent age must always misjudge it. The very immorality of Eumolpus' many deceptions is itself hard to condemn as ultimately immoral, since it may represent the necessary and inevitable actions of a Socrates in the age of

[69] On Nero as actor, see C. Edwards (1994).

Nero. Yet to use the word "genius" (*ingenium*) of Eumolpus is itself to beg the question, to put an ironizing satiric frame around any reflections which the readers' confrontation with him may have prompted. Indeed, the very fact that the world the text portrays may on some level be taken as an image of the world in which it was produced only increases the already crippling amassment of ironies.

As in the selection of artists in the gallery, Petronius shows a remarkable ability both for being right up with the trendiest and most extravagant instances of modern taste and for deflating them at the same time. Yet even as he deflates what he portrays, he questions ironically the very process of adopting such a critical stance. In Petronius, *the* great satirist of the dining room, one is perhaps tempted to describe this quality as having one's cake and eating it too.

$$\boxed{8}$$

GENDERS OF VIEWING

Visualizing Woman in the Casket of Projecta

IN THE PURSUIT OF ROMAN VIEWERS, finding the female gaze is a perennial problem. Despite the attempts of some literary critics,[1] it is well-nigh impossible to use texts to help in this enterprise, as they are (with rare and fragmentary exceptions) the productions of elite men. Most surviving works of art were available to the gaze of both men and women (whether in domestic or public contexts) and hence they allow very little by way of an opening to a specifically gendered female response. But one special case, where we can at least feel reasonably secure that women did have a privileged use of objects, is in the realm of silverware, especially items of the toilette. Certainly this class of material belongs to the elite (though its viewing and handling was of course also by servants and slaves). Here I shall examine one specific item in what we can infer of its context to try to establish at least some elements of a specifically female-centered way of viewing.

THE OBJECT

The Projecta casket is the most famous object in a spectacular silver treasure of perhaps more than sixty items found in the remains of a private Roman house behind the choir of the convent of San Francesco di Paola on the Esquiline hill in Rome in the spring of 1793.[2] Sixty-one pieces survive, all

[1] See esp. M. Skinner (2001), with the critique of Goldhill (forthcoming).

[2] Recent accounts are by David Buckton in Buckton (1994), 33–34, and Kenneth Painter in Ensoli and La Rocca (2000), 493–95. The standard discussion is Shelton (1981), 13–17, on date and find-spot; 19–23, for the number of items, their state and contents; 71–97, for the catalog. But see also Buschhausen (1971), 210–14, with earlier bibliography. For further discussion of the find, see Ridley (1996).

but two in the British Museum, with one each now in Naples and Paris. At least four further pieces, attested to Ennio Quirino Visconti's description of the treasure, written in late 1793, are now lost—including what was apparently a rather striking and elaborate candelabrum.[3] Of these sixty-five items (surviving and attested), at least thirty-one pieces—effectively the most ornate and impressive in the treasure—can be securely identified as being part of the original find in Rome; and of these, twenty-seven pieces still survive.[4]

The objects belong to a collection of private silverware used for domestic purposes and—in the case of the Projecta and Muse caskets—likely associated with the toilette of the lady of the house. Most are probably the work of a single Roman workshop of the mid- to late fourth century A.D.[5] It is impossible to say whether individual items were added piecemeal to a family collection of silverware over several years—perhaps even over more than one generation—or whether the major pieces, at least, were purchased as a single lot.[6] Likewise, in the case of the Projecta casket, it is not possible to say whether the famous inscription SECUNDE ET PROIECTA VIVATIS IN CHRISTO ("Secundus and Projecta, may you live in Christ") was original to the making of the casket or was added by a later owner.[7] Hence it is impossible to say with certainty whether the figures depicted in the medallion on the casket's lid actually do represent Secundus and Projecta (figure 8.3), or whether the lady at her toilette on the base is an image of Projecta herself (figures 8.1 and 8.2). Likewise, it is not certain when the handles, hinges, and feet of the casket—which intervene in a rather ugly way in the visual program of its base—were fitted. Kathleen Shelton, who published the Esquiline treasure for the British Museum, believed them to be integral to the original workshop product,[8] but admitted that the earliest published drawings of the casket

[3] See Shelton (1981), 94.

[4] See Shelton (1981), 22–23, and Shelton (1985), 147.

[5] For the dating c. 330–70 (with which I would broadly concur for stylistic reasons), see Shelton (1981), 47–55; for a later and narrower date (c. 380), see Will (1983), 347; Cameron (1985), 139–41; Dresken-Weiland (1991), 39n221; and Kiilerich (1993), 165. For a contextualized historical discussion of late antique silver, see Leader-Newby (2004), 1–8. I am unpersuaded by the suggestion that the casket was made by the same workshop as that which made the Nea Herakleia reliquary: see Noga-Banai (2004), 532–36.

[6] For the suggestion that the pieces of the treasure may have been acquired over at least a generation, see Strong (1966), 182–83, and Cameron (1992), 183. The inscription of Sevso's hunting plate certainly implies that silver treasure was regarded as a family heirloom over several generations: see Mango and Bennett (1994), 77. On the culture of collecting in late antiquity (focusing on sculpture), see now Stirling (2004), especially 165–232.

[7] On the inscription, see Shelton (1981), 31–35.

[8] Shelton (1981), 47–48.

FIGURE 8.1. Projecta casket from the Esquiline treasure: figure of "Projecta" seated at her toilette be-tween two attendants in an arcade of strigillated columns, with peacocks, birds, and baskets of fruit. From the front of the base. Gilded silver. Second or third quarter of the fourth century A.D. (Photo: British Museum.)

(those of J. Seroux d'Agincourt)[9] omit all these details, which are first seen in the engravings to the 1827 edition of Visconti's essay.[10] The hinges, feet, and swing handles *may* be ancient (in which case, they may be original to the making, though perhaps not to the design as conceived iconographically, or they may have been added at a later date), but they may also be the result of the early-nineteenth-century restoration which possibly accompanied the treasure's first sale and was certainly completed by 1827.[11] The handles, hinges, and feet do seem to be perfectly good late antique forms and the integration of such addenda into the overall design of late antique caskets appears not to have been a priority. At any rate, however the treasure was acquired in antiq-

[9] These were published in Seroux d'Agincourt (1823). The exact dates of the volumes of this pub-lication are subject to dispute—the title pages carry the date 1823, but citations to unpublished manu-scripts and drawings from the work reach back as early as 1789, before the finding of the Esquiline treasure. Shelton believes the discussion of the Esquiline silver dates to between 1795 and 1800; see Shelton (1981), 16–17n2.

[10] Shelton (1981), 51n11. See also Visconti (1827).

[11] Shelton (1981), 20. This is an issue which modern scientific analysis of the silver used in the main casket by contrast with that of the feet, hinges, and handles might perhaps resolve. It should be noted that the same questions arise with the Muse casket, cf. Shelton (1981), 48. Traces of solder and scratchings on the fourth- or fifth-century casket in the Sevso treasure—now an object without hinges, latch, catch-plate, or suspension chain—seem to indicate that these items were once attached to it, presumably in antiquity. Their siting in this case, without the slightest regard for the casket's el-egant repoussé decoration, was even more ugly than on the Projecta casket. See Mango and Bennett (1994), 454, 463–64.

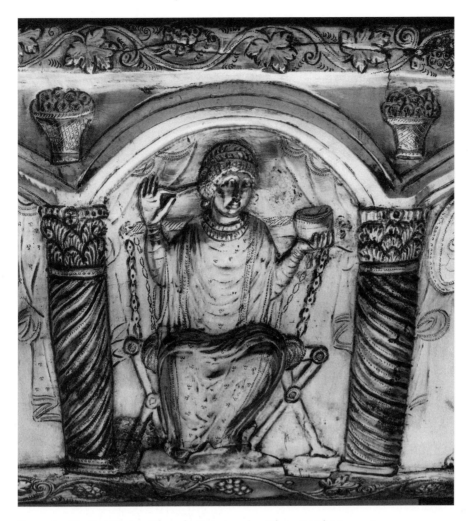

FIGURE 8.2. Detail of "Projecta" from the Projecta casket. (Photo: British Museum.)

uity and whatever state its components had got themselves into after the wear and tear of perhaps half a century's use, it appears to have been buried where it was found in 1793 at the end of the fourth century or the beginning of the fifth.[12]

Apart from archeological discussions, studies of the Projecta casket have largely been devoted to assessing the identities of its owners (and hence its date),[13] to the striking contrast of its flamboyantly pagan iconography of Venus with its Christian inscription,[14] and to the social meanings embedded

[12] Shelton (1981), 55; Cameron (1985), 144.

[13] For instance, Poglayen-Neuwall (1930), Tozzi (1932), Cameron (1985), and Shelton (1985).

[14] See Shelton (1989), 106; Elsner (1995), 251–58; and Elsner (1998a), 746–47. Generally on mythology and late antique silverware, see Leader-Newby (2004), 123–71.

in its iconography of elite life.[15] My purpose is to follow one lead within the last of these general lines of attack, and to examine the casket's extraordinarily rich iconographic program in relation to its presentation of a woman's role and place in elite society at the end of the fourth century.

First I should make transparent some assumptions. It is usual to regard the casket as a wedding gift, perhaps part of a dowry, celebrating the union of Secundus and Projecta.[16] The central wreathed medallion at the top, with its double portrait of a richly dressed, bearded man and a woman with jeweled collar and scroll, does appear to represent a married couple (figure 8.3). But it is by no means certain that the casket was commissioned for their wedding, though from its owners' point of view it might have alluded to their wedding even if it were purchased some time thereafter. Nor is it necessarily the case that the couple in the tondo at the top were originally intended to be the Secundus and Projecta of the inscription which runs along the horizontal the rim of the casket lid below them, since the inscription could have been added later. What is certain is that the visual formula of two nude putti holding a celebratory box or medallion and accompanied by a dedicatory wish of inscribed well-being was common in fourth-century Rome. One might think, for instance, of the title page of the Codex-Calendar of A.D. 354, with its two putti holding a box inscribed with various good wishes (figure 8.4).[17] This visual formula also appears on numerous sarcophagi, where the inscription commemorates a death (or the deceased's life) rather than a wedding.[18] Likewise, the celebratory double-portrait tondo of husband and wife (broadly the same formula as that of the Projecta casket, with the man on the right and woman in a jeweled collar) is frequent on fourth-century sarcophagi[19] and is found also—often in conjunction with valedictory invocations—in gold-glass medallions.[20]

A second assumption which requires a little skepticism is the question of

[15] See especially the outstanding contribution of Schneider (1983), 5–38, with the useful discussion of Reece (1997), 145–46.

[16] See Poglayen-Neuwall (1930), 135; Shelton (1981), 31; Schneider (1983), 9, 17–18; Cameron (1985), 135; and Kiilerich (1993), 163.

[17] See Stern (1953), 153–68, and Salzman (1990), 25–26.

[18] For instance, see Bovini and Brandenburg (1967), nos. 11, 28, 52, 77, 132, 143, 145, 146, 147, 320, 472, 475, and so forth.

[19] See Bovini and Brandenburg (1967), nos. 40, 42, 44, for examples of couples in a conch-shell roundel surrounded by Christian scenes; nos. 188, 239, and 244 for couples in a conch-shaped roundel in a strigilated field (the latter tondo being supported by erotes); nos. 39 and 43 for couples in an imago clipeata surrounded by Christian scenes; nos. 87, 689, 778, 962 for couples in an imago clipeata within a strigilated field.

[20] See Morey (1959), nos. 43, 93, 98, 99, 259, 418. For couples including children, see nos. 59, 89, 94, 244. At least half of these have inscribed invocations. See also Laubenberger (1995) and Grigg (2004), 205–9, with table 1 and bibliography.

FIGURE 8.3. Projecta casket: figures of "Secundus and Projecta" in a wreath supported by cupids. On the lid. Gilded silver. Second or third quarter of the fourth century A.D. (Photo: British Museum.)

the casket's value. Unlike, say, the Corbridge lanx or the Parabiago plate (both also pieces of fourth-century silverware), which are solid cast, though certainly subjected to a certain amount of chasing and stippling from the front and perhaps the back, the Projecta and Muse caskets from the Esquiline treasure were hammered out in repoussé technique and raised in relief from the back (figure 8.5). Like the Meleager plate from the Sevso treasure (which has undergone detailed scientific analysis),[21] they may well have been raised from a cast blank with chasing, hammering, and punching from front and back. The difference between the Projecta casket and, say, the Parabiago plate is that the silver was thinner and hence lighter, although the relief was also deeper (and hence perhaps more spectacular). If the initial work involved hammering from the front onto a mold, the possibility must be that more than one example was originally produced. The Projecta casket is lavishly gilded on all sides except its back (for example, plate VII), but neither this nor its silver content nor its rich iconography necessarily implies workmanship of the highest

[21] See Mango and Bennett (1994), 103–8.

FIGURE 8.4. Codex Calendar of A.D. 354 (Romanus 1 ms, Barb. lat. 2154, fol. 1). Dedication to Valentinus supported by two cupids. Seventeenth-century copy of a lost Carolingian copy of the lost original. Now in the Vatican Library. (Photo: Bibliotheca Apostolica Vaticana.)

FIGURE 8.5. Projecta casket: interior. (Photo: British Museum.)

aristocratic quality for the grandest of patrons.[22] The interior of the casket appears not to have been filled with the kind of smooth silver lining which would disguise the rough, hammered-out back of the object's repoussé silver-work,[23] and the casket's workmanship represents what may be a competent but not outstanding imitation of court style.[24]

The iconography of the Projecta casket is extremely rich. Constructed in the form of two truncated rectangular pyramids joined together at their wider ends so that one forms the lid and the other the base, the casket offers ten flat surfaces of which every one except the bottom is decorated (figures 8.6 and 8.7). The front and back are clearly defined visually (even if the handles and hinges are not original), since the two panels of the back (on the base and on the lid) are not gilded, while the double-portrait medallion and putti of the top face in the same direction as the front; the nereids astride sea monsters

[22] There has been a debate about the ownership and status of late antique silver, in which K. Painter has argued for high status against A. Cameron. See Painter (1988), Cameron (1992), Painter (1993). As Cameron rightly says (1992, 185), "silver was not all that valuable."

[23] Such linings were normal in Roman silver, see Sherlock (1976), 19.

[24] Broadly the conclusion also of Kiilerich (1993), 164.

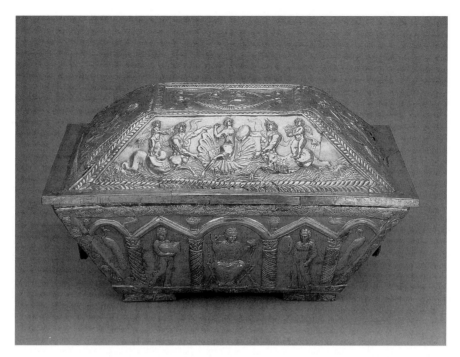

FIGURE 8.6. Projecta casket: general view of the front (lid and base) from the left. (Photo: British Museum.)

on the lid's two side panels also turn inward toward the lid's frontal image of Venus.

The lid has five decorated faces, of which the top shows the couple in an imago clipeata between erotes (figure 8.3) and the front shows Venus seated on a round cockleshell supported by two centaurotritons flanking her on either side (figure 8.8). On each triton stands a cupid, who offers Venus a gift (a casket from the one on her right and a basket of fruit from that on her left). Venus holds a pin in her right hand and turns toward a mirror (in which her face is faintly picked out in gilding and stippling) on her left (figure 8.9); this is held out by the centaurotriton on our right. The two side panels complete Venus' retinue, with each boasting a nereid riding on a sea monster toward the goddess, accompanied by dolphins and erotes. The iconography of the toilette of Venus is of course common in late antique art from the private sphere, not only in the patera (now in Paris) which also comes from the Esquiline treasure,[25] but especially in domestic mosaics.[26] The subject of the scene on

[25] See Shelton (1981), 78.

[26] For a brief but by no means complete introduction to this iconography, see Schmidt *LIMC* VIII.1, 208–12. On the mosaics (mostly from the coast of Roman North Africa), see Lassus (1965); Blanchard-Lemée (1975), 73–81; and Dunbabin (1978), 154–58.

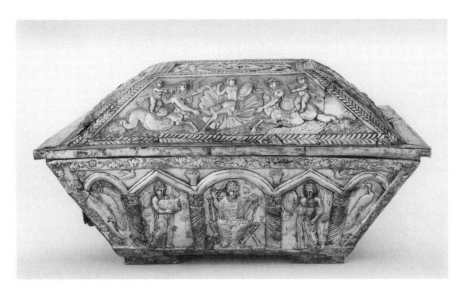

FIGURE 8.7. Projecta casket: general view from the front (Photo: British Museum.)

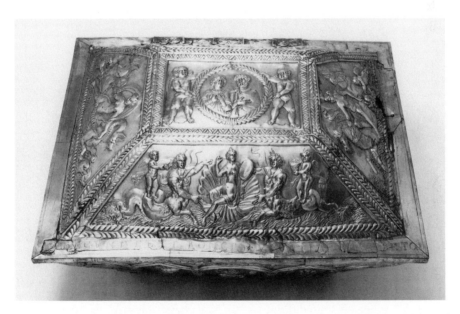

FIGURE 8.8. Projecta casket: front from above. The front and side panels of the lid show a toilette of Venus, nude, in a large cockle shell supported by centaurotritons accompanied by cupids. The panels to the left and right, respectively, show a nereid on a ketos with accompanying cupid and a nereid on a hippocampus with a cupid swimming behind. On the rim beneath the front panel is the Christian inscription "Secundus and Projecta, live in Christ." (Photo: British Museum.)

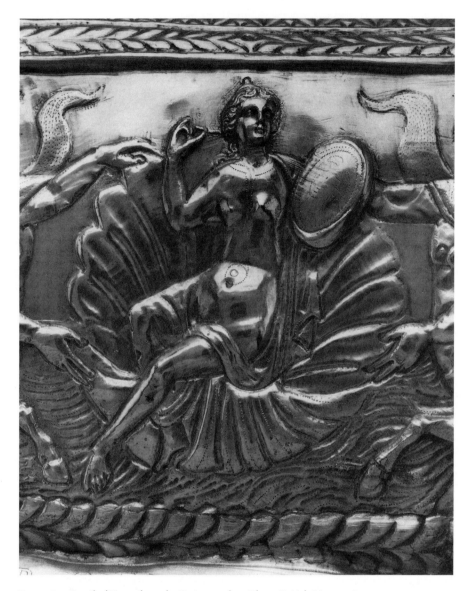

FIGURE 8.9. Detail of Venus from the Projecta casket. (Photo: British Museum.)

the back has been disputed (figure 8.10). Most have assumed that it represents the "deductio sponsae" in which Projecta is led to her marriage and her new home with Secundus;[27] but it has also been argued that it represents a procession to the baths.[28] Either of these views is possible in the light of the casket's other imagery and even both at the same time.

[27] For instance, Schneider (1983), 16–24.
[28] In favor of the baths, see Barbier (1962), followed by Shelton (1981), 27.

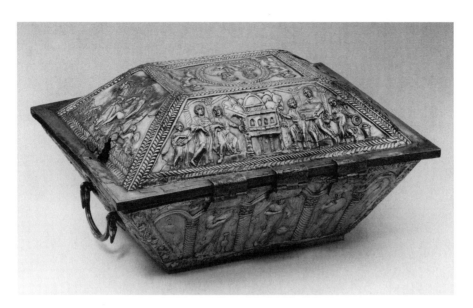

FIGURE 8.10. Projecta casket: back panel of the lid showing a woman (to the left) accompanied by slaves, maids and youths (to the left and right) carrying accoutrements of the toilette to a baths building. The arcading at the back emulates that around the casket's base. This side alone has no gilding. (Photo: British Museum.)

The four decorated faces of the bottom resemble a columnar sarcophagus with alternating round and pointed arches carried on spirally fluted columns (much like base of the Muse casket) (for example, figure 8.1).[29] On each face there is a central figure flanked by two attendants, each one standing in an arch between the columns. The most important figure of the twelve is a woman at her toilet seated on an elaborate chair and wrought in larger scale than the others. She is placed under the wider central arch of the front panel of the base, immediately below that section of the inscription which reads "Projecta," which is below the figure of the seated Venus, who is herself below the roundel of the married couple on the top of the lid. The iconography of her panel reflects that of Venus in that her gesture of pinning her hair with her right hand mimics that of Venus, while she inclines her head to her left to where an attendant holds out a mirror (figures 8.2 and 8.9). Like Venus' mirror, this one too has a faint reflection (figures 8.1 and 8.9). The attendant on her right carries an oblong casket, like the cupid on Venus' right, and in the space above the columns on either side of her are two baskets bearing fruit, echoing that held by the cupid on Venus' left. The iconography of this panel, like that of Venus, is paralleled by surviving late Roman silverware,[30] and

[29] For the comparison with a sarcophagus, see Kiilerich (1993), 162.

[30] For example, the toilet scene on the base of the casket from the Sevso treasure. See Mango and Bennett (1994), 445–71, especially 464–71.

mosaics—especially the impressive late-fourth- or early-fifth-century panel from a private baths complex at Sidi Ghrib near Tunis found in 1975 (figure 8.11).[31] There the seated lady (fully dressed, like the figures on the body of the Projecta casket) is also adorning her hair on the right side (possibly using a pin), accompanied by two female attendants—the one to her left holding a mirror and the one to her right an open basket perhaps containing jewelry. Just as the Venus scene of the Projecta casket has several visual, formal, and thematic resonances with the toilet scene below, so it echoes the medallion portrait of the couple above (figure 8.8). Venus sits in a central circle, effectively a seashell medallion, reflecting the roundel containing the couple above. Both these tondi are supported from either side by divine figures—erotes in the case of the couple and centaurotritons in the case of the goddess. Like the couple, whose life together she blesses, Venus too has two winged cupids in attendance.[32]

Shelton describes the remaining figures of the base as forming a procession from left to right,[33] but it may be more natural to see them simply as attendants bringing various accoutrements of the toilet. Like other fourth-century groups of single figures between columns,[34] they clearly defer to the main image of the seated woman at the front in what may be described as the center of their activity (despite the broadly frontal stance of the central figure on each side). Every one of these attendants carries items relevant to the toilette or to bathing. Many of these objects, moreover, appear to reflect other objects actually within the Esquiline treasure—for instance, the central figure of the back holds a circular casket suspended by chains much like the Muse casket, while other figures carry ewers, paterae, and candlesticks (all of which are attested within the treasure). This feature too is paralleled by the toilet mosaic from Sidi Ghrib, where several accoutrements of the toilet are stacked up along the sides of the scene, including a conch-shaped basin, a ewer, a hexagonal casket with a chain and an open casket in the form of the body of the Projecta casket (that is, an oblong truncated pyramid with trapezoidal-shaped sides) containing towels (figure 8.11).[35] The cross-referential nature of

[31] See Ennabli (1986), 42–44. On the date, see Blanchard-Lemée (1988), 367.

[32] For discussion of some of these parallels, see Schneider (1983), 27–33, and Shelton (1981), 72–75.

[33] See Shelton (1981), 74.

[34] I am thinking of the wonderful fourth-century tapestry now in Bern, in which Dionysus and Ariadne occupy what were presumably the central two arcades in a long series of arched columns each containing a member of their retinue, including Maenads, a satyr, and Pan. See Rutschowscaya (1990), 82–86. For a parallel but more fragmentary example, see MacMillan Arenberg (1977). For earlier Dionysiac columnar sarcophagi on a similar formal scheme, see Matz (1975), nos. 246, 276, 277, 278, 280.

[35] See Ennabli (1986), 42.

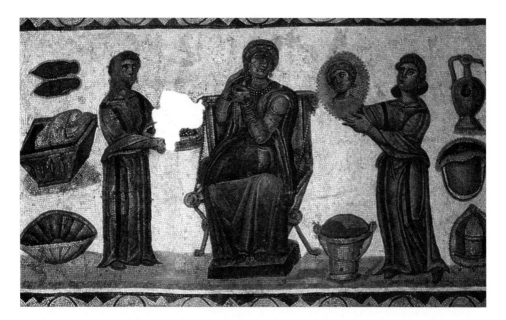

FIGURE 8.11. Floor mosaic from a large private baths at Sidi Ghrib near Tunis, showing a lady at her toilette flanked by two female attendants and various accoutrements of the toilette and bathing. Late fourth or early fifth century A.D. Now in the Carthage Museum. (Photo: Roger Wilson.)

the items within the treasure is not confined to form alone: the decoration and iconography of other items in the Esquiline cache appear reflected on the casket. Hence the hinges (if original) resemble the decorative design of the incised fluted dish,[36] the erotes of the lid and the vine imagery which encircle the panels of the base (figures 8.1 and 8.12) are reflected in the flask with vintaging erotes,[37] the toilet of Venus scene on the casket's lid echoes the imagery of the Paris patera. One attendant on each panel of the casket's body appears to be carrying a large casket (perhaps something like the Projecta casket itself), as do two figures of the six featured in the procession scene on the back of the lid.

All this indicates a particularly careful program of interrelated and self-referential iconography in which the casket's domestic functions within the female sphere of the household were both portrayed on its surface and reflected upon in its imagery. The female emphasis of the decoration is striking. Apart from the bearded male figure in the double portrait at the top, all other human males (excluding erotes and centaurotritons) are beardless attendants. The two groups of three in the procession on the back of the lid are each led by a male—on the left a beardless youth showing the way and on the right a

[36] On the fluted dish, see Shelton (1981), 78–79.
[37] On this flask, see Shelton (1981), 81–82.

FIGURE 8.12. Projecta casket: Left end of the base with a maid carrying a casket flanked by two youths (eunuchs?), both carrying lighted candles in an arcade supported by strigillated columns. The whole visual field, like all the panels of the base, is framed with a frieze of vines and grapes. (Photo: British Museum.)

boy with candelabra (figure 8.10). On the left end of the casket's base, the female servant in the center carrying a casket is flanked by two beardless youths with flaming candles (figure 8.12). In all these cases one wonders whether these male attendants are not intended to be understood as eunuchs.[38]

INTERPRETING THE ICONOGRAPHY

The function of the casket—as suggested by its resolutely female-centered iconography, its inclusion of images of other caskets in its depiction of the toilet, and the implied functions of similar caskets (such as that included in the

[38] The second half of the fourth century was, of course, a key moment for the flourishing of eunuchs, especially at court. See K. Hopkins (1978), 172–96, on court eunuchs; Guyot (1980), 121–29 (on the first to third centuries A.D.), 130–76 (on the fourth century); and Scholten (1994), on the fourth and fifth centuries. The iconography of eunuchs is unlikely to have been firmly established by the 380s, but in later Byzantine art (for instance the mid-sixth-century Theodora panel from San Vitale in Ravenna), they are distinctively beardless, as they are in earlier literary accounts such as Lucian, *Eun.* 9–10. By 899, when the Byzantine court official Philotheos composed his *Kterologion*, the definition of eunuchs as "beardless" is implicit through Philotheos' description of their opposites (noneunuch court officials) as "bearded" (οἱ βαρβάτοι): Philotheos in Oikonomides (1972), 135, line 9, with Tougher (1997), 171–72.

Sidi Ghrib mosaic)—places it firmly in the female sphere. Its purpose, at least in part, is to help achieve what its complex iconography advertizes—the beautification of a woman for her husband's delight. On this reading, the casket's function helps to provide the means for the lady on the bottom ("Projecta," figure 8.2) to be so gorgeously adorned as to mimic Venus on the lid (figure 8.9) for the purposes of fostering her union with the man depicted beside her on the top ("Secundus," figure 8.3). Like the casket itself, the adorned woman is a carefully crafted object of display—a luxury ornament for her husband's possession and pleasure.[39] Within this line of interpretation, the imagery of the mirror and the focus of the female principals (both "Projecta" and Venus) on themselves—their reflections and their bodies within the private sphere away from male intruders—together help to render the process of crafting the female body into an object of male desire.[40] These scenes figure the construction of the woman's self-image in terms of an absent but anticipated male viewer—the actual viewer of the casket in antiquity (who is outside the iconography's imaginative world but is nonetheless its intended recipient) and the viewer of "Projecta" once the process of adornment has been accomplished.

The iconography of the casket is fundamentally woman- and marriage-centered, although the referent is the man for whom all this is being prepared. This gender-specificity ties the imagery into the principal social context available to women in late antiquity—and presumably the overarching sphere of their aspirations as these were socially constructed—the process of marriage.[41] As Roman law ordained it (at least from the Augustan period when legislation had been specifically targeted at encouraging population growth), marriage was supremely about producing children.[42] In the words of the Code of Justinian (A.D. 531): "Nature produced women for this very purpose, that they might bear children, and this is their greatest desire" (*Codex Justinianus* 6.40.2). The casket, however, while it focuses firmly on the female sphere in relation to the man depicted on its top, avoids any illustration of children produced by the marriage of "Secundus" and "Projecta." At the same time, the

[39] So Wyke (1994), 143–44. The supreme male myth of such craftsmanship creating an ideal woman, the adornment of her maker's sexual needs, is Ovid's Pygmalion; see chapter 5 above.

[40] On the mirror in earlier Greco-Roman culture, see Frontisi-Ducroux and Vernant (1997), passim and especially 55–71 on the mirror and the female realm, and A. Stewart (1996); on the mirror in the Roman rhetoric of adornment, see Wyke (1994), 134–38; for some visual discussion of Roman Venus scenes, see Balensiefen (1990), 75–78; and on the complex significations of mirroring in Roman culture, see McCarty (1989) and Too (1996), 141–44.

[41] On marriage in the period, see Clark (1993), 13–17, and Arjava (1996), 28–156. For literary validations of marriage in Second Sophistic and late antique fiction and poetry, see J. Perkins (1995), 41–76; Cooper (1996), 28–31; and Morales (1999), 61–65.

[42] See Arjava (1996), 77–84.

marital tondo of the top and the Christian inscription of the rim surely preclude any courtesan- (or even brothel-) centered interpretation, as is likely, for instance, for the erotic poetry concerning adornment written by the first-century Roman elegists (who also avoid mentioning children). The scene on the back of the casket's lid does appear to show children (if we take the small scale of certain figures to function naturalistically, rather than simply indicating low status), but these carry implements of the toilette and are surely servants or slaves (figure 8.10). Likewise, all the other children on the lid are winged cupids, and thus none of the children depicted on the casket belong to the marriage itself.

In effect, the casket shows the *processes* of adornment, bathing, and beautification which foster the desire within marriage that will ultimately lead to the procreation of children. Its emphasis on process is thus an exposition of the generation of desire. Just as its imagery of adornment is about the self-absorption of the female sphere in its art of crafting "Projecta" into a Venus worthy of "Secundus," so the desires created within the casket's imaginative world include the glorious adornment of the wife (figured as her husband's jeweled companion on the lid, figure 8.3), the beautiful disrobing of the wife (emblematized as the nude Venus of the lid, figures 8.8 and 8.9), and the deferred product of their union (the children never depicted but implied by all the other images of children, human and divine, who are not their offspring).

This line of interpretation takes the casket's focus on women to render them ultimately as objects displayed for the various pleasures and desires of men.[43] The casket develops the notion of display, as emphasized by the parallel mirrors and the crowning scene of the carefully arrayed "Projecta" posing beside her husband within a wreath as a perpetual and public image of marital bliss (figure 8.3). In this regime of representation, display emphasizes the objectification of the woman as a *product*—a result of the parallel processes of adornment (with jewels, pins, clothes, cosmetics) on the body of the casket and of bathing as represented on the lid. If the casket's imagery can be characterized as an iconographic microcosm of late antique elite life,[44] it certainly

[43] This reading frames the casket in a venerable feminist art history which was characterized as that of "women connoting to-be-looked-at-ness," Pointon (1997), 7, and ultimately tending toward male objectification. Fundamental accounts include Berger (1972), 45–64, and Mulvey (1989; first published 1975). See also La Belle (1988), 53–55. In the literature on the Projecta casket, this is the basic approach of Wyke (1994), 143–44. For woman as object of the gaze in the fourth-century sermons of Chrysostom, see Layerle (1993), 159–67. For the dangers of the woman who gazes in Chrysostom, see ibid., 167–69.

[44] This is effectively the argument of Schneider (1983), 5–38. For him the scene on the back of the lid (interpreted as the bringing of the chattels of the dowry to the husband's house) is crucial, since it ties the images of myth and toilette within a socioeconomic transaction; see Schneider (1983), 16–25. Of course, this iconographic interpretation (and hence the entire argument) is open to contestation.

makes its point through focusing on the hard work of beautification at the heart of the women's sphere—the very work of adornment in which the casket itself played a part. Moreover, every item on the back and the base—the peacocks and birds, the baskets of fruit and the grapevines, the objects of silverware and the clothing, the buildings of the lid's back panel, all the slaves and attendants (for example, figures 8.1, 8.10, and 8.12)—all these are effectively chattels of the household. In this case the wife herself, even though she may be mistress of all this action, is in the end no more than the raw material for the arts of beautification. She too is figured as a decorous adornment for her husband's gaze, the supreme chattel of his possessions.

Yet this approach, however compelling, cannot be wholly satisfactory. Although the casket was surely made by men, and probably commissioned and paid for by men, it is nonetheless an object of the female sphere. It was at least subjected to, if not partially designed for, the female gaze. The problem might be seen as analogous to that of women's wills in eighteenth-century England: they may have been drafted by men within a legal discourse entirely created and controlled by men, and yet, though we may not hear women's voices from the past, we simply cannot discount some female input into the wills' production, formulation, and reception.[45] In part, at least, the casket presents to the women of the household a visual space in which to see themselves. The very visual images and scenes that figure the desires of the ruling male—however carefully policed and safeguarded—are open to reinterpretation and transformation when they come to represent also the desires of the household's women.[46] The women are not only male-controlled actors in the process of beautification but also manufacturers of desire and its potential satisfaction, generators of seduction and controllers of the means and materials of seduction within the casket's visualization of the household. The man may rule alongside his suitably attired wife on the top, but the arrangements for that dominion—in terms of prized objects like the casket itself and the use of the family's property and wealth—lie properly with the servants and their mistress on the casket's base.

In celebrating the domestic world, and especially that part of domesticity most specifically within the realm of female control,[47] the casket may be said to mirror and hence to affirm the identity of its female viewers. "Projecta" (figure 8.1) is seated in regal splendor on a high-backed chair with a curtain and legs resembling the imperial "sella curulis" within a curtained

[45] See Pointon (1997), 3–4.
[46] See on classical material Kampen (1997), 273–75. The general point is well made by Doane (1987), 5–9, 178–83.
[47] On the domestic sphere in the period, see Clark (1993), 94–105.

GENDERS OF VIEWING

niche.[48] She seems something between a late antique emperor (with pin and casket instead of orb and scepter)[49] and an emulation of the divine Venus enthroned in her cockleshell above (figure 8.9). While the female servants are engaged in acts which commemorate their social condition of servitude, they are nonetheless implicitly compared with the nereids, tritons, and erotes of Venus' retinue. Their activity, moreover, in arraying one of their own gender speaks for a certain sexual politics of collaboration, despite the obvious differences of class.[50]

Most striking in a reading which might seek to see female subjectivity rendered empathetically and even self-assertively by the casket, is the juxtaposition of "Projecta" and Venus. We know that dress was essential to the complex of rhetorics surrounding ancient women. Female frivolity (especially in moralizing discourse) could not be better summed up than in the time wasted and money spent on clothes, jewelry, hair, and makeup, the very things celebrated in the casket.[51] At the same time, nothing was worse (despite all the moral rhetoric about adornment) than its dreaded opposite, nudity. This was especially so for Christians (as the inscription of the Projecta casket proclaimed its owners to be), but was hardly unproblematic for pagans.[52] On the casket, "Projecta" is made up with the full panoply of accoutrements available to the Roman upper class, and displayed—dressed to kill—in the seated splendor of her curtained arch as well as in the medallion on the casket's lid. But between these images, reflecting the posture of "Projecta" on the base and mimicking her gaze into the mirror by her side, sits Venus—resplendently naked in her circular shell. "Projecta" is clothed head to foot, with only hands and face emerging, as a Roman matron should be.[53] But Venus' drapery falls around her, revealing all that "Projecta's" clothing hides, while the goddess's gilded collar and pendant, nestling between her breasts and dropping to her

[48] This chair is certainly "elaborate"—Shelton (1981), 74. It resembles that of the lady at her toilette in the Sevso casket (figure 8.13); see Mango and Bennett (1994), 465. On chairs and thrones, see Mathews (1993), 104–8, with bibliography.

[49] For instance, Constantius II in the Codex-Calendar of 354, fol. 13. See Stern (1953), 153–68, and Salzman (1990), 34–35.

[50] For some reflections on the parallelism between Roman slaves and matrons, see Parker (1998).

[51] On clothing in the period, see Clark (1993), 105–18; on the dangers of adornment, see Wyke (1994), 146–48. For the poetic motif of natural beauty falsified by adornment, see, for example, Propertius 1.2, 2.18c; Ovid, *Amores* 1.14, *Ars Amatoria* 3.193–250 (purporting to be lessons in the art of seductive adornment); *Medicamina Faciei Femineae*.

[52] On nudity in relation to pagan Rome, see, for instance, Toner (1995), 58–59; Fagan (1999), 24–39, with special reference to bathing; and Hallett (2005), 61–101, mainly on an earlier period but excellent on the images; on Christianity, see Brown (1988), 315–17. On nudity and sexuality in relation to the baths, see Fagan (1999), 24–29, 30–39, and Sidonius Apollinaris, *Epistles* 2.2.5–6 for a Christian's disapproval of nudity in bath decoration.

[53] Cf. Clark (1993), 107–10.

navel, only serve to emphasize her sexuality without even pretending to disguise it. One wonders if the difference between the pinning gestures is not that "Projecta" is pinning up her hair while Venus is unpinning hers—removing her adornments along with her clothing.

In a wonderful affirmation of the culture of late Roman hellenism,[54] the image of Venus renders visible not only a male desire for the wife as nude woman, but also Projecta's desire to be woman in the bare and physical sense of mistress of her own nakedness. The antique visual language of myth strips away the conventions of matronly adornment and reveals the wife as woman, reveals her as she fundamentally and nakedly is, concealed only by device that the image is not a portrait of "Projecta" but a toilette of Venus. The image of nude Venus, placed ostentatiously between the marital snapshot on the top of the lid and the wifely work of beautification on the base, brilliantly unites in a single emblematic scene the wife's desire and self-image as a woman with the husband's desire for woman as sexual partner. The casket, in its iconographic tiering of images along the front (from top to base), manages to create a space both for female and for male identification, desire and subjective self-affirmation. The daring gesture whereby this is achieved is to juxtapose the inscriptional invocation for a shared life in Christ with the pagan celebration of a sex life in Venus.[55]

The evocation of a sexy Venus within the context of Christian culture in fourth-century Rome is not unprecedented. In the panegyric composed by Claudian to celebrate the wedding of the young Christian emperor Honorius with Maria, daughter of the general Stilicho in A.D. 398, Venus appears in her palace in Cyprus in the same pagan splendor as on the casket:[56]

> caesariem tunc forte Venus subnixa corusco
> fingebat solio . . .
> . . . speculi nec vultus egebat
> iudicio; similis tecto monstratur in omni
> et capitur quocumque videt. dum singula cernit
> seque probat . . . (*Epithalamium* vv. 99–100, 106–9).

[54] For a general account, see Bowersock (1990).

[55] It might be remarked that, as in Ovid's *Heroides*, briefly discussed in chapter 4, the world of mythology (in both art and text) is here used to construct a space where the normally objectified female can speak, look back, or find a space of identification. The mythical world had the huge advantage of being "real" but at the same time of a different order from the reality of normative social convention (the space of lover, wife, and mistress in elegiac poetry or of wife and husband in late antiquity). As far back as Greek tragedy, mythical women had been used to stage unconventional and nonnormative responses to social conditions.

[56] See Cameron (1970), 93–94, 99–102. For discussion of the quoted passage, see Frings (1975), 56–61.

Venus was seated on her glorious throne, adorning her hair. . . . Her face did not fail the mirror's judgement; her likeness was reflected throughout the whole palace, and wherever she looked, she was charmed, while she surveyed each detail and approved her beauty.

Here the goddess—self-absorbed in her toilette—finds her beauty reflected throughout her abode and is herself captivated by it wherever she turns to look. This self-reflexivity of divine love (combined with images of Triton, vv. 137 and 180, and nude nereids, vv. 159 and 171) is called upon to bless the imperial union and pray for its fruitfulness (vv. 339–41), despite the strongly Christian convictions of the young emperor. Together Claudian's poem and the Projecta casket bear witness to a brief moment of equilibrium between the ancient hellenistic culture of Rome and the new Christian ascendancy which was soon to begin the long extirpation of such pagan ways of thinking.

Art and the Mediation of Discourse

Just as the juxtaposition of the picture of Venus with the inscription of Christ walks a tightrope across a chasm of what would soon become insoluble cultural exclusivities, so many of the other themes on the casket raise issues of complex and even contradictory discourses in late antique Rome. Beautification itself is always about the clash between the naturalness of bare beauty and the artificial nature of beauty's construction through adornment. It implies both the possession of an engaging physical presence and a social positioning within a rhetorically complex public discourse of value judgments, approbation, and disapproval.[57] Likewise, the motifs of adornment and bathing embody a multiplicity of rhetorical contradictions. As I have suggested, neither theme was simple or unambiguous in Roman culture. While the rhetoric of adornment implies a potentially falsifying presentation of the woman, that of bathing hints at the improprieties of nudity and hence at immorality.

Moreover, the act of bathing appears to undo everything that adornment seeks to establish. Venus is naked and cleansed of all the clothes and unguents which the casket's body presents "Projecta" as putting on. In this removal of adornments, the body which emerges is more beautiful still—in the case of the casket's imagery, it is divine. In an episode from the second-century A.D. novel by Chariton, the heroine Callirhoe is shown in the bath:

They went in and rubbed her with oil, and wiped it off carefully; when she undressed they were even more awestruck—indeed, although when she was

[57] For an elegant formulation of these issues in the context of a later period, see R. Jones (1995), 30.

clothed they admired her face as divinely beautiful, when they saw what her clothes covered, her face went quite out of their thoughts. Her skin gleamed white, sparkling like some shining substance; her flesh was so soft you were afraid even the touch of a finger would cause a bad wound. (Chariton, *Chaereas and Callirhoe* 2.2)

In the novel, this bath is the prelude for Callirhoe's visit to the shrine of Aphrodite near Miletus, where a local aristocrat, Dionysius, will see her and fall in love—despite the slave's clothing in which Callirhoe is dressed. Effectively, the motifs of dressing and bathing, of created and natural beauty as well as of concealed and exposed beauty, work to generate desire. The casket's use of the same themes appears to tell a similar tale, this time evoking the chronologies of seduction—the use of dress and ornament as a prelude to their removal, the use of washing and nudity as a preparation for dressing. What is figured here is not a single idealized moment of a lifetime (the wedding procession itself, for instance, or a novel's key moment of the first sighting of lovers) or a particular or generalized "preparation of the bride," but rather the constant oscillation of the wife between being matron and being Venus, between robing and nudity, within a married life in which (at least on the fronts depicted within the casket) she is to some extent empowered.[58]

The use of the contrast between Venus and "Projecta" to express these themes marks a significant difference between the Projecta casket's iconography of the boudoir and that of the frieze on the body of the casket from the Sevso treasure (figures 8.13 and 8.14). In the latter, the seated woman being adorned (figure 8.13) is placed in the center between two sets of four standing figures, all apparently female (although the child holding an oval basket or basin immediately to the lady's right could be a boy perhaps even another eunuch).[59] As on the Projecta casket, a maid holds an oval mirror, in this case to the lady's left. On the other side, between curtains, is a bathing scene showing a woman undressing with the help of an attendant and two naked women standing on either side of a basin (figure 8.14).[60] In the Sevso casket, the themes of bathing and adornment are both more down to earth, even documentary, and more troubling than in the Projecta casket. For the problematic issue of a real woman's nudity is neither disguised by the frisson of the naked Venus glimpsed amid the waves and sea beasts nor elevated to the grandeur of

[58] A late antique literary parallel for this oscillation is the presentation of Hero in Musaeus' epyllion as "virgin by day, woman by night" (*Hero and Leander* 287), on which see Morales (1999), 56–60.

[59] See Mango and Bennett (1994), 464–71, for this scene in general. They believe the figure to be a girl (468–69), but the long dress and hair parallel the clean-shaven male torchbearers on the left end of the base of the Projecta casket.

[60] See Mango and Bennett (1994), 471–73.

FIGURE 8.13. Casket from the Sevso treasure: On the base, a lady seated at her toilette between attendants carrying various accoutrements of the toilette; on the lid winged erotes between wreaths and masks. Late fourth century A.D. (Photo: Courtesy of the Marquess of Northampton 1987 Settlement.)

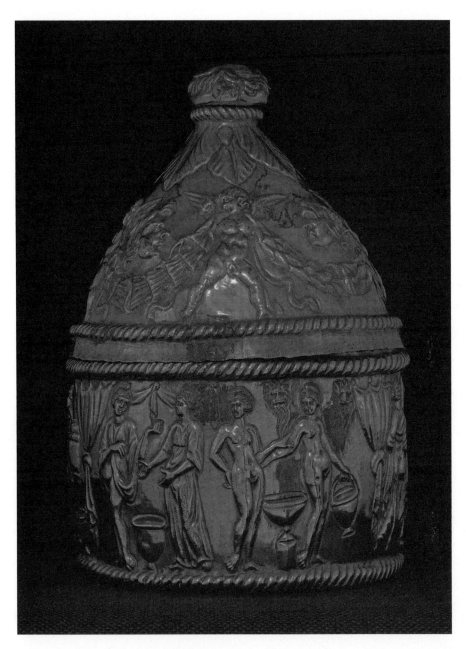

FIGURE 8.14. Sevso casket: Four female figures between curtains in the process of bathing. To the left, a lady undressing with the help of a maid; to the right, two nudes. (Photo: Courtesy of the Marquess of Northampton 1987 Settlement.)

a divinely inspired eroticism, as suggested by the Projecta casket. While the Sevso casket may offer a certain voyeurism to male viewers, it does not play with anything like the same elegance or subtlety on the variety of desires elicited by the imagery on the casket from the Esquiline treasure.

The movements of desire in the Projecta casket and its visual placing of itself in an ideal, pastoral world—where the colonnade of the base is framed by fruitful grapevines, with flowers, birds, and baskets of fruit above the arches, while the lid combines the divine world of Venus with the household's procession on the back and the marital portrait between cupids on the lid—raise interesting questions of viewing. The casket both reflects the "real" world of the toilette (of which it was part) and idealizes it through the mirror of Venus. The imagery shows the household both as it was and as it might be imagined to be—which was of course something very different from the reality. Within this world of enchanted simulations,[61] the casket figures the desires and seductions of the home (with extreme decorum, one should say, by contrast with other much more plainly pornographic Roman silverware).[62] This seduction extends beyond the imaginary world of the casket itself to its viewers, male and female. The casket simultaneously objectifies women (or, more correctly, offers the viewer the opportunity to objectify them) and elicits responses of identification with women.[63] It effectively creates a space of multiple viewing positions accommodating the various desires of multiple viewers (differentiated not just by gender but also by class). In a single object, albeit one very richly decorated, the casket makes its own visual argument within a series of contrary discourses and rhetorics—in relation to religion, gender, beauty, and adornment. The tenor of this argument is to accept, even to foreground, apparent contradictions in the cultural rhetoric of the period, but at the same time to find ways of holding them together in simultaneous and even mutually fruitful play.

[61] Cf., for thoughts on simulation and seduction, Baudrillard (1990), 60–71.

[62] For instance the first century A.D. Warren cup, now in the British Museum, although admittedly its context is sympotic rather than of the boudoir, and its iconography is homosexual. See J. R. Clarke (1993) and Pollini (1999).

[63] For a discussion of some of these issues in relation to Titian, see Zorach (1999), 245–48.

VIEWING THE GODS

The Origins of the Icon in the Visual

Culture of the Roman East

ACCORDING TO THE *Historia Augusta*, when the emperor Aurelian (A.D. 270–275) had taken over the rebellious town of Tyana in Cappadocia in the eastern part of Asia Minor and was considering the slaughter of its inhabitants, he was visited in his tent by a sacred vision (*HA, Divus Aurelianus* 24.2–9).[1] The deified first-century holy man Apollonius of Tyana, recognizable because he manifested "in the form in which he was usually portrayed," appeared to the emperor and persuaded him to spare the lives of his "fellow citizens" of Tyana. As proof of his divine versatility, Apollonius addressed Aurelian in Latin rather than Greek, "in order that he might be understood by a man from Pannonia." Aurelian, we are told, "recognized the countenance of the venerated philosopher, and, in fact, he had seen his portrait in many a temple. And so, at once stricken with terror, he promised him a portrait and statues and a temple, and returned to his better self."

This story—whether strictly "true" or not (and the *Historia Augusta* is a distinctly unreliable source)—points to a remarkable continuity in the ancient imagination between the sacred arts of the pagan east and their Christian successors. The eastern empire, in its early Byzantine incarnation, has long been seen as the crucible in which were formed such particular Christian forms of visual representation as icons (see figure 3.1, plate I).[2] The worship of icons, one of the more characteristic manifestations of medieval spirituality,[3] was to

[1] With Homo (1904), 91–92; Brandt (1995), 111–12; Paschoud (1996), 140–41; and A. Watson (1999), 72.

[2] See, for example, Cormack (1985, 1997), Brubaker (1995), Maguire (1996), and Eastmond and James (2003).

[3] See especially Belting (1994).

become a substantial arena for theological debate from the fourth century until the Iconoclastic controversy of the eighth and ninth centuries,[4] and beyond. One specific use of Christian icons was as a means for visualizing the holy. Just like Apollonius, whom Aurelian recognized from his resemblance to his statue, visions of Christian saints were recognized by their worshippers from their likeness to their icons.[5] Like Apollonius, whom the emperor propitiated with "a portrait and statues and a temple," the Christian saints were offered portraits in the form of icons and churches by their grateful or fearful worshippers.

Nothing now appears to survive of the temple erected at Tyana on the site of the sage's birth, a temple which was—according to Apollonius' third-century A.D. biographer, Philostratus—"singled out and honoured with royal officers, for the emperors have not denied to him the honours of which they themselves were worthy" (Philostratus, *Life of Apollonius of Tyana* 8.31, trans. Conybeare, also 1.5). But we know from later sources of a persistent tradition of magical talismans associated with Apollonius which circulated throughout the Christian east,[6] of pilgrimage to his shrine at Tyana—which attracted among others the earliest known Christian pilgrim to the Holy Land (*Itinerarium Burdigalense* 578.1)—and of Apollonius' place in the hierarchy of late pagan sages as, for example, a figure portrayed in the fourth-century contorniate medallions issued as tokens of exchange by the Roman aristocracy (figure 9.1).[7] Apollonius of Tyana, once a man but now a divine being, had become by the third century a miracle-working and oracle-producing deity typical of imperial Roman polytheism: he attracted pilgrims, offered visions, and blessed the social interrelationships of late antique Roman citizens. The world evoked by his images and their use is the world of religious visual culture in the Roman east.

One feature of the *Historia Augusta*'s interview between Apollonius and Aurelian is of particular interest. It presents, in a Latin text designed to be read in the Latin-speaking west, a perhaps surprising instance of a Roman emperor—albeit still alive and not yet a *divus*—subordinate to an eastern sage. Like Philostratus' *Life of Apollonius*, in which the much traveled sage is cast as the Greek holy man who counsels, confronts, and triumphs over various Roman emperors (from Nero via Vespasian and Titus to Domitian) and who inaugurates a religious revival in the Roman empire before ascending into divinity,[8] Aurelian's interview at Tyana hints at a new east-centered

[4] See, for example, Pelikan (1990), Barasch (1992), and Barber (2002).
[5] See Kazhdan and Maguire (1991), 4–6, and Dagron (1991), 31–33.
[6] See Dzielska (1986), 99–127.
[7] See Settis (1972), 244–47, and Alföldi, and Alföldi, (1990), 53–55, 102–3.
[8] See, for example, Elsner (1997) and Swain (1999).

FIGURE 9.1. Apollonius of Tyana, bronze contorniate medallion from Rome (obverse), diameter 3.7 cm. Fourth century A.D. The inscription reads APOLLONIUS TEANEUS. Bibliothèque Nationale, Cabinet des Médailles, Paris. (Photo: Cabinet des Médailles.)

cultural dynamic. In the second and third centuries A.D., the eastern provinces subject to Rome began to assert their independence of the west—even their dominance within the empire—through religious proselytism rather than through political control, through the promulgation of sacred cult rather than through temporal power. Whether this process appears on the high imperial level of Elagabalus' attempting to transfer his Syrian god Elagabal to Rome or on the more populist dissemination of eastern cults throughout the empire, there is little doubt that the second and third centuries saw the east "strike back" at its western conqueror through religion. This was not, so far as we can tell, a program planned through the agency of any particular individuals; rather it was an aspect of a cultural phenomenon, the so-called Second Sophistic,[9] in which the unity of the empire was reasserted in Greek-speaking cultural terms through the revival of Greek rhetoric and philosophy, the promulgation of eastern mythology and *paideia*, and the affirmation of eastern religions and iconographies. The highly symbolic icons produced by eastern religions were a prime means by which the propagation of such cults was achieved.

To follow some of the implications of Aurelian's vision of Apollonius, I trace a double theme: the visuality of deities (what might be called the pagan prehistory of the icon) in the Roman world and the east's self-assertion against the center through religion. For the worship, cultivation, and visionary experience of Christian sacred images have their roots in the extraordinary and generally neglected culture of image-worship, pilgrimage, and sacred art generated by the polytheism of the Roman east; and the eventual triumph of Christianity, in many ways (including in its eccentricities) a typical eastern cult, was

[9] See the seminal discussions of Bowersock (1969, 1974) and Bowie (1970). A terrific brief and up-to-date introduction is Whitmarsh (2005), building on the fundamental work of G. Anderson (1993), Swain (1996), Schmitz (1997), and Whitmarsh (2001). See Müller (1994), 139–70, and several of the essays in Borg (2004b) for some visual issues.

prepared by the ascendance of the eastern cults in the later Roman world, propagated through images and rituals.

In fact these two apparently divergent implications of Aurelian's vision—the prehistory of the icon and the intimation of eastern resistance to the center—are more closely connected than appears at first. I shall argue that the visual propaganda of iconographically idiosyncratic eastern "icons" (from mystery cults like mithraism and Christianity as well as from more civic religions like the worship of Ephesian Artemis or the Syrian Goddess) was disseminated throughout the Roman empire in part as a parade of the east's difference from and hence resistance to Rome. Here the excellent literature on the development of communal and cultural identity in the east needs to be supplemented with an emphasis on visual culture as a prime signifier of identity.[10] The importance for the history of Christian art of this empirewide growth in the cult of pre-Christian icons is twofold. First, the origins of Christian art appear to have been motivated by visual competition with the symbolic arts of the other cults.[11] Second, the visual impetus behind the process of Christianization after the fourth century borrowed its methods from the cults which Christianity supplanted, in particular a reliance on the dissemination of sacredly "loaded" imagery as a marker of cult identity.

"GREAT IS ARTEMIS OF THE EPHESIANS"
(Acts of the Apostles 19.28)

The God and Her City

About a decade before Aurelian's vision of Apollonius at Tyana, another city in Ionian Asia Minor which revered Apollonius among its gods[12] suffered a catastrophe. The Gauls, who had taken advantage of the military and political crisis in the Roman empire during the middle years of the third century A.D., sacked the wealthy coastal city of Ephesus and destroyed its famous temple of Artemis in about 262. One of the fabled "seven wonders of the world," the temple of Artemis Ephesia and its famous cult image (see figures 9.2 and 9.3 for some Roman-period versions of this statue) had been an archetypal site of pagan religious activity since archaic times.[13] It was a major pilgrimage center, lauded in at least one Greco-Roman epigram as the pinnacle of sights:

[10] On identity in the east, for example, Millar (1987, 1993); 225–36; Alcock (1993); and Woolf (1994).

[11] See Grabar (1968), 27–30; Mathews (1993), 3–10; and Elsner (2003b), 73–75.

[12] See Oster (1976), 26–27, and (1990), 1684–85.

[13] On the seven wonders, see Clayton and Price (1988) and Brodersen (1992).

I have gazed on the walls of lofty Babylon with its chariot road,
and the statue of Zeus by the Alpheus,
the hanging gardens and the colossus of the Sun,
the huge labour of the high pyramids,
and the vast tomb of Mausolus; but when I saw
the house of Artemis which mounted to the clouds,
those other marvels lost their brilliancy and I said, "behold,
except Olympus, the Sun never looked on anything so grand."
(Antipater of Sidon in the *Palatine Anthology* 9.58)

The worship of the goddess had many manifestations and was utterly integral to the cultural and political life of the city of Ephesus.[14] It was also perhaps the prime sanctuary in all Ionia, as Pausanias informs us: "The land of the Ionians has the finest possible climate, and sanctuaries such as are to be found nowhere else. First of these, because of its size and wealth, is that of the Ephesian goddess" (7.5.4). Earlier in his *Description of Greece*, Pausanias writes:

> All cities worship Artemis of Ephesus, and individuals hold her in honour above all the gods. The reason, in my view, is the fame of the Amazons, who traditionally dedicated the image, also the extreme antiquity of the sanctuary. Three other points as well have contributed to her renown, the size of the temple, surpassing all buildings among men, the eminence of the city of the Ephesians and the renown of the goddess who dwells there. (4.31.8)

Here the preeminence of the Ephesian Artemis is presented in a sacred topography which leads from the actual image, with its famed mythic dedicators and sanctuary whose origins are lost in irrecoverable antiquity, to the house of the image—the temple which (as in Antipater's poem) "surpasses all buildings among men"—and culminates in the city itself where the temple stands. This interrelationship of image, temple, and city—that is, of deity, the house of the deity, and the worshippers most closely identified with her—is of central significance to sacred images in pagan antiquity. The interrelationship was expressed not only spatially, as in Pausanias' brief account, but also as a series of liturgical or processional rituals which actively linked the urban spaces of the city with the "goddess who dwells there."[15]

An inscription of the early second century A.D., carved in both the theater and the Artemisium of Ephesus (perhaps the city's most public and most

[14] For overviews of the city in the Roman period, see Scherrer (1995) and White (1995). For a brief summary of the cult of Artemis in Roman times, see Knibbe (1995), which builds on his fundamental archeological work in Ephesus—Knibbe and Langmann (1993) and Knibbe and Thür (1995).

[15] Cf. Price (1984), 101–14.

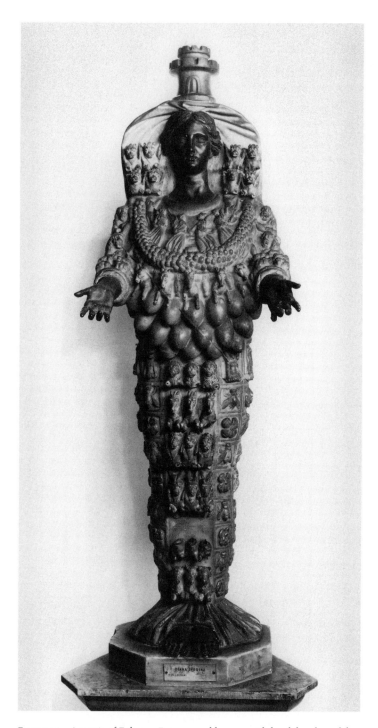

Figure 9.2. Artemis of Ephesus, Roman marble copy with head, hands, and feet of bronze. 1.15 m in height. Imperial, perhaps second century A.D. Museo Conservatori, Rome. (Photo: Schwanke, DAI 80.3343.)

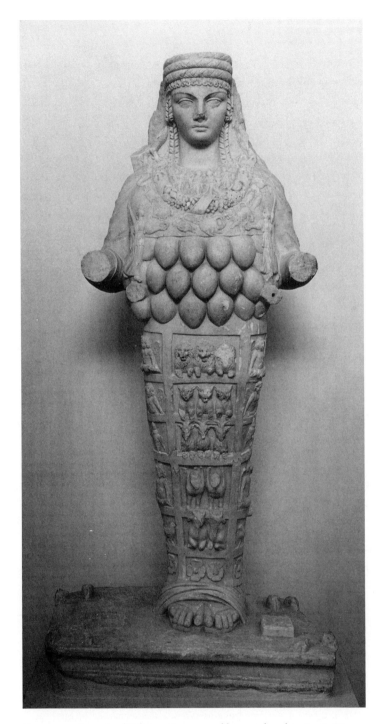

FIGURE 9.3. Artemis of Ephesus, Roman marble copy found in Leptis Magna, Libya, in 1912. 1.57 m in height. Second century A.D., perhaps Hadrianic. Tripoli Museum, Libya. (Photo: Koppermann, DAI 61.1728.)

sacred spaces), records a bequest made to the *boulē* and *dēmos* of the Ephesians in A.D. 104 by a wealthy Roman *eques* named Caius Vibius Salutaris.[16] The inscription dedicates to Artemis thirty-one statue-types made mainly of silver, but some gilded and one of solid gold. These were to be carried in a procession—"a conveyance before everyone, from the temple to the theatre and from the theatre into the temple of Artemis."[17] This procession went through the heart of the city, beginning and ending at its most sacred temple; it appears to have been repeated on sacred and festal days roughly every two weeks[18] and was linked with the distribution of public doles and lotteries.[19]

The images in the Salutaris bequest represented not only Artemis herself but also the emperor Trajan, his empress Plotina, the Roman Senate, the Equestrian order, and the people of Rome, as well as some fifteen statues which personified the tribes, *boulē*, and city of the Ephesians. In effect, the evidence of this one private (if very generous) bequest portrays a civic culture centered on the Ephesian goddess, where the city, its myths, and its very place within the wider context of the Roman empire were remembered and reenacted through the rite of the public procession of images.[20] The sacred identity of Ephesus as myth, ritual, and space was continually reaffirmed in this repetition. We cannot know how long the Salutaris processions continued after the donor's death (although the grand inscriptions announcing the dedication have survived to the present day) or whether the statues carried through the city ever changed (for example, with the addition of images representing the emperors who succeeded Trajan and Plotina). Salutaris' foundation was only one of many such bequests and rituals,[21] and in some respects it may have been exceptional. But it vividly brings to life a culture of images—visual embodiments of the sacred and political world—which could be used symbolically to reenact the myths which linked Ephesian Artemis with her city and to perpetuate ritually the harmonious existence of the city within the empire. The culture of urban liturgy anticipates very similar sacred practices in early Christian times,[22] including, in particular, the parading of icons and relics in cities like Constantinople and Rome.[23]

[16] See the discussion of Rogers (1991).

[17] *IE* 27.90–92: Rogers (1991), 156–57.

[18] Rogers (1991), 80–115.

[19] Ibid., 39–72.

[20] Knibbe's comment, "the procession funded in 104 CE by C. Vibius Salutaris has no relationship to the cult of Artemis" (1995, 154), is only true on the most schematic and reductive of definitions of the relationship of private dedications and processions to the temple and its cult. Needless to say, I think it oversimplifies.

[21] For analogous examples, see Rogers (1991), 186–90.

[22] See especially Baldovin (1987).

[23] With Belting (1994), 47–77; Limberis (1994), 45–97.

An evocation of the atmosphere of processions like that of Salutaris is given in the second-century A.D. description of a festival of Artemis Ephesia in a novel, the *Ephesian Tale of Anthia and Habrocomes*, by Xenophon of Ephesus:[24]

> The local festival of Artemis was in progress, with its procession from the city to the temple nearly a mile away. All the local girls had to march in the procession, richly dressed, as well as all the young men. . . . There was a great crowd of Ephesians and visitors alike to see the festival, for it was the custom at this festival to find husbands for the young girls and wives for the young men. So the procession filed past—first, the sacred objects, the torches, the baskets and the incense; then horses, dogs and hunting equipment. . . . And when the procession was over, the whole crowd went into the temple for the sacrifice, and the files broke up; and men and women, girls and boys came together. (1.2–3)

Although the romantic emphasis is related to the theme of Xenophon's love story, the carnivalesque enthusiasm in which the normal distinctions of age, society, and sex were broken down in the fervor of ritual points to the function of such festivals in attempting to unify the diverse interests of the local community in a single identity. The whole of Xenophon's novel is ultimately a testament to Artemis' care for her devotees, even in adversity; and it ends with the lovers Anthia and Habrocomes, finally reunited, dedicating "an inscription in honour of the goddess, commemorating all their sufferings and all their adventures" (5.15).

The central focus of these various forms of civic and sanctuary ritual was the famous cult image of Artemis. To understand the full range of meanings and social significances which a statue of this prestige came to embody and to symbolize, we have to look beyond it to some of the roles and implications of the Ephesus temple. First, the Artemisium was both ritually and spacially apart from the city; this very peripheral quality served to enhance its centrality as sacred guarantor for a whole range of highly civic activities. The rituals and taboos surrounding the temple served to demarcate and enhance the sanctity of the deity by emphasizing the god's liminal position beyond ordinary space, in a location which needed a special (ritualized) means of approach, and beyond ordinary time, since the origins of the sanctuary lay in mythic tradition. At the same time, rituals like the Salutaris procession linked the goddess with the temporal world outside her temple by taking images of Artemis around the city and by taking images of the city and the empire into the Artemisium.

[24] On the uses of Ephesus by the ancient novelists, see C. M. Thomas (1995).

A vivid account of some of the taboos surrounding Ephesian Artemis can be found in Achilles Tatius' second-century A.D. novel *Leucippe and Clitophon*, whose climax is set in Ephesus:

> From ancient days the temple had been forbidden to free women who were not virgins. Only men and virgins were permitted here. If a non-virgin woman passed inside, the penalty was death, unless she was a slave accusing her master, in which case she was allowed to beseech the goddess, and the magistrates would hear the case between her and her master. If the master had in fact done no wrong, he recovered his maid-servant, swearing he would not bear a grudge for her flight. If it was decided that the serving girl had a just case, she remained there as a slave to the goddess. (7.13)

One must exercise some circumspection in using the evidence of fiction in history,[25] but there is little doubt that this passage—even if it does not tell the whole story—represents the kinds of religious regulations which would have come as little surprise to the novel's readers. Such precise rules about who might enter a temple and when, or about what sort of offerings might be made and to which images, are typical of Greek religious practice.[26]

What is of particular interest in Achilles Tatius' novel is the emphasis on Artemis' divine intervention in matters of law.[27] The statue of Artemis, spatially peripheral but spiritually central to the city of Ephesus, came to stand for a final divine insurance for the social life of the city and its dealings with the wider world. Underlying the cultural interpenetration of god and city was the shrine's economic and legal centrality. Both Leucippe and Clitophon (the novel's heroine and hero) seek asylum in the temple (7.13; 7.15; 8.2–3). The sacred nature of Artemis (rather like the name of Caesar in Apuleius' *Golden Ass* 3.29)[28] serves as a final court of appeal and a divine guarantee for justice, despite the shortcomings and machinations of human beings (see *Leucippe and Clitophon* 8.8–14).

Beside this function as ultimate legal arbiter, the sanctity of Artemis also served as a potent financial guarantee. Dio Chrysostom writes of the

> large sums of money . . . deposited in the temple of Artemis, not only money of the Ephesians but also of aliens and of persons from all parts of the world,

[25] For thoughts on fiction and history, see especially K. Hopkins (1993) and Bowersock (1994).

[26] Pausanias, for example, is full of similar quite specific injunctions about temple entry (Elsner, 1995, 144–50) and of equally systematic attention to the details of ritual, as we saw in chapter 2. In such careful ritual regulation—as in Achilles Tatius' careful distinction of free women into virgins and nonvirgins by contrast with slave women (who either have just cause or not, but need not be virgin)—the correct cultivation of the deity lies in the detail.

[27] See Oster (1976), 35–36.

[28] C. M. Thomas (1995), 98–106. Cf. Price (1984), 192–93, for other examples of asylum.

and in some cases of commonwealths and kings, money which all deposit in order that it may be safe, since no one has ever dared to violate that place, although countless wars have occurred in the past and the city has often been captured. (*Oratio* 31.54)

Although Dio exaggerates the safety of the Artemisium (and demonstrates why it should have been so appealing to the Gauls), his comments give a sense of the security inspired by the goddess. As a financial center, the sanctuary of Artemis not only held money but made money through mortgages, loans carrying interest, and other financial services.[29] In these financial and legal dealings, the image of the goddess stood as a talisman for divine sanction and security. Apart from her particular iconographic form and religious meanings, one aspect of the statue's significations was as the ultimate arbiter of all these civic activities.

The God and the Roman World

Although the great statue of Artemis which was the ultimate cult focus for these varied activities—religious, financial, and legal—has not survived, it is striking that it was repeatedly copied throughout Greco-Roman antiquity,[30] from as early as Xenophon's private shrine at Scillus near Olympia in the fourth century B.C.[31] These copies (ranging from large-scale marble replicas to small bronze or terracotta statuettes to gems and coins) allow us to make some sense of the appearance of the original cult image.[32] The statue was a *xoanon* made of wood, with only face, hands and feet visible to the viewer, peeping beyond robes whose designs offered a highly symbolic iconography. In some copies (for example, figure 9.2), the blackened color of the original's wooden head and extremities (constantly treated with oil) is rendered by the use of bronze. The most famous feature of the iconography are the "breasts"—so called in Christian polemical attacks on the idol—whose pagan significance and even correct identification have never been sufficiently explained. But it is clear that the goddess's robes included references to the natural world (in the images of a large number of animals, including horses, lions, and bulls as well as mythical beasts such as griffins) and to the cosmological or astrological order (in the zodiac on the breast of figure 9.3, for instance). In a number of versions, the Ephesian Artemis wears a lofty *polos* crown, or *kalathos* (figures 9.2, 9.4b, 9.5b, 9.7, 9.9, 9.10), and fillets hang from her wrists (figures 9.4b, 9.5b, 9.7, 9.8, 9.10).

[29] See Oster (1990), 1717–19.

[30] See Fleischer (1973, 1978, and 1984); also Seiterle (1979), Portefaix (1994), Brenk (1998), Karwiese (1999), and Szidat (2004).

[31] See Gaifman (2006), 274–75, with further bibliography at n.76.

[32] For example, Fleischer (1984), 762–63.

FIGURE 9.4. a and b. Silver coin (cistophoric tetradrachm) with Claudius on the obverse (bearing the legend TI CLAUD CAES AUG) and the temple of Artemis at Ephesus on the reverse (bearing the legend DIAN EPHE). The cult statue of Artemis (Diana) is shown in characteristic form, with fillets hanging from her wrists and polos crown on her head, standing in the center of her temple, which is represented as a tetrastyle building on a four-stepped podium with a decorated pediment. Mint of Ephesus, probably A.D. 41–42. British Museum, London (BMC Claudius 229). (Photo: British Museum.)

FIGURE 9.5. a and b. Silver coin (cistophoric tetradrachm) with Hadrian on the obverse (bearing the legend HADRIANUS AUGUSTUS PP) and the cult statue of Artemis in the reverse (bearing the legend DIANA [EPHESI]A COS). The cult statue, wearing veil and polos crown, stands between two stags, with fillets hanging from her wrists. Mint of Ephesus, 130s A.D. British Museum, London (BMC Hadrian 1085). (Photo: British Museum.)

Large replicas of the Ephesian goddess appeared in temples throughout the Roman empire from the near east and Greece to Africa, Italy, and Gaul. The stereotypical replication of what was visually and iconographically a highly idiosyncratic statue was part of a deliberate missionary expansion of the cult of the Ephesian Artemis,[33] whereby sanctuaries were established throughout the

[33] See Oster (1990), 1703–6.

FIGURE 9.6. a and b. Bronze coin with bust of Septimius Severus on the obverse (bearing the legend ΑΥ ΚΑΙ Λ ϹΕΠ ϹΕΟΥΗΡΟϹ ΠΕΡ) and, on the reverse, the tetrastyle temple of Ephesian Artemis containing her statue flanked on either side by a distyle temple in each of which is nude male statue (probably) of the emperor resting on a sceptre (bearing the legend ΕΦΕϹΙΩΝ ΠΡΩΤΩΝ ΑϹΙΑϹ). Late second or early third century A.D. British Museum, London (BMC Ionia, Ephesus 261). (Photo: British Museum.)

Greco-Roman world.[34] Of the examples illustrated here, figure 9.2 is probably from Rome,[35] while figure 9.3 comes from Leptis Magna in North Africa;[36] both are likely to have been made in the second century A.D. They indicate that while some aspects of the iconography (the pose, the "breasts," the animals depicted on the goddess's body) were standardized, others (such as the color of the face) could vary from replica to replica. In the more schematic versions (for example, figures 9.4–9.10), the pose, "breasts," fillets, and crown appear to be the most significant identifying features. In every case, from the very schematic to the most elaborately finished, what is striking is the image's particularity in the pantheon of Greco-Roman deities—its visual difference from the more naturalistic norms of representing ancient deities.

In addition to this network of Ephesian sanctuaries and statues spread throughout the empire, the cult center at Ephesus produced a plethora of small images to be distributed outside the city. The range of items includes coins struck in the imperial mints of Ephesus, whose celebration of the goddess was a tribute to the financial clout of her sanctuary as well as to the sacred significance of her shrine, and tokens made for the pilgrims who visited Artemis' shrine to take home with them. The coins, struck in the names of a variety of emperors from Claudius in the first century to Valerian and Maximus in the third, testify to the continued importance of the temple until the Gallic sack.[37]

[34] See Wernicke (1895), 1385–86.
[35] See Stuart Jones (1926), 51–54, and Thiersch (1935), 24–26.
[36] See Thiersch (1935), 38–51.
[37] On the coins, see ibid., 78–85, and Price and Trell (1977), 127–32.

FIGURE 9.7. Artemis of Ephesus, center, with a deer on either side of her, between busts of Helios and Selene (facing her) and a Nemesis of Smyrna on each side. Sard gem. 19 × 15 mm. Second century A.D. British Museum, London. (Photo: British Museum.)

They show the cult image of Artemis Ephesia, the goddess in her temple, or the goddess and temple flanked by other temples—for instance belonging to the imperial cult (figures 9.4–9.6).

The earlier coins imply both an imperial acknowledgment of the importance of a provincial eastern cult and a civic alignment on the part of the Ephesians with the charisma of the imperial center, where the image of Artemis (standing for the city of Ephesus) proudly decorated the reverse of coins with the imperial portrait (figures 9.4–9.5). These coins of the first and early second centuries A.D., inscribed in the Latin language of the conquering foreigner (just as Augustus' *Res Gestae* was inscribed in Latin at prime sites in the cities of Asia Minor),[38] place the balance of emphasis on the east's dependence on—or alignment with—the western emperor. But the pattern of priority is interestingly reversed in later coins (such as figure 9.6), where temples to the imperial cult nestle around the temple of Artemis—as if drawing their sacred charisma from hers. Such later imperial coins, inscribed not in Latin but in Greek, and often supporting the claims of emperors with eastern

[38] For discussion, see Elsner (1996c).

FIGURE 9.8. Artemis of Ephesus, bronze statuette. 0.11 m in height. Imperial period. Museo Civico, Bologna. (Photo: Fuhrmann, DAI 34.1152.)

connections (like Septimius Severus or Elagabalus) attest to a transformation in the weight of charismatic authority from the imperial center toward the peripheral cult.

While the coins emphasize the continuing public significance and imperial appropriation of the Artemis cult at Ephesus in the visual politics of state propaganda, the many surviving small-scale statuettes and gems depicting Artemis Ephesia give vivid material evidence for the personal impact of the goddess on her numerous pilgrims and worshippers. Such objects—gems (for example, figure 9.7)[39] and statuettes which survive in bronze (for example, figure 9.8)[40] and in terracotta (for example, figures 9.9 and 9.10)[41]—are

[39] On gems, see Thiersch (1935), 70–77.

[40] On the bronze statuettes, see ibid., 56–57; Fleischer (1973), 25–27; and Fleischer (1984), 762.

[41] On the terracottas, see Thiersch (1935), 58–62; Fleischer (1973), 27–34; and Fleischer (1984), 761–62.

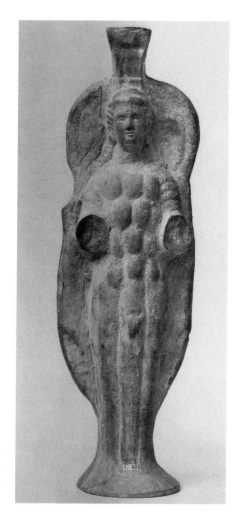

FIGURE 9.9. Artemis of Ephesus, terracotta stat-
uette from Ephesus. 0.25 m in height. Imperial
period. British Museum, London. (Photo: British
Museum.)

testimony to the kinds of pilgrimage souvenirs generated by important pagan
cults and taken home by pilgrims. In the case of the Ephesian goddess, these
sacred mementos appear to have been purchased mainly by relatively local
pilgrims from Asia Minor (if we are to accept the pattern of archeological
finds as evidence for the ancient distribution of such objects).[42] It is possible
that the gems were used as protective amulets and in magic.[43] The statuettes
(for example, figures 9.8–9.10) are, of course, considerably less grand than the
fine large-scale replicas of the cult statue—not only in size but in the relative
cheapness of their material, the rough quality of their workmanship, and the
fact that they were made by a process of mass production. They are highly

[42] See Fleischer (1973), 27–34. At length now on pilgrimage in the Greek and Roman worlds, see
the essays in Elsner and Rutherford (2005).
[43] Cf. Bonner (1950) and Philipp (1986).

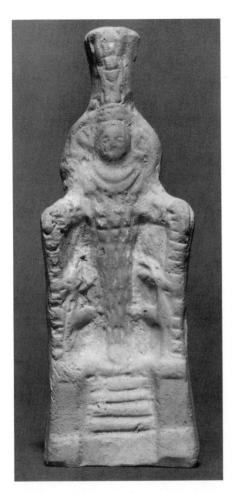

FIGURE 9.10. Artemis of Ephesus, terracotta statuette. 0.17 m in height. The back of the image is inscribed MAXIMOU. The find-spot is unknown. Imperial period. British Museum, London. (Photo: British Museum.)

schematic (certainly not exquisite miniatures), purchased as an act of devotion—like so many *linga* (the phallic cult form of the Hindu god Shiva) in modern Indian Shiva temples, or Virgin statuettes in the great pilgrimage centers of Catholic Europe or Latin America. They speak of the depth and range of the goddess's constituency in a class of worshippers not usually evoked by the evidence of our literary texts.

What all the images and coins have in common, despite the differences in expense, grandeur, and execution, is their iconographical particularity. They make stereotypical reference to one original and authentic statue of Artemis Ephesia, housed in the great temple at Ephesus. The wider their distribution, the more strongly the visual argument worked to focus the mind of the viewer, coin handler, or devotee onto that sacred statue whose correct cultivation at Ephesus, and in her shrines around the empire, helped to establish the continued prosperity of the city where she dwelt, the success of its relations with the outside world, and the general well-being of the empire as a whole.

The spread of the Ephesian cult, like that of so many other eastern and mystery religions in the periods of the Second Sophistic and late antiquity, was one way—perhaps a major way—in which the Roman east claimed its priority, even its superiority, over the empire which governed it. By the second century A.D., it would be possible for worshippers of Artemis Ephesia (wherever they lived) to see the heart of the Roman world as focused not around the political center (in Rome) but around the sacred center where their goddess dwelt. The same shift toward a sacred (and usually eastern) deity was, of course, open to devotees of other cults (such as Lucius in Apuleius' *Golden Ass* or Kalasiris in Heliodorus' *Aethiopica* 7.8, both of whom are worshippers of Isis)—and, not least, the Christians. Indeed, it is one of the marked features of the spirituality of the polytheistic east in the second century and after, that cultural resistance to Rome could be expressed as devotion to deities from the periphery, whose spread throughout the whole empire, whose offers of salvation, and whose iconography often carried cosmic allusions which gave them a claim to universal sovereignty in the spiritual if not the temporal realm. Such universal implications are present, for example, in the mastery of the astrological world implied by the zodiac above the "breasts" of figure 9.3 (a motif frequently repeated on the larger replicas of the Ephesia) and by the zodiacs which often encircle or arch over mithraic images (for instance, the bull-slaying scene from the London mithraeum).[44]

While the eastern religious cults, including that of Ephesian Artemis, were not backed by the kind of unifying religious organization apparent in the case of the state-propagated imperial cult,[45] their spread through the empire and their collective impact do have certain resemblances to the promulgation of emperor-worship.[46] Through religious expansion, the Roman east struck back at the imperial appropriation of its sacred and civic spaces. This was not a process of overt resistance; indeed, on the contrary, the eastern provinces incorporated the charisma of the center through upholding the imperial cult.[47] Rather, the religions of the east mastered a policy parallel to that of the imperial cult and modeled on it, whereby the local religions of the periphery (like that of Ephesian Artemis) or mystery cults (like those of Isis, Serapis, Cybele

[44] For a rich survey of examples, see Gundel (1992), with 150–52 on Artemis Ephesia. For mithraism, see, for example, Beck (1988).

[45] See Price (1984), 130–31; Friesen (1993), 142–68; and especially Gradel (2002), 73–108, on the spread of the imperial cult in Italy with specific discussion of its uniformity in the *municipia* at 97–103.

[46] For instance, one might note the slippage of the term "neokoros" (literally, "temple warden") in the sense of a city's relation to a prestigious cult (for instance, that of Ephesus to Artemis) to meaning also its relation to the imperial cult. On Ephesus, see Friesen (1995), 230–36. On the terminology of "neokoros," see Price (1984), 64–65 and n. 47; Friesen (1993), 1–3, 50–58; Friesen (1995), 230–31.

[47] See Price (1984), 205–6.

and Attis, Mithras, or Jesus) were promulgated on an empirewide basis.[48] "Resistance" in this sense, which I discuss further in chapter 10, represents not an active manning of barricades or fomenting of rebellion (as in the earlier case of, say, the Jewish wars), but lies rather in the provision of religious identities on an empirewide basis but with their center or origin provocatively located on the empire's eastern periphery. Such religious identities provided a space of more intense or exclusive subjectivity to those who subscribed to them than did the normal rituals of Roman citizenship. Ultimately, one such form of eastern initiate identity—Christianity—would (like the proverbial poacher turned gamekeeper) cease to represent a culture of silent resistance and take over the establishment.[49] It is ironic that the model for the universal spread of these cults was the earlier spread of the imperial cult.[50]

All these religions, through their highly symbolic and non-Roman iconographies, their mythologies, and their cosmological systems rooted in often iconographic allusions to non-Greco-Roman sacred myths, foregrounded their origins and identities as *eastern* cults.[51] For example, Mithras invariably and Attis frequently, as well as a number of recurring characters in Christian iconography from the Hebrews in the fiery furnace to the Magi, appear in Roman art wearing the Phrygian cap (figures 9.11–9.13). Thus iconographically they signaled their eastern genesis—at least to anyone who wished to notice such signals (for example, initiates). Specific visual allusions to non-normative forms of religious action (for instance, Mithras' sacrifice of the

[48] On these cults, see Ferguson (1970); Turcan (1989); and Beard, North, and Price (1998), 1:245–312.

[49] On the intimate relations of early Christianity and the imperial cult, see Brent (1999) and Friesen (2001).

[50] Scholarship on Roman Greece has recognized the resistance of Greece to many aspects of romanization (Woolf, 1994), in particular in areas of traditional cult (Alcock, 1993, 213–14). Such resistance in matters of religion was clearly offered by other conquered peoples in the empire, not least Jews (de Lange, 1978) and Druids (King, 1990). What I suggest here is a more sophisticated kind of spiritual subversion of the center in which the state's universalist strategy of supporting an imperial cult was emulated by the religions of the periphery in spreading their non-Roman cults with universalist claims throughout the empire. Although implicit non-Romanness was clearly far from being the only or main reason for following such religions, it may well have offered an added attraction for adherents. The effects of the tendency to universalism in the late empire (both from the center and from the periphery) were to encourage increasing syncretism and ultimately to prepare the ground for the monotheist universalism of Christianity (see Fowden, 1993, 37–60). See at greater length the argument in chapter 10 below.

[51] Cf. Liebeschuetz (1994), 195. In the case of mithraism, we need to refine the current orthodoxy that there was nothing Persian about Roman mithraism. This was established in the wake of the theories of Franz Cumont and his followers, who argued that Roman mithraism was an Iranian cult for which the texts of Iranian mazdaism could be used in order to elucidate its beliefs and practices (see especially the refutation of Gordon, 1975, and also Ulansey, 1988, 3–14). There may well have been nothing Iranian about the internal workings of Roman mithraism, but its iconography continually affirmed its claims to eastern (above all non-Roman) origins and values.

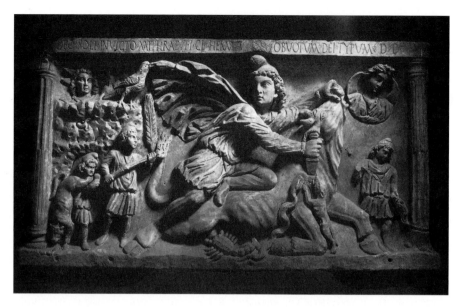

FIGURE 9.11. White marble relief of the tauroctony from a mithraeum in Rome, excavated in 1932. Mithras, in Persian dress, slays the bull, with the scorpion at the bull's genitals, and the dog and serpent licking the blood. To the left and right, respectively, are the torchbearers, Cautes and Cautopates, also in Persian dress. To the left is a grotto with Mithras (again in Persian dress) carrying the bull in front of its entrance and the raven perched above. The busts to left and right represent Sol and Luna. 0.87 × 1.64 m. Second half of the third century A.D. (Photo: Faraglia, DAI 34.227.)

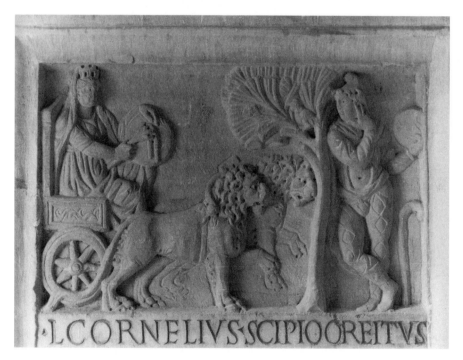

FIGURE 9.12. Marble altar from the Via Appia, Rome, with Cybele in a *biga* drawn by two lions and Attis in a Phrygian cap leaning against a pine tree. The altar, whose inscription records L. Cornelius Scipio Orfitus as the donor, is dated to 26 February A.D. 295. Villa Albani, Rome. (Photo: Felbermeyer, DAI 35.100.)

FIGURE 9.13. The marble sarcophagus of Adelphia, detail of the Magi in Phrygian dress before the Virgin and Child. From the catacomb of San Giovanni, Syracuse. Fourth century A.D. Museo Archeologico, Syracuse. (Photo: DAI 71.865.)

bull,[52] see figure 9.11) or to non-Roman mysteries (from the Incarnation to the "breasts" of the Ephesia) only added to the potential effect of otherness. Despite considerable syncretism, adaptation, and reinterpretation in a Roman context, Isis and Serapis always maintained a link with their Egyptian origins, Mithras in his Phrygian clothing appeared and claimed to be Persian, and Jesus—so often represented in connection with Old Testament typologies— was Palestinian-Jewish. Even Ephesian Artemis, who occupied a much more civic and less mystical point in the spectrum of eastern religions within the empire, insistently proclaimed her non- (or perhaps pre-) Greco-Roman identity through the imagery and iconography of her cult statue. Such religions, in particular the mystery cults, given their much more defined ethnic roots, more complex initiatory systems, and insistence on a stronger degree of personal faith than the imperial cult, had the potential for generating much more powerful systems of symbolic meaning, belief, and commitment—founded on complex salvific iconographies of the Other World—than did the loosely inclusive participation in state religion, which was much more rooted in broadly

[52] With Turcan (1981), 352, and Gordon (1988), 49.

accepted social norms. For these reasons, it is perhaps not entirely surprising that one of these cults—Christianity—would eventually replace the imperial cult as the official religion of the empire.

PILGRIMAGE AT HOME AND ELSEWHERE: PAUSANIAS AND LUCIAN

The double case for the importance of the arts in the religions of the eastern empire and for the use of such sacred art in a discourse of the east's self-affirmation can be made by looking at pilgrimage texts. We possess two remarkable writings in this genre from the polytheism of the eastern empire, both dating to the second century A.D.—texts that we have already had cause to use extensively in chapters 1 and 2. They are Pausanias' *Description of Greece* and Lucian's *De Dea Syria*.[53] Like Pausanias in Greece, the narrator of the *De Dea Syria*—who says he writes "as an Assyrian" (1), whether as Lucian himself or as his persona—tours a series of important sanctuaries in Syria (including Tyre, Sidon, and Byblos, 1–9) before coming to the sacred site of his prime interest, the temple of the Syrian Goddess at Hierapolis. Like Pausanias, the narrator of the *De Dea Syria* is a believer and participant in the religious activities he describes; his entire account ends with an affirmation of this in the following sentence (60): "When I was still a youth I, too, performed this ceremony [of offering one's beard] and even now my locks and name are in the sanctuary."[54]

Among several shared features, both these texts emphasize the processes of temple visiting as a key element of religious experience, presenting their narratives as first-person accounts whose validity is guaranteed by authorial autopsy. Both have a marked interest in matters of ritual, as we saw in chapter 2, in art—not only in its stylistic or iconographic particularities but also in its cultic functions—and in myths, as well as in wonders (whether natural, man-made, or supernatural). Both texts show a certain religious reticence or taboo in describing the most sacred parts of holy buildings or the most profound myths told about sacred places or images.[55]

In the case of both these texts, it is worth emphasizing their insistent parochialism. Other kinds of temple visiting in the Second Sophistic took the form of empirewide travel, such as Artemidorus' search for dreams "in the different cities of Greece and at great religious gatherings in that country,

[53] On the pilgrimage elements in these texts, see, on Lucian, Lightfoot (2005), and, on Pausanias, Elsner (1992), Rutherford (2001), and Hutton (2005a).

[54] On the end of the text, see Lightfoot (2003), 531–36; on pilgrimage in the *De Dea Syria*, see ibid., 514–31.

[55] On Pausanias, see Elsner (1995), 144–52.

in Asia and in the largest and most populous of the islands" (*Oneirocritica* 1.proem, cf. 5.proem). In marked contrast, Pausanias focuses single-mindedly on Greece and Lucian on Syria.[56] In each case, there is an assertion of a kind of sacred primacy about the locale described in the text. Pausanias' Greece—an idealizing version of the lost pre-Roman Greece, an amalgam of history, myth, and art which serves to create a canon—exists as a permanent metonymic link to a religious and mythical reality of archaic times, peopled by long-dead heroes, to which access is still available through ritual and through art. Lucian's Syria is a place of sanctuaries and temples, less ancient than those of Egypt but explicitly more venerable than those of Greece and Rome (2–3).[57] For example, "the sanctuary of Heracles at Tyre. This is not the Heracles whom the Greeks celebrate in story. The one I mean is much older and is a Tyrian hero" (3). In this rhetoric of parochial sanctity shared by Pausanias and Lucian, there is a distinctive quality of local self-assertion, presented in terms of what has been called a "landscape of memory."[58] A province on the periphery of empire is presented as the central focus for a sacred world of ancient and animated images, of ritual traditions, of myths reaching back to the beginnings of time. Whether this is to be read as a directly anti-Roman propagation of peripheral (that is, non-Roman, whether Syrian or Greek) spirituality is hard to determine. But it certainly fits with the visual rhetoric of "otherness" espoused with such success by the eastern cults in their spread through the Roman world.

The self-assertion of the east can be examined in Pausanias and in Lucian's *De Dea Syria* by looking at their detailed descriptions of some privileged cult statues. These images, the principal sacred focus of the main sites visited in these texts, not only epitomize the most visual aspects of pilgrimage but also provide a focus for the key myths and rituals evoked at a sacred center. In Pausanias, the great set-piece descriptions of chryselephantine cult statues also happen to be among his major ekphraseis of the "masterpieces" of Classical sculpture—the Athena Parthenos and the Olympian Zeus of Phidias (1.24.5–7; 5.10.2 and 5.11.1–9) and the Hera by Polyclitus at Argos (2.17.4)—as well as the Asclepius at Epidaurus (2.27.2) and Apollo at Amyclae (3.18.9–19.3).

[56] This kind of parochialism has often been equated with antiquarianism. This equation is correct, but elides the politics that may lie behind the choice of subject matter. For example, in a very different context, the Brothers Grimm's selection of *German* folktale as a subject for antiquarian scholarship had a crucial contemporary politics. It is here that Paul Veyne's excellent account of Pausanias as "the equal of any of the great German philologists or philosophers" (Veyne, 1988, 3—whence the quote—and 95–102) does not quite do full justice to some aspects of the impetus behind his author's scholarship.

[57] For detailed discussion, see Lightfoot (2003), 294–331.

[58] Alcock (1996), her title.

What is striking about Pausanias' cult statues is his concentration on iconography as a means for representing Greek mythology. The Athena Parthenos becomes the occasion for learned digressions on sphinxes and griffins—creatures from the imaginary world of archaic myth—and for brief references to Medusa and the Athenian Erichthonius, and to the mythical first woman Pandora. The Epidauran Asclepius evokes "the exploits of Argive heroes" Bellerophon and Perseus (2.27.2). The throne of Apollo Amyclaeus is an excuse for a resumé, virtually a catalog, of major Greek myths (3.18.10–16), and the visual surroundings of Zeus at Olympia likewise refer to numerous myths, from the death of Niobe's children to the labors of Heracles (5.11.2–8). Although the images connected with each statue have a particular local resonance (the significance of Erichthonius for Attica, Bellerophon and Perseus for Argos, and Heracles for Olympia), the overall effect is of a deeply Greek mythological system surrounding and grounding these Greek artistic and sacred masterworks in an ethos of hellenic localism. The iconography of Polyclitus' Argive Hera points both to mythology (the tales of Zeus and Hera, which Pausanias claims to disbelieve at 2.17.4, though he later comes round to viewing such stories allegorically as "one kind of Greek wisdom," 8.8.3) and to mysteries which cannot be written about or spoken of.

It may be that these moves from imagery to mythology were obvious—the natural and immediate reflex of any observer looking at the art in a temple. But it may also be that Pausanias deliberately chooses to set these special and significant objects within his discourse in the light of a mythological master narrative. His insistence on apparently parochial (that is, specifically local Greek) myths has the effect of deliberately affirming the sacred Greece of pre-Roman times. Implicitly—but inevitably—this Greek mythological *paideia* or antiquarianism by which Pausanias interprets the objects he describes (and not just the cult images) and through which his whole travelogue is presented largely excludes thought of Rome or of the present day. In this sense Pausanias' cult images become arguments in a narrative of hellenism's monumental sacred and mythological self-affirmation.[59]

Lucian's statues, by contrast, are presented not by means of a mythological narrative but in comparison with other (more familiar) iconographic types:[60]

In this chamber are set statues of the gods. One is Hera and the other is Zeus, whom, however, they call by another name. Both are of gold and both are seated, but lions support Hera, while the god sits on bulls. The statue of Zeus

[59] On Pausanias and the Romans, see Elsner (1995), 140–44; Alcock (1996); Bowie (1996), 216–29; and Hutton (2005b), 41–47.

[60] On the iconography, see Lightfoot (2003), 16–38, 434–46, following in particular Polanski (1998), 79–117. On the problems of transcribing Syrian actuality into Greek language and literary genres, see Elsner (2001a), especially 136–37.

certainly looks like Zeus in every respect: his head, clothes, throne. Nor will you, even if you want to, liken him to anyone else. As one looks at Hera, however, she presents many different forms. On the whole she is certainly Hera, but she has something of Athena, Aphrodite, Selene, Rhea, Artemis, Nemesis and the Fates. (31–32)

Here we have, in a Syrian context presented by a Syrian author writing in Greek, a Zeus who is not Zeus (since he is called something else) but who looks just like (the Greek) Zeus, and a Hera who "is certainly Hera" but who clearly has as much in common with nearly every other female deity in the Greek pantheon. The attempt to present non-Greek gods to a Greek readership in Greek terms leads to a discourse of visual identification through iconography (the Zeus is Zeus because, despite his name, he looks like Zeus) and of syncretism whereby peculiarities are explained by Hera having "something of" a whole catalog of other Greek deities. What all this succeeds in affirming (despite, even perhaps because of, the attempt to assimilate the gods of Hierapolis to those of Greece) is the radical difference, the cultural otherness, of Lucian's Syrian religion. It is distinct not only from Greek cult (and the language which describes Greek cult) but implicitly also from the religion of the Roman masters of the east.

The superiority of these non- (or are they anti-?) Greco-Roman attitudes becomes explicit as Lucian discusses other increasingly non-Greek gods in the sanctuary. There is a golden "Sēmeion," "not at all like the other statues. It does not have its own particular character, but it bears the qualities of the other gods" (33).[61] This may be a *xoanon*, but its nature as a divine epitome for all the gods in the temple is certainly not typical in Greek terms. There is a throne but no statue for Helios—"they say it is right to make images for the other gods, for their forms are not visible to everyone, but Helios and Selene [the Sun and the Moon] are completely visible and all see them. So, what reason is there to make statues of those gods who appear in the open air?" (34).[62] The target of this criticism (as much a self-affirmation of the unusual visual tradition at Hierapolis) is not made explicit, but Greek and Roman religious practice is surely implied. And finally there is a miraculous image of "Apollo" represented (in direct contrast with Greek tradition) as bearded and clothed:[63]

> All others think of Apollo as young and show him in the prime of youth. Only these people display a statue of a bearded Apollo. In acting in this way they commend themselves and accuse the Greeks and anyone else who worships

[61] See Elsner (2001a), 138–39, and Lightfoot (2003), 446–49, 540–47.
[62] With Lightfoot (2003), 449–55.
[63] With Elsner (2001a), 139–41, and Lightfoot (2003), 456–69.

Apollo as a youth. They reason like this. They think it utter stupidity to make the forms of the gods imperfect and they consider youth an imperfect state. (35)

Here finally is a self-assertive assault on the Greco-Roman culture of the conqueror. In matters of deep religious knowledge and representational practice, not only are the Syrians different from the Greeks and "anyone else" but they are proclaimed as wiser. Despite centuries of conquest, hellenization, and romanization, Lucian's sacred Syria—his aptly named city of Hierapolis—affirms its superiority through the continuance of its most holy traditions of knowledge manifested in images. In focusing his entire text on the sacred world of Syria, Lucian makes the marginal, the self-confessedly eccentric (by Greek standards), into something not only central and significant in a religious sense but also important beyond the peripheral confines of the Levant because it is presented in terms accessible to Greek speakers from a Greek cultural context.

As pilgrimage texts, rare narrative survivals of a thriving ancient culture of temple visiting and worship, the works of Pausanias and Lucian present a literary discourse of eastern self-assertion. This literary discourse supports the visual arguments for eastern self-affirmation made by the art and iconography of cults like that of Ephesian Artemis, Mithras, or Attis. The great icons are a principal locus for the pilgrims' discussions, and they argue a rhetoric—both iconographic and mythological—of localism. The sacred center is located, in this discourse, not in Rome—the faraway political center—but in the east, wherever stands the main shrine of whichever deity one has taken as one's prime object of worship. As we saw in the case of the Artemisium, the sacred center, even if spatially peripheral, was symbolically the fundamental guarantor of a whole range of nonsacred or nonritual activity; it was the insurance underlying social life. So the positing of sacred centers in the eastern periphery of the empire was not merely an act of ideological and sacred resistance to Rome. It was implicitly a marginalization of Rome, the conqueror; it suggested that fundamentally Roman dominion was an irrelevance.

Of course the modes of resistance varied in the range of eastern cultures: Pausanias affirms Greece (implicitly against Rome), while Lucian denies both Greece and Rome in his Greek apologia for the sanctity of Syria. The bulk of eastern mystery cults did not reject the imperial cult, but implicitly their promise of salvation suggested that individual salvation was not a commodity available from state religion. Judaism and Christianity—affirming a monotheist intolerance for religious pluralism—tended to an exclusivity which was to deny all the polytheist religions of the Roman empire, east and west. Moreover, in the period before Constantine, we should not expect that all manifestations of cults which were scattered over the breadth of the empire (least of

all Christianity) professed the same beliefs or practices even if they assumed more or less stereotypical iconographies. Yet despite all these nuances and variations, one feature shared by the religions of the east, from the highly traditional (as in Pausanias) and the civic-local (as in Lucian or the cult of Artemis Ephesia) to the mystical and initiate fringe (as in Mithraism or Christianity), was a profession of eastern identity which proved simultaneously iconographic and ideological. This served as a means of self-definition by the affirmation of difference from the visual norms and the cult practices of the center. In looking non-Roman, the eastern cults implied that their kind of religion was not Roman and, implicitly, was better than Roman religion, at least for their devotees.

THE POLITICS OF VISUAL RELIGIOUS SELF-ASSERTION

In the Pre-Christian east pagan cult images served as the center of a sacred nexus for defining identity, mythology, and locality. The icons of pagan polytheism in the east were used during and after the second century A.D.—in rituals like that of Salutaris, in texts like that of Pausanias, and in the visual propagation of the cults throughout the empire—as a prime means for ethnic and religious self-assertion. That visual self-assertion was by definition articulated by difference from Rome—the use of non-naturalistic styles and of iconographies evoking the east. The particular feature of this use of sacred art for eastern self-affirmation was that it never denied the logic of empire: it never argued for nationalism or separatism. Instead, the east appropriated the universalist and centralizing religious techniques created by the imperial cult to spread a variety of polytheisms originating in the periphery but with universal claims. Such universalism manifested in numerous ways—from the emphasis on a ritual space and time whose value lay beyond the present (in Pausanias, for instance, but also in early Christianity), to specifically missionary expansion (as in the case of sanctuaries of the Ephesia and other deities like Isis or Mithras), to the claims of access to particular and exclusive forms of salvation (in many of the mystery cults including Christianity). Iconography, often stereotypical and frequently overdetermined with mystical or astrological or typological symbols, proclaimed both the peripheral origins and the universal claims of a cult.

By the third and fourth centuries, the universalizing aspirations of a plurality of cults led to increasing syncretism (one thinks for instance of the sanctuary of Severus Alexander, who is said to have combined statues of the deified emperors with images of Apollonius of Tyana, Christ, Abraham, and Orpheus as well as Virgil, Cicero, Achilles, and Alexander the Great, *HA, Severus Alexander* 29.2–3, 31.4–5). The growing strength of the eastern religions motivated several attempts by the weakening center to appropriate their

success and appeal to itself. In 218, Elagabalus brought the cult of Elagabal and other Syrian rites to Rome (*HA, Antoninus Elagabalus* 3.4, 6.9, 7.1–5) and explicitly attempted to establish Elagabal, his particular version of Baal, as the supreme god (Dio, *Roman History* 80.11.1); in the 270s Aurelian emphasized the cult of Sol Invictus as the supreme deity;[64] and ultimately in the early fourth century Constantine would convert to the religion of Christ. The appropriation of Christianity by the center was nothing new: it was an already typical instance of using the energy and drive of an eastern cult as a means to inject new life into the old religion. But Christianity, by being monotheist and exclusive, was unlike anything generated within the broad and pluralist aegis of Greco-Roman polytheism. Although it skillfully adapted the successful dynamics of the eastern cults (their liking for the visual, for public ritual, for great official temples), it was to supplant the others and to invigorate the Roman state in ways of which Constantine could never have dreamed. In the light of my argument here about the importance of cult images as a visual means for the propagation of the polytheistic cults, there is a small irony in Christianity's development of the icon as its most characteristic visual form.

[64] Generally, see Gradel (2002), 349–52; specifically on Aurelian, see Homo (1904), 184–88, and A. Watson (1999), 188–98.

VIEWING AND RESISTANCE

Art and Religion in Dura Europos

IN HIS WONDERFUL ANTHROPOLOGIST'S TRAVEL BOOK, *Tristes Tropiques,* Claude Lévi-Strauss tells the story of the Caduveo and their traditions of body painting. He analyzes the complex patterns with which they adorn their faces and sometimes even their whole bodies as a symbolic representation of everything their culture is not:

> In the last resort the graphic art of the Caduveo women is to be interpreted, and its mysterious appeal and seemingly gratuitous complexity to be explained, as the phantasm of a society ardently and insatiably seeking a means of expressing symbolically the institutions it might have, if its interests and superstitions did not stand in the way. In this charming civilization, the female beauties trace the outlines of the collective dream with their make-up; the patterns are hieroglyphics describing an inaccessible golden age, which they extol in their ornamentation, since they have no code in which to express it, and whose mysteries they disclose as they reveal their nudity.[1]

The art of the Caduveo—unconsciously, one presumes—constructs a space in which the cultural system of their social norms and structures is reversed and in which a world other than their usual reality is imagined.

Such a space in any culture need not be an affirmation of "resistance"; but at any particular time it may be. As a visual and creative form of art, this space may not serve as a challenge to the cultural system which Clifford Geertz has argued is upheld—even to an extent created—by a society's artistic acts;[2] but it

[1] Lévi-Strauss (1973), 229–56, quotation at 256.
[2] See especially "Deep Play: Notes on the Balinese Cockfight," in Geertz (1973), 412–53, especially 448–53, and "Art as a Cultural System," in Geertz (1983), 94–120, especially 99.

may be. Such things will depend on specific circumstances and particular conditions. My point is that the imaginative space offered by images—perhaps because of their very ambivalence and richness of possible meaning—offers the potential to incorporate and even encourage self-affirmations which may in their different ways challenge the different levels of domination and power in a society.

Although studies of resistance—especially to colonial hegemony—have been subtle and complex across a range of disciplines,[3] the potential of art to create alternative spaces, as in the body painting of the Caduveo, has perhaps not been sufficiently explored. As we come to understand the more nuanced kinds of silent resistance as forms of self-definition, the place of art as a prime means for articulating such affirmations may come to acquire a certain analytic significance. My interest here, however, is far from attempting a general theory of art as an anticultural system or defining precisely art's place among the various armories of potential resistance. My project is to look at images in the specific context of their use within religion as self-affirming and self-defining statements of cult identity within the Roman world at the dawn of late antiquity.

Studies of religion have of course been central to our understanding of resistance—since both the modern colonial enterprise and much of the opposition to it (for instance, both 1970s and 1980s Polish Catholicism in the era of Solidarity and 1970s and 1980s evangelical Protestant Zionism among the Tishidi of South Africa) have drawn a good deal of their energy from the Christian missionary project. But we have to be wary of all such (stimulating) comparative cases when we come to study the Roman empire.[4] First, its colonialism (if we may still use the word)[5] was not a religious or religiously justified exercise in any modern sense. Second, unlike any post-Renaissance colonial empire, Rome's mainstream not only was culturally colonized by one of its own conquests, but was entirely open, self-conscious, even a little embarrassed about this process. Nor was Greek influence on Roman culture the sole foreign "colonization" of the center (though it was certainly the most significant). After all, by the third century at least one emperor, Elagabalus, attempted to impose his Syrian Baal on Rome, as we saw in the last chapter.

In looking at religion and at art, I am not trying to say with any certainty

[3] In particular one might mention Comaroff (1985), in the anthropology of religion; J. Scott (1985), especially 28–41, 289–303, and J. Scott (1990), especially 4–5, 108–82, in the anthropology of class struggle; Pile and Keith (1997), in geography. All these deal broadly though not exclusively with colonial circumstances.

[4] For some useful discussion of such comparisons, see Webster (1996) and Freeman (1997).

[5] For discussion of (post-) colonialism in the Roman imperial context, see, for example, Webster (1997), Van Dommelen (1998) and S. Scott (2003).

CHAPTER TEN

that "resistance" was present in a given example or to quantify how much there was. Rather, I want to discuss spaces—indeed a cultural system of related spaces—in which self-definition (something which began a long time before the Roman conquest of any particular province and which continued long after the fall of Rome) was possible. During the period of Roman hegemony such self-definition offered the scope for a culture within a culture, a space for initiates (in the context of religion) which need not resist the dominating power but which—if the circumstances arose—might do so. Moreover, within the broad grip of imperial control, the various local religions of the empire were tolerated and encouraged to compete. Such competition, which we will observe in the case of Dura Europos, was an effective form of the "segmentary opposition" that the empire had every reason to encourage on the sound hegemonic principle of "divide and rule."[6] But it engendered in the various competing religions an element of resistance to each other—of self-definition by polemic against other cults and by reversal of other cults' practices. The risk, from the dominating state's point of view, in such a system (as it had developed by the third century A.D.) was that only a small step was needed for a cult to move from resisting the others to resisting the center (in the form of the imperial cult, for instance). Such resistance was always potentially possible. Nothing proves the power of the cults as a means of engendering a strong sense of cultural identity among their followers so much as the state's decision under Constantine to harness one of the most eccentric to its own bandwagon as the new state religion.

"RESISTANCE" AND THE PROBLEM OF EVIDENCE

Since—at least among ancient historians—we tend to find a subtle resistance to the notion of "resistance" in the Roman empire (often in the form of a loud silence), let me try to define my own use of the term. Let us say that Roman culture was the range of objects, beliefs, and practices that were characteristic of people who considered themselves to be, or were widely acknowledged as, Roman, or belonged to territory controlled by the Romans and were to varying extents assimilated to Roman ways of life.[7] Cultural resistance is the internal friction—whether potential (that is, on the level of sentiments and feelings) or actualized (that is, made concrete and public in some formal sense)—generated within the culture against its Romannness or romanization. In the case of this chapter, whose prime concerns are with the periphery of the empire in the

[6] I still find the clearest exposition of segmentary opposition to be the classic one by Evans-Pritchard (1940), 136–50.

[7] My definition is broadly borrowed from Woolf (1998), 11–14. See also Mattingly (2004).

Roman east, the particularities of local culture—of local objects, beliefs, and practices—will to some extent have been created by tensions between local pre-Roman ways of life and imported Roman (but also Greek and Parthian) ways of being, and the various resistances of different communities to all these. Geographically, in the case of Dura Europos, the town at the center of my discussion, local culture was marked by the particularity of being part of a permanent frontier. Like many other towns in this area in both the pre-Christian and the early Byzantine periods in which our interest focuses on issues of religion and the military (for example, Hierapolis, Palmyra, Rusafa), Dura belonged to the Syrian steppe, a frontier zone between the old established Roman and Parthian (later Sasanian) empires.[8] This situation can hardly be said to reduce the complexities of local cultural identities and of cultural resistance.

In the study of the Roman world, no one has ever had difficulties with the idea of military resistance, which is well documented.[9] But that is not my subject. Much more subtle and complex is the issue of cultural resistance,[10] which in studies of North Africa and Spain has been presented as a crucial counterpoint to the process of romanization.[11] A number of problems with this approach are evident,[12] not least the methodological difficulty that in the absence of strong documentary evidence in favor of "resistance," one may be seized by the temptation to identify any and every instance of indigenous culture or pre-Roman survival as an example of cultural resistance to romanization.[13] Moreover, in the late 1990s especially scholars have shown "romanization" to be a highly complex phenomenon—varied in type across regions and social groupings within the empire,[14] in which religion (my focus of interest here) has special and specific problematics.[15] The kinds and varieties of "resistance" were inevitably as complex as the kinds and varieties of "control."[16]

[8] For an excellent account of this particular and problematic geography, focusing on the Christian period before the advent of Islam, see Key Fowden (1999), especially 1–5. On the fortress cities of this region in antiquity, see Pollard (2000), 35–81.

[9] For example, Dyson (1971, 1975); Goodman (1991) includes a good discussion of the methodological problems in discovering such active opposition.

[10] See, for example, Kurchin (1995).

[11] On North Africa, see Bénabou (1976a), especially 255–589, and (1976b), with critiques by Garnsey (1978), 252–54, and Rives (1995), 132–53. On Spain, see Keay (1992) and Curchin (1991), 180–90.

[12] Woolf (1998), 19–23.

[13] Woolf (1998), 20 and, in relation to cults, 206–8; also Kurchin (1995), 126–27.

[14] On the difficulties of interpreting romanization, see, for example, Barrett (1997), Woolf (1997), Häussler (1998), and Grahame (1998).

[15] On romanization and religions, see the essays in section C of Metzler et al. (1995) and, on Gaul, Derks (1998), especially 11–21, 73–246.

[16] For some interesting comments on resistance within the empire, see Hingely (1997), Alcock (1997a), Webster (1997b); specifically on art, see Webster (2003) and Newby (2003), 199–202.

I will return to the question of evidence, but first it is worth reminding ourselves that cultural resistance—when it manifests as more than a set of latent feelings—may be directed against a great many other things than romanization per se: against imperialism, or the state, or much more local forms of power, for instance. Perhaps a better way to look at the theme, at least for a project overtly concerned with *viewing*, might be to regard the establishment and governing apparatus (at any given time and place within the empire) as eliciting a multiplicity of responses among the empire's subjects and also outsiders. Some of these responses will be strongly affirmative, others strongly opposed, and plenty on any position within the range between these two poles. This spectrum of different responses is where the subjective space for different kinds of cultural resistance may be found. Let me be quite clear here—"resistance" is no more than one shade of response within this spectrum; it is no more than one of the options available to the subjects of the empire in relation to their government and its cultural norms.

The problem here is evidence. There were thousands of indigenous cults, for example, throughout the empire. How definitively can we say that any one of these gave rise to, or became a focus for, cultural resistance? The answer is that we cannot. Yet we must beware of the positivistic urge only to argue from certainty and only to allow definitive facts as the basis for discussion. In a parallel field to resistance studies, that of popular religion, there is a strong line held by a number of distinguished historians of the ancient world that there was no such thing as popular religion in the Roman empire (just as there was no such thing as resistance to its cozy control). This stems, at least in my view, from a misplaced (though methodologically rigorous) rejection of that for which there is no documentary evidence. In the early 1970s, Arnaldo Momigliano made an elegant argument against the assumption of there being popular religious beliefs in the writings of late Roman historians on the correct grounds that we have no popular sources.[17] By the 1980s Peter Brown had extended what was essentially a historiographic argument to a general assault on the "two-tier" theory of elite and popular religion, arguing that whatever we might wish to call "popular" reflects a case of the elite's propagating particular beliefs or practices.[18] Popular religion did not exist. As a

[17] Momigliano (1971). The later essays of Momigliano, however, give the feeling of a continuing search among different kinds of historiographic materials (never archeology or art, of course!) for evidence that would take him closer to "how people lived a faith or, to put it in a less Christian way, how they behaved according to a religious tradition." See Momigliano (1987), 159–77 (quotation at 163) and 178–201, especially 191–92.

[18] See especially Brown (1981), 12–22, 27–30, 48–49, and Averil Cameron (1991), 7–8, 32, 36–39, cf. 107–8. For critiques of Brown, see Van Dam (1993), 4n3, with bibliography. In recent work on ancient religion, the popular has returned with a vengeance, as if it had never been dismissed—see, for example, Frankfurter (1998), 37–144.

VIEWING AND RESISTANCE

subject, "popular religion" resembles "resistance" in that both describe alternative positions to those prescribed or encouraged by the dominant elite. By definition, since the elite both wrote the majority of our textual sources and saw to it that most of what it disapproved of did not survive, neither popular religion nor cultural resistance is particularly well attested to in the texts. But this does not amount to any kind of proof that they did not exist.

The trouble with turning to the archeological archive in the hope of finding some spaces of potential resistance is that we must necessarily deal in the messy and uncertain business of likelihood, probability, and possibility rather than the pristine clarity of fact. Instead of the strong beam of certainty, we have the diffracted spectrum of multiple subjectivities. The question, at least from the art historical standpoint, is what kinds of visual signs offer spaces where cultural resistance was possible. Here we might follow a late suggestion of Momigliano and look for cultural resistance in the space of religion.[19] I find two forms of visual self-advertisement among religious cults, within the specific confines of second- and third-century Dura Europos in the Roman near east, which I argue offer different potential models of resistance with which viewers, by whom I mean cult initiates, might identify. It is important that such images offer a potential reading as "culturally resistant" rather than an unambiguous one, since one of the problems of opposing a dominant state perfectly capable of religious persecution was that one always needed an alibi to avoid conviction if actually accused of opposition. The advantage of art as a means of "resistance" is that it is sufficiently open to multiple meanings for its oppositions not to be *too* obvious. To put this another way, we might say that one of the benefits of the interpretative ambivalence of images is that their viewing was always open to the casting of a blind eye.

As students of late antique religion have long recognized, one key aspect of the rich plurality of cults in the Greco-Roman world lay in their need for self-definition.[20] This is no less the case in the visual decorations of the sacred spaces which art appropriates for cult status and activities than it is in matters of ritual, writing, theology, or initiation. While visual claims to cult identity need hardly be defined as resistant, the use of methods of sacrifice, kinds of dress, or other ritual features specifically and structurally differentiated from those of other cults or from the state cult offered the potential for the affirmation of identity to be more than merely a claim for attention. It could also be implicitly a comment on how being, say, a Jew or a mithraist was different from (dare one say, better than) being the adherent of another cult. Although

[19] Momigliano (1987), 120–41. For a subtle account of religions and resistance, see Gordon (1990), 235–55. See also D. Edwards (1996), 15–27, and Webster (1997b), 165–84.

[20] See, for instance, the three volumes of Sanders and Meyer (1980–82).

this self-differentiation was partly a matter of competition for custom and even of advertising (to apply the concepts of late-twentieth-century capitalism to the phenomenon), such differentiation did imply a negative commentary on (a form of resistance to) the other cults in the very act of self-affirmation.[21] Some religions went further than visual self-definition in the positive sense: they actively represented other cults in a negative light, as a kind of visual version of the polemical religious pamphlets we find written by late antique pagans, Christians, heretics, and Jews.

The Images of Dura Europos

A word is in order about the context of Dura Europos. Although originally founded by Greeks on the west bank of the Euphrates in about 300 B.C., by the later second century B.C. the city had come under Parthian control.[22] During the Roman empire, the city was a complex and perhaps problematic example of the kinds of acculturation we find elsewhere in the east. Its inscriptions, for instance, are found in Greek, Latin, Aramaic, Syriac, Palmyrene, Middle Persian, and Safaitic,[23] though—to judge by the preponderance of epigraphic evidence—the city's basic culture was Greek.[24] Its political affiliation changed more than once until it was seized and sacked by the Parthians in 256 or 257 and failed to recover thereafter.[25] The surviving art—both sculpture and painting—is primarily religious,[26] and the images of its different cults share a frontal style typical of the near east.[27]

Leafing through the first (and only fundamental) publication of the main pagan temples,[28] found when Dura was discovered in 1920 and excavated in

[21] For the "marketplace" metaphor for religious competition in the empire, see North (1992), 178–79. For the invocation of the image of advertising to late antique religious art and its subject matter, see Mathews (1993), 65. On art as a means of promulgating competing religions in the period, see Grabar (1968), 27–30, and Mathews (1993), 3–10. Specifically on pluralism as largely noncompetititve in Dura (with the exception of Jews, Christians, and mithraists), see Dirven (2004).

[22] On Parthian Dura, see Millar (1998) and Dirven (1999), 4–11.

[23] See Arnaud (1986) and Millar (1993), 445–52, 467–72.

[24] See Millar (1998), 478.

[25] The history is told by Rostovtzeff (1938), 10–31, and C. Hopkins (1979), 251–65. On the date of the fall, see MacDonald (1986).

[26] On the religions of Dura, see Dirven (1999), xviii–xxii.

[27] On Durene style, see Rostovtzeff (1938), 82–86 and A. Perkins (1973), 114–26. For a critique of the uses of connoisseurship and the general orientalism of Durene art history, see Wharton (1995), 15–23, 33–34. For the suggestions that not only the Christian and Jewish but also some of the pagan temples shared artists in their decoration, see Jensen (1999), 184–86. For issues of Roman influence on the Dura synagogue paintings at least, see Moon (1995) and contra, for the claim that "the paintings of Dura do not constitute an example of Roman provincial art," Brilliant (1973).

[28] Cumont (1926).

FIGURE 10.1. Dura Europos, "temple of Bel," south wall of the "naos." Fresco of Conon and his family making sacrifice. Late second or early third century A.D. Now largely destroyed, fragments in the Damascus Museum. Tinted print of Breasted's photograph (1925). (Photo: After Cumont, 1926, pl. 31.)

the years leading up to World War II,[29] one is struck by how many images represent the act of sacrifice. In what was probably a temple of Zeus (but is usually labeled the temple of Bel or the temple of the Palmyrene Gods),[30] located in the northwest corner of the city,[31] no fewer than five frescoes were excavated which depicted sacrifice (although one was in a very fragmentary state when Cumont published it in 1926 and most are all but lost today). These include the image of Conon and his family making sacrifice (figure 10.1),[32] from the lower tier of the south wall in a room containing a shrine which the earliest excavator, James Breasted, described as "hall II" but which has subsequently come to be labeled the "naos."[33] A fragmentary Greek inscription was recorded naming several of the figures—Conon being the man with the pink turban at the far left and most of the others placed in family

[29] For a history of the excavation, see C. Hopkins (1979).

[30] On the dedication, see Millar (1998), 482, and Dirven (1999), 294.

[31] Inexplicably, Cumont (1926), 30, says "northeast."

[32] On the Conon fresco, now in very bad condition in Damascus, see Breasted (1922), 188–99; Breasted (1925), 75–88; Cumont (1926), 41–73; Rostovtzeff (1938), 69–70; A. Perkins (1973), 36–41; Wharton (1995), 34–38; and Dirven (2004), 10–12.

[33] Breasted (1922), 187f., and (1924), 75f., has "hall II" (or "salle II"); all others follow Cumont's use of "naos" (with "pronaos" for Breasted's "hall I").

FIGURE 10.2. Dura Europos, "temple of Bel," south wall of the "pronaos." Fresco of Lysias, Lysias, Apollophanes, and Zenodotus making sacrifice. Late second or early third century A.D. Fragments in the Damascus Museum. Tinted print of Cumont's photograph (1926). (Photo: Yale University Art Gallery, Dura-Europos Collection.)

relationship to him. The figures in white with white caps who stand before altars and carry sacrificial implements appear to be priests.[34] These paintings are thought to be late second century A.D.[35] A second, fragmentary, scene of sacrifice decorated the south wall of the "pronaos," with the sacrificants here each framed between spiral columns. Again an inscription identifies the figures—two are called Lysias, the third Apollodorus, and the fourth Zenodotus, while

[34] There may have been a set of parallel scenes on the north wall opposite, but this did not survive. The west wall appears to have had a large painting of the cult deity, Zeus, of which only the right foot is preserved. See A. Perkins (1973), 37.

[35] See A. Perkins (1973), 41, contra Breasted (1924), 92, and Cumont (1926), 57, who suggested c. A.D. 75.

FIGURE 10.3. Dura Europos, "temple of Bel," north wall of the "pronaos." Fresco of the tribune Julius Terentius and other members of his cohort making sacrifice to three deities (or their statues) and to the Tyches of Dura and Palmyra. 230s A.D., and certainly before 239. Actual state. Now in the Yale University Art Gallery. (Photo: Yale University Art Gallery, Dura-Europos Collection.)

the artist was Ilasamsos (figure 10.2).[36] This scene is also likely to be a family group and has been dated slightly later, to the end of the second or early third century. On the north wall of the "pronaos" is a sacrificial scene showing Julius Terentius, the tribune of the 20th Palmyrene Cohort (stationed in Dura in the 230s),[37] in the company of various other men—perhaps his military unit—as well as the standard bearer of the cohort (figure 10.3). They pour a libation to three deities represented as statues in military dress on round pedestals (the names of these gods are not given in the inscriptions) as well as to the Tyches, or divine personifications, of Dura and Palmyra.[38] Finally, in a room to the south of the sanctuary, there were two frescoes depicting sacrifice, of which one was hopelessly fragmentary,[39] while the other showed the eunuch Otes and the "bouleutes" Iabsymsos, accompanied by two boy

[36] On the Ilasamsos fresco, see Breasted (1924), 90–92; Cumont (1926), 76–84; A. Perkins (1973), 41–42.

[37] On Terentius (who may have been killed in a Persian raid in 239), see Millar (1993), 132, 469.

[38] On the Terentius fresco, now at Yale, see Breasted (1924), 94–98; Cumont (1926), 89–114; A. Perkins (1973), 43–45; and Dirven (1999), 302–7.

[39] See Cumont (1926), 134–36.

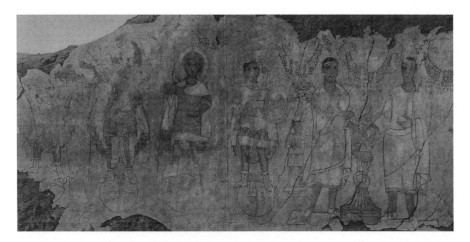

FIGURE 10.4. Dura Europos, "temple of Bel," room to the south of the sanctuary ("room K"). Fresco from the façade of an aedicula, showing Otes and Iabsymsos with boy acolytes offering an incense sacrifice to five deities (or their statues), four of these standing on globes and the fifth to the far left almost obliterated. Roughly 230s A.D. Now lost. Tinted and retouched print of Cumont's photograph (1926). (Photo: After Cumont, 1926, pl. 55.)

acolytes, making sacrifice to five deities (in Parthian and military dress) standing on globes (figure 10.4).[40]

Some of the other pagan temples in Dura have still more fragmentary frescoes than those of the "temple of Bel." Sacrificial scenes something like those we have just been looking at have been reconstructed (using the usual combination of fragments and imagination) for the rear wall of the naos of the temple of Adonis, with the cult deity painted alongside his worshippers.[41] Likewise, the decorative program of the naos of the temple of Zeus Theos has been imaginatively visualized on the basis of what the excavators describe as "several thousand fragments" with sacrifical scenes reconstructed on the walls to the left and right of the main scene.[42] A dipinto from the temple of Azzanthkova, perhaps a form of votive offering, shows a soldier making sacrifice to the god Iarhibol.[43] In addition to these paintings, a number of the pagan temples also boasted limestone reliefs depicting priests making sacrifice to the temple deity. For instance, in the temple of the Gaddé, there is an inscribed slab showing the priest Hairan, the dedicant, making sacrifice to the Gad of

[40] On the Otes fresco, now lost, see Cumont (1926), 122–34; A. Perkins (1973), 45–47; Texidor (1979), 74–75; and Dirven (1999), 295–302.

[41] On the temple of Adonis, see Brown in Rostovtseff, Brown, and Welles (1939), 158–63.

[42] On the paintings in the temple of Zeus Theos, see Brown in ibid., 196–210, especially 204–8 for the side walls.

[43] See Rostovtzeff (1934a), 153–54, and S. James (2004), 39–40, 41.

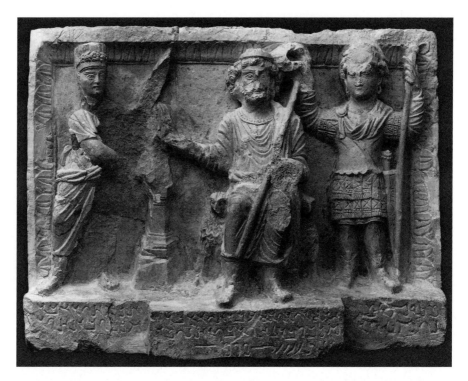

FIGURE 10.5. Dura Europos, "temple of the Gaddé," from the "naos." Deep relief in Palmyrene lime-stone showing the priest Hairan (left) conducting sacrifice to the Gad, or Tyche, of Dura enthroned as Zeus Olympios between eagles and crowned by Seleucus Nicator, the legendary founder of Dura. The inscriptions in Aramaic and Greek identify the figures. The dedicatory inscription in Aramaic at the base identifies both the donor and the date: "The Gad of Dura made by Hairan, son of Maliku, son of Nasor, in the month of Nisan, the year 470" (A.D. 159). Now in the Yale University Art Gallery. (Photo: Yale University Art Gallery, Dura-Europos Collection.)

Dura, enthroned as Zeus Olympios between two eagles, and accompanied by Seleucus Nicator, the legendary founder of the city (figure 10.5).[44] In the temple of Aphlad, an inscribed gypsum votive relief, deeply cut, was discovered, showing a priest—perhaps the dedicant Adadiabos—offering incense at an altar before the cult image of the god, who is dressed in military uniform and mounted on a pair of griffins (figure 10.6).[45]

In all these cases we have cult sanctuaries with votive images offering visual renditions of the chief ritual activity of the temple. In the case of the Conon and possibly the Ilasamsos frescoes (the latter is incomplete, of course)

[44] See Brown, in Rostovtseff, Brown, and Welles (1939), 258–62; A. Perkins (1973), 82–84; S. B. Downey (1977), 14–17; Millar (1998), 483–84; and Dirven (1999), 111–13, 245–47. Compare also the parallel relief of the Gad of Palmyra, with S. B. Downey (1977), 17–19, and Dirven (1999), 247–48.

[45] See Hopkins in Rostovtzeff (1934a), 107–16; A. Perkins (1973), 77–79; and S. B. Downey (1977), 7–9.

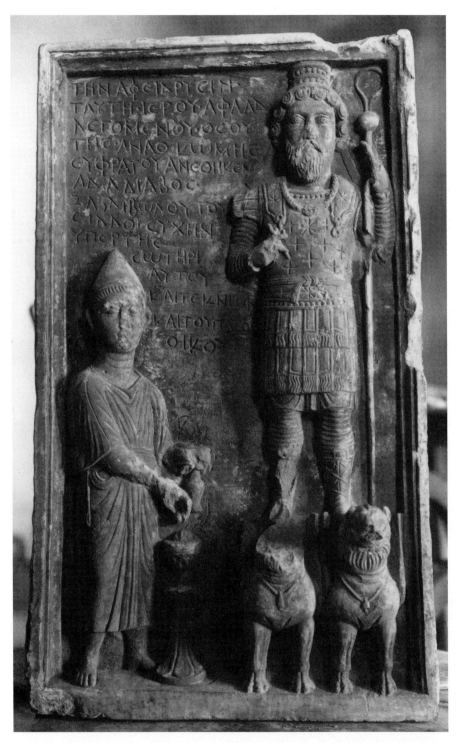

FIGURE 10.6. Dura Europos, "temple of Aphlad," from the "naos." Deep relief in white limestone show-
ing the priest Adadiabos offering incense to the god Aphlad, who stands frontally on two eagle griffins,
is clothed in military dress, and holds a scepter. The inscription in Greek reads: "Adadiabos, son of Zab-
dibol, son of Silloi, founded this branch of the sanctuary of Aphlad called god of the village of Anath of
the Euphrates, in thanks for the safety of himself and his children and his whole house." Roughly A.D.
55. Now in the Damascus Museum. (Photo: Yale University Art Gallery, Dura-Europos Collection.)

only the sacrificial act is shown, while the other images make the divine recipient visible. In the case of the Terentius and Otes images, these deities are supplementary to the main cult god of the temple, while in the two reliefs and in the frescoes from the temples of Zeus Theos and Adonis, the main deity has himself been represented. The consistent insistence on inscription in all the images points to a strong assertion of personal and religious identity on the parts of the dedicators (and even, in one case, the artist). On the face of it, none of these images implies "resistance." But at the same time all imply a certain element of religious affiliation to broadly local gods, as opposed to, say, the imperial cult or deities directly sponsored by the Roman establishment elsewhere in the empire. In this sense they establish and affirm peripherality, or the centrality of local cult and identity, in a way that ignores the Roman empire and the distant imperial center. For Durene pagans, the center which mattered lay not in Parthia nor in Rome nor in Greece but in the very local context of the near east—in Dura Europos itself and in several nearby cities such as Palmyra and Hierapolis, whose deities were also revered by the Durenes.[46]

This very parochial space, where the many languages of the Durenes celebrate a multicultural community, is not affirmed in the same way by the arts of the mithraists, Jews, and Christians at Dura. One difference, in the case of all three of these religions, is that the central ritual focus of all the polytheistic cults we have just been looking at, namely the act of sacrifice, is avoided.[47] Instead, the mithraeum, synagogue, and Christian *domus ecclesiae* turn away from representing actual ritual practice and instead depict their own—very different—initiate mythologies. These initiate mythologies, which, unlike the sacrifical images, demand some kind of exegetic key for their viewers to understand them (which is why we do not and perhaps will never fully understand the meanings of mithraic art despite its survival in large quantities), take the space of viewer identification away from a local god and the actions performed locally in his or her honor to a more universalizing deity with salvific implications,[48] and an exclusive focus which denied the value of other religious cults (especially in the case of Christians and Jews).[49]

Let us begin with the mithraeum. Here the final stage of decoration, from the 240s A.D., offers a series of *al secco* paintings in black and red, signed by

[46] For Palmyra, see the relief of the Gad of Palmyra in S. B. Downey (1977), 17–19, and the Tyche of Palmyra in the Terentius fresco. For Hierapolis, see the relief of Atargatis and Hadad from the temple of Atargatis (Lucian's Syrian Goddess) in S. B. Downey (1977), 9–11, with bibliography (see figure 1.5).

[47] On sacrifice as the Roman empire's normative model of mediation between human and divine, see Gordon (1990), 201–55.

[48] On mithraic "soteriology," see Turcan (1982).

[49] For some of the complexities of monotheism in the cults, see Beard, North, and Price (1998), 286–87.

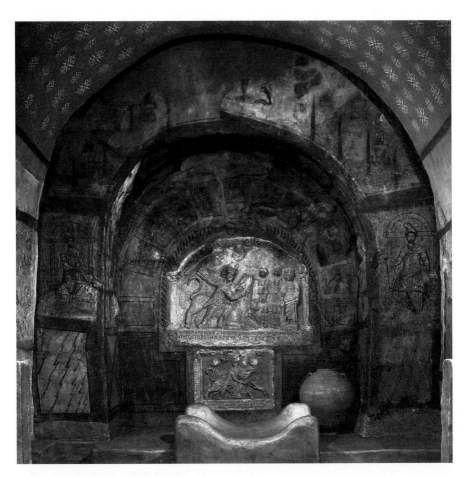

Figure 10.7. Dura Europos, mithraeum. General view of the reconstruction in Yale University Art Gallery of the main cult images. These are two gypsum cult reliefs of the bull-slaying (or tauroctony) scene, originally brightly colored, and their surrounding *al secco* painted decorations in black and red, showing scenes from the sacred mythology of Mithras. The paintings and ensemble date from the 240s A.D., the smaller relief from A.D. 168 and the larger from A.D. 170–71. (Photo: Yale University Art Gallery, Dura-Europos Collection.)

the artist Mareos, which represent images from the still obscure sacred mythology of Mithras,[50] as well as two gypsum bas-reliefs depicting the central cult icon of mithraea across the length and breadth of the Roman empire—namely the tauroctony, or bull-slaying scene (figure 10.7; compare figure 9.11 for a tauroctony from Rome).[51] Although a number of aspects of

[50] On the mithraeum, see Rostovtzeff (1934b); Cumont and Rostovtzeff in Rostovtseff, Brown, and Welles (1939), 104–16; Cumont (1975), 169–94; and Beck (1984), 2013–16. The most recent description is in White (1997), 261–71, with bibliography. A sophisticated but unpublished discussion is Bowes (1993).

[51] On the Dura examples, see Campbell and Gute in Rostovtseff, Brown, and Welles (1939), 91–101; Cumont (1975), 165–69; S. B. Downey (1977), 22–29, 217–25, 265–68; and Dirven (1999), 267–72.

the mithraic decorations are unique (or at least very unusual) within the rich iconographic repertoire of Roman mithraism, including the two figures in Persian costume described by Cumont as Magi and the scene of Mithras hunting,[52] in other respects the Dura mithraeum reflects the relatively standard iconography of the cult throughout the Roman empire. The style of the mithraic images and the Persian dress point toward the east and have resonances with the other arts of Dura, while the stereotypical nature of the iconography aligns the mithraeum and its worshippers with a cult which was specific to the *Roman* empire—extending to its northern and western borders as well as to the east. Mithraism was by no means exclusively a religion of the center, but the greatest density of surviving mithraea certainly occur in Rome and Ostia.[53] It was not an official cult, but it does appear to have been tolerated by the elite.[54] Its cult icon seems to be predicated on a set of structural reversals of normal Roman sacrificial practice—including differences in the way the animal is led to slaughter, in the way it is killed, in the place of killing, in making the god rather than his worshippers the sacrificer, and in making the image of sacrifice into a cult icon rather than a votive supplement to a self-standing cult image.[55] Although the arts of the mithraeum never specifically comment on the other polytheistic cults of Dura, they proclaim a cult allegiance which in one sense is supplementary to them within the pluralism of Roman religions in the second and third centuries, but in another sense is implicitly antagonistic. Far from affirming a parochial identity grounded in a near eastern deity with a firm local base, the mithraic images reflect adherence to a universal god (universal at least within the Roman empire) whose mythic origins may lie in Persia but whose specially designated supreme center of cult (as Ephesus was that of Artemis, Hierapolis of Atargatis, and so forth) was nowhere.[56] "Cultural resistance" here is again not explicit, but the mythology and iconography of the cult prescribe a mystic space which is neither the civic-local nor that of the imperial center.

Like the mithraeum, the relatively crude paintings of the Christian house-church (also dating from about 240) evoke a space in initiate mythology

[52] See Cumont (1975), 182–92, on these paintings; with Bowes (1993), 5–7, 10, 18–22, on "the Magi," and 27–30, on the hunting scenes.

[53] See Coarelli (1979).

[54] On the social profile of mithraism, see Gordon (1972); Beck (1998), 119 and nn. 30–31; and Beard, North, and Price (1998), 300–301.

[55] On these issues in relation to the tauroctony, see Turcan (1981), 352–54; Gordon (1988), 49; Gordon (1990), 250; and Elsner (1995), 210–21.

[56] On the similarities of the Dura mithraeum images with Roman mithraic iconography, see Roll (1977), 59–62.

FIGURE 10.8. Dura Europos, Christian building, c. A.D. 240 as reconstructed at Yale University Art Gallery in the second half of the twentieth century. (Photo: Yale University Art Gallery, Dura-Europos Collection.)

(figure 10.8).[57] Unlike mithraic art, so far as we know, that mythology is located not only in a set of *texts* (which had perhaps not yet become a full canon in the mid-third century) but also in the exegesis of those texts. For instance, the juxtaposition of images of Adam and Eve and the Good Shepherd in what is the most important part of the room, in the west wall beneath a barrel-vaulted aedicule (figure 10.9), indicates that by the mid-third century in Syria, Christian art was already given to what would become its characteristic model of typological interpretation, whereby the Old Testament (here the Fall) was set against and completed by the New (here the visual version of Christ's salvific statement in John 10:11–15 that he was the Good Shepherd).[58] On the north wall are images of miracles—that of the paralytic (Matt. 9:2–8) and of Christ and Peter walking on water (Matt. 14:22–33)—and below these the scene of the three women at the Holy Sepulchre (Matt. 28:1–8, Mk. 16:1–8).[59]

[57] These frescoes, now in very poor condition, are at Yale. On the Christian *domus ecclesiae*, see Hopkins and Baur in Roztovtzeff (1934a), 238–88, and Kraeling (1967). See also White (1997), 123–31, with bibliography.

[58] On Christian typology, see Elsner (1995), 283–87, and Schrenk (1995). For the Good Shepherd scene, see, for example, Quasten (1947).

[59] The identification of this scene is contested. The excavators, followed, for example, by Grabar (1956), argue for the Women at the Tomb. Others (notably Millet, 1956, written in 1934–35, and Pijoan, 1937, followed for instance by Quasten, 1947, 1, and Mathews, 1993, 152–53) interpret this scene as the parable of the Wise and Foolish Virgins. See the discussion by Wharton (1995), 53–60.

FIGURE 10.9. Dura Europos, Christian building, west wall. Tracing of the fresco in the lunette within the aedicula showing the Good Shepherd and his sheep (center) and Adam and Eve (bottom left). Roughly 240s A.D. Now in the Yale University Art Gallery. (Photo: After the diagram in Kraeling, 1967, pl. 31.)

If these identifications of the iconography are correct, it is not just an abbreviated life story of Christ but also a selective aretalogy, in which the miracles and the resurrection of the man who was God become the key to the narrative. On the south wall are images of David defeating Goliath and the Samaritan woman at the well (Jn. 4:7–28), but we should beware of overinterpretation, as only about half of the paintings have survived and some identifications are contested.

Like the mithraeum, the Dura Christian building creates a sacred space specifically located in a cult's initiate mythology. By contrast with the mithraeum, that mythology was locally determined by its reference to Jesus' life in nearby Palestine, but it was at the same time universalizing in its use of non–place-specific images like the Good Shepherd and its promise of salvation. Like the mithraeum, the Christian house-church ignores the other religions of the Durene context (except in its references to Jewish scripture). In the case of Christianity, we know that this turning away from polytheism

(and specifically from the kinds of sacrifices celebrated in the rituals and images of the pagan temples) was a form of resistance in the sense that monotheism was exclusive and rejected other gods even at the risk of persecution.

The most elaborate of the surviving decorated temples of Dura is the synagogue (figures 10.10 and 10.11).[60] Its extensive cycle of frescoes (of which about two-thirds are extant) cover the walls of the main hall from floor to ceiling and were probably made as part of the renovations of the building in the 240s.[61] I shall not venture here into the mountainous scholarly debate about whether these images represent a concerted program or a less systematic set of myth-historical evocations, or whether they are the products of mystic symbolism or of an attempt to visualize narrative history.[62] Rather I wish to emphasize that among the various biblical subjects chosen for the decoration, a strong emphasis on what might be called actively antipagan imagery is evident.

In the middle tier of the three which adorn the west wall of the synagogue's large hall, on either side of the Torah niche (figure 10.12), are a series of images which focus on temples, cult implements, and the ark of the covenant. To the left of the Torah shrine is an image of the temple of Aaron (whose name is conspicuously inscribed in Greek), often described as the consecration of the tabernacle (figure 10.13),[63] and to the right is a painting of a closed temple with a number of pagan motifs (especially on the doors) which may or may not be the temple of Solomon (figure 10.14).[64] At the left of the image of Aaron's temple, with its vivid rendition of the cult utensils of Judaism, is a picture of Moses miraculously producing a well in the wilderness, from which water flows to twelve tents, one for each of the twelve tribes of Israel (figure 10.15). Here again the cult implements of the Jews are strongly

[60] The literature is vast. See, for example, Pearson and Kraeling in Rostovtzeff et al. (1936), 309–83; Kraeling (1956); Gutmann (1973); Neusner (1987); White (1997), 272–87, with bibliography; and Jensen (1999).

[61] On the frescoes, in addition to the works in the previous note, see Goodenough (1964, to be used with some caution—see, for example, Neusner, 1987, 43–57, and Brilliant, 1994); A. Perkins (1973), 55–65; Weitzmann and Kessler (1990); and Hachlili (1998), 96–197. For a useful survey of the many disagreements on the interpretation of the iconography, see Gutmann (1984), 1315–24.

[62] For an elegant critical review of these issues, see Wharton (1995), 38–51; against a Messianic reading of the frescoes, see Flesher (1995).

[63] Kraeling (1956), 125–33; Goodenough (1964), 10:1–26; and Weitzmann and Kessler (1990), 55–63.

[64] Kraeling (1956), 105–13 (followed by most scholars, for example, Weitzmann and Kessler, 1990, 98), identifies this as the Temple; Goodenough (1964), 10:42–73, especially 45, disagrees. Du Mesnil du Buisson (1939), 84–92 (followed, for example, by Grabar, 1941a, 181, and 1941b, 6–7, suggested it represented the temple of the Sun at Beth Shemesh, whither the ark was taken after its sojourn in the temple of Dagon (1 Sam. 6:12–21). Moon (1995), 296–99, suggests it may represent the temple of Dagon itself with the ark enclosed inside it.

FIGURE 10.10. Dura Europos, synagogue, general view of the west wall, including the Torah shrine in the center. These frescoes were executed in two phases between about A.D. 220 and 240. Now in the Damascus Museum. (Photo: After Goodenough, 1964, by kind permission of Princeton University Press.)

FIGURE 10.11. Dura Europos, synagogue, general view to the northwest. Now in the Damascus Museum. (Photo: Courtesy of Lucinda Dirven.)

emphasized in the center top of the painting.[65] Counterbalancing this miracle, at the far right of the room (to the right of the closed temple scene) is a painting of the ark of the covenant in the temple of Dagon (figure 10.16). In narrative sequence, reading—as in Hebrew—from right to left, this image follows that of the battle of Ebenezer next to it but over the corner in the middle tier of the north wall. In the battle, the Philistines defeated the Israelites and carried away the ark to the temple of their idol, Dagon (1 Sam. 4:1–2, 11).[66] Once the ark had arrived in the house of Dagon, however, it caused the statues of the Philistine god to topple and break to pieces (1 Sam. 5:1–5). As a result of this miracle, which the right half of the image depicts, on the left-hand side, the ark is dispatched in a cart drawn by cattle on a journey that eventually leads it back to the Jews (1 Sam. 6:1–12, conflated here with

[65] Kraeling (1956), 118–25; Goodenough (1964), 10:27–41; Weitzmann and Kessler (1990), 63–67. Scholars disagree on the precise biblical well in the wilderness represented here. Kraeling (1956), followed by Weitzmann and Kessler, suggests the biblical well at Be'er (Numbers 21:16–18); earlier he had suggested the legendary well of Miriam (in Rostovtzeff et al., 1936, 353–54) followed, for example, by Gutmann (1984), 1320–21. On the significance of the menorah in Jewish art, see e.g. Levine (2000), especially 144–45 on these two images and the Torah shrine at Dura.

[66] Kraeling (1956), 95–99; Goodenough (1964), 10:171–79; Weitzmann and Kessler (1990), 72–75; and Dirven (2004), 5–7.

FIGURE 10.12. Dura Europos, synagogue, west wall, niche, and Torah shrine. The imagery painted over the façade represents the menorah, the temple, and the sacrifice of Isaac (right). First phase of decoration, about A.D. 220–30. Now in the Damascus Museum. (Photo: After Goodenough, 1964, by kind permission of Princeton University Press.)

CHAPTER TEN

FIGURE 10.13. Dura Europos, synagogue, west wall, central tier, near-left of Torah shrine. Fresco of the temple of Aaron ("the consecration of the tabernacle"). Roughly A.D. 240. Now in the Damascus Museum. (Photo: After Goodenough, 1964, by kind permission of Princeton University Press.)

FIGURE 10.14. Dura Europos, synagogue, west wall, central tier, near-right of Torah shrine. Fresco of a temple ("the temple of Solomon"). Roughly A.D. 240. Now in the Damascus Museum. (Photo: After Goodenough, 1964, by kind permission of Princeton University Press.)

VIEWING AND RESISTANCE

FIGURE 10.15. Dura Europos, synagogue, west wall, central tier, far-left of Torah shrine. Fresco of Moses producing a miraculous well in the wilderness. Roughly A.D. 240. Now in the Damascus Museum. (Photo: After Goodenough, 1964, by kind permission of Princeton University Press.)

2 Sam. 6:1–19).[67] In terms of the visual scheme on the west wall, the positive miracle of the well (positive, that is, for the Israelites) is counterpoised against the negative miracle of the fall of Dagon (negative, that is, for the enemies of Israel). In the well image, the ritual objects of the Jews preside beneath a central aedicula representing the tabernacle; in the Dagon scene, the cult implements of the Philistines are scattered along with their god, while the ark rolls away on its cart.

Whatever the precise identity of all these images and their relation to specific scriptural texts and the broader narrative meanings of the Dura synagogue frescoes as a whole, they appear to present a visual meditation on temples—pagan and Jewish—and to make the case for one over the other in no uncertain terms. As Robert Du Mesnil du Buisson suggested in 1939 in the

[67] Kraeling (1956), 99–105; Goodenough (1964), 10:74–97; and Weitzmann and Kessler (1990), 75–84. Scholars disagree on whether *one* statue is represented (it fell twice according to 1 Sam. 5:3–4)—so Kraeling (1956), 103, and Weitzmann and Kessler (1990), 75—or whether *two* images are intended, so Goodenough (1964), 10:78–79, and Moon (1995), 299.

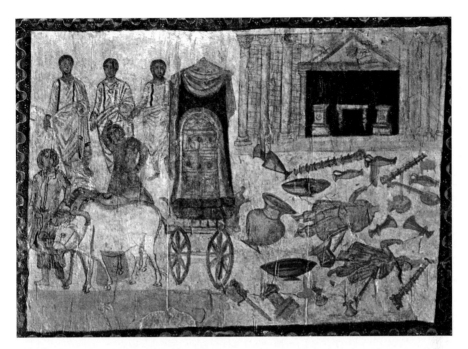

FIGURE 10.16. Dura Europos, synagogue, west wall, central tier, far-right of Torah shrine. Fresco of the ark of the covenant in the land of the Philistines. Right-hand side: the fallen idol of Dagon in the temple of Dagon; left-hand side: the ark leaving the land of the Philistines on a cart drawn by cattle. Roughly A.D. 240. Now in the Damascus Museum. (Photo: After Goodenough, 1964, by kind permission of Princeton University Press.)

first monograph devoted to the synagogue frescoes, it may not be too fanciful to recognize in the fallen statues of Dagon a resemblance to some of the pagan paintings of deities from Dura itself.[68] More recently, Warren Moon has suggested that the poses of the broken statues of Dagon with their arms raised resemble those of imperial images from the idolatrous imperial cult,[69] which was probably established within the praetorium, or military camp, of Dura in a room with dedications to the emperors Geta and Caracalla.[70] This active and aggressive commentary on local religion, in which the pagan Durenes—and possibly even the Romans—appear in the role of contemporary

[68] Du Mesnil (1939), 77, followed by Goodenough (1964), 10:75, and Weitzmann and Kessler (1990), 76. The obvious attraction of this theory should be tempered by the very fragmentary survival of the image of Adonis, to which Mesnil was comparing Dagon. For Adonis, see Brown in Rostovtzeff, Brown, and Welles (1939), 158–63 and pl. xix. Kraeling (1956), 103, disapproved of the introduction of the issue of resistance (what he called "short-range polemic") into the Dura synagogue paintings, to which Goodenough (1964), 10:78n19 responded that the synagogue frescoes were full of " 'short-range' references."

[69] Moon (1995), 299.

[70] See Hopkins and Rowell in Rostovtzeff (1934a), 214.

VIEWING AND RESISTANCE

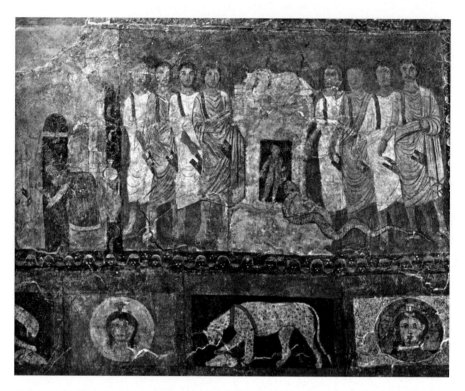

FIGURE 10.17. Dura Europos, synagogue, south wall, lower tier. Fresco of the prophets of Baal making sacrifice on Mount Carmel. Roughly A.D. 240. Now in the Damascus Museum. (Photo: After Goodenough, 1964, by kind permission of Princeton University Press.)

Philistines, is extended in two surviving frescoes from the story of Elijah in the lowest tier of the south wall (1 Kings 18:26, 30–38). Here two scenes of sacrifice are juxtaposed. On the left, the priests of Baal fail to summon divine fire to consume the garlanded bullock on their altar (figure 10.17). In the niche at the centre of the altar is Hiel, who, according to Jewish legend, tried to ignite the faggots manually when Baal failed his priests supernaturally, but was destroyed by a serpent sent by the Lord. On the right, Elijah is calling down fire from heaven, standing by his altar on Mount Carmel, while four lads bring water in amphorae to make the promised miracle more difficult (figure 10.18).[71] It is hardly impossible that the defeat of the prophets of Baal would summon to Jewish minds at Dura the sacrifical activities of the temple of Bel (the Philistine Baal's Durene version), which are so emphasized in its visual propaganda, as we have seen.

The last sacrificial image in the Dura synagogue is the scene of Abraham's

[71] On these images, see Kraeling (1956), 137–43; Goodenough (1964), 10:149–59; and Weitzmann and Kessler (1990), 110–14.

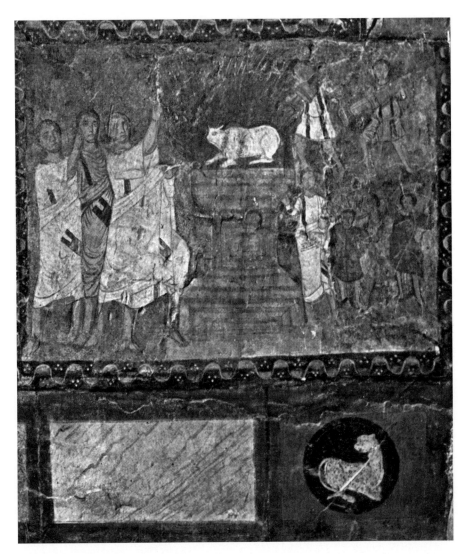

FIGURE 10.18. Dura Europos, synagogue, south wall, lower tier. Fresco of Elijah making sacrifice to God on Mount Carmel. Roughly A.D. 240. Now in the Damascus Museum. (Photo: After Goodenough, 1964, by kind permission of Princeton University Press.)

sacrifice in the fresco painted over the Torah shrine (figure 10.19, compare figure 10.12). This fresco, executed in the first stage of the synagogue's decoration before the main mural program was added, was preserved during the second phase to become what was effectively the visual centerpiece of the redecorated building.[72] Not only is it at the heart of the west wall, but its imagery of menorah, temple building, and sacrificial scene conflates and

[72] See Kraeling (1956), 39–41; St. Clair (1986), 109; and Kessler (2000), 75–76.

VIEWING AND RESISTANCE

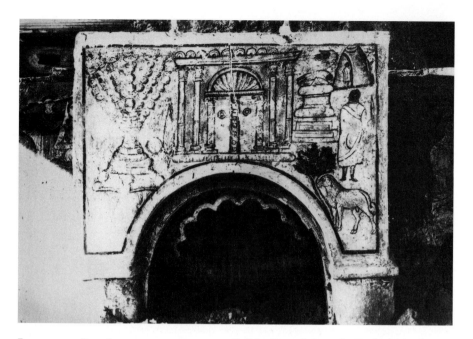

FIGURE 10.19. Dura Europos, synagogue, west wall. Painted panel above the Torah shrine, showing from left to right, a menorah, the temple, and the sacrifice of Isaac. In the sacrifice scene, Abraham, sword in hand, stands with his back to the viewer, above the ram tied to a tree. To the left is the altar with Isaac lying on top, also with his back to the viewer and his head to the right, and the hand of God above. On the upper right is a disputed scene with what may be a figure, also seen from behind, in a tent. First or second quarter of the third century A.D. Now in the Damascus Museum. (Photo: Yale University Art Gallery, Dura-Europos Collection.)

summarizes key elements of the imagery we have been exploring.[73] Unlike the other sacrificial images, the sacrifice of Isaac does not allude to anything outside Judaism (at least in the explicit manner of the Elijah or Dagon scenes) but refers directly to one of the Hebrews' central myths. It is a scene of human sacrifice, but of that sacrifice aborted and replaced with animal slaying. Unlike the other, largely frontal, figures of the Dura synagogue, Abraham and Isaac (lying prone at the altar) turn their backs on the spectator (as does the little figure in what may be a tent in the top right).[74] While the imagery has been interpreted as anti-Christian (in the sense that the Christians appropriated the Abraham and Isaac narrative as a Christian typology),[75] I think we should take it as an internal affirmation of Jewish identity. Like the menorah and the

[73] For discussions of the Torah shrine, see Kraeling (1956), 56ff.; Goodenough (1964), 9:68ff.; and St. Clair (1986).

[74] For the range of interpretations advanced of this figure (none conclusive), see Kessler (2000), 76–77.

[75] See Weitzmann and Kessler (1990), 154–57, especially 157.

CHAPTER TEN

temple in the Torah shrine, this fresco defines Judaism by its specific (divinely ordained) rejection of human sacrifice and its equally divinely ordained espousal of the pattern of animal sacrifice which the Elijah panels further affirm with specific allusion to their pagan rivals. Even in their self-affirmation as Jewish through the visualizing of specifically Jewish-centered ancestral myth, the synagogue frescoes use the sacrificial mode of critical polemic—here against a sacrificial model attempted by divine will and then rejected.

There is no doubt that the synagogue frescoes actively promulgate Judaism by denigrating other religions. These are specifically the religions of the local Syrian environment—the worship of Baal and Dagon, as represented in scripture, and their contemporary Durene successors such as Bel and Adonis. In particular, the Jewish frescoes strike at the two key items in pagan religious practice (at least as emphasized by the frescoes and sculptures we have looked at)—the idolatrous worship of polytheistic deities in the form of statues and the specific act of sacrifice. Of course, all this can easily be explained away, if that is what one wants to do, as simply the illustrations of a text set in the distant ancestral myth-history of the Hebrews. In other words, one may reject the implication that the synagogue frescoes are a commentary on the contemporary Durene environment. This view is certainly possible, but to insist on its exclusive correctness would be naive.

RESISTANCE AND THE ART OF DURA

We have explored several different kinds of visual affirmations of religious affiliation, most produced within the half century before the fall of Dura in 256 or 257. The majority of polytheistic temples produced images celebrating their own—locally based—deity through the act of sacrifice. Judaism, mithraism, and Christianity adopted a different strategy of visual propagation, emphasizing mythologies accessible only to initiates and avoiding the normative pagan model of cult sacrifice—despite the possibility that the different cults may well have shared artistic workshops and even artists in the production of their images.[76] The frescoes of the Dura synagogue are unique among the arts of the town in actively representing the failure of other cults in direct competition with its own. All these images offer spaces of potential resistance, but we must ask—resistance by whom and to what?

In one sense, the parochial emphasis on near eastern deities is a classic example of Roman religious pluralism.[77] But equally, the single-minded focus (even by a Roman military tribune) on local gods might imply a certain

[76] See, for example, Wharton (1995), 60–61, and Jensen (1999), 184–86.
[77] My conceptual model here is elaborated at length in Elsner (2003a).

provincial disdain for the center.[78] Certainly our one near eastern text celebrating this kind of local deity, Lucian's *De Dea Syria*, which as we have seen describes pilgrimage to the temple of Atargatis in Hierapolis, appears actively to propagate the cult's superiority over its Greco-Roman rivals.[79] Of course such "resistance," if that is the right word, was not only tolerated but perhaps even actively encouraged in a cultural context where rhetorical polemic against religions other than one's own was normal,[80] as was apologetic.[81] In a sense Roman dominion, on this scenario, was the factor underlying the babble of tolerated, conflicting voices whose very capacity to articulate their differences from one another and from the center depended on the center's strength and well-being. The fact that the local religions of Dura all focus on the image of sacrifice demonstrates their "buying in" to the dominant sacred ideology of sacrificial mediation, which we find propagated so insistently for instance in the public monuments of Rome.[82] Moreover, the sharing of a sacrificial language of art which owed something to the ways sacrifice was represented by the Romans meant that even if hegemony was contested (through the assertion of a local deity), it was at the same time being affirmed through the visual discourse used.[83]

The initiate cults were different. In a sense their "resistance" is more private—located in the exclusive and recondite mythologies visualized by their images, which simply ignore and even reverse all the norms of Greco-Roman public religion. Yet we know that mithraism was a cult of the army and of the petty bureaucracy;[84] its social functions were therefore supplementary to mainstream Roman culture and not opposed to it, even if some aspects of its iconography encouraged the idea of at least a private retreat from *romanitas* into an orientally visualized initiate world. If we did not know a great deal more about Christianity, even at this period, than about any other ancient religion except Judaism, we would hardly read resistance into the frescoes of the *domus ecclesiae*. Knowing them to be Christian, however, and knowing that (at least some) Christians at this period were willing to make a stand against the religious hegemony of both the state and the local

[78] On parochialism in Roman religion see chapter 9 above and Frankfurter (1998), especially 65–144.

[79] See Elsner (2001a).

[80] One thinks not only of Christian writings by the likes of Clement, Origen, and Tertullian, and of the attacks on Christianity by Celsus and Porphyry, but also of Lucian's *Alexander* and *Peregrinus*.

[81] See Edwards, Goodman, and Price (1999) for discussions of various apologetic texts, including, on the pagan side, Swain (1999).

[82] See Scott Ryberg (1955).

[83] Further on this issue, see Stewart and Shaw (1994), 19–21, and Kempf (1994), 114–23.

[84] See, for example, Liebeschuetz (1994), 200–211. On the Dura mithraeum and the army, see Pollard (2000), 144–46.

hierarchies, it is difficult to deprive the Christian paintings of at least the possibility of implying cultural resistance. Their Christian iconography is a turn to a private initiate world, like that of mithraism, but a world which—unlike mithraism—had in principle no space for Greco-Roman or Syrian religious activities or beliefs, whatever compromises individual Christians may have made in practice. While the images of the mithraeum offered a potential space for cultural resistance, which was nonetheless explicitly discouraged by the sociology of the cult, those of the Christian building offered a similar space whose resistant possibilities the religion actively fostered.

Ironically, given that the Christians were more frequently persecuted than the Jews in this period, it is the images of the synagogue which are most explicitly and unequivocally resistant. Again we have in the synagogue a visual mythology, this time also a tribal history (less mystical perhaps than the images of the mithraists and the Christians), but one which was in a fundamental sense predicated on the explicit rebuttal of non-Jewish gods and rituals. The direct cultural resistance of the synagogue frescoes is against local pagan religion (something which need not necessarily be against the sanction of Roman law), but implicitly the Synagogue was asserting the monotheistic and exclusive supremacy of a God who had nothing to do with the Roman empire.

In the single space of a relatively small frontier town—and it is worth noting that the mithraeum, synagogue, and Christian *domus ecclesiae* as well as the temples of Bel, Adonis, Zeus Kyrios, and Aphlad occupy buildings along what are effectively two adjacent streets running parallel with the west wall—we have seen a remarkable range of kinds of religious self-affirmation. The fact that these appear stylistically similar and that their style has tended to be dismissed as hopelessly provincial[85] has blinded scholars to their interesting differences in this regard. In the polyglot context of a Roman frontier town in Syria, the various sacred images of Dura evoke an interrelated set of religious definitions and propagations of cult identity through art, within which the issue of cultural resistance cannot be denied.

On Resistance in Late Antiquity

The images of Dura open up ways of thinking about the visuality of resistance in the Roman empire more generally. The term "resistance" itself may be misleading, at least if it continues to imply a particular opposing force generated by and against a subordinating and exploitative dominating power.[86]

[85] See Wharton's comments (1995), 17–25.

[86] This is the strongest disadvantage of using James Scott's class-struggle model of resistance for antiquity. See the references in n.3 above.

Moreover, as long as the notion of "resistance" is a strong one—implying conscious motivation and explicit articulations on the part of the "resisters"—it is both too crude in relation to modern ethnographic observations and inappropriate to the phenomena in the Roman world we have been looking at. Rather, in the words of John and Jean Comaroff, "there is an analytic lesson to be taken from the fact that most historical situations are extremely murky" so that "for the most part the ripostes of the colonized hover in the space between the tacit and the articulate, the direct and the indirect."[87]

What the cults of the Roman empire offered—no less than the strong visual, inscriptional, and ritual assertions of civic pride and myth-history throughout the Roman east during the Second Sophistic—was a space of self-affirmation through self-definition.[88] This self-affirmation need by no means be "resistant" in and of itself. But the process of self-definition came with a particular and interesting mix of elements. It implied a strong sense of localism (other terms for this might be parochialism, peripheralism, or provincialism), which we have seen among the polytheistic cult images of Dura in the emphasis on local deities and dress (for instance Conon's turban and the white-capped priests), not to speak of artistic style. This localism in all matters pertaining to religion was commonplace throughout Greco-Roman paganism, not only in the east but also in Egypt and in Greece in the multiplicity of cults described by Pausanias.[89] Localism's centrifugal tendencies and its concentration on parochial identity were in direct opposition to the state's attempts to create a religious universalism both in the polytheistic second and third centuries and in the Christian empire thereafter.[90] Indeed, the Christians were profoundly right to underline the importance of local identity when they defined the multiplicity of religions opposed to theirs with the blanket term "paganism." Whatever the word's numerous disadvantages as a characterization of the polytheistic reality of the Mediterranean world, its etymology stresses the fundamental significance and longevity of parochial religious subjectivities and mythologies which would take the forces of christianization centuries to uproot.

[87] See Comaroff and Comaroff (1991), 31; also Comaroff (1985), 191–97, 260–64.

[88] What Gordon (1990), 246, calls "numerous positions for the faithful in rituals and sacred buildings and in . . . collegiate organization."

[89] The case of localism is well made by Frankfurter (1998), 65–144, writing of polytheistic religion in Roman Egypt. Briefly on Greece and the east, see chapter 9 above.

[90] On universalism, see Fowden (1993), 37–60. On Trajan Decius' attempt in A.D. 249 to impose a universal (or at least empirewide) obligation on individuals in the empire to sacrifice, and hence to undermine the kinds of pluralism in religious localism run rife at Dura, see Rives (1999), 144–47, 152–54. For an interesting account of the parallelism of the imperial cult and Christianity in the second and third centuries, with the latter forming a countercultural inversion of the former but both with increasingly universalizing tendencies, see Brent (1999), especially 1–16.

CHAPTER TEN

Moreover, self-definition through religious cult implied the use of cult-specific languages and mythologies based on initiation. The narrative pictures of the mithraic, Christian, and Jewish places of worship at Dura are obvious examples of this—but the dress of Conon's priests or the attire of the deities in the Otes and Terentius frescoes, let alone the appearances of the lost cult deities of the Durene temples, may well have offered similar potential for initiate discourse confined to their respective cult groups. Like local identity, such languages may not be "resistant." But they offer ample space for what James Scott has termed "hidden transcripts," in which an "off-stage" or unofficial discourse could be elaborated in "relatively unmonitored physical locations."[91] That is to say, the internalized cult discourses—themselves fostering locally based collective subjectivities and identities in cult members—were an ideal space for generating resistance if and when it was required. The polemical language of the synagogue frescoes proves the point.

The kinds of resistance which might arise in these situations are more a matter of what have been called "latent identities" than of active opposition.[92] The space of a cult is one which fosters a strong sense of being a subgroup. What might be described as "largely unselfconscious counter-hegemonies" or "implicit resistance,"[93] may arise "when subgroups of a given society are imperfectly integrated within the larger aggregate, so that their primary sentiments of affinity remain lodged at the subgroup level while they retain correspondingly strong sentiments of estrangement from, or antipathy toward, other subgroups."[94] What is interesting in the case of Dura Europos is not only the presence of this kind of segmentary opposition but also the likelihood that it would have broadly remained the same had Dura been under Parthian rule and fallen to the Romans in the 250s rather than the other way around. Only the Terentius fresco would have been out of place in a Parthian Dura—though its exact equivalent (of a Parthian soldier making sacrifice perhaps to the very same set of deities) would have been by no means impossible. Moreover the subgroups defined by the images at Dura are not just (relatively) large religious communities, but may also include the more socially (rather than religiously) defined group of Terentius' cohort and the family groups of the Conon and the Ialasamsos frescoes. As Diaspora Judaism was

[91] See J. Scott (1990), 4–5, 108–35, especially 123.

[92] On the notion of "latent identity," see Frankfurter (1998), 66. This differs from the kinds of more active religious resistance offered (say) by the Druids as described by Webster (1999), 13–18. But it has some affinities (as well as numerous differences) with the options available in urban religious pluralism in second- and third-century Africa, as discussed by Rives (1995), 173–273.

[93] These quotations are from Comaroff (1985), 260–61.

[94] See Lincoln (1989), 73–74, quotation at p. 73. The significance of sentiment in issues of religion should never be underrated.

brilliantly to affirm, the ultimate initiate subgroup able to preserve a dissident and hence resistant identity, was the family itself, relatively secure in the private confines of its own home.

What is most particular about the situation at Dura and about late antique religion within the empire, for which I have used Dura as an emblem, is that no cult existed in a vacuum.[95] What we see is a structured system of differentiated religions which evolved alongside and against one another, creating parallel (but usually exclusive) mythologies and classifications. Of course, each was influenced by the others (even if that meant by opposition or contradiction), while the cult centers of each of these religions nestled side by side in adapted domestic buildings and were conceivably decorated by the same teams of artists.[96] This intricately structured Durene model of cultic affirmations was, as I have said, able to "resist" Parthia no less than Rome: a cluster of differentiated parochial self-affirmations is the key to the generation of local identitites in this period, and the particular dominating or oppressing or colonizing power is largely irrelevant. On the level of art, there was a certain iconographic integration of the colonizer into the parochial model, so the Roman army appears in the Terentius fresco just as the pre-Christian imagery of the official monuments of the Roman state was rapidly integrated into Christian art.

As weapons of resistance, nothing proves the potential and effectiveness of the system of structured and opposed differences evolved by late antique religion, and examined here through the example of Dura, than a glance at the post-Constantinian empire. The kinds of polytheistic cults which we observed emphasizing localism in Dura became the vanguard of the long fight against christianization. In a sense the process of christianization may be equally well described from the pagan side as the gritty persistence on the local and popular level of a polytheistic sacred culture grounded in parochial deities whose resistance to Roman Christianity lasted for the *longue durée*.[97] That is, a system of segmentarily opposed local religions whose focus was on parochial self-definition—which, as we have seen, was already well established in third-century Dura—turned out to be an effective vehicle for resistance to

[95] For discussions of the cults in the Roman empire, see Turcan (1996) and Beard, North, Price (1998), 1:246–51, 263–312.

[96] For architectural and visual parallels between the different temples at Dura, see Bowes (1993), 24–27, 28–31; on shared artists, Jensen (1999), 184–86.

[97] On the long survival of pagan "Hellenism," see Bowersock (1990); Chuvin (1990); Beard, North, Price (1998), 1:387–88. For specific Egyptian examples of the persistence of local deities, see Frankfurter (1998), 106–11, and on the process of christianization in Egypt, ibid., 265–84.

Christianity when the need arose, as it did after the end of the fourth century. Moreover, especially in the east, Christianity itself (following the model of its early roots as a mystery cult rather than that of an imperially imposed and unified state religion) split into a variety of locally based cults whose propositions were intellectualized and objectivized by the church councils under grand names like Donatism, Arianism, Nestorianism, Monophysitism, and the like in order be declared heretical and anathematised. Despite these efforts at centralization, which were inaugurated at Nicaea by Constantine himself, the local Christianities of Syria and Egypt resisted the "orthodox" center with a persistence which outlasted even the most dogged pagans. The Jews, whose polemical efforts at stealing Greco-Roman culture's visual vocabularies at Dura we have already seen, were to prove the most spectacularly adaptable of all the cults. They switched from resisting the Roman empire's pagan environment to resisting Christianity's monotheistic hegemony with appetite, aplomb, and remarkable (if low-key) success.

EPILOGUE

FROM DIANA VIA VENUS TO ISIS
Viewing the Deity with Apuleius

THE FIRST CHAPTER OF THIS BOOK proposed an account of two forms of visuality in the ancient world—a mimesis-related culture of viewing, and entertaining the fantasies evoked by, statues or paintings and a ritual-centered visuality in which sacred images functioned to open a door to the other world. Both these forms of visuality involve desire and viewer investment, but the first is largely "horizontal," taking in social and personal relationships with others (as evoked through images), while the second is largely "vertical," involving the relationship with divine powers or forces as embodied in images. Successive chapters have sought to exemplify, instantiate, and elaborate both these forms of viewing. One way perhaps to frame the polarity is by means of a passage in Pausanias about the sanctuary of the Mistress near Acacesium in Arcadia: "On the right as you go out of the temple there is a mirror fitted into the wall. If anyone looks into the mirror, he will see himself very dimly indeed or not at all, but the actual images of the god and the throne will be seen quite clearly" (8.37.7).[1] In "vertical" visuality, the individual subjectivity of the ritual-sensitive viewer, like Pausanias' temple visitor, is elided into a world of cult and sacred realities where ultimately the presence of the god looms large and dominates. Even if not entirely eclipsed, personal identity is subsumed by a larger divine reality before which the individual is placed. As one gazes into the mirror at Acacesium, what one sees is not oneself but the god. By contrast, in "horizontal" visuality, the viewer's own needs or appropriations come to dominate the world of the image (and the image imagined as real)— in extreme cases, to the delusive extents dramatized by the Greco-Roman accounts of Encolpius, Pygmalion, or Narcissus and others.

[1] With Frontisi-Ducroux and Vernant (1997), 196–99, and Platt (2002b), 44.

Yet in the end it is not so simple or so schematic. I conclude by complicating my opening polarity. As we have seen, even in the most extreme instances of sexual desire as viewer-investment (for instance the narratives and images of Narcissus or the story of Pygmalion), antiquity did not fully separate the magical effects of divine intervention from its portrayal of the psychopathologies of visual attraction. In the fresco of Narcissus from the Casa di M. Loreius Tiburtinus (Pompeii, II.2.2–5), what looks like a Gorgon's head is made to float in the water as Narcissus' reflected face (figure 6.8). In Ovid's story of Pygmalion, Venus herself intervenes to turn the desired ivory into flesh. Although conceptually we may separate visualities and ways of viewing, in the lived experience of actual people (whether Greeks and Romans or moderns today) shifts, combinations, and inconsistencies in ways of viewing are easy, frequent, and unsystematic. In effect viewers—even in sacred contexts—can shift between what I have called vertical and horizontal visualities at ease and at will; they may be skeptical as well as collusive, polemical as well as apologetic, about the effects of religious images.

Just as the supreme ancient accounts of the effects of naturalism find themselves bordering on the edge of the supernatural, so the most religiously centered descriptions of divine vision tend to withhold actual epiphany. When it comes to addressing the actual divine confrontation to which the complex of ritual and pilgrimage in ancient religion was to lead the worshipper (we might say the worshipping viewer or the viewer defined as worshipper), we find ourselves beset with problems. Actual cult images (as opposed to their replicas) rarely survive and never in the impressive architectural and visual contexts which were designed to empower them,[2] and our texts on matters of epiphany are deeply, deliberately, and often brilliantly ambivalent.[3] One might argue that Lucian's account of the "Hera" of Hierapolis, holding the gaze of all who approach her, discussed in chapter 1, is one of our most vivid glimpses of how ancient gods appeared to the worshipping viewer. But the most personal descriptions of such epiphanies tend to revolve not on statues as such but—like Aurelian's vision of Apollonius—on dreams and waking visions where the gods take on the appearances of their statues.

The classic instance is Lucius' vision of Isis in the eleventh book of the *Golden Ass*, whose interpretation happens also to be one of the trickiest, most

[2] On cult images, see Gladigow (1985/6); Scheer (2000), 131–46; Bettinetti (2001); and see Lapatin (2001) on the chryselephantine examples.

[3] This is the independent conclusion of two excellent recent theses: Stevens (2002) and Platt (2003). See also Platt (2002b).

elusive, and controversial issues in all Latin literature.[4] Indeed the *Golden Ass* as a whole—a single work probably written around A.D. 170 or 180, touching richly on many of the visualities which we have been exploring here—is perhaps the perfect test case for the difficulties of separating viewing in a sacred frame from that of nonreligious naturalism. The fact that its modern interpretations veer from a denial of any kind of artistic unity,[5] to the affirmation of a straightforward religious allegory,[6] to the hypersophisticated ironical take on religious commitment[7] expresses *in nuce* the problems of studying Roman subjectivity and viewing. Two problems especially stand out. First, we have the fundamental difficulty of divorcing our own cultural and often unconscious presuppositions and prejudices (especially on matters of religion and supremely when they are expressed as common sense) from our picture of how the Romans saw and experienced the world. This is, of course, impossible, although being self-conscious and aware of our limitations is a start. It is here that the critical readings of the *Golden Ass* effectively reveal much deeper (and often conflicting) reflexes about culture and religion in the critics themselves than they necessarily illuminate the *Ass*. Second, the Greeks and Romans, as I hope this book has shown, did not offer any less complex a culture of contradictory visualities than our own world. In attempting to understand them, we study not one thing but many, not a harmony but a babble of voices.

The *Golden Ass* alludes to a series of works of art and their viewings in the course of the travels of Lucius, its protagonist—most notably, images of deities.[8] Most impressively at 2.4, there is the atrium of Byrrhena's house in Thessaly with its statues of palm-bearing goddesses,[9] and its remarkable marble group representing Diana and Actaeon, which was discussed briefly at

[4] For useful summaries of the literature, see Finkelpearl (1998), 24–28, and Harrison (2000), 235–38. Generally on the history of interpretations of Apuleius, see Harrison (2002). The key problem (once one accepts the text's coherence and unity, which is to say also its literary value) is whether the religion of Book 11 is sincere, or parodic and satirical. The fundamental reading (leading to an aporetic view of the text's position on this) is Winkler (1985), especially 404–47. Other useful discussions of the Isis book include Griffiths (1975); Penwill (1975); Schlam (1992), 113–22; Shumate (1996), 285–328; Finkelpearl (1998), 199–217; Harrison (2000), 238–52; and Egelhaaf-Gaiser (2000), 30–37, 74–102. But it is worth noting that the problem of sincerity is precisely the same one to have bedeviled other elegantly contrived literary works on religious topics in antiquity, notably Lucian's *De Dea Syria* (see Lightfoot, 2003, 184–89, 196–221). In principle, I think this a difficulty largely of our own making—a secular modernist and postmodernist self-distancing from the investments and emotive effects of religion (not only in antiquity) that transfers our problems in this area onto the texts we read.

[5] See especially Perry (1967), 242–45.

[6] See Merkelbach (1962), 1–90.

[7] Especially Harrison (2000), 238–52.

[8] See Egelhaaf-Gaiser (2000), 116–45, on ekphrasis in general in the *Golden Ass*, and especially 117–25 on Götterbilder.

[9] See Peden (1985); Slater (1998), 27–8; and Mal-Maeder (2001), 94–95.

the beginning of chapter 7.[10] Much has been said about this passage as presaging the later action of the novel (as Byrrhena says to Lucius, "everything you see belongs to you," 2.5) from the bestial metamorphosis of Actaeon via the dangers of curiosity (Actaeon's *curioso optutu*—his curious gaze, 2.4).[11] The potential implication here of the predictive qualities of art was already prepared at the beginning of Book 2 in Lucius' frenetic thoughts about magic when he remarks "soon statues and pictures would begin to talk, walls to speak" (2.1).

But for our purposes it is worth noting Apuleius' juxtaposition of visualities in this ekphrasis. On the columns in the atrium's four corners stand "statues, likenesses of palm-bearing goddesses; their wings were outspread, but instead of moving, their dewy feet barely touched the slippery surface of a rolling sphere; they were positioned as though stationary, but you would think them to be in flight" (2.4). Here, divine figures (who may or may not be concealed prefigurations of Isis)[12] are nonetheless seen in terms of illusionistic naturalism—static, "but you would think them to be in flight."[13] The Diana and Actaeon group—a "splendid image" (*signum perfecte luculentum*, 2.4)—is described with all the standard ekphrastic emphasis on naturalistic detail. Diana's robe billows in the breeze; she runs forward vividly, coming to meet you as you enter; the dogs are so convincing you would think them to be barking if you heard the sound of dogs from next door; their sculptor is a superb craftsman, making the dogs seem to run; the landscaping is spectacular:

> Up under the very edge of the rock, hung apples and the most skillfully polished grapes which art, rivaling nature, displayed to resemble reality. . . . If you bent down and looked into the pool that runs along by the goddess' feet shimmering in a gentle wave, you would think that the bunches of grapes hanging there, as if in the country, possessed the quality of movement, among all other aspects of reality. (2.4)

The revelry in illusion is such that not only is the marble carving realistic but even its realization of its own reflection in water (whether this is carved water or real water, implying the described statue to be a fountain group at the atrium's central *impluvium*, is left unclear) has the power to make one imag-

[10] See Winkler (1985), 168–70; Shumate (1996), 67–71; Laird (1997), 62–64; Slater (1998), 26–37; Merlier-Espenel (2001); Mal-Maeder (2001), 91–93, 98–113; and Paschalis (2002), 135–39.

[11] On *curioso optutu* (or *curiosum optutum*) as the crucial interpretative steer in this ekphrasis, see Mal-Maeder (2001), 109–12. For curiosity as a central theme of the novel, see, for example, Wlosok (1999) and DeFilippo (1999).

[12] If one follows Peden (1985), 382–83.

[13] See Mal-Maeder (2001), 94–98, with bibliography.

ine it were real.[14] Yet we are reminded that Diana is "awesome with the sublimity of godhead" (*maiestate numinis venerabile*, 2.4). That awesomeness meets those who enter the room (*introeuntibus obvium*), while the eyes of her dogs threaten (*oculi minantur*). The description ends with the viewer's looking at the doomed Actaeon, already turning into a stag, who is himself looking at the goddess with a curious glance (*curioso obtutu*): the naturalistic gaze of curiosity and its framing as the voyeurism of both Actaeon looking at the goddess and Lucius looking at Actaeon, is already offset by the hint of a more worrying supernatural gaze.

Later in the same book, the maid Photis arrives for her first night of passion with Lucius:

> Without a moment's delay, she whipped away all the dishes, stripped herself of all her clothes and let down her hair. With joyous wantonness she beautifully transformed herself into the picture of Venus rising from the ocean waves (*in speciem Veneris quae marinos fluctus subit*). For a time she even held one rosy little hand in front of her smooth-shaven pubes, purposely shadowing it rather than modestly hiding it. "Fight," she said, "and fight fiercely, since I will not give way and I will not turn back. Close in and make a frontal assault, if you are a real man." (2.17)

As has been pointed out, the text evokes famous images here—not only Apelles' painting of the Venus Anadyomene but also Praxiteles' sculpture of Aphrodite of Cnidos, whose hand quivers in the ambivalence between defense or suggestion (see the ancient replica at figure 5.2).[15] Even Photis' shaved pudenda evoke the hairlessness of ancient statues and in particular that of the Aphrodite of Cnidos, whose lack of pubic hair defies her celebrated naturalism.[16] In this sense, the appearance of Photis as refracted in Lucius' first-person wish-fulfillment account of seduction is a case of life imitating art, by contrast with the repeatedly emphasized naturalism of the Diana and Actaeon

[14] Cf. also the reflection of Actaeon in the spring at 2.4. On the reflection theme, see Slater (1998), 40–46. The illusionist thematics of this passage appear to relate also to the classic Roman *texts* about naturalism—so the grapes recall Pliny's Zeuxis and Parrhasius story (*Natural History* 35.65–66), while the invitation to look into a pool reflects Narcissus.

[15] See, for example, Schlam (1992), 71–72; Laird (1997), 64–65; Slater (1998), 20–24; and Egelhaaf-Gaiser (2000), 119–20. On this theme in the Aphrodite of Cnidos, see, for example, R. Osborne (1994), 81–85; R. Osborne (1998), 231–35; and Platt (2002b), 33–36, 44.

[16] See, for example, Smith (1991), 83; D'Ambra (1996), 225 (with a long bibliography at n. 30); and Stewart (1997), 99. As these writers point out, even more deficient of naturalism is her lack of a sculpted vulva. That the most celebrated erotic female statue in antiquity—and indeed ancient nude sculpture of females in general—should deny naturalistic rendition in this arena (by contrast with the rendition of male genitalia) and in the context of repeated narratives that fantasize the image's penetration, speaks volumes about some fundamental cultural problems in relation to eroticism which must be said to precede Christianity's culture of resistance to sexuality.

FROM DIANA VIA VENUS TO ISIS

group—where the marble imitates reality. Yet in emulating Praxiteles' famous statue down even to the pudenda, Photis takes on the sex—rather than the divine majesty—of Venus. One might add that the description of the Venus Pudica posture is one cultivated by Latin literature for moments of sexual excess (on which the full polemic of the moral rhetoric of decadence can descend)—as in the *Historia Augusta*'s extraordinary account of Elagabalus in the role of Venus, taken here by Photis, for the benefit of a male "partner in depravity" (*H.A. Elagabalus* 5.4–5). The emphasis in Photis' speech on frontal assault appears to comment on discussions like that in Lucian's *Amores* 17 about which way a "new Anchises" might attempt to penetrate the Cnidian statue.[17] But most pertinent to the issue of visuality here is the way a famous set of artistic likenesses of a goddess are summoned not for divine vision or to evoke the sublimity of godhead but to spice up sexual intercourse. Statuary here is a masquerade and Venus (*qua* goddess) is a fake. Within the structure of the novel one might see Photis' role-play in the form of Venus here as a very dangerous because transgressive, even potentially metamorphic, act, hinting at the future development of the plot. In this section, she may be "Venus," but later in the novel she plays the "Diana" role in the narrative of Lucius-as-Actaeon, when by mistake she is responsible for his metamorphosis into an ass (3.21–25).

The theme of the masquerade of Venus—where a woman takes on the role and image of the goddess (or has it foisted upon her)—runs through the *Golden Ass*.[18] Psyche, for instance, who is admired "as people admire an exquisitely finished statue" (4.32), is offered "prayers as if she were the very goddess Venus herself" (4.28–29), thus inciting Venus' wrath at 4.29–31.[19] Again the Aphrodite of Cnidos is the statue explicitly evoked—this time in the list of Venus sanctuaries abandoned by worshippers as they flock to supplicate Psyche. These are Paphos, Cnidos, and Cythera—of which Cnidos is the one specifically associated with a world-famous statue. Whereas the account of Photis has the human impersonator appropriating Venus to emphasize sex above religion for the benefit of her spectator/lover Lucius (and her

[17] See briefly chapter 5 above. The description of their lovemaking, with Photis sitting on top of Lucius, further complicates the dynamics here (the warrior is certainly attacked and conquered rather than being the attacker), while the phrase "if you are a man" is highly ironic given Lucius' imminent metamorphosis into a donkey at the hands of Photis. Later, in the sex scene at 3.20, "Photis of her own generosity played the boy's part (*puerile*) with me as a bonus," hence reversing her declaration at 2.17 of not turning her back on Lucius. Apart from the erotic frissons of all this, it seems a further telling commentary on the Aphrodite of Cnidos theme, reduced again to pure sexual gratification. One wonders if the implicit punishments that fall on Lucius (becoming an ass) and on the boy in pseudo-Lucian's *Amores* (his suicide at *Amores* 16) are not the result of attempting to use Aphrodite in his way—as a boy (cf. *Amores* 17).

[18] See Laird (1997), 65–69. Generally on theatricality and spectacle, see Slater (2003).

[19] See, for example, Shumate (1996), 252–54.

vicarious spectators reading the text), the narrative of Psyche has her, albeit innocently, appropriating the sanctity of Venus so that her spectator/worshippers abandon the real goddess in her real temples, emphasizing religion above sex. In both cases, whether through pose or site, the ambivalence of the visuality of the Aphrodite of Cnidos (between sex and religion) is a means for Apuleius to achieve parallel effects—whereby a human figure effectively supplants the divine.

At 10.30–35, Apuleius stages ekphrastically the theatrical performance whose culmination was to be the public exposure of Lucius the ass in sexual intercourse with a condemned woman. Among the warm-up acts is a masque of the Judgment of Paris starring a girl

> surpassingly beautiful to look at, with a charming ambrosial complexion, representing Venus as Venus looked when she was a virgin (*qualis fuit Venus cum fuit virgo*).[20] She displayed a perfect figure, her body naked and uncovered except for a piece of sheer silk with which she veiled her comely charms. An inquisitive breeze would at one moment blow this veil aside in wanton playfulness so that it lifted to reveal the flower of her youth, and at another moment it would gust exuberantly against it so that it clung tightly and graphically displayed her body's voluptuousness. (10.31)[21]

Again, as with the position of the Venus-hand in the Photis love scene and the statue of Aphrodite of Cnidos, the coverings explicitly reveal the pudenda they are designed to veil. In the context of explicit and chiastically placed accounts of sexual intercourse in the novel's second and penultimate books (2.17 and 10.21–22),[22] even the wording of *lasciviam* (2.17) and *lasciviens* (10.31) has the episodes echoing each other.[23] In both this scene and the Photis "epiphany" as Venus, the divine is traduced by being appropriated to human sexual ends, and the complex of mixed visualities, admittedly with a predictive and even threatening edge, implicit in the Atrium sculptures of 2.4, is reduced to a single "horizontal" investment in the image as object of desire.

By contrast, Book 11, the Isis book, opens with Lucius the ass—newly escaped from the imminent threat of "Venus' embrace" in public with a condemned woman (10.34)—waking from sleep.[24] Before him is the full moon,

[20] This is frankly a truly remarkable idea—could Venus ever be conceived as virginal?

[21] On this passage, see Finkelpearl (1991), 223–24; Zimmerman–de Graaf (1993), 147–53, and Zimmerman (2000), 375–78.

[22] See Schlam (1992), 72–73, and Zimmerman (2000), 26.

[23] Other parallels: the slaves withdraw to ensure the lovers' privacy (2.15 and 10.20), the use of diminutives (with Zimmerman, 2000, 276).

[24] There is a clear parallel with the opening of Book 2: see Laird (1997), 70. In general on sleep and dream in the *Golden Ass*, see Kenaan (2004).

which is described as the "sacred image of the goddess now present before me" (*augustum specimen deae praesentis*, 11.1), picking up on the novel's thematics of religious images, but this time in the form of a natural aniconic rather than naturalistic man-made image and in the frame of a personal ritual obeisance. Lucius, still an ass, purifies himself by bathing in the sea (plunging in seven times) and then addresses the goddess. In response to his prayer, as he falls asleep, "from the midst of the sea a divine face arose, displaying a countenance worthy of adoration even by the gods. Slowly it appeared until its whole body came into view and, the brine shaken off, a radiant vision stood before me" (11.3). There follows a lengthy ekphrasis of "her wonderful appearance," especially of the range of her divine accoutrements, including sounds and smells (11.3–4). Then Isis speaks, offering Lucius salvation in the form of metamorphosis from his donkey-form and instructing him in what he must do at her festival to achieve his transformative return to human shape (11.5–6). Immediately the goddess "withdrew into herself," and Lucius wakes from his mystical sleep (11.7). The narrative then unfolds, recounting the festival of Isis (11.8–17) and Lucius' miraculous transformation (11.13), after which he undergoes repeated ritual initiations into the mysteries of Isis (11.19–25) and then Osiris (11.27–30).[25]

Significantly, Lucius' prayer to the queen of heaven addresses her as a series of goddesses—including Ceres, Venus, Diana, and Proserpina (11.2)—but admits that he does not know her true identity: "By whatever name, with whatever rite, in whatever image it is meet to invoke you" (11.2). In her response, Isis accepts these titles and adds more—Cybele, Minerva, Juno, Bellona, Hekate, Rhamnusia, and "my real name which is Queen Isis" (11.5): "My divinity is one, worshipped by all the world under different forms, with various rites and by manifold names" (11.5). In effect the figures of Diana and Venus, whose images Apuleius has used earlier in the book, are subsumed in Isis and turn out to have prefigured her.

In the ritual procession during which Lucius is transformed and in the initiation rites he subsequently performs, there are repeated reversals of earlier false rituals, travesties, and parodies in the novel. The gods deigning to walk with human feet (11.11) reverse the theatrical masquerade of humans performing as god—Paris, Mercury, Juno, Minerva, Venus, and so forth—in 10.30–34. The procession and temple of Isis are replete with holy images.[26] These reverse the image possessed by the corrupt eunuch priests of the Syrian Goddess who buy Lucius the ass at 8.24 and use him to carry their

[25] On Apuleius' evocation of the Isis cult, see Egelhaaf-Gaiser (2000), 77–84, 251–58.

[26] See 11.16, *simulacris rite despositis*; 11.17, *divinas effigies, simulacra spirantia, vestigiis deae, quae gradibus haerebat argento formata*; 11.20, *deae venerabilem conspectum*; 11.24, *deae simulacrum*; 11.25, *inexplicabili voluptate simulacra divini*.

statue (8.27, 8.30, 9.10). Likewise the series of sincerely performed rituals and obligations of the Isis cult—culminating in the final image of Lucius, head shaved, like an ancient Hare Krishna, wandering Rome as a priest of Isis (11.30)[27]—reverse the false rituals performed to cheat the credulous by the priests of the Syrian Goddess at 8.27–30 and 9.8–9.[28]

Strikingly, the scene of Lucius' first initiation into the mysteries of Isis has him assimilated into statuehood: "I was set up in the guise of a statue (*me . . . in vicem simulacri constituto*, 11.24)."[29] He stands before the goddess' own statue on a wooden base in "very holy attire" consisting of "twelve robes as a sign of consecration." He is the "focus of attention because of my garment which was only linen, but elaborately embroidered." Like the goddess in his vision and in her images, he carries accoutrements: "In my right hand I carried a torch alight with flames, and my head was beautifully bound with a crown made of leaves of shimmering palm, jutting out like rays of light." Standing on his base before the statue of Isis, Lucius effectively forms a statue group with her,[30] which counterpoints the earlier group of Diana and Actaeon. There Actaeon gazed at the goddess surreptitiously, without performing the necessary rituals and rites of initiate viewing, and was metamorphosed into a quadruped in punishment. Now, metamorphosed back from a quadruped to humanity at the goddess' own injunction, after a series of initiations that turn him into the perfectly trained ritual viewer, Lucius can gaze at Isis face to face. This new group has Lucius posing as a statue before a cult image, picking up on the masquerade theme of people as images of gods from Book 10, but now as part of the initiate ritual rather than as a travesty. Nothing seems to define the differences of ancient visualities, their apparent and dangerous similarities (in terms of masquerades, the use of common statue forms, the significance of viewing), and the possibilities of passage between them (via a series of misconceived Venuses), than the novel's move from the Diana and Actaeon group to that of Lucius and Isis.[31]

It is worth noting that Apuleius clearly likes the formulation of statue groups with a worshipper gazing at a goddess. In the *Florida*, an anthology of

[27] See Winkler (1985), 233–37, for discussion.

[28] The Isis rituals include: abstinence and chastity (11.19); abstinence from certain foods (11.21, 23, 28); head shaving (11.28, 30); ritual baths and sprinklings (11.23); sacred rites and rituals, some secret (11. 22, 23); prayers and libations (11.20).

[29] Cf. Griffiths (1975), 316–17: "The identity of the mystes and his god could not be more clearly expressed."

[30] Cf. Slater (1998), 39–40, and (2003), 100.

[31] On contemplative adoration of Isis by Lucius, see Festugière (1954), 80–84. For an intriguing parallel concatenation of images reflecting Diana and Actaeon, the former in the posture of "crouching Venus," and a bald priest of Isis in the Casa di Loreius Tiburtinus in Pompeii (II.2.2.), see Platt (2002a) and at greater length (2003), 117–133.

some of his best rhetorical turns, Apuleius writes of the statue of Bathyllus before the altar in the Heraion of Samos, dedicated by the young singer's lover, the tyrant Polycrates (*Florida* 15.6–12).[32] The statue is described at length ("I don't think I've seen anything better (*effectius*) than this," 15.6) with several allusions to the love of Polycrates (15.11), including the refutation of the statue's misidentification as an image of Pythagoras on the grounds that Polycrates was never Pythagoras' lover (15.6, 12). But as in the group made by Lucius and Isis (by contrast with that of Diana and Actaeon), Bathyllus eschews the amatory for the celebration of deity: "he looks at the goddess (*deam conspiciens*, 15.8)" and sings to her playing his lyre (15.8–10). Even his robe, "decorated with figures in a variety of colours that reaches down to his feet," seems to echo the decorations of Lucius' tunic in the *Golden Ass* 11.24.

It is as if in the ritual visuality of the sacred (whether one takes Apuleius as sincere or mocking or both), the worshipper is himself reconstituted as image in a divine dispensation that thereby allows the initiate to confront the gods not merely through their images but face to face. The novel concludes (if we can trust the manuscripts regarding its correct ending)[33] with a final vision: "He that is mightiest of the great gods, the highest of the mightiest, the loftiest of the highest and the sovereign of the loftiest, Osiris, appeared to me in a dream. He had not transformed himself into a semblance other than his own, but deigned to welcome me face to face with his own venerable utterance" (11.30). The novel ends with an end to transformations (the god appears as himself) and with Lucius making the choice of self-transformation (through mystical initiation and ritual) rather than being turned into something other than he is.[34] The willing statue-ification of Lucius is again in contrast with a pattern of petrification and stupefaction that runs through the novel—notably, the way Lucius is "frozen into stone just like one of the other statues or columns in the theatre" (3.10) after the practical joke at his expense during the Risus festival when he is tried for murder (3.2–9), and the city's offer to him of a bronze statue (3.11), which he rejects.[35]

The novel effectively negotiates its way through the dual culture of horizontal and vertical visualities characteristic of Greco-Roman antiquity. In every case before Book 11, images of the gods may be capable of divinity but they tend to be traduced—appropriated to the arts of seduction, to the titillation

[32] For discussion, see Hunink (2001), 139–41, 143–46.

[33] On the mss, see Mal-Maeder (1997), 112–17.

[34] On this passage, see Laird (1997), 80–85.

[35] For a list of such passages, see Winkler (1985), 170–71, though he fails to note the one at 11.24. For Apuleius and the offer of honorific statues, see *Florida* 16.1, 46–47; also Too (1996), 134–41. For a versatile and sensitive account of statues in the Roman world, see P. Stewart (2003).

of their viewers or to ripping them off (as in the case of the image of the Syrian Goddess which the *galli* load on Lucius the donkey's back). Only in the opening ekphrasis at 2.4 do Diana and Actaeon offer the challenge of a sublime godhead side by side with naturalistic realism and Actaeon's voyeurism. In Book 11, all this is reversed. We find sacred images, epiphanies, and symbols in abundance—but the question becomes whether Lucius is a dupe (as the leading citizen, *vir principalis*, is duped by the *galli* at 8.30) or truly saved, whether we (and Apuleius) are to laud his salvific transformation or lament his further journey into ruin. Certainly his course of initiations leaves him all but financially ruined (11.28),[36] yet the god's favor brings him success as a lawyer (11.28, 30)—unless this success is no more than a dupe's shot at self-justification.

Strictly speaking, in exploring the *Golden Ass*'s evocation of visualities, it is not necessary to assess the work's sincerity. What matters is that the attitudes it presents could be sincerely adopted in the Roman world. Here Aelius Aristides is a potent case—since he not only was roughly contemporary with Apuleius but specifically attributed his undoubted success as a sophist to the divine activity of Asclepius.[37] Indeed the likes of Aristides might even be construed as a butt of the *Golden Ass*'s satire, if satirical it is.[38] Intriguingly, Aristides was also given to visions of Isis:

> I was staying at the warm springs, and the goddess [Isis] ordered me to sacrifice two geese to her. I went to the city, having first sent ahead men to look for them, and having told them to meet me at the temple of Isis with the geese. On that day there were no other geese for sale, except only two. When they approached and tried to buy them, the man who raised the geese said that he was not able to sell them, for it was foretold to him by Isis to keep them for Aristides, and he would surely come and sacrifice them. When he learned the whole story he was dumbstruck and making obeisance, gave them to them. And these things I learned at the sacrifice itself. There was also a light from Isis and other unspeakable things which pertained to my salvation. Sarapis also approached in the same night, both he himself and Asclepius. They were marvelous in beauty and in magnitude and in some way like one another. (*Sacred Tales* 3, *Or* 49.45–46)

What is striking here is the parallelism with Lucius' vision. In the *Golden Ass*, Isis not only appears to Lucius, giving him precise instructions (11.5–6),

[36] With, for example, Winkler (1985), 219–23, and Schlam (1992), 121.

[37] Effectively the subject of *Sacred Tales* 4, especially *Or* 50.15–102, with Harrison (2000–2001), 251–52. On Aristides' revelations of divinities, see, for example, Festugière (1954), 45–47.

[38] See especially Harrison (2000–2001). On Aristides and Apuleius' both reflecting sincere spirituality, see Festugière (1954), 85–104.

but simultaneously appears to the priest who will officiate at the procession, priming him too (11.6, 13).[39] This careful fixing of details in simultaneous dreams may be characteristic of Isis' divine workings given its inclusion in both accounts, but there is no doubt about the wonder it evokes both in the *Sacred Tales* and the *Golden Ass*,[40] and that it is genuine in the case of Aristides, whose *Sacred Tales* cannot be read as other than sincere. In both the Apuleian and the Aristidean Isis visions, the need for an external audience to witness the miracle occasioned by her parallel visions effects a sacred theatricality which might be said to be a counterpoint to the voyeurism of nonsacred visuality, at least as performed in the *Golden Ass*.

By staging the range of Roman visualities in relation to a series of statues and statues imitated by characters in the course of his novel, Apuleius frames the gaze between curiosity and reverence. The gaze in the *Golden Ass* ranges between the intensity of personal revelation (whether sexual as in the case of Lucius and Photis, or sacred as in the visions of Osriris and Isis, or both sacred and sexual as in Psyche's illicit vision of Cupid at 5.22–23) and the social panopticon of being gazed at while gazing as in the masquerade of 10.30–34 (with its planned culmination in public bestial intercourse) or of religious miracle (when the crowd watches Lucius' transformation back to man, 11.13, 16) or of mistaken reverence (the collective gaze at Psyche as if she were the statue of a goddess, 4.32). The structure of the novel, literally undertaking a journey into revelation and initiate vision, promises to negotiate the passage between these visualities into the positive joy (*gaudens* is the text's penultimate word) of salvific redemption. This parallels the positive structure of the Cupid and Psyche interlude, which ends happily with the divine marriage of the couple and the birth of their daughter Pleasure (*Voluptas*, 6.24).[41] Yet that structure is potentially but persistently undermined with the sense that the sacred visions and initiations may all be self-delusion—on the pattern of the willful deceptions orchestrated by the priests of the Syrian Goddess.[42] Likewise the story of Cupid and Psyche, for all its happy ending, emanates from the mouth of a "crazy, drunken old woman" (6.25).[43]

[39] The type is what is called the "double dream vision," on which see Hanson (1980), 1414–21. For another interesting parallel also from an Egyptian-related context in the second century A.D., see P. Oxy. 11.1381, lines 91–145, with Nock (1933), 86–88, and Hanson (1980), 1416–17.

[40] Cf. 11.13, *sacerdos miratus*; 11.13–14, *populi mirantur, ego stupore . . . defixus*. The theme of wonder specifically picks up the repetition of wonder at the sight of Psyche at 4.32: *mirantur . . . mirantur*.

[41] On parallels between the Psyche story and the cult-myth of Isis, see Merkelbach (1958) and Krabbe (1989), 93–95.

[42] As the old woman who tells the Cupid and Psyche story remarks, "visions which come with naps during the day are said to be false" (4.27)—throwing into relief if not doubt the vision of Isis at 11.3.

[43] Thus itself putting into doubt the doubts her tale may have raised, as in the previous footnote.

EPILOGUE

The critical impasse about how to read the *Golden Ass*[44] reflects both the exclusivity of ancient visualities (religious or ritual-centered, on the one hand, and mimetic, on the other) and the inability of modern scholarship and perhaps also Apuleius' ancient readership to legislate between them or to determine their sincerity unambiguously. Shrewdly, Apuleius chose repeated elliptical references to the Aphrodite of Cnidos as the figure through which to represent this problem—for in no other work of art is the instability of sacred or sexual, the difference between being adored as god and being assaulted as sex object, more acutely clear. Rightly, in his attack on both these arenas of pre-Christian visuality (sex and religion), Clement of Alexandria—a slightly later contemporary of Apuleius and Aelius Aristides, writing in the later second and early third century—was able to dismiss them both together:

> If one sees a woman represented naked, one understands it to be "golden" Aphrodite. So the well-known Pygmalion of Cyprus fell in love with an ivory statue: it was of Aphrodite and it was naked. The man of Cyprus is captivated by its shapeliness (*schemati*) and embraces the statue. . . . There was also an Aphrodite in Cnidos, made of marble and beautiful. Another man fell in love with this and had intercourse with the marble. (*Protrepticus* 4.50)

But Clement's choice of the Aphrodite of Cnidos type to deprecate both the sexuality of viewing and its ritual-centeredness (at least in the case of what he took to be idols)[45]—that is, both the Photis and the Psyche versions of Venus—is of course not only polemical but willful. The *Golden Ass*, having opened its discourse of statues and goddesses with Diana in the bathing stance of Aphrodite (of Cnidos) takes Lucius through a series of versions of Venus (not only Photis and Psyche but also the masquerade's personification) to her real identity (*vero nomine*, 11.5) as Isis—a truly horrifying option for a Clement.

It is as if Apuleius, having laid out the frame of visuality, both as personal epiphany and as social panopticon—the intensity of personal gazing and the potential paranoia of being gazed at while gazing—chooses the key image of ancient religious art around which the mimetic and religious gazes collide. Whether we take the Aphrodite type as Diana, as Photis, as Psyche, as the masquerade Venus, or as Isis is in the end not legislated by any means other than the viewer's choice. And in making our choice, as the novel's narrative reveals, there are always prices to pay. The two visualities with which I began this book, and even the gazing (at a naked Venus) of Browning's epigram

[44] Best expressed, still, by Winkler (1985), for example, 123–32, 247.

[45] Later in the same passage, Clement is even more explicit about the way illusion beguiles: "for it leads you, though not to be in love with statues and paintings, yet to honour and worship them."

which I discussed in the prologue, turn out to flip as two sides of a coin about a single image. At least in the case of Aphrodite, the efforts needed to ensure one kind of viewing over another are great and never wholly secure.

The novel's final choice of Isis as savior, and of initiation into her cult, is both personal for Lucius and certainly not unambivalently or overtly endorsed by Apuleius. Cult visuality offers a space which, as we have seen in relation to other mystery cults in antiquity, could have a social politics both of collective sectarian identity for religious subgroups and even of resistance to other groups or to more normative authority. It is above all a space where visuality and subjectivity come together in a series of choices about personal belief and social identity. What is perhaps most amazing about the gaze in its ancient discussions and visual exemplification is how potent, wide-ranging, and fundamental are the ramifications entailed by the amazement to which it gave rise.

BIBLIOGRAPHY

Abbreviations

AJA	*American Journal of Archaeology*
AJP	*American Journal of Philology*
ANRW	W. Haase and H. Temporini, eds., *Aufstieg und Niedergang der römischen Welt* (Berlin, 1972–)
CA	*Classical Antiquity*
CJ	*Classical Journal*
CP	*Classical Philology*
CQ	*Classical Quarterly*
GRBS	*Greek, Roman and Byzantine Studies*
HSCP	*Harvard Studies in Classical Philology*
IE	*Die Inschriften von Ephesos* Ia-VIII, 2 (Bonn 1974–1984)
JbAC	*Jahrbuch für Antike und Christentum*
JdAI	*Jahrbuch des deutschen Archäologischen Instituts*
JJS	*Journal of Jewish Studies*
JRA	*Journal of Roman Archaeology*
JRS	*Journal of Roman Studies*
LIMC	*Lexicon Iconographicum Mythologiae Classicae*
MD	*Materiali e discussioni per l'analisi dei testi classici*
MEFRA	*Mélanges de l'école française de Rome. Antiquité*
OJA	*Oxford Journal of Archaeology*
PBSR	*Papers of the British School at Rome*
PCPS	*Proceedings of the Cambridge Philological Society*
PPM	I. Baldassare and G. Pugliese Carratelli, eds., *Pompei: Pitture e Mosaici*, 10 vols. (Rome, 1990–2003)
PPM documentazione	I. Baldassare, T. Lanzillotta, and S. Salomi, eds., *Pompei: Pitture e Mosaici: la documentazione nell' opera di disegnatori e pittori dei secoli XVIII e XIX* (Rome, 1995)
RA	*Revue archéologique*
RAC	*Reallexikon für Antike und Christentum*
RE	A. F. von Pauly et al., *Real-Encyclopädie der klassischen Altertumswissnschaft* (Stuttgart 1894–)
REL	*Revue des études latines*
RM	*Römische Mitteilungen*

TAPhA Transactions and Proceedings of the American Philological
 Association
YCS Yale Classical Studies

Agosti, G., et al., eds. 1993. *Giovanni Morelli e la cultura dei conoscitori.* Bergamo.

Ahl, F. 1985. *Metaformations.* Ithaca, NY.

Akujärvi, J. 2005. *Researcher, Traveller, Narrator: Studies in Pausanias'* Periegesis. Stockholm.

Alberti, Leon Battista. 1977. *On Painting.* New Haven, CT. First appeared in 1435.

Alcock, S. E. 1993. *Graecia Capta: The Landscapes of Roman Greece.* Cambridge.

———. 1994. "Minding the Gap in Hellenistic and Roman Greece." In S. E. Alcock and R. Osborne, eds., *Placing the Gods: Sanctuaries and Sacred Space in Ancient Greece,* 247–61. Oxford.

———. 1996. "Landscapes of Memory and the Authority of Pausanias." In *Pausanias Historien. Entretiens Fondation Hardt* 41: 241–67.

———. 1997a. "Greece: A Landscape of Resistance?" In Mattingly (1997), 103–15.

———, ed. 1997b. *The Roman Empire in the East.* Oxford.

Alcock, S. E., J. F. Cherry, and J. Elsner, eds. 2001. *Pausanias: Travel and Memory in Roman Greece.* Oxford.

Alföldi, A., and E. Alföldi. 1990. *Die Kontorniat-Medaillons: II, Text.* Berlin.

Alpers, S. 1960. "Ekphrasis and Aesthetic Attitudes in Vasari's Lives." *Journal of the Warburg and Courtauld Institutes* 23: 190–215.

Amory, A. 1966. "The Gates of Horn and Ivory." *YCS* 20: 1–57.

Ancona R., and E. Greene, eds. 2005. *Gendered Dynamics in Latin Love Poetry.* Baltimore.

Anderson, G. 1976. *Lucian: Theme and Variation in the Second Sophistic. Mnemosyne* suppl. 41. Leiden.

———. 1986. *Philostratus: Biography and Belles Lettres in the Third Century A.D.* London.

———. 1993. *The Second Sophistic: A Cultural Phenomenon in the Roman Empire.* London.

Anderson, J., ed. 1991. *G. Morelli, Della Pittura Italiana.* Milan.

Anderson, W. S. 1963. "Multiple Changes in the *Metamorphoses,*" *TAPhA* 94: 1–27.

Andreae, B. 1975. "Rekonstruktion des Grossen Oecus der Villa der P. Fanius Sinistor in Boscoreale." In B. Andreae and H. Kyrieleis, eds., *Neue Forschungen in Pompeji,* 71–83. Recklinghausen.

Annas, J. 1980. "Truth and Knowledge." In Schofield, Burnyeat, and Barnes (1980), 84–104.

Arafat, K. 1992. "Pausanias' Attitude to Antiquities." *Annual of the British School at Athens* 87: 387–409.

———. 1995. "Pausanias and the Temple of Hera at Olympia." *Annual of the British School at Athens* 90: 461–73.

———. 1996. *Pausanias' Greece.* Cambridge.

Arjava, A. 1996. *Women and Law in Late Antiquity.* Oxford.

Arnaud, P. 1986. "Doura-Europos, microcosme Grec ou rouage de l'administration Arsacide?" *Syria* 63: 135–55.

Attridge, H., and R. Oden. 1976. *De Dea Syria.* Missoula, MT.

Austin, R. G. 1977. *P. Vergili Maronis: Aneidos Liber Sextus.* Oxford.

Baldovin, J. 1987. *The Urban Character of Christian Worship.* Rome.

Balensiefen, L. 1990. *Die Bedeutung des Spiegelbildes als ikonographisches Motiv in der antiken Kunst*. Tübingen.

Balmaseda, L. J. 1990. "Hercules (in periphera occidentali)." *LIMC* V.1, 253–62.

Bann, S. 1989. *The True Vine: On Visual Representation and the Western Tradition*. Cambridge.

Barasch, M. 1992. *Icon: Studies in the History of an Idea*. New York.

Barber, C. 2002. *Figure and Likeness: On the Limits of Representation in Byzantine Iconoclasm*. Princeton, NJ.

Barbier, E. 1962. "La signification du coffret de 'Projecta.' " *Cahiers archéologiques* 12: 7–33.

Barchiesi, A. 1994. "Rappresentazioni del dolore e interpretazione nell' Eneide." *Antike und Abendland* 40: 109–24.

———. 1997a. "Ekphrasis." In Martindale (1997), 271–81.

———. 1997b. *The Poet and the Prince*. Berkeley.

———. 2001. *Speaking Volumes: Narrative and Intertext in Ovid and Other Latin Poets*. London.

Barkan, L. 1991. *Transuming Passion: Ganymede and the Erotics of Humanism*. Stanford.

———. 1993. "The Beholder's Tale: Ancient Sculpture, Renaissance Narratives." *Representations* 44: 133–66.

Barnes, E. J. 1973. "Petronius, Philo, and Stoic Rhetoric." *Latomus* 32: 787–98.

Barrett, J. C. 1997. "Romanization: A Critical Comment." In Mattingly (1997), 51–64.

Barton, C. 1993. *The Sorrows of the Ancient Romans*. Princeton, NJ.

Barton, T. 1994. *Power and Knowledge: Astrology, Physiognomics, and Medicine under the Roman Empire*. Ann Arbor, MI.

Bartsch, S. 1989. *Decoding the Ancient Novel: The Reader and the Role of Description in Heliodorus and Achilles Tatius*. Princeton, NJ.

———. 1994. *Actors in the Audience: Theatricality and Doublespeak from Nero to Hadrian*. Cambridge, MA.

———. 1998. "Ars and the Man: The Politics of Art in Vergil's *Aeneid*." *CP* 93: 322–42.

———. 2000. "The Philosopher as Narcissus: Vision, Sexuality, and Self-Knowledge in Classical Antiquity." In Nelson (2000), 70–99.

Bassett, S. G. 1991. "The Antiquities in the Hippodrome of Constantinople." *Dumbarton Oaks Papers* 45: 87–96.

———. 1996. "*Historiae Custos*: Sculpture and Tradition in the Baths of Zeuxippos." *AJA* 100: 491–506.

———. 2000. " 'Excellent Offerings': The Lausos Collection in Constantinople." *Art Bulletin* 82: 6–25.

———. 2004. *The Urban Image of Late Antique Constantinople*. Cambridge.

Baudrillard, J. 1990. *Seduction*. London.

Bauer, D. F. 1962. "The Function of Pygmalion in the *Metamorphoses* of Ovid." *TAPhA* 93: 1–21.

Bazant, J., and E. Simon. 1986. "Echo." *LIMC* III.1, 680–83.

Beall, S. M. 1993. "Word Painting in the 'Imagines' of the Elder Philostratus." *Hermes* 121: 350–63.

Beard, M. 1985. "Reflections on 'Reflections on the Greek Revolution.' " *Archaeological Review from Cambridge* 4: 207–13.

Beard, M., and J. North, eds. 1990. *Pagan Priests*. London.

Beard, M., J. North, and S. Price. 1998. *Religions of Rome*. 2 vols. Cambridge.

Beazley, J. D. 1956. *Attic Black-Figure Vases*. Oxford.

Beck, R. 1979. "Eumolpus Poeta, Eumolpus Fabulator: A Study of Characterization in the Satyricon." *Phoenix* 33: 239–53.

———. 1984. "Mithraism since Franz Cumont." *ANRW* 2.17.4: 2002–2115.

———. 1988. *Planetary Gods and Planetary Orders in the Mysteries of Mithras*. Leiden.

———. 1998. "The Mysteries of Mithras: A New Account of Their Genesis." *JRS* 88: 115–28.

Behr, C. A. 1968. *Aelius Aristides and the Sacred Tales*. Amsterdam.

Bek, L. 1980. *Towards a Paradise on Earth (Analecta Romana 9)*. Odense.

Bell, C. 1992. *Ritual Theory, Ritual Practice*. Oxford.

Belting, H. 1994. *Likeness and Presence: A History of the Image before the Era of Art*. Chicago.

Bénabou, M. 1976a. *La résistance africaine à la romanisation*. Paris.

———. 1976b. "Résistance et romanisation en Afrique du Nord sous le Haut-Empire." In D. M. Pippidi, ed., *Assimilation et résistance à la culture gréco-romaine dans le monde ancien*, 367–75. Paris.

Benoît, F. 1952. "L'Ogmios de Lucien et Hercule Psychopompe." In G. Moro, ed., *Beiträge zur älteren europäischen Kulturgeschichte: Festschrift für Rudolf Egger*, 1: 144–58. Klagenfurt.

Berenson, B. 1950. *Aesthetics and History*. London.

Berger, J. 1972. *Ways of Seeing*. Harmondsworth.

———. 1980. *About Looking*. London.

Berger-Doer, G. 1994. "Pero II." *LIMC* VII.1, 327–29.

Bergmann, B. 1994. "The Roman House as Memory Theater: The House of the Tragic Poet in Pompeii." *Art Bulletin* 76: 225–56.

Bergmann, B., and C. Kondoleon, eds. 1999. *The Art of Ancient Spectacle*. Studies in the History of Art 56 Washington, DC.

Bernheimer, C. 2002. *Decadent Subjects*. Baltimore.

Besançon, A. 2000. *The Forbidden Image: An Intellectual History of Iconoclasm*. Chicago.

Beschi, L., and D. Musti. 1982. *Pausania: Guida della Grecia*. Book 1: *L'Attica*. Milan.

Bettinetti, S. 2001. *La statue di culto nella pratica rituale greca*. Bari.

Bettini, M. 1999. *The Portrait of the Lover*. Berkeley.

Bianchi Bandinelli, R. 1970. *Rome: The Centre of Power*. London.

Billault, A. 2000. *L'univers de Philostrate*. Brussels.

Blagg, T.F.C., and M. Millett, eds. 1990. *The Roman Empire in the West*. Oxford.

Blanchard, J. M. 1978. "The Eye of the Beholder: On the Semiotic Status of Paranarratives." *Semiotica* 22: 235–68.

Blanchard, M. E. 1986. "Philostrate: Problèmes du texte et du tableau." In B. Cassin, ed., *Le plaisir du parler*, 131–54. Paris.

Blanchard-Lemée, M. 1975. *Maisons à mosaïques du quartier central de Djemila (Cuicul)*. Aix-en-Provence.

———. 1988. "À propos les mosaïques de Sidi Ghrib." *MEFRA* 100: 367–84.

Boardman, J. 1982. "Herakles, Theseus, and Amazons." In D. Kurtz and B. Sparkes, eds., *The Eye of Greece: Studies in the Art of Athens*, 1–28. Cambridge.

Bodel, J. 1993. "Trimalchio's Underworld." In J. Tatum, ed., *The Search for the Ancient Novel*, 237–59. Baltimore.

Boeder, M. 1996. *Visa est Vox: Sprache und Bild in der spätantiken Literatur*. Frankfurt.

Bömer, F. 1976. *P. Ovidius Naso: Metamorphosen*. Books 6–7. Heidelberg.

———. 1980. *P. Ovidius Naso: Metamorphosen*. Kommentar, Books 10–11. Heidelberg.

Bonner, C. 1950. *Studies in Magical Amulets*. Ann Arbor.

Borg, B. 2004a. "Bilder zum Hören—Bilder zum Sehen: Lukians Ekphraseis und die Rekonstuktion antike Kunstwerke." *Millennium* 1: 25–57.

———, ed. 2004b. *Paideia: The World of the Second Sophistic*. Berlin.

Bothmer, D. von. 1957. *Amazons in Greek Art*. Oxford.

Bovini, G., and H. Brandenburg. 1967. *Repertorium der Christlich-Antiken Sarkophage*. Vol. 1, *Rom und Ostia*. Wiesbaden.

Bowersock, G. W. 1969. *Greek Sophists in the Roman Empire*. Oxford.

———, ed. 1974. *Approaches to the Second Sophistic*. University Park, PA.

———. 1990. *Hellenism in Late Antiquity*. Cambridge.

———. 1994. *Fiction as History: Nero to Julian*. Berkeley.

Bowes, K. 1993. "Prophetic Images: Mithraism and the Mithraeum at Dura-Europos." M.A. thesis, Courtauld Institute of Art.

Bowie, E. L. 1970. "Greeks and Their Past in the Second Sophistic." *Past and Present* 46: 3–41.

———. 1996. "Past and Present in Pausanias." In *Pausanias Historien. Entretiens Fondation Hardt* 41: 207–40.

Bowie, E. L., and J. Elsner, eds. Forthcoming. *Philostratus*. Cambridge.

Boyd, B. 1995. "*Non enarrabile textum*: Ecphrastic Trespass and Narrative Ambiguity in the *Aeneid*." *Vergilius* 41 (1995): 71–92.

Boyle, A. J. 1986. *The Chaonian Dove: Studies in the* Eclogues, Georgics, *and* Aeneid *of Virgil*. Leiden.

———. 1999. "*Aeneid* 8: Images of Rome." In Perkell (1999b), 148–61.

———. 2003. *Ovid and the Monuments*. Bendigo.

Bragantini, I. 2004. "Una pittura senza maestri: La produzione della pittura parietale romana." *JRA* 17: 131–45.

Bramble, J. 1970. "Structure and Ambiguity in Catullus LXIV." *PCPS* 16: 22–41.

Brandt, H. 1995. "Die 'Heidnische Vision' Aurelians (HA A 24.2-8) und die 'Christliche Vision' Konstantins des Grossen." *Historiae Augustae Colloquia III: Colloquium Maceratense*, 107–17. Bari.

Braund, S. 1988. *Beyond Anger*. Cambridge.

Breasted, J. 1922. "Peintures d' époque romaine dans le désert de Syrie." *Syria*, 177–211.

———. 1924. *Oriental Forerunners of Byzantine Painting*. Chicago.

Breen, C. 1986. "The Shield of Turnus, the Sword-belt of Pallas, and the Wolf." *Vergilius* 32: 63–71.

Brendel, O. 1979. *Prolegomena to the History of Roman Art*. New Haven, CT.

Brenk, F. 1998. "Artemis of Ephesos: An Avant-garde Goddess." *Kernos* 11: 157–71.

Brenkman, J. 1976. "Narcissus in the Text." *Georgia Review* 30: 293–327.

Brent, A. 1999. *The Imperial Cult and the Development of Church Order*. Leiden.

Brilliant, R. 1973. "Painting at Dura and Roman Art." In Gutmann (1973), 23–30.

———. 1984. *Visual Narratives: Story Telling in Etruscan and Roman Art*. Ithaca, NY.

———. 1994. "Jewish Symbols: Is That Still Goodenough?" In *Commentaries on Roman Art*, 233–44. London.

Brodersen, K. 1992. *Reiseführer zu den Sieben Weltwundern*. Frankfurt.

Brown, P. 1981. *The Cult of the Saints*. London.

———. 1988. *The Body and Society.* New York.

Brubaker, L. 1995. "The Sacred Image." In R. Ousterhout and L. Brubaker, eds., *The Sacred Image: East and West.* Urbana, IL.

Bruit Zaidman, L., and P. Schmitt Pantel. 1992. *Religion in the Ancient Greek City.* Cambridge.

Bryson, N. 1983. *Vision and Painting: The Logic of the Gaze.* London.

———. 1984. *Tradition and Desire: From David to Delacroix.* Cambridge.

———. 1988. "The Gaze in the Expanded Field." In H. Foster, ed., *Vision and Visuality,* 87–114. Seattle.

———. 1990. *Looking at the Overlooked.* London, 1990.

———. 1994. "Philostratus and the Imaginary Museum." In S. Goldhill and R. Osborne, eds., *Art and Text in Ancient Greek Culture,* 255–83. Cambridge.

Buckton, D., ed. 1994. *Byzantium.* London.

Buschhausen, H. 1971. *Die spätrömische Metallscrinia und frühchristliche Reliquiare.* Vol. 1. Vienna.

Calo, M. A. 1994. *Bernard Berenson and the Twentieth Century.* Philadelphia.

Calza, R. 1977. *Antichità di villa Doria Pamphilj.* Rome.

Cameron, A. 1970. *Claudian: Poetry and Propaganda at the Court of Honorius.* Oxford.

———. 1985. "The Date and Owners of the Esquiline Treasure." *AJA* 89: 135–45.

———. 1992. "Observations on the Distribution and Ownership of Late Roman Silver Plate," *JRA* 5: 178–85.

Cameron, Averil. 1991. *Christianity and the Rhetoric of Empire.* Berkeley.

Cämmerer, B. 1967. *Beitrage zur Beurteilung der Glaubwürdigkeit der Gemäldebeschreibungen des älteren Philostrat.* Freiburg.

Carey, S. 2003. *Pliny's Catalogue of Culture: Art and Empire in the* Natural History. Oxford.

Casali, S. 1995. "Aeneas and the Temple of Apollo." *CJ* 91: 1–9.

Charles, M. 2002. "*Calvus Nero*: Domitian and the Mechanics of Predecessor Denigration." *Acta Classica* 45: 19–50.

Cherry, J. 1992. "Beazley in the Bronze Age? Reflections on Attribution Studies in Aegean Pre-History." In R. Laffineur and J. L. Crowley, eds., *Eikon: Aegean Bronze Age Iconography: Shaping a Methodology. Aegaeum* 8, 123–44. Liège.

Chuvin, P. 1990. *A Chronicle of the Last Pagans.* Cambridge, MA.

Clare, R. 1996. "Catullus 64 and the Argonautica of Apollonius Rhodius: Allusion and Exemplarity." *PCPS* 42: 60–88.

Clark, G. 1993. *Women in Late Antiquity.* Oxford.

Clarke, J. 2003. *Imagery of Colour and Shining in Catullus, Propertius, and Horace.* New York [= J. Clarke, 2003].

Clarke, J. R. 1993. "The Warren Cup and the Context for Representations of Male-to-Male Lovemaking in Augustan and Early Julio-Claudian Art." *Art Bulletin* 75: 275–94.

———. 1997. "Living Figures within the *Scaenae Frons*: Figuring the Viewer in Liminal Space." In Corlàita (1997), 43–47.

———. 1998. *Looking at Lovemaking: Constructions of Sexuality in Roman Art 100 BC–AD 250.* Berkeley.

———. 2002. "Look Who's Laughing at Sex: Men and Woman Viewers at the *Apodyterium* of the Suburban Baths at Pompeii." In Fredrick (2002), 149–82.

———. 2003a. *Roman Sex, 100 BC–AD 250*. New York.

———. 2003b. *Art in the Lives of Ordinary Romans*. Berkeley.

Clay, D. 1988. "The Archaeology of the Temple to Juno at Carthage." *CP* 83: 195–205.

Clayton, P., and M. Price, eds. 1988. *The Seven Wonders of the Ancient World*. London.

Clerc, C. 1914. "Plutarche et la culte des images." *Revue de l'histoire des religions* 70: 107–24.

———. 1915. *Les théories relatives au culte des images chez les auteurs Grecs du IIme siècle après J.-C.* Paris.

Coarelli, F. 1979. "Topografia mitriaca di Roma." In U. Bianchi, ed., *Mysteria Mithrae*. 69–83. Leiden.

Coffey, M. 1989. *Roman Satire*. 2nd ed. Bristol.

Coleman, K. 1990. "Fatal Charades: Roman Executions Staged as Mythological Enactments." *JRS* 80: 44–73.

Comaroff, J. 1985. *Body of Power, Spirit of Resistance*. Chicago.

Comaroff, J., and J. Comaroff. 1991. *Of Revelation and Revolution*. Vol. 1. Chicago.

Conan, M. 1987. "The *Imagines* of Philostratus." *Word and Image* 3: 162–71.

Connors, C. 1994. "Famous last words: Authorship and death in the Satyricon and Neronian Rome." In Elsner and Masters (1994), 225–35.

———. 1998. *Petronius the Poet*. Cambridge.

Conte, G. B. 1986. *The Rhetoric of Imitation*. Ithaca, NY.

———. 1996. *The Hidden Author*. Berkeley.

Cooper, K. 1996. *The Virgin and the Bride: Idealized Womanhood in Late Antiquity*. Cambridge, MA.

Corlàita Scagliarini, D. 1974–76. "Spazio e decorazione nella pittura pompeiana." *Palladio* 23–25: 3–44.

———, ed. 1997. *I temi figurativi nelle pittura parietale antica*. Bologna.

Cormack, R. 1985. *Writing in Gold*. London.

———. 1997. *Painting the Soul: Icons, Death Masks and Shrouds*. London.

Courtney, E. 1962. "Parody and Literary Allusion in the Menippean Satire." *Philologus* 106: 86–100.

———. 1995. *Musa Lapidaria*. Atlanta.

———. 2001. *A Companion to Petronius*. Oxford.

Cox Miller, P. 1994. *Dreams in Late Antiquity: Studies in the Imagination of a Culture*. Princeton, NJ.

Crary, J. 1990. *Techniques of the Observer*. Cambridge, MA.

Croisille, J. M., and Y. Perrin, eds. 2002. *Neronia VI: Rome à l'époque néronniene*. Brussels.

Cumont, F. 1926. *Fouilles de Doura-Europos*. Paris.

———. 1975. "The Dura Mithraeum." In J. R. Hinnells, ed., *Mithraic Studies*, vol. 1, 151–214. Manchester.

Cunningham, V. D. 2000. *The Victorians: An Anthology of Poetry and Poetics*. Oxford.

Curchin, L. A. 1991. *Roman Spain: Conquest and Assimilation*. London.

Curran, J. 2000. *Pagan City and Christian Capital*. Oxford.

Curran, L. 1966. "Vision and Reality in Propertius I.3." *YCS* 19: 189–207.

Dagron, G. 1991. "Holy Images and Likeness." *Dumbarton Oaks Papers* 45: 23–33.

Dalí, Salvador. 1937. *Métamorphose de Narcisse*. Paris.

D'Ambra, E., ed. 1993. *Roman Art in Context*. Englewood Cliffs, NJ.

———. 1996. "The Calculus of Venus: Nude Portraits of Roman Matrons." In Kampen (1996), 219–32.

Damisch, H. 1970. "La partie et le tout." *Revue d' Esthétique* 23 (1970): 168–88.

———. 1971–72. "Le guardien de l'interprétation." *Tel Quel* 44–45: 70–96.

Davis, W. 1990. "Style and History in Art History." In M. Conkey and C. A. Hastorf, eds., *The Uses of Style in Archaeology*, 18–31. Cambridge.

Decharme, P. 1904. *La critique des traditions religieuses chez les Grecs des origines aux temps du Plutarque*. Paris.

DeFilippo, J. 1999. "*Curiositas* and the Platonism of Apuleius' *Golden Ass*." In Harrison (1999), 269–89.

Derks, T. 1998. *Gods, Temples, and Ritual Practices: The Transformation of Religious Ideas and Values in Roman Gaul*. Amsterdam.

Didi-Huberman, G. 1999. *Ouvrir Vénus: Nudité, rêve, cruauté*. Paris.

Dillon, M. 1997. *Pilgrims and Pilgrimage in Ancient Greece*. London.

Dirven, L. 1999. *The Palmyrenes of Dura-Europos*. Leiden.

———. 2004. "Religious Competition and the Decoration of Sanctuaries: The Case of Dura Europos." *Eastern Christian Art* 1: 1–20.

Doane, M. A. 1987. *The Desire to Desire: The Woman's Film in the 1940s*. Bloomington, IN.

Donohue, A. A. 1988. *Xoana and the Origins of Greek Sculpture*. Atlanta.

Dover, K. J. 1978. *Greek Homosexuality*. London.

Downey, G. 1959. "Ekphrasis." *RAC* 4: 921–44.

Downey, S. B. 1977. *The Stone and Plaster Sculpture: Excavations at Dura-Europos. Final Reports III.1.2*. Los Angeles.

Drerup, H. 1959. "Bildraum und Realraum in der römischen Architektur." *RM* 66: 147–74.

Dresken-Weiland, J. 1991. *Reliefierte Tischplatten aus theodosianischer Zeit*. Vatican.

Drijvers, H.J.W. 1986. "Dea Syria." *LIMC* III.1: 355–58.

Dubel, S. 1997. "*Ekphrasis* et *enargeia*: La description antique comme parcours." In Lévy and Pernot (1997), 249–64.

Dubois, P. 1982. *History, Rhetorical Description, and the Epic*. Cambridge.

Du Mesnil du Buisson, R. 1939. *Les peintures de la Synagogue de Doura-Europos, 245–56 après J-C*. Rome.

Dunbabin, K. 1978. *The Mosaics of Roman North Africa*. Oxford.

———. 2003. *The Roman Banquet: Images of Conviviality*. Cambridge.

Duncan, C. 1991. "The Aesthetics of Power in Modern Erotic Art." In A. Raven, C. Langer, and J. Frueh, eds., *Feminist Art Criticism: An Anthology*, 59–70. New York.

———. 1995. *Civilizing Rituals: Inside Public Art Museums*. London.

Dyson, S. L. 1971. "Native Revolts in the Roman Empire." *Historia* 20: 239–74.

———. 1975. "Native Revolt Patterns in the Roman Empire." *ANRW* II.3: 138–75.

Dzielska, M. 1986. *Apollonius of Tyana in Legend and History*. Rome.

Eade, J., and M. Sallnow, eds. 1991. *Contesting the Sacred: The Anthropology of Christian Pilgrimage*. London.

Eastmond, A., and L. James, eds. 2003. *Icon and Word: The Power of Images in Byzantium*. Aldershot.

Edwards, C. 1993. *The Politics of Immorality in Ancient Rome*. Cambridge.

———. 1994. "Beware of Imitations: Theatre and the Subversion of Imperial Identity." In Elsner and Masters (1994), 83–97.

———. 1996. *Writing Rome*. Cambridge.

Edwards, D. 1996. *Religion and Power: Pagans, Jews, and Christians in the Greek East*. Oxford.

Edwards, M., M. Goodman, and S. Price, eds. 1999. *Apologetics in the Roman Empire: Pagans, Jews, and Christians*. Oxford.

Effe, B. 1987. "Der Greichische Liebesroman und die Homoerotik." *Philologus* 131: 95–108.

Egelhaaf-Gaiser, U. 2000. *Kulträume im römischen Alltag: Das Isisbuch des Apuleius und der Ort von Religion im kaizerzeitlichen Rom*. Stuttgart.

Egger, B. 1994. "Looking at Chariton's Callirhoe." In J. Morgan and R. Stoneman, eds., *Greek Fiction: The Greek Novel in Context*, 31–48. London.

Egger, R. 1943. "Aus der Unterwelt der Festlandkelten." *Wiener Jahreshefte* (= *Jahreshefte des Österreichisches Archäologisches Institut*) 35: 99–137.

Ehrhardt, W. 1988. *Casa Dell' Orso*. Munich.

Eitrem, S. 1935. "Narkissos." *Realencyclopädie der classischen Altertumswissenschaft* 16: 1721–33.

Eliot, T. S. 1969. *The Complete Poems and Plays of T. S. Eliot*. London.

Ellinger, P. 2005. *La fin des maux: D'un Pausanias à l'autre*. Paris.

Elsner, J. 1992. "Pausanias: A Greek Pilgrim in the Roman World." *Past and Present* 135: 5–29.

———. 1994. "From the Pyramids to Pausanias and Piglet: Monuments, Writing and Travel." In S. Goldhill and R. Osborne, eds., *Art and Text in Ancient Greek Culture*, 224–54. Cambridge.

———. 1995. *Art and the Roman Viewer: The Transformation of Art from Paganism to Christianity*. Cambridge.

———, ed. 1996a. *Art and Text in Roman Culture*. Cambridge.

———. 1996b. "Introduction." In Elsner (1996a), 1–6.

———. 1996c. "Inventing Imperium: Texts and the Propaganda of Monuments in Augustan Rome." In Elsner (1996a), 32–53.

———. 1997. "Hagiographic Geography: Travel and Allegory in the *Life of Apollonius of Tyana*." *Journal of Hellenic Studies* 117: 22–37.

———. 1998a. "Art and Architecture A.D. 337–425." In A. Cameron and P. Garnsey, eds., *The Cambridge Ancient History* 13, 736–61. Cambridge.

———. 1998b. *Imperial Rome and Christian Triumph: The Art of the Roman Empire AD 100–450*. Oxford.

———. 2000. "Making Myth Visual: The Horae of Philostratus and the Dance of the Text." *Römische Mitteilungen* 207: 253–76.

———. 2001a. "Describing Self in the Language of Other: Pseudo (?)-Lucian at the Temple of Hierapolis." In Goldhill (2001a), 123–53.

———. 2001b. "Structuring 'Greece': Pausanias' Periegesis as a Literary Construct." In Alcock, Cherry, and Elsner (2001), 3–20.

———. 2002. "The Birth of Late Antiquity: Riegl and Strzygowski in 1901." *Art History* 25 (2002): 358–79.

———. 2003a. "Archaeologies and Agendas: Jewish and Early Christian Art in Late Antiquity." *JRS* 83: 114–28.

———. 2003b. "Inventing Christian Rome: The Role of Early Christian Art." In G. Woolf and C. Edwards, eds., *Rome the Cosmopolis*, 71–99. Cambridge.

———. 2003c. "Style." In Nelson and Shiff (2003), 108–119.

———. 2004. "Seeing and Saying: A Psycho-analytic Account of Ekphrasis." *Helios* 31: 153–80.

———. 2006. "Reflections on the 'Greek Revolution' in Art: From Changes in Viewing to the Transformation of Subjectivity." In S. Goldhill and R. Osborne, eds., *Rethinking Revolutions through Ancient Greece*, 68–95. Cambridge.

Elsner, J., and J. Masters, eds. 1994. *Reflections of Nero: Culture, History, and Representation*. London.

Elsner, J., and I. Rutherford, eds. 2005. *Pilgrimage in Classical Antiquity and the Early Christian World: Seeing the Gods.* Oxford.

Ennabli, L. 1986. "Les thermes du Thiase Marin de Sidi Ghrib." *Monuments Piot* 68: 1–59.

Ensoli, S., and E. La Rocca, eds. 2000. *Aurea Roma*. Rome.

Etienne, R. 1992. "Autels et sacrifices." *Entretiens Fondation Hardt* 37: 291–319.

Evans-Pritchard, E. E. 1940. *The Nuer*. Oxford.

Fagan, G. 1999. *Bathing in Public in the Roman World*. Ann Arbor.

Faraone, C. A. 1991. "Binding and Burying the Forces of Evil: The Defensive Use of 'Voodoo' Dolls in Ancient Greece." *Classical Antiquity* 10: 165–205.

———. 1992. *Talismans and Trojan Horses: Guardian Statues in Ancient Greek Myth and Ritual*. New York.

Farrell, J. 1998. "Reading and Writing the *Heroides*." *HSCP* 98: 307–38.

Feeney, D. 1990. "The Reconciliation of Juno." In S. Harrison, ed., *Oxford Readings in the Aeneid*, 339–62. Oxford.

Ferguson, J. 1970. *The Religions of the Roman Empire*. London.

Festugière, A.-J. 1954. *Personal Religion among the Greeks*. Berkeley.

Finkelpearl, E. 1991. "The Judgment of Lucius: Apuleius, *Metamorphoses* 10.29–34." *CA* 10: 221–36.

———. 1998. *Metamorphosis of Language in Apuleius*. Ann Arbor.

Fitzgerald, J. T., and L. M. White. 1983. *The Tabula of Cebes*. Chico, CA.

Fitzgerald, W. 1984. "Aeneas, Daedalus and the Labyrinth." *Arethusa* 17: 51–61.

———. 1995. *Catullan Provocations*. Berkeley.

Fleischer, R. 1973. *Artemis von Ephesos und verwandte kultstatuen aus Anatolien und Syrien*. Leiden.

———. 1978. "Artemis von Ephesos und verwandte kultstatuen aus Anatolien und Syrien. Supplement." In S. Sahin, E. Schwertheim, and J. Wagner, eds., *Studien zur Religion und Kultur Kleinasiens: Festschrift für F. K.Dörner*, 324–58. Leiden.

———. 1984. "Artemis Ephesia." *LIMC* II.1: 755–63.

Flesher, P.V.M. 1995. "Rereading the Reredos; David, Orpheus and Messianism in the Dura Europos Synagogue." In D. Urban and P.V.M. Flesher, eds., *Ancient Synagogues*, 2:346–66. Leiden.

Flower, H. 2002. "Roman Theatrical Drama and Nero on Stage." *Symbolae Osloenses* 77: 68–72.

Foucault, M. 1970. *The Order of Things*. London.

———. 1990. *The History of Sexuality*. Vol. 3, *The Care of the Self*. Harmondsworth.

Fowden, G. 1993. *Empire to Commonwealth: Consequences of Monotheism in Late Antiquity*. Princeton, NJ.

Fowler, D. 2000. *Roman Constructions*. Oxford.

Franciscis A. de, et al., eds. 1991. *La pittura di Pompei*. Milan.

Fränkel, H. 1945. *Ovid: A Poet between Two Worlds*. Berkeley.

Frankfurter, D. 1990. "Stylites and Phallobates: Pillar Religions in Late Antique Syria." *Vigiliae Christianae* 44: 168–98.

———. 1998. *Religion in Roman Egypt: Assimilation and Resistance*. Princeton, NJ.

Frazer, J. G. 1898. *Pausanias's Description of Greece*. 6 vols. London.

Fredrick, D. 1995. "Beyond the Atrium to Ariadne: Erotic Painting and Visual Pleasure in the Roman House." *Classical Antiquity* 14: 266–87.

———, ed. 2002. *The Roman Gaze: Vision, Power, and the Body*. Baltimore.

Freedberg, D. 1989. *The Power of Images: Studies in the History and Theory of Response*. Chicago.

Freeman, P. 1997. "'Romanization-Imperialism'—What Are We Talking About?'" *Theoretical Roman Archaeology Conference* 96, 8–14. Oxford.

Freudenburg, K. 2001. *Satires of Rome*. Cambridge.

Friedländer, P. 1912. *Johannes von Gaza und Paulus Silentarius*. Berlin.

Friesen, S. 1993. *Twice Neokoros*. Leiden.

———. 1995. "The Cult of the Roman Emperors in Ephesos." In Koester (1995), 229–50.

———. 2001. *Imperial Cults and the Apocalypse of John*. Oxford.

Frings, U. 1975. *Claudius Claudianus: Epithalamium de nuptiis Honori Augusti*. Meisenheim am Glan.

Frontisi-Ducroux, F. 1996. "Eros, Desire, and the Gaze." In Kampen (1996), 81–100.

Frontisi-Ducroux, F., and J.-P. Vernant. 1997. *Dans l'oeil du miroir*. Paris.

Fulkerson, L. 2005. *The Ovidian Heroine as Author: Reading, Writing, and Community in the* Heroides. Cambridge.

Gaifman, M. 2006. "Statue, Cult, and Reproduction." *Art History* 29: 260–82.

Galavaris, G. 1990. "Icons." In K. Manafis, ed., *Sinai: Treasures of the Monastery*, 91–101. Athens.

Gale, M. 1997. "The Shield of Turnus (Aen. 7.783–92)." *Greece and Rome* 44: 176–96.

Galinsky, G. K. 1974. "Ovid's Metamorphosis of Myth." In G. K. Galinsky, ed., *Perspectives of Roman Poetry*, 105–28. Austin, TX.

Gallo, A. 1988. "Le pitture rappresentanti Arianna abbandonata ambiente pompeiano." *Rivista di Studi Pompeiani* 2: 57–80.

Gandelman, C. 1991. *Reading Pictures, Viewing Texts*. Bloomington, IN.

Garnsey, P. 1978. "Rome's African Empire under the Principate." In P. Garnsey and C. R. Whittaker, eds., *Imperialism in the Ancient World*, 223–54. Cambridge.

———. 2004. "Roman Citizenship and Roman Law in the Late Empire." In Swain and Edwards (2004), 133–55.

Gaskell, I. 2003. "Sacred to Profane and Back Again." In A. McClellan, ed., *Art and Its Publics: Museum Studies at the Millennium*, 149–64. Oxford.

Gazda, E., ed. 2002. *The Ancient Art of Emulation*. Ann Arbor, MI.

Geertz, C. 1973. *The Interpretation of Cultures*. New York.

———. 1983. *Local Knowledge*. New York.

Gerber, D. E. 1982. *Pindar's Olympian I: A Commentary*. Toronto.

Gilman, R. 1979. *Decadence: The Strange Life of an Epithet*. New York.

Ginzburg, C. 1983. "Morelli, Freud, and Sherlock Holmes: Clues and the Scientific Method." In U. Eco and T. Sebeok, eds., *The Sign of Three*, 81–118. Bloomington, IN.

Gladigow, B. 1985–86. "Präsenz der Bilder—Präsenz der Götter." *Visible Religion* 4–5: 114–33.

———. 1990. "Epiphanie, Statuette, Kultbild." In H. G. Kippenberger, ed., *Genres in Visual Representations (Visible Religion 7)*, 98–121. Leiden.

Gleason, M. 1995. *Making Men: Sophists and Self-Presentation in Ancient Rome*. Princeton, NJ.

Goldhill, S. 1991. *The Poet's Voice*. Cambridge.

———. 1994. "The Naïve and Knowing Eye: Ecphrasis and the Culture of Viewing in the Hellenistic World." In Goldhill and Osborne (1994), 197–223.

———. 1995. *Foucault's Virginity: Ancient Erotic Fiction and the History of Sexuality*. Cambridge.

———, ed. 2001a. *Being Greek under Rome: Cultural Identity, the Second Sophistic, and the Development of Empire*. Cambridge.

———. 2001b. "The Erotic Eye: Visual Stimulation and Cultural Conflict." In Goldhill (2001a), 154–94.

———. Forthcoming. "What Is Ekphrasis for?" *CP*.

Goldhill, S., and R. Osborne. 1994. *Art and Text in Ancient Greek Culture*. Cambridge.

Gombrich, E. H. 1960. *Art and Illusion*. London.

———. 1966. *Norm and Form*. London.

———. 1968. "Style." In D. Sills, ed., *Encyclopaedia of the Social Sciences* 15:352–61. New York.

———. 1976. *The Heritage of Apelles*. London.

Goodenough, E. R. 1964. *Jewish Symbols in the Greco-Roman Period*. Vols. 9–11. Princeton, NJ.

Goodman, M. R. 1991. "Opponents of Rome: Jews and Others." In L. Alexander, ed., *Images of Empire*, 222–38. Sheffield.

Gordon, R. 1972. "Mithraism and Roman Society." *Religion* 2: 92–121.

———. 1975. "Franz Cumont and the Doctrines of Mithraism." In J. R. Hinnells, ed., *Mithraic Studies*, 2 vols., 1:215–48. Manchester.

———. 1979. "The Real and the Imaginary: Production and Religion in the Graeco-RomanWorld." *Art History* 2: 5–34.

———. 1988. "Authority, Salvation, and Mystery in the Mysteries of Mithras." In J. Huskinson, M. Beard, and J. Reynolds, eds., *Image and Mystery in the Roman World*, 45–80. Gloucester.

———. 1990. "The Roman Empire." In Beard and North (1990), 177–255.

Gowers, E. 1994. "Persius and the Decoction of Nero." In Elsner and Masters (1994), 131–50.

Grabar, A. 1941a. "La thème religieux des fresques de la synagogue de Doura." *Revue de l'histoire des religions* 123: 143–92.

———. 1941b. "La thème religieux des fresques de la synagogue de Doura." *Revue de l'histoire des religions* 124: 5–35.

———. 1956. "La fresque des saintes femmes au tombeau à Doura." *Cahiers Archéologiques* 8: 9–26.

———. 1968. *Christian Iconography: A Study of Its Origins*. Princeton, NJ.

Gradel, I. 2002. *Emperor Worship and Roman Religion*. Oxford.

Graf, F. 1995. "Ekphrasis: Die Entstelung der Gattung in der Antike." In G. Boehm and H. Pfotenhauer, eds., *Beschreibungskunst-Kunstbeschreibung*, 143–55. Munich.

Grahame, M. 1998. "Redefining Romanization: Material Culture and the Question of Social Continuity in Roman Britain." *Theoretical Roman Archaeology Conference 97*, 1–10. Oxford.

Greene, E. 1995. "Elegiac Woman: Fantasy, *Materia* and Male Desire in Propertius I.3 and I.11." *AJP* 116: 303–18.

———. 1998. *The Erotics of Domination*. Baltimore.

Grenier, A. 1947. "Le dieu gaulois Ogmios et la danse macabre." *Comptes rendus de l'Académie des Inscriptions* 20: 254–58.

Griffin, A.H.F. 1977. "Ovid's *Metamorphoses*." *Greece and Rome* 24: 57–70.

Griffin, J. 1985. *Latin Poets and Roman Life*. London.

Griffiths, J. 1975. *Apuleius of Madauros: The Isis Book* (Metamorphoses *Book XI*). Leiden.

Grigg, L. 2004. "Portraits, Pontiffs and the Christianization of Fourth Century Rome." *PBSR* 72: 203–30.

Gualandi, G. 1982. "Plinio e il collectionizmo d'arte." In *Plinio il Vecchio sotto il profilo storico e letterario. Atti di Convegno di Como*, 259–98. Como.

Gundel, H. G. 1992. *Zodiakos: Tierkreisbilder im Altertum*. Mainz.

Gunderson, R. 1998. "Discovering the Body in Roman Oratory." In M. Wyke, ed., *Parchments of Gender: Deciphering the Body in Antiquity*, 169–89. Oxford.

Gutmann, J., ed. 1973. *The Dura-Europos Synagogue: A Re-Evaluation*. Chambersburg, PA.

———. 1984. "Early Synagogue and Jewish Catacomb Art and Its Relation to Christian Art." *ANRW* 2.21.2: 1313–42.

Gutzwiller, K. 2002. "Art's Echo: The Tradition of Hellenistic Ecphrastic Epigram." In M. Harder, R. Regtruit, and G. Wakker, eds., *Hellenistic Epigrams* (*Hellenistica Groningiana* 6), 85–112. Leuven.

———. 2004. "Seeing Thought: Timomachus' Medea and Ecphrastic Epigram." *AJP* 125: 339–86.

Guyer, P. 1997. *Kant and the Claims of Taste*. Cambridge.

Guyot, P. 1980. *Eunuchen als Sklaven und Freigelassene in der griechisch-römanischen Antike*. Stuttgart.

Guzzo, G., ed. 1997. *Pompeii—Picta Fragmenta*. Turin.

Habicht, C. 1985. *Pausanias' Guide to Ancient Greece*. Berkeley.

Hachlili, R. 1998. *Ancient Jewish Art and Archaeology in the Diaspora*. Leiden.

Hadot, P. 1976. "Le mythe de Narcisse et son interprétation par Plotin." *Nouvelle revue de psychanalyse* 13: 81–108.

Hafner, G. 1958. "Herakles-Geras-Ogmios." *Jahrbuch des römisch-germanischen Zentralmuseums Mainz* 5: 139–53.

Hales, S. 2003. *The Roman House and Social Identity*. Cambridge.

Hall, J. 1981. *Lucian's Satire*. New York.

Hallett, C. 2005. *The Roman Nude: Heroic Portrait Statuary 200 BC–AD 300*. Oxford.

Hanson, J. 1980. "Dreams and Visions in the Graeco-Roman World and Early Christianity." *ANRW* 2.23.2: 1385–1427.

Harbsmeier, M. 1987. "Elementary Structures of Otherness." In J. Céard and J. C. Margolin, eds., *Voyager à la Renaissance*, 337–55. Paris.

Hardie, P. 1986. *Vergil's* Aeneid: *Cosmos and Imperium*. Oxford.

———. 2002a. "Another Look at Virgil's Ganymede." In T. P. Wiseman, ed., *Classics in Progess: Essays on Ancient Greece and Rome*, 333–61. Oxford.

———. 2002b. *Ovid's Poetics of Illusion*. Cambridge.

Hardie, P., S. Hinds, and A. Barchiesi, eds. 1999. *Ovidian Transformations*. PCPS suppl. 23. Cambridge.

Harmon, D. 1974. "Myth and Fanatsy in Propertius I.3." *TAPhA* 104: 151–65.

Harrison, S. 1994. "Drink, Suspicion, and Comedy in Propertius I.3." *PCPS* 40: 18–26.

———. 1998. "The Sword-Belt of Pallas: Moral Symbolism and Political Ideology: *Aeneid* 10.495–505." In H. P. Stahl, ed., *Vergil's* Aeneid: *Augustan Epic and Political Context*, 223–42. London.

———, ed. 1999. *Oxford Readings in the Latin Novel*. Oxford.

———. 2000. *Apuleius: A Latin Sophist*. Oxford.

———. 2000–2001. "Apuleius, Aelius Aristides, and Religious Autobiography." *Ancient Narrative* 1: 245–59.

———. 2001. "Picturing the Future: The Proleptic Ekphrasis from Homer to Vergil." In S. Harrison, ed., *Texts, Ideas, and the Classics*, 70–90. Oxford.

———. 2002. "Constructing Apuleius: The Emergence of a Literary Artist." *Ancient Narrative* 2: 143–71.

Hart, J., R. Recht, and M. Warnke. 1993. *Relire Wölfflin*. Paris.

Haskell, F., and N. Penny. 1981. *Taste and the Antique*. New Haven, CT.

Häussler, R. 1998. "Motivations and Ideologies of Romanization." *Theoretical Roman Archaeology Conference 97*, 11–19. Oxford.

Havelock, C. M. 1995. *The Aphrodite of Knidos and Her Successors: A Historical Review of the Female Nude in Greek Art*. Ann Arbor, MI.

Haynes, D. 1992. *The Technique of Greek Bronze Statuary*. Mainz.

Heer, J. 1979. *La personnalité de Pausanias*. Paris.

Heffernan, J. 1993. *Museum of Words: The Poetics of Ekphrasis from Homer to Ashberry*. Chicago.

Heinze, R. 1899. "Petron und der Greichische Roman." *Hermes* 34: 494–519.

Helbig, W. 1963–72. *Führer durch die öffentlichen Sammlungen klassischer Altertürmer in Rom*. 4th ed. Tübingen.

Henderson, J. 1991. "Wrapping up the Case: Reading Ovid *Amores* 2.7 (+ 8)," part I. *Materiali e Discussioni per l'Analisi dei Testi Classici* 27: 37–88.

———. 1996. "Footnote: Representation in the *Villa of the Mysteries*." In Elsner (1996a), 235–76.

———. 1997. *Figuring Out Roman Nobility*. Exeter.

———. 1999. *Writing Down Rome*. Oxford.

———. 2002. *Pliny's Statue: The Letters, Self-Portraiture, and Classical Art*. Exeter.

Hershkowitz, D. 1998. *The Madness of Epic*. Oxford.

———. 1999. "The Creation of Self in Ovid and Proust." In Hardie, Hinds, and Barchiesi (1999), 182–96.

Hine, H. 1982. "Aeneas and the Arts (Vergil's *Aeneid* 6.847–50)." In M. Whitby, P. Hardie, and M. Whitby, eds., *Homo Viator: Classical Essays for John Bramble*, 173–83. Bristol.

Hingely, R. 1997. "Resistance and Domination: Social Change in Roman Britain." In Mattingly (1997), 81–100.

Holzberg, N. 2002. *Ovid: The Poet and His Work*. Ithaca, NY.

Homo, L. 1904. *Essai sur la règne de l'empereur Aurélien*. Paris.

Hopkins, C. 1979. *The Discovery of Dura-Europos*. New Haven, CT.

Hopkins, K. 1978. *Conquerors and Slaves*. Cambridge.

———. 1993. "Novel Evidence for Roman Slavery." *Past and Present* 138: 3–27.

———. 1999. *A World Full of Gods*. London.

Hunink, V. 2001. *Apuleius of Madauros: Florida*, 139–41. Amsterdam.

Hunt, E. D. 1984. "Travel, Tourism, and Piety in the Roman Empire." *Echos du monde classique* 28: 391–417.

Hunter, R. 1983. *A Study of* Daphnis and Chloe. Cambridge.

———. 1993. *The Argonautica of Apollonius: Literary Studies.* Cambridge.

Hurley, A. K. 2004. *Catullus.* Bristol.

Hutchinson, G. O. 2003. "The Catullan Corpus, Greek Epigram, and the Poetry of Objects." *CQ* 53: 206–21.

Hutton, W. 2005a. "The Construction of Religious Space in Pausanias." In Elsner and Rutherford (2005), 291–317.

———. 2005b. *Describing Greece: Landscape and Literature in the Periegesis of Pausanias.* Cambridge.

Imbert, C. 1980. "Stoic Logic and Alexandrian Poetics." In Schofield, Burnyeat, and Barnes (1980), 183–216.

Ioppolo, A. M. 1990. "Presentation and Assent: A Physical and Cognitive Problem in Early Stoicism." *CQ* 40: 433–49.

Isager, J. 1991. *Pliny on Art and Society.* London.

James, L. 1996. " 'Pray Not to Fall into Temptation and Be on Your Guard.' " *Gesta* 35: 12–20.

———. 2004. "Senses and Sensibility in Byzantium." *Art History* 27: 523–37.

James, S. 2004. *The Excavations at Dura-Europos. Final Report VII: The Arms and Armour and Other Military Equipment.* London.

James, L., and R. Webb. 1991. " 'To Understand Ultimate Things and Enter Secret Places': Ekphrasis and Art in Byzantium." *Art History* 14: 1–17.

Janan, M. 1988. "The Book of Good Love? Design and Desire in *Metamorphoses* 10." *Ramus* 17: 110–37.

Jashemski, W. 1993. *The Gardens of Pompeii, Herculaneum, and the Villas Destroyed by Vesuvius.* Vol. 2. New Rochelle, NY.

Jay, M. 1993. *Downcast Eyes.* Berkeley.

Jay, M., and T. Brennan, eds. 1996. *Vision in Context.* London.

Jenkyns, R. 1982. *Three Classical Poets.* London.

Jensen, R. M. 1999. "The Dura Europos Synagogue, Early Christian Art, and the Religious Life of Dura." In S. Fine, ed., *Jews, Christians, and Polytheists in the Ancient Synagogue,* 174–89, esp. 184–86. London.

Johnson, W. R. 1976. *Darkness Visible: A Study of Virgil's* Aeneid. Berkeley.

Joly, R. 1968. *Le tableau de Cebes et la philosophie religieuse.* Brussels.

Jones, C. P. 1984. "Tarsos in the *Amores* ascribed to Lucian." *GRBS* 25: 177–81.

———. 1986. *Culture and Society in Lucian.* Cambridge, MA.

———. 1991. "Dinner Theater." In W. Slater, ed., *Dining in a Classical Context,* 185–98. Ann Arbor, MI.

Jones, F. M. 1991. "Realism in Petronius." In H. Hofmann, ed., *Groningen Colloquia on the Novel* 4: 105–20.

Jones, R. 1995. " 'Such Strange Unwanted Softness to Excuse': Judgement and Indolence in Sir Joshua Reynolds' Portrait of Elizabeth Gunning, Duchess of Hamilton and Argyl." *Oxford Art Journal* 18: 29–43.

Jung, F. 1984. "Gebaute Bilder." *Antike Kunst* 27: 71–122.

Kalinka, E., and O. Schönberger. 1968. *Philostratos: Die Bilder.* Munich.

Kampen, N. B., ed. 1996. *Sexuality in Ancient Art.* Cambridge.

———. 1997. "Gender and Desire." In Koloski-Ostrow and Lyons (1997), 267–77.

Kant, I. 1790. *Kritik der Urteilkraft*. Berlin.

Karwiese, S. 1999. "Artemis Ephesia 'Sebasteia': Ein Eintzifferungsbeitrag." In P. Scherrer, H. Taeubar, and H. Thür, eds., *Steine und Wege: Festschrift für Dieter Knibbe zum 65 Geburtstag*, 61–75. Vienna. 1999.

Kässer, C. 2002. "The Body Is Not Painted On: Ekphrasis and Exegesis in Prudentius, *Peristephanon* 9." *Ramus* 31: 158–74.

Kazhdan, A., and H. Maguire. 1991. "Byzantine Hagiographical Texts as Sources on Art." *Dumbarton Oaks Papers* 45: 1–22.

Kearns, E. 1992. "Between God and Man: Status and Function of Heroes and Their Sanctuaries." In A. Schachter, ed., *Le sanctuaire Grec*, 65–99. Entretiens Fondation Hardt 37. Geneva.

Keay, S. J. 1992. "The 'Romanisation' of Turdetania." *OJA* 11: 275–315.

Kempf, W. 1994. "Ritual, Power, and Coial Domination: Male Initiation among the Ngaing of Papua New Guinea." In Stewart and Shaw (1994), 108–27.

Kenaan, V. Lev. 2004. "Delusion and Dream in Apuleius." *Classical Antiquity* 23: 247–84.

Kennedy, D. 2002. "Epistolarity: The *Heroides*." In P. Hardie, ed., *The Cambridge Companion to Ovid*, 217–32. Cambridge.

———. 2004. "Afterword." *Helios* 31: 247–57.

Kennell, N. M. 1995. *The Gymnasium of Virtue: Education and Culture in Ancient Sparta*. Chapel Hill.

Kerenyi, K. 1926. *Die griechisch-orientalische Romanliteratur in religionsgeschichtlich Beleuchtung*. Tübingen.

Kessler, E. 2000. "Art Leading the Story: The *'Aqedah* in Early Synagogue Art." In Levine and Weiss (2000), 73–81.

Key Fowden, E. 1999. *The Barbarian Plain: Saint Sergius between Rome and Islam*. Berkeley.

Kiilerich, B. 1993. *Late Fourth-Century Classicism in the Plastic Arts*. Odense.

King, A. 1990. "The Emergence of Romano-Celtic Religion." In T. Blagg and M. Millett, eds., *The Early Roman Empire in the West*, 220–41. Oxford.

Kinsey, T. E. 1965. "Irony and Structure in Catullus 64." *Latomus* 24: 911–31.

Kitzinger, E. 1954. "The Cult of Images in the Age before Iconoclasm." *Dumbarton Oaks Papers* 8: 84–150. Reprinted in E. Kleinbauer, ed., *The Art of Byzantium and the Medieval West: Selected Studies by Ernst Kitzinger*, 90–156. Bloomington, IN.

———. 1976. "On Some Icons of the Seventh Century." In E. Kleinebauer, ed., *The Art of Byzantium and the Medieval West*, 233–55. Bloomington, IN.

Klein, W. 1912. "Pompejanishe Bildstudien." *Jahreshefte des Österreichischen Archäologischen Institutes in Wien* 15: 143–67.

Klingner, F. 1956. *Catulls Peleus-Epos*. Munich.

Knibbe, D. 1995. "Via Sacra Ephesiaca." In Koester (1995), 141–55.

Knibbe, D., and G. Langmann. 1993. *Via Sacra Ephesiaca*. Vol. 1. Vienna.

Knibbe, D., and H. Thür. 1995. *Via Sacra Ephesiaca*. Vol 2. Vienna.

Knox, P. E. 1986. *Ovid's* Metamorphoses *and the Traditions of Augustan Poetry*. Cambridge Philological Society suppl. vol. 11. Cambridge.

Koepp, F. 1919. "Ogmios: Bemerkungen zur gallischen Kunst." *Bonner Jahrbücher* 125: 38–73.

Koester, H., ed. 1995. *Ephesos: Metropolis of Asia*. Cambridge, MA.

Koloski-Ostrow, A. 1997. "Violent Stages in Two Pompeian Houses: Imperial Taste, Aristocratic Response and Messages of Male Control." In Koloski-Ostrow and Lyons (1997), 243–66.

Koloski-Ostrow, A., and C. Lyons, eds. 1997. *Naked Truths: Women, Sexuality, and Gender in Classical Art and Archaeology*. London.

Kondoleon, C. 1995. *Domestic and Divine: Roman Mosaics in the House of Dionysos*. Ithaca, NY.

König, J. 2005. *Athletics and Literature in the Roman Empire*. Cambridge.

Krabbe, J. 1989. *The Metamorphoses of Apuleius*. New York.

Kraeling, C. H. 1956. *The Excavation at Dura-Europos: Final Report VIII.1: The Synagogue*. New Haven, CT.

———. 1967. *The Christian Building: Excavations at Dura-Europos, Final Report VIII.2*. New Haven, CT.

Kurchin, B. 1995. "Romans and Britons on the Northern Frontier: A Theoretical Evaluation of the Archaeology of Resistance." In P. Rush, ed., *Theoretical Roman Archaeology: Second Conference Proceedings*, 124–31. Aldershot.

La Belle, J. 1988. *Herself Beheld: The Literature of the Looking Glass*. Ithaca, NY.

Lacan, J. 1979. *The Four Fundamental Concepts of Psycho-Analysis*. Harmondsworth.

Laird, A. 1993. "Sounding Out Ecphrasis: Art and Text in Catullus 64." *JRS* 83: 18–30.

———. 1996. "*U figura poesis*: Writing Art and the Art of Writing in Augustan Poetry." In Elsner (1996a), 75–102.

———. 1997. "Description and Divinity in Apuleius' *Metamorphoses*." *Groningen Colloquia on the Novel* 8: 59–85.

Lane Fox, R. 1986. *Pagans and Christians*. London.

Lang, B., ed. 1979. *The Concept of Style*. Philadelphia.

Lange N. de. 1978. "Jewish Attitudes to the Roman Empire." In P.D.A. Garnsey and C. R. Whittaker, eds., *Imperialism in the Ancient World*, 255–81. Cambridge.

Lapatin, K. 2001. *Chryselephantine Statuary in the Ancient Mediterranean World*. Oxford.

Lassus, J. 1965. "Venus marine." In *La mosaïque Gréco-Romaine*, vol. 1, 175–90. Paris.

Laubenberger, M. 1995. "Porträts auf Romischen Zwischengoldglasse." *Mitteilungen zur Christliche Archäologie* 1: 51–59.

Laurence, R., and J. Berry, eds. 1998. *Cultural Identity in the Roman Empire*. London.

Layerle, B. 1993. "John Chrysostom on the Gaze." *Journal of Early Christian Studies* 1: 159–74.

Leach, E. W. 1974. "Ekphrasis and the Theme of Artistic Failure in Ovid's *Metamorphoses*." *Ramus* 3: 102–42.

———. 1988. *The Rhetoric of Space*. Princeton, NJ.

———. 1999. "Viewing the Spectacula of *Aeneid* 6." In Perkell (1999b), 111–27.

———. 2000. "Narrative Space and the Viewer in Philostratos' *Eikones*." *RM* 107: 237–51.

———. 2004. *The Social Life of Painting in Ancient Rome and on the Bay of Naples*. Cambridge.

Leader-Newby, R. 2004. *Silver and Society in Late Antiquity*. Aldershot.

Lehmann-Hartleben, K. 1941. "The Imagines of the Elder Philostratus." *Art Bulletin* 23: 16–44.

Leitao, D. 1998. "Senecan Catoptrics and the Passion of Hostius Quadra." *MD* 41: 127–60.

Levi, D. 1947. *Antioch Mosaic Pavements*. Princeton, NJ.

Levine, L. I. 2000. "The History and Significance of the Menorah in Antiquity." In Levine and Weiss (2000), 131–53.

Levine, L. I., and Z. Weiss, eds. 2000. *"From Dura to Sepphoris: Studies in Jewish Art and Society in Late Antiquity*. *JRA* suppl. 40. Portsmouth, RI.

Lévi-Strauss, C. 1973. *Tristes Tropiques*. London.

Lévy, C., and L. Pernot, eds. 1997. *Dire l'évidence (philosophie et rhétorique antiques)*. Paris.

Liebeschuetz, W. 1994. "The Expansion of Mithraism among the Religious Cults of the Second Century." In J. R. Hinnells, ed., *Studies in Mithraism*, 195–216.

Lightfoot, J. 2003. Lucian: περὶ τῆς Συρίης θεοῦ. Oxford.

———. 2005. "Pilgrimage to the Holy City (Hierapolis/Membij)." In Elsner and Rutherford (2005), 333–352.

Limberis, V. 1994. *Divine Heiress: The Virgin Mary and the Creation of Christian Constantinople*. London.

Lincoln, B. 1989. *Discourse and the Construction of Society*. New York.

Linders, T., and G. Nordquist, eds. 1987. *Gifts to the Gods*. Boreas 15. Uppsala.

Lindheim, S. H. 2003. *Mail and Female: Epistolary Narrative and Desire in Ovid's Heroides*. Madison, WI.

Ling, R. 1991. *Roman Painting*. Cambridge.

Little, A. 1964. "The Boscoreale Cycle." *AJA* 68: 62–66.

Lively, G. 1999. "Reading Resistance in Ovid's *Metamorphoses*." In Hardie, Hinds, and Barchiesi (1999), 190–213.

Long, A. A. 1974. *Hellenistic Philosophy*. London.

L'Orange, H. P. 1947. *Apotheosis in Ancient Portraiture*. Oslo.

Lyne, R.O.A.M. 1970. "Propertius and Cynthia: Elegy 1.3." *PCPS* 16: 60–78.

Lynn-George, M. 1988. *Epos: Word, Narrative, and the* Iliad. London.

MacDonald, D. 1986. "Dating the Fall of Dura-Europos." *Historia* 35: 45–68.

Macginnis, H.B.J. 1990. "The Role of Perceptual Learning in Connoisseurship: Morelli, Berenson, and Beyond." *Art History* 13: 104–17.

MacMillan Arenberg, S. 1977. "Dionysos: A Late Antique Tapestry." *Boston Museum Bulletin* 75: 4–26.

MacMullen, R. 1981. *Paganism in the Roman Empire*. New Haven, CT.

Madden, T. F. 1992. "The Serpent Column of Delphi in Constantinople: Placement, Purposes, and Mutilations." *Byzantine and Modern Greek Studies* 16: 111–45.

Maddoli, G., and V. Saladino. 1995. *Pausania: Guida della Grecia*. Book 5. Verona.

Maffei, S. 1994. *Luciano di Samosata: Descrizioni di Opere d' Arte*. Turin.

Maguire, H. 1996. *Icons of Their Bodies: Saints and Their Images in Byzantium*. Princeton.

Maiuri, A. 1931. *La Villa dei Misteri*. Rome.

Majeska, G. P. 1984. *Russian Travellers to Constantinople in the Fourteenth and Fifteenth Centuries*. Washington, DC.

Mal-Maeder, D. van. 1997. "*Lector, intende, laetaberis*: The Enigma of the Last Book of Apuleius' *Metamorphoses*." *Groningen Colloquia in the Novel* 8: 87–118.

———. 2001. *Apulieus Madaurensis, Metamorphoses*. Book 2. Groningen.

Mango, C. A. 1963. "Antique Statuary and the Byzantine Beholder." *Dumbarton Oaks Papers* 17: 55–75.

Mango, M. M., and A. Bennett. *The Sevso Treasure: Part I*. Ann Arbor, MI.

Mansuelli, G. 1958–61. *Galleria degli Uffizi: Le Sculture*. Rome.

Marchand, S. 1996. *Down from Olympus: Archaeology and Philhellenism in Germany, 1750–1970*. Princeton, NJ.

Martin, J. 1946. "Ogmios." *Würzburger Jahrbücher* 1: 359–99.

Martindale, C. 1997. *The Cambridge Companion to Vergil*. Cambridge.

Marvin, M. 1993. "Copying in Roman Scuplture: The Replica Series." In D'Ambra (1993), 161–88.

———. 1997. "Roman Sculptural Reproductions or Polykleitos: The Sequel." In A. Hughes and E. Ranfft, eds., *Sculpture and Its Reproductions*, 7–28. London.

Mathews, T. F. 1993. *The Clash of Gods*. Princeton. Revised 1999.

Mattingly, D. J., ed. 1997. *Dialogues in Roman Imperialism*. JRA suppl. 23. Portsmouth, RI.

———. 2004. "Being Roman: Expressing Identity in a Provincial Setting." *JRA* 17: 1–25.

Mattusch, C. 1988. *Greek Bronze Statuary from the Beginnings to the Fifth Century B.C.* Ithaca, NY.

Matz, F. 1975. *Die Dionysischen Sarcophage*. Vol. 4. Berlin.

McCarty, W. 1989. "The Shape of the Mirror: Metaphorical Catoptics in Classical Literature." *Arethusa* 22: 161–90.

McGlathery, D. 1998. "Reversals of Platonic Love in Petronius' *Satyricon*." In D. Larmour, P. Miller, and C. Platter, eds., *Rethinking Sexuality: Foucault and Classical Antiquity*, 204–27. Princeton, NJ.

McMahon, J. 1998. *Paralysin Cave: Impotence, Perception, and Text in the Satyricon of Petronius*. Leiden.

McNally, S. 1985. "Ariadne and Others: Images of Sleep in Greek and Early Roman Art." *CA* 4: 152–92.

Meadows, A. 1995. "Pausanias and Classical Sparta." *CQ* 45: 92–113.

Meredith, J., ed. and trans. 1952. *The Critique of Judgment*, by I. Kant. Oxford.

Merkelbach, R. 1958. "Eros und Psyche." *Philologus* 102: 103–16.

———. 1962. *Roman und Mysterium in der Antike*. Berlin.

Merlier-Espenel, V. 2001. "Dum haec identidem rimabundus exime delector: Remarques sur le plaisir ésthétique de Lucius dan l'*atrium* de Byrrhène (Apulée, *Met.* II, 4–II,5,1." *Latomus* 60: 135–48.

Metzler, J., M. Millett, N. Roymans, and J. Slofstra, eds. 1995. *Integration in the Roman West: The Role of Culture and Ideology*. Luxembourg.

Meyer, E. 1971. *Pausanias, Führer durch Olympia*. Zurich.

Michel, D. 1982. "Bemerkungen über Zuschauerfiguren in pompejanischen sogenannten Tafelbildern." In *La regione sotterata dal Vesuvio: Studi e prospettive*, 537–98. Naples.

Mielsch, H. 1975. *Römische Stuckreliefs. Römische Mitteliungen Ergänzungsheft* 21. Heidelberg.

Millar, F. 1987. "Empire, Community and Culture in the Roman Near East: Greeks, Syrians, Jews and Arabs." *JJS* 38: 143–64.

———. 1993. *The Roman Near East 31 B.C.–A.D. 337*. Cambridge, MA.

———. 1998. "Dura-Europos under Parthian Rule." In J. Wiesehöfer, ed., *Das Partherreich und seine Zeugnisse / The Arsacid Empire: Sources and Documentation*, 473–92. Stuttgart.

Miller, J. M. 1988. "Some Versions of Pygmalion." In C. Martindale, ed., *Ovid Renewed* 205–14. Cambridge.

Millet, G. 1956. "Doura et el-Bagawat." *Cahiers Archéologiques* 8: 1–8.

Milnor, K. 2005. *Gender, Domesticity, and the Age of Augustus: Inventing Private Life.* Oxford.

Möllendorf, P. von. 2004. "Puzzling Beauty: Zur ästhetischen Konstruktion von *Paideia* in Lukians 'Bilder'-Dialogen." *Millennium* 1: 1–24.

Momigliano, A. 1971. "Popular Religious Beliefs and the Late Roman Historians." *Studies in Church History* 8: 1–18.

———. 1987. *On Pagans, Christians, and Jews*, 159–77. Middletown, CT.

Moon, W. G. 1995. "Nudity and Narrative: Observations on the Synagogue Paintings from Dura-Europos." In W. G. Moon, ed., *Polykleitos, the Doryphoros, and Tradition*, 283–316. Madison, WI.

Morales, H. 1996a. "The Torturer's Apprentice: Parrhasius and the Limits of Art." In Elsner (1996a), 182–209.

———. 1996b. "A Scopophiliac's Paradise: Vision and Narrative in Achilles Tatius' Leucippe and Clitophon." PhD. thesis, Cambridge University.

———. 1999. "Gender and Identity in Musaeus' *Hero and Leander*." In R. Miles, ed., *Constructing Identities in Late Antiquity*, 41–69. London.

———. 2004. *Vision and Narrative in Achilles Tatius'* Leucippe and Clitophon. Cambridge.

Morelli, G. 1883. *Italian Masters in German Galleries.* London.

Morey, C. R. 1942. *Early Christian Art.* Princeton, NJ.

———. 1959. *The Gold-Glass Collection of the Vatican Library with Additional Catalogues of Other Gold-Glass Collections.* Vatican City.

Morris, S. P. 1992. *Daidalos and the Origins of Greek Art.* Princeton, NJ.

Mortley, R. 1998. "The Face and the Image in Plotinus." *Journal of Neoplatonic Studies* 6: 3–21.

Most, G. 2001. "Memory and Forgetting in the *Aeneid*." *Vergilius* 47: 148–70.

Muller, C. 1841–70. *Fragmenta Historicorum Graecorum.* Paris.

Müller, F. 1994. *The So-Called Peleus and Thetis Sarcophagus in the Villa Albani: Iconological Studies in Roman Art I.* Amsterdam.

Mulvey, L. 1989. "Visual Pleasure and Narrative Cinema" (1975). In *Visual and Other Pleasures.* London.

Musti, D., and M. Torelli. 1991. *Pausania: Guida della Grecia. Book 3: La Laconia.* Milan.

Myerowitz, M. 1992. "The Domestication of Desire: Ovid's *Parva Tabella* and the Theater of Love." In A. Richlin, ed., *Pornography and Representation in Greece and Rome*, 131–57. Oxford.

Nagy, G. 1986. "Pindar's Olympian I and the Aetiology of the Olympic Games." *TAPhA* 116: 71–88.

Nead, L. 1992. *The Female Nude: Art, Obscenity, and Sexuality.* London.

Neer, R. 1997. "Beazley and the Language of Connoisseurship." *Hephaistos* 15: 7–30.

———. 2005. "Connoisseurship and the Stakes of Style." *Critical Inquiry* 32: 1–26.

Nelson, R. 2000a. "To Say and to See: Ekphrasis and Vision in Byzantium." In Nelson (2000b), 143–68.

Nelson, R., ed. 2000b. *Visuality before and beyond the Renaissance.* Cambridge.

Nelson, R., and R. Shiff, eds. 1996. *Critical Terms for Art History.* Chicago. Second ed., Chicago, 2003.

Nesselrath, H. G. 1990. "Lucian's Introductions." In D. A. Russell, ed., *Antonine Literature*, 111–40. Oxford.

Neusner, J. 1987. "Studying Judaism through the Art of the Synagogue." In D. Adams and D. Apostolos-Cappadona, eds., *Art as Religious Studies*, 29–57. New York.

Newby, Z. 2002a. "Reading Programs in Greco-Roman Art: Reflections on the Spada Reliefs." In Fredrick (2002), 110–48.

———. 2002b. "Testing the Boundaries of Ekphrasis: Lucian's *On the Hall.*" *Ramus* 31: 126–35.

———. 2003. "Art and Identity in Asia Minor." In Scott and Webster (2003), 192–213.

———. 2005. *Greek Athletics in the Roman World: Victory and Virtue.* Oxford.

Nightingale, A. W. 2004. *Spectacles of Truth in Classical Greek Philosophy.* Cambridge.

Nisbet, G. 2003. *Greek Epigram in the Roman Empire.* Oxford.

Nock, A. D. 1933. *Conversion.* Oxford.

Noga-Banai, G. 2004. "Workshops with Style: Minor Arts in the Making." *Byzantinische Zeitschrift* 97: 531–42.

Nolan, E. P. 1990. *Now through a Glass Darkly.* Ann Arbor, MI.

North, J. 1992. "The Development of Religious Pluralism." In J. Lieu, J. North, and T. Rajak, eds., *The Jews among Pagans and Christians in the Roman Empire*, 174–93. London.

———. 2000. *Roman Religion.* Greece and Rome: New Surveys in the Classics 30. Oxford.

Oakley, J. 1990. "Hylas." *LIMC* V, 574–79.

Ockman, C. 1995. *Ingres' Eroticized Bodies: Retracing the Serpentine Line.* New Haven, CT.

Oden, R. 1977. *Studies in Lucian's* De Syria Dea. Missoula, MT.

Oikonomides, N. 1972. *Les listes de préséance Byzantines des IXe et Xe siècles.* Paris.

O'Neill, K. 2000. "Propertius 4.2: Slumming with Vertumnus." *AJP* 121: 259–77.

———. 2005. "The Lover's Gaze and Cynthia's Glance." In Ancona and Greene (2005), 243–68.

Osborne, C. 1987. "The Repudiation of Representation in Plato's *Republic* and Its Repercussions." *Proceedings of the Cambridge Philological Society* 33: 53–73.

Osborne, R. 1994. "Looking on Greek Style: Does the Sculpted Girl Speak to Women Too?" In I. Morris, ed., *Classical Greece: Ancient Histories and Modern Archaeologies*, 81–96. Cambridge.

———. 1998. *Archaic and Classical Greek Art.* Oxford.

Oster, R. E. 1976. "The Ephesian Artemis as an Opponent of Early Christianity." *Jahrbuch für Antike und Christentum* 19: 24–44.

———. 1990. "Ephesus as a Religious Centre under the Principate." *ANRW* 2.18.3: 1662–1728.

Otis, B. 1970. *Ovid as an Epic Poet.* Cambridge.

Paglia, C. 1990. *Sexual Personae: Art and Decadence from Nefertiti to Emily Dickinson.* New Haven, CT.

Painter, K. 1988. "Roman Silver Hoards: Ownership and Status." In F. Baratte, ed., *Argenterie romaine et byzantine*, 97–111. Paris.

———. 1993. "Late Roman Silver: A Reply to Alan Cameron." *JRA* 6: 109–15.

Panayotakis, C. 1994a. "Quartilla's Histrionics in Petronius, *Satyrica* 16.1–26.6." *Mnemosyne* 47: 319–36.

———. 1994b. "A Sacred Ceremony in Honour of the Buttocks: Petronius, *Satyrica* 140.1–11." *CQ* 44: 458–67.

———. 1995. *Theatrum Arbitri: Theatrical Elements in the Satyrica of Petronius.* Leiden.

Panofsky, E. 1995. *Three Essays on Style.* Cambridge, MA.

Panoussi, V. 2003. "Ego Maenas: Maenadism, Marriage and the Construction of Female Identity in Catullus 63 and 64." *Helios* 30: 101–26.

Panzeri, M., and G. O. Bravi. 1987. *La figura e l'opera di Giovanni Morelli: Materiale de ricerca.* Bergamo.

Parise Badoni, F. 1990. "Arianna a Nasso: La rielaborazione di un mito Greco in ambiente Romano." *Dialoghi di Archeologia* 8: 73–89.

Parker, H. 1998. "Loyal Slaves and Loyal Wives." In S. R. Joshel and S. Murnaghan, eds., *Women and Slaves in Greco-Roman Culture,* 152–73. London.

Paschalis, M. 1986. "The Unifying Theme of Daedalus' Sculptures on the Temple of Apollo Cumaeus (*Aen.* 6.20–33)." *Vergilius* 32: 33–41.

———. 2002. "Reading Space: A Re-Examination of Apuleian *Ekphrasis.*" In Paschalis and Frangoulidis (2002), 132–42.

Paschalis, M., and S. Frangoulidis, eds. 2002. *Space in the Ancient Novel (Ancient Narrative,* suppl. 1). Groningen.

Paschoud, F. 1996. *Histoire Auguste V.1: Vies d'Aurélien et Tacite.* Paris.

Peden, R. 1985. "The Statues in Apuleius *Metamorphoses* 2.4." *Phoenix* 39: 380–84.

Pelagia, O., and J. J. Pollitt, eds. 1996. *Personal Styles in Greek Sculpture (Yale Classical Studies* 30). Cambridge.

Pelikan, J. 1990. *Imago Dei: The Byzantine Apologia for Icons.* New Haven, CT.

Pellizer, E. 1987. "Reflections, Echoes, and Amorous Reciprocity: On Reading the Narcissus Story." In J. Bremmer, ed., *Interpretations of Greek Mythology,* 107–20. London.

Penwill, J. 1975. "Slavish Pleasures and Profitless Curiosity: Fall and Redemption in Apuleius' *Metamorphoses.*" *Ramus* 4: 49–82.

Perkell, C. 1999a. "*Aeneid* 1: An Epic Programme." In Perkell (1999b), 29–49.

———, ed. 1999b. *Reading Virgil's* Aeneid: *An Interpetative Guide.* Norman, OK.

Perkins, A. 1973. *The Art of Dura-Europos.* Oxford.

Perkins, J. 1995. *The Suffering Self: Pain and Narrative Representation in the Early Christian Era.* London.

Pernice, E., and W. Gross. 1969. "Beschreibungen von Kunstwerken in der Literatur: Rhetorische Ekphrasis." In U. Hausmann, ed., *Allgemeine Grundlagen der Archäologie,* 433–47. Munich.

Perry, B. 1967. *The Ancient Romances.* Berkeley.

Peters, W., and E. Moormann. 1993. "Le decorazione parietali di IV stile." In W. Peters, ed., *La casa di Marcus Lucretius Fronto a Pompei e le sue pitture.* Amsterdam.

Petsalis-Diomidis, A. 2001. "Truly beyond Miracles: The Body and Healing Pilgrimage in the Eastern Roman Empire in the Second Century AD." Ph.D. thesis, Courtauld Institute, University of London.

———. 2002. "Narratives of Transformation: Pilgrimage Patterns and Authorial Self-Presentation in Three Pilgrimage Texts." *Journeys* 3: 84–109.

Philipp, H. 1986. *Mira et Magica.* Mainz am Rhein.

Philips, K. 1968. "Perseus and Andromeda." *AJA* 72: 1–20.

Pijoan, J. 1937. "The Parable of the Virgins at Dura-Europos." *Art Bulletin* 19: 592–95.

Pile, S., and M. Keith, eds. 1997. *Geographies of Resistance.* London.

Platt, V. 2002a. "Viewing, Desiring, Believing: Confronting the Divine in a Pompeian House." *Art History* 25: 87–112.

———. 2002b. "Evasive Epiphanies in Ekphrastic Epigram." *Ramus* 31: 33–50.

———. 2003. "Epiphany and Representation in Greco-Roman Culture: Art, Literature, Religion." D.Phil., Oxford University.

———. 2006. "Making an Impression: Replication and the Ontology of the Graeco-Roman Seal Stone." *Art History* 29: 235–59.

Plaza, M. 2000. *Laughter and Derision in Petronius' Satyrica.* Stockholm.

Pluhar, W., ed. and trans. 1987. *The Critique of Judgment,* by I. Kant. Indianapolis.

Podro, M. 1982. *The Critical Historians of Art.* New Haven, CT.

Poglayen-Neuwall, S. 1930. "Über die ursprünglichen Besitzer des spätantiken Silberfundes von Esquilin und seiner Datierung." *RM* 45: 124–36.

Pointon, M. 1990. *Naked Authority: The Body in Western Painting, 1830–1908.* Cambridge.

———. 1997. *Strategies for Showing: Women, Possession, and Representation in English Visual Culture, 1665–1800.* Oxford.

Polanski, T. 1998. *Oriental Art in Greek Imperial Literature.* Trier.

Pollard, N. 2000. *Soldiers, Cities, and Civilians in Roman Syria.* Ann Arbor, MI.

Pollini, J. 1999. "The Warren Cup: Homoerotic Love and Symposial Rhetoric in Silver." *Art Bulletin* 81: 21–52.

Pollitt, J. 1974. *The Ancient View of Greek Art.* New Haven, CT.

Portefaix, L. 1994. "The 'Hand-Made' Idol of Artemis Ephesia." In *Opus Mixtum,* 61–72. Stockholm.

Porter, J. 2001. "Ideals and Ruins: Pausanias, Longinus, and the Second Sophistic." In Alcock, Cherry and Elsner (2001), 63–92.

———. 2004. "Vergil's Voids." *Helios* 31: 127–56.

Potts, A. 1994. *Flesh and the Ideal: Winckelmann and the Origins of Art History.* New Haven, CT.

Praechter, C. 1885. *Cebetis Tabula quanam aetate conscripta esse videatur.* Marburg.

Prehn, W. 1997. "Der Spiegel des Narziss: Die Bedeutung sozialer Geschlechterrollen für die Narzißikonographie." In Corlàita (1997), 107–11.

Prezler, M. 2005. "Pausanias and Oral Tradition." *CQ* 55: 235–49.

Price, M., and B. Trell. 1977. *Coins and Their Cities.* London.

Price, S.R.F. 1984. *Rituals and Power: The Roman Imperial Cult in Asia Minor.* Cambridge.

Putnam, M. 1995. *Virgil's* Aeneid: *Interpretation and Influence.* Chapel Hill, NC.

———. 1998. *Virgil's Epic Designs: Ekphrasis in the* Aeneid. New Haven, CT.

———. 1999. "*Aeneid* 12: Unity in Closure." In Perkell (1999b), 210–30.

Quasten, J. 1947. "The Painting of the Good Shepherd at Dura-Europos." *Medieval Studies* 9: 1–18.

Rafn, B. 1992. "Narkissos." *LIMC* VI.1, 703–11.

Raoul-Rochette, M. 1867. *Choix de peintures de Pompeii: Lithographieés en couleur par M. Roux.* Paris.

Ravenna, G. 1974. "L'Ekphrasis poetica di opere d'arte: Temi e problemi." *Quaderni dell' Istituto Filologica Latina Padova* 3: 1–52.

———. 1985. "Ekphrasis." *Enciclopedia Virgiliana.* Vol. 2, 183–85. Rome.

Real Museo Borbonico. 1824–57. 16 vols. Naples.

Reardon, B. P. 1971. *Courants littéraires Grecs des IIe et IIIe siècles après J-C.* Paris.

———. 1989. *Collected Ancient Greek Novels.* Berkeley.

Reece, R. 1997. "The Myths and Messages of Silver Plate." *Antiquité Tardive* 5: 142–52.

Rees, A., and F. Borzello, eds. 1986. *The New Art History.* London.

Richardson, L. 2000. *A Catalog of Identifiable Figure Painters of Ancient Pompeii, Herculaneum, and Stabiae*. Baltimore.

Richardson, N. J. 1974. *The Homeric Hymn to Demeter*. Oxford.

Richter, D. 2001. "Plutarch on Isis and Osiris: Text, Cult, and Cultural Appreciation." *TAPhA* 131: 191–216.

Ridgway, B. S. 1970. *The Severe Style in Greek Sculpture*. Princeton, NJ.

Ridley, R. T. 1996. "The Finding of the Esquiline Treasure: An Unpublished Letter." *Antiquaries Journal* 76: 215–22.

Riegl, A. 1985. *Late Roman Art Industry*. Rome. First published 1901.

———. 1988. "Late Roman or Oriental?" In G. Schiff, ed., *German Essays on Art History*, 173–79. New York. First published as "Spätrömisch oder Orientalisch," in *Münchner Allgemeine Zeitung* 93–94 (1902).

Rimell, V. 2002. *Petronius and the Anatomy of Fiction*. Cambridge.

Rist, J. M. 1969. *Stoic Philosophy*. Cambridge.

Rives, J. 1995. *Religion and Authority in Roman Carthage from Augustus to Constantine*. Oxford.

———. 1999. "The Decree of Decius and the Religion of Empire." *JRS* 89: 135–54.

Rizzo, G. E. 1929. *La pittura Ellenistico-Romana*. Milan.

Robert, C. 1888. "Olympische Glossen." *Hermes* 23: 425–53.

Robertson, C. M. 1975. *A History of Greek Art*. Cambridge.

Roccos, L. J. 1994. "Perseus." *LIMC* VII.1, 332–48.

Rodenwaldt, G. 1940. "Römische Reliefs vorstufen zur Spätantike." *JdAI* 55: 12–43.

Rogers, G. M. 1991. *The Sacred Identity of Ephesus: Foundation Myths of a Roman City*. London.

Roll, I. 1977. "The Mysteries of Mithras in the Roman Orient: The Problem of Origins." *Journal of Mithraic Studies* 2: 18–62.

Rosati, G. 1976. "Narciso o L'Illusione Dissoluta." *Maia* 28: 83–108.

———. 1983. *Narciso e Pigmalione: Illusione e spettacolo nelle Metamorfosi di Ovidio*. Florence.

———. 1999. "Trimalchio on Stage." In S. Harrison, ed., *Oxford Readings in the Roman Novel*, 85–104. Oxford.

Rose, J. 1986. *Sexuality in the Field of Vision*. London.

———. 1988. "Sexuality and Vision: Some Questions." In H. Foster, ed., *Vision and Visuality*, 115–30. Seattle.

Rostovtzeff, M. I., ed. 1934a. *The Excavations at Dura-Europos: Preliminary Reports of the Fifth Season of Work*. New Haven, CT.

———. 1934b. "Das Mithraeum von Dura." *RM* 49: 180–207.

———. 1938. *Dura-Europos and Its Art*. Oxford.

Rostovtzeff, M. I., A. R. Bellinger, C. Hopkins, and C. B. Welles, eds. 1936. *The Excavation at Dura-Europos: Preliminary Report of the Sixth Season of Work*. New Haven, CT.

Rostovtseff, M. I., F. E Brown, and C. B. Welles, eds. 1939. *The Excavations at Dura-Europos: Preliminary Reports of the Seventh and Eighth Seasons of Work*. New Haven, CT.

Rouveret, A. 1987. "Toute le mémoire du monde: La notion de la collection dans la NH de Pline." In J. Pigeaud and J. Oroz, eds., *Pline l'Ancient: Témoins de son temps*, 431–39. Salamanca.

Roux, F. Le 1960. "Le dieu celtique aux liens." *Ogam* 12: 209–24.

Roux Ainé, H., and M. L. Barré. 1861–63. *Herculaneum et Pompei—receuil général des peintures, bronzes, mosaïques etc.* 8 vols. Paris.

Rudich, V. 1997. *Dissidence and Literature under Nero.* London.

Russo, J., ed. 1985. *Omero: Odissea.* Vol. 5 (Books 17–20). Verona.

Rutherford, I. 1995. "Theoric Crisis: The Dangers of Pilgrimage in Greek Religion and Society." *Studi e Materiali si Storia della Religioni* 61: 275–92.

———. 1999. "To the Land of Zeus: Patterns of Pilgrimage in Aelius Aristides." *Aevum Antiquum* 12: 133–48.

———. 2000. "*Theoria* and *Darshan*: Pilgrimage and Vision in Ancient Greece and India." *CQ* 50: 133–46.

———. 2001. "Tourism and the Sacred: Pausanias and the Traditions of Greek Pilgrimage." In Alcock, Cherry, and Elsner (2001), 40–52.

Rutschowscaya, M.-H. 1990. *Tissus Coptes.* Paris.

Scott Ryberg, I. 1955. *Rites of State Religion in Roman Art.* Rome.

St. Clair, A. 1986. "The Torah Shrine at Dura-Europos: A Re-evaluation." *JbAC* 29: 109–17.

Salomon, N. 1997. "Making a World of Difference: Gender, Asymetry, and the Greek Nude." In Koloski-Ostrow and Lyons (1997), 197–219.

Salzman, M. R. 1990. *On Roman Time: The Codex-Calendar of 354 and the Rhythms of Urban Life in Late Antiquity.* Berkeley.

Sanders, E. P., and B. F. Meyer, eds. 1980–82. *Jewish and Christian Self-Definition.* London.

Saradi-Mendelovici, H. 1990. "Christian Attitudes towards Pagan Monuments in Late Antiquity and Their Legacy in Later Byzantine Centuries." *Dumbarton Oaks Papers* 44: 47–61.

Sartre, J.-P. 1956. *Being and Nothingness.* New York.

Sauerländer, W. 1983. "From Stilus to Style: Reflections on the Fate of a Notion." *Art History* 6: 253–70.

Sauron, G. 1998. *La grande fresque de la villa des Mystères à Pompéi.* Paris.

Schapiro, M. 1994. *Theory and Philosophy of Art: Style, Artist, Society.* New York.

Scheer, T. 2000. *Die Gottheit und ihr Bild: Untersuchungen zur Funktion greichischer Kultbilder in Religion und Politik.* Munich.

Scherf, V. 1967. *Flügelwesen in römisch-kampanischen Wandbildern.* Hamburg.

Scherrer, P. 1995. "The City of Ephesos from the Roman Period to Late Antiquity." In Koester (1995), 1–26.

Schissel von Fleschenberg, O. 1913. "Die Technik des Bildeinsatzes." *Philologus* 72: 83–114.

Schlam, C. 1992. *The Metamorphoses of Apuleius: On Making an Ass of Oneself.* London.

Schmidt, E. "Venus" section VIII, *LIMC* VIII.1, 208–12.

Schmitz, T. 1997. *Bildung und Macht: Zur sozialen unde politischen Funktion der zweiten Sophistik in der greichischen Welt der Kaiserzeit.* Munich.

Schnapp, A. 1989. "Eros the Hunter." In C. Bérard et al., *A City of Images: Iconography and Society in Ancient Greece,* 71–88. Princeton, NJ.

———. 1997. *Le chasseur et la cité: Chasse et érotique dans la Grèce ancienne.* Paris.

Schneider, L. 1983. *Die Domäne als Weltbild: Wirkungsstrukturen der spätantiken Bildersprache.* Wiesbaden.

Schofield, M. 1978. "Aristotle on the Imagination." In G.E.R. Lloyd and G.E.L. Owen, eds., *Aristotle on Mind and Senses*, 99–140. Cambridge.

Schofield, M., M. Burnyeat, and J. Barnes, eds. 1980. *Doubt and Dogmatism*. Oxford.

Scholten, H. 1994. *Der Eunuch in Kaisernähe*. Frankfurt.

Schönberger, O. 1995. "Die 'Bilder' des Philostratos." In G. Boehm and H. Pfotenhauer, eds., *Beschreibungskunst-Kunstbeschreibung: Ekphrasis von der antiker bis zur Gegenwart*. 157–73. Munich.

Schrenk, S. 1995. *Typos und Antitypos in der frühchristlichen Kunst*. Munster.

Schubert, C. 1998. *Studien zum Nerobild in der lateinischen Dichtung der Antike* Stuttgart.

Schwartz, G. 1988. "Connoisseurship: The Penalty of Ahistoricism." *Artibus et Historiae* 18: 201–6.

Scott, J. 1985. *Weapons of the Weak: Everyday Forms of Peasant Resistance*. New Haven, CT.

———. 1990. *Domination and the Arts of Resistance*. New Haven, CT.

Scott, S. 2003. "Provincial Art and Roman Imperialism: An Overview." In Scott and Webster (2003), 1–7.

Scott, S., and J. Webster, eds. 2003. *Roman Imperialism and Provincial Art*, 24–52. Cambridge.

Segal, C. P. 1969. *Landscape in Ovid's* Metamorphoses, *Hermes Einzelschriften* 23, Wiesbaden.

———. 1972. "Orpheus and Augustan Ideology." *TAPhA* 103: 473–94.

———. 1994. "Philomela's Web and the Pleasures of the Text: Reader and Violence in the Metamorphoses of Ovid." In I. de Jong and J. P. Sullivan, eds., *Modern Critical Theory and Classical Literature*, 257–80. Leiden.

Seiterle, G. 1979. "Artemis—Die Große Göttin von Ephesos." *Antike Welt* 10.3: 3–16.

Seroux d'Agincourt, J. 1823. *L'histoire de l'art par les monuments depuis sa décadence au IV e siècle jusqu' à son renouvellement au XVIe*. 6 vols. Paris.

Settis, S. 1972. "Severo Alessandro e i suoi lari (*S.H.A., S.A.* 29.2–3)." *Athenaeum* 60: 237–51.

Sharrock, A. 1991a. "The Love of Creation." *Ramus* 20: 169–82.

———. 1991b. "Womanufacture." *JRS* 81: 36–49.

———. 1994. *Seduction and Repetition in Ovid's* Ars Amatoria II. Oxford.

———. 2000. "Constructing Characters in Propertius." *Arethusa* 33: 263–84.

Sharrock, A., and H. Morales, eds. 2000. *Intratextuality: Greek and Roman Textual Relations*. Oxford.

Shelton, K. J. 1981. *The Esquiline Treasure*. London.

———. 1985. "The Esquiline Treasure: The Nature of the Evidence." *AJA* 89: 147–55.

———. 1989. "Pagan Aristocrats, Christian Commissions: The Carrand Diptych." In F. M. Clover and R. S. Humphreys, eds., *Tradition and Innovation in Late Antiquity*, 105–27. Madison, WI.

Sherlock, D. 1976. "Silver and Silversmithing." In D. Strong and D. Brown, eds., *Roman Crafts*, 11–24. London.

Shumate, N. 1996. *Crisis and Conversion in Apuleius'* Metamorphoses. Ann Arbor, MI.

Sichtermann, H. 1988. "Ganymedes" *LIMC* IV, Zurich, 154–70.

Silverman, A. 1991. "Plato on *Phantasia*." *Classical Antiquity* 10: 123–47.

Silverman, K. 1996. *The Threshold of the Visible World*. New York.

Simon, E. 1982. "Vergil und die Bildkunst." *Maia* 34: 203–17.

Skinner, M. 2001. "Ladies' Day at the Art Institute: Theocritus, Herodas, and the Gendered Gaze." In A. Lardinois and L. McClure, eds., *Making Silence Speak: Women's Voices in Greek Literature and Society*, 201–22. Princeton, NJ.

Skinner, V. 1965. "Ovid's Narcissus—An Analysis." *Classical Bulletin* 41: 59–61.

Slater, N. 1987. " 'Against Interpretation': Petronius and Art Criticism." *Ramus* 16: 165–76.

———. 1990. *Reading Petronius*. Baltimore.

———. 1998. "Passion and Petrifaction: The Gaze in Apuleius." *Classical Philology* 93: 18–48.

———. 2003. "Spectator and Spectacle in Apuleius'." In S. Panayotakis, M. Zimmerman, and W. Keulen, eds., *The Ancient Novel and Beyond*, 85–100. Leiden.

Smith, R.R.R. 1991. *Hellenistic Sculpture*. London.

Snodgrass, A. 2001. "Pausanias and the Chest of Kypselos." In Alcock, Cherry, and Elsner (2001), 127–41.

Solodow, J. 1988. *The World of Ovid's* Metamorphoses. Chapel Hill, NC.

Sotiriou, G., and M. Sotiriou. 1956–58. *Icones du Mt Sinai*. 2 vols. Athens.

Spentzou, E. 2003. *Readers and Writers in Ovid's* Heroides. Oxford.

Spivey, N. 1995. "Bionic Statues." In A. Powell, ed., *The Greek World*, 442–59. London.

———. 1996. *Understanding Greek Sculpture: Ancient Meanings, Modern Readings*. London.

Steiner, D. 2001. *Images in Mind: Statues in Archaic and Classical Greek Literature and Thought*. Princeton, NJ.

Stemmer, K. 1992. *Casa dell' Ara Massima (VI.16.15–17)*. Haüser in Pompeji 6. Munich.

Stern, H. 1953. *Le calandrier de 354*. Paris.

Stevens, A. 2002. "Telling Presences: Narrating Divine Epiphany in Homer and Beyond." Ph.D. thesis, Cambridge University.

Stewart, A. 1977. *Skopas of Paros*. Park Ridge, NJ.

———. 1990. *Greek Sculpture*. New Haven, CT.

———. 1996. "Reflections." In Kampen (1996), 136–54.

———. 1997. *Art, Desire, and the Body in Ancient Greece*. Cambridge.

Stewart, C., and R. Shaw, eds. 1994. *Syncretism/Anti-syncretism: The Politics of Religious Synthesis*. London.

Stewart, P. 2003. *Statues in Roman Society: Representation and Response*. Oxford.

Stirling, L. 2004. *The Learned Collector: Mythological Statuettes and Classical Taste in Late Antique Gaul*. Ann Arbor, MI.

Stirrup, B. E. 1976. "Ovid's Narrative Technique: A Study in Duality." *Latomus* 35: 97–107.

Stoltenberg, J. 1992. "Pornography, Homophobia, and Male Supremacy." In C. Itzin, ed. *Pornography: Women, Violence, and Civil Liberties*, 145–65. Oxford.

Strong, D. E. 1966. *Greek and Roman Silver Plate*. London.

———. 1994. "Roman Museums." In D. A. Strong, *Roman Museums*, 13–30. Oxford. First published in 1973.

Strzygowski, J. 1901. *Orient oder Rom. Beiträge zur Geschichte der spätantiken und frühchristlichen Kunst*. Leipzig.

———. 1905. "Die Schicksale des Hellenismus in der Bildenden Kunst." *Neue Jahrbücher für das klassische Altertum, Geschichte und deutsche Literatur* 8: 19–33.

Stuart Jones, H. 1895. *Select Passages from Ancient Writers Illustrative of the History of Greek Sculpture*. London.

————. 1926. *A Catalogue of the Ancient Sculptures Preserved in the Municipal Collections of Rome: The Sculptures of the Palazzo dei Conservatori.* Oxford.

Sullivan, J. P. 1968. *The Satyricon of Petronius.* London.

Summers, D. 1989. " 'Form,' Nineteenth Century Metaphysics, and the Problem of Art Historical Description." *Critical Inquiry* 15: 372–406.

Swain, S. 1996. *Hellenism and Empire; Language, Classicism, and Power in the Greek World, AD 50–250.* Oxford.

————. 1999. "Defending Hellenism: Philostratus, *In Honour of Apollonius.*" In M. Edwards, M. Goodman, and S. Price, eds., *Apologetics in the Roman Empire,* 157–96. Oxford.

Swain, S., and M. Edwards, eds. 2004. *Approaching Late Antiquity.* Oxford.

Szidat, S. 2004. "Die 'Buckel' der Artemis Ephesia—zur Bedeutung des Motivs und zu seinen ikonographischen Vorläufern." *JdAI* 119: 83–129.

Taylor, C.C.W. 1980. "All Perceptions Are True." In Schofield, Burnyeat, and Barnes (1980), 105–24.

Texidor, J. 1979. *The Pantheon of Palmyra.* Leiden.

Theodorakopoulos, E. 2000. "Catullus 64: Footprints in the Labyrinth." In Sharrock and Morales (2000), 115–42.

Thiersch, H. 1935. *Artemis Ephesia: Eine Archäologische Untersuchung.* Berlin.

Thomas, C. M. 1995. "At Home in the City of Artemis." In Koester (1995), 81–117.

Thomas, E. 1994. "The Monumentality of Roman Architecture, AD 98–180." D.Phil. thesis. Oxford University.

Thomas, R. 1982. "Catullus and the Polemics of Poetic Reference: Poem 64.1–18." *AJP* 103: 144–64.

————. 1983. "Virgil's Ekphrastic Centrepieces." *HSCP* 87: 175–84.

Toner, J. 1995. *Leisure and Ancient Rome.* Cambridge.

Too, Y. L. 1996. "Statues, Mirrors, Gods: Controlling Images in Apuleius." In Elsner (1996a), 133–52.

Touchette, L.-A. 1995. *The Dancing Maenad Reliefs: Continuity and Conformity in Roman Copies,* BICS suppl. 62. London.

Tougher, S. 1997. "Byzantine Eunuchs." In L. James, ed., *Women, Men, and Eunuchs,* 168–84. London.

Tozzi, M. T. 1932. "Il Tesoro di Projecta." *Rivista di Archeologia Cristiana* 9: 279–314.

Trapp, M. 1997. "On the *Tablet* of Cebes." In R. Sorabji, ed., *Aristotle and After,* 159–78. London.

Trendelenburg, A. 1914. *Pausanias in Olympia.* Berlin.

Trimble, J. 2000. "Replicating the Body Politic: The Herculaneum Woman Statue Types in Early Imperial Italy." *JRA* 13: 41–68.

Turcan, R. 1981. "Le sacrifice mithriaque: innovations de sens et de modalités." In *Le sacrifice dans l' antiquité,* 341–80. Entretiens Hardt 27. Geneva.

————. 1982. "Salut mithriaque et sotériologie néoplatonicienne." In U. Bianchi and M. J. Vermaseren, eds., *La soteriologia dei culti orientali nell' Impero Romano,* 173–91. Leiden.

————. 1989. *Les cultes orientaux dans le monde Romain.* Paris.

————. 1996. *The Cults of the Roman Empire.* Oxford.

Turner, V., and E. Turner. 1978. *Image and Pilgrimage in Christian Culture.* Oxford.

Ulansey, D. 1988. *The Origins of the Mithraic Mysteries.* Oxford.

Valladares, H. 2005. "The Lover as Model Viewer: Gendered Dynamics in Propertius I.3." In Ancona and Greene (2005), 206–42.

Van Dam, R. 1993. *Saints and Their Miracles in Late Antique Gaul*. Princeton, NJ.

Van Dommelen, P. 1998. "Punic Persistence: Colonialism and Cultural Identities in Roman Sardinia." In Laurence and Berry (1998), 25–48.

Van Eck, C., J. McAllister, and R. Van de Vall, eds. 1995. *The Question of Style in Philosophy and the Arts*. Cambridge.

Vasari, Giorgio. 1550. *The Lives of the Artists*. Florence.

Verducci, F. 1985. *Ovid's Toyshop of the Heart*. Princeton, NJ.

Vermaseren, M. J., 1977–89. ed., *Corpus cultus Cybelae Attidisque*. Vols. 1–7. Leiden.

Verrall, M., and J. E. Harrison. 1890. *Mythology and Monuments of Ancient Athens*. London.

Veyne, P. 1963. "Cave Canem." *MEFRA* 75: 59–66.

———. 1988. *Did the Greeks Believe in Their Myths?* Chicago.

———. 1997. "La fresque dite des Mystères à Pompéi." In P. Veyne, F. Lissarague, and F. Frontisi-Ducroux, *Les mystères du gynécée*. Paris.

Viarre, S. 1968. "Pygmalion et Orphee chez Ovide." *REL* 46: 235–47.

Vigne, G. 1995. *Ingres*. New York.

Villard, L., and F. Villard. 1990. "Hyakinthos." *LIMC* V, 546–50.

Vinge, L. 1967. *The Narcissus Theme in West European Literature up to the Early Nineteenth Century*. Lund.

Visconti, E. Q. 1827. *Lettera di Ennio Quirino Visconti intorno ad una antica supelletile d' argento scoperta in Roma nell' anno 1793*. Rome.

von Blanckenhagen, P. H., and C. Alexander. 1990. *The Augustan Villa at Boscotrecase*. Mainz.

von Gonzenbach, V. 1961. *Die Römischen Mosaiken der Schweitz*. Basel.

Wace, A.J.B. 1910. "The Reliefs in the Palazzo Spada." *Papers of the British School at Rome* 5: 167–200.

Walker, A. 1992. "Erōs and the Eye in the *Love-letters* of Philostratus." *Proceedings of the Cambridge Philological Society* 38: 132–48.

Wallace-Hadrill, A. 1994. *Houses and Society in Pompeii and Herculaneum*. Princeton, NJ.

Walsh, G. 1984. *The Varieties of Enchantment*. Chapel Hill, NC.

Walsh, P. G. 1968. "Eumolpus, the *Halosis Troiae*, and the *De Bello Civili*." *CP* 63: 208–12.

———. 1970. *The Roman Novel*. Cambridge.

Watson, A. 1999. *Aurelian and the Third Century*. London.

Watson, G. 1988. *Phantasia in Classical Thought*. Galway.

Webb, R. 1992. "The Transmission of the Eikones of Philostratus and the Development of Ekphrasis from Late Antiquity to the Renaissance." Ph.D. thesis, London University.

———. 1997a. "Mémoire et imagination: Les limites de *l'enargeia* dans la théorie rhétorique grecque." In Lévy and Pernot (1997), 229–48.

———. 1997b. "Imagination and the Arousal of the Emotions in Greco-Roman Rhetoric." In S. Braund and C. Gill, eds., *The Passions in Roman Thought and Literature*, 112–27. Cambridge.

———. 1999. "*Ekphrasis* Ancient and Modern: The Invention of a Genre." *Word and Image* 15: 7–18.

———. 2001. "The *Progymnasmata* as Practice." In Y. L. Too, ed., *Education in Greek and Roman Antiquity*, 289–316. Leiden.

Webster, J. 1996. "Roman Imperialism and the 'Post-Imperial Age.'" In Webster and Cooper (1996), 1–18.

————. 1997a. "Necessary Comparisons: A Post-Colonial Approach to Religious Syncretism in the Roman Provinces." *World Archaeology* 28: 324–38.

————. 1997b. "A Negotiated Syncretism: Readings on the Development of Romano-Celtic Religion." In Mattingly (1997), 165–84.

————. 1999. "At the End of the World: Druidic and Other Revitalization Movements in Post-Conquest Gaul and Britain." *Britannia* 30: 1–20.

————. 2003. "Art as Resistance and Negotiation." In Scott and Webster (2003), 24–52.

Webster, J., and N. Cooper, eds. 1996. *Roman Imperialism: Post-Colonial Perspectives.* Leicester.

Weitzmann, K. 1976. *The Monastery of St Catherine at Mt Sinai: The Icons.* Vol. 1. Princeton, NJ.

Weitzmann, K., and H. Kessler. 1990. *The Frescoes of the Dura Synagogue and Christian Art.* Washington, DC.

Wernicke, K. 1895. "Artemis." *RE* 2.1: 1335–1440.

Wharton, A. J. 1995. *Refiguring the Post-Classical City.* Cambridge.

Wheeler, S. 1999. *A Discourse of Wonders: Audience and Performance in Ovid's* Metamorphoses, Philadelphia.

White, L. M. 1995. "Urban Development and Social Change in Imperial Ephesos." In Koester (1995), 27–80.

————. 1997. *The Social Origins of Christian Architecture.* Harvard Theological Studies 42. Valley Forge, PA.

Whitley, J. 1997. "Beazley as Theorist." *Antiquity* 71: 40–47.

Whitmarsh, T. 2001. *Greek Literature and the Roman Empire: The Politics of Imitation.* Oxford.

————. 2002. "Written on the Body: Ecphrasis, Perception and Deception in Heliodorus' *Aethiopica*." *Ramus* 31: 111–25.

————. 2005. *The Second Sophistic.* Greece and Rome New Surveys in the Classics no. 35. Oxford.

Whittaker, H. 1991. "Pausanias and His Use of Inscriptions." *SymOslo* 66: 171–86.

Wilkinson, J. 1971. *Egeria's Travels.* London.

Wilkinson, L. P. 1955. *Ovid Recalled.* Cambridge.

Will, E. 1983. "A propos du Coffret de Projecta." *Mosaique: Recueil d'hommages à Henri Stern*, 345–48. Paris.

Williams, R. 1960. "The Pictures on Dido's Temple." *CQ* 10: 145–51.

Williams, S., and G. Friell. 1994. *Theodosius: The Empire at Bay.* London.

Wind, E. 1985. *Art and Anarchy.* London.

Winkler, J. 1985. *Auctor and Actor: A Narratological Reading of Apuleius'* Golden Ass, Berkeley.

Wlosok, A. 1967. "Die dritte Cynthia-Elegie des Properz." *Hermes* 95: 330–52.

————. 1999. "On the Unity of Apuleius' *Metamorphoses*." In Harrison (1999), 142–56.

Wölfflin, H. 1950. *Principles of Style Art History: The Problem of the Development of Style in Later Art.* New York.

Wollheim, R. 1973. *On Art and Mind.* London.

Woolf, G. 1994. "Becoming Roman, Staying Greek: Culture, Identity, and the Civilizing Process in the Roman East." *Proceedings of the Cambridge Philological Society* 40: 116–43.

————. 1997. "Beyond Roman and Natives." *World Archaeology* 28: 339–50.

———. 1998. *Becoming Roman: The Origins of Provincial Civilization in Gaul.* Cambridge.

Wycherley, R. E. 1935. *Pausanias: Description of Greece.* Companion volume to the Loeb edition. vol. 5. Cambridge, MA.

Wyke, M. 1987a. "The Elegiac Woman at Rome." *PCPS* 33: 153–78.

———. 1987b. "Written Women: Propertius' *Scripta Puella.*" *JRS* 77: 47–61.

———. 1994. "The Woman in the Mirror: The Rhetoric of Adornment in the Roman World." In L. Archer, S. Fischler, and M. Wyke, eds., *Women in Ancient Societies,* 134–51. London.

———. 1995. "Taking the Woman's Part: Engendering Love Elegy." In A. J. Boyle, ed., *Roman Literature and Ideology: Ramus Essays for J. P. Sullivan,* 110–28. Bendigo.

———. 2002. *The Roman Mistress.* Oxford.

Zanker, G. 2004. *Modes of Viewing in Hellenistic Poetry and Art.* Madison, WI.

Zanker, P. 1966. " 'Iste ego sum.' Der naive und der bewuste Narziß." *Bonner Jarbücher* 166: 152–70.

———. 1994. "Nouvelles orientations de la recherché en iconographie: Commanditaires et spectateurs." *RA,* 281–91.

———. 1997. "In Search of the Roman Viewer." In D. Buitron-Oliver, ed., *The Interpretation of Architectural Sculpture in Greece and Rome,* 179–92. Studies in the History of Art, 49. Washington, DC.

———. 1998. *Pompeii: Public and Private Life.* Cambridge, MA.

Zeitlin, F. I. 1971a. "Petronius as Paradox: Anarchy and Artistic Integrity." *TAPhA* 102: 631–84.

———. 1971b. "Romanus Petronius." *Latomus* 30: 56–82.

———. 1982. *Under the Sign of the Shield: Semiotics and Aeschylus'* Seven Against Thebes. Rome.

———. 1990. "The Poetics of Eros: Nature, Art, and Imitation in Longus' Daphnis and Chloe." In D. M. Halperin, I. I. Winkler, and F. I. Zeitlin, eds., *Before Sexuality,* 417–65. Princeton, NJ.

———. 2001. "Visions and Revisions of Homer." In Goldhill (2001a), 195–268.

———. 2003. "Living Portraits and Sculpted Bodies in Chariton's Theater of Romance." In S. Panayotakis, M. Zimmerman, and W. Keulen, eds., *The Ancient Novel and Beyond,* 71–84. Leiden.

Zetzel, J. 1996. "Poetic Baldness and Its Cure." *MD* 36: 73–100.

Zimmerman, M. 2000. *Apuleius Madaurensis,* Metamorphoses *Book X.* Groningen.

Zimmerman-de Graaf, M. 1993. "Narrative Judgment and Reader Response in Apuleius' *Metamorphoses* 10.29–34: The Pantomime of the Judgment of Paris." *Groningen Colloquia on the Novel* 5: 143–61.

Zorach, R. 1999. "Despoiled at the Source." *Art History* 22: 244–69.

INDEX LOCORUM

INDEX LOCORUM

INDEX LOCORUM

9.39.5–14 35n30

9.41.1 55n19

10.18.5 42

10.32.6 41

10.32.13 42

10.38.6–7 54

Petronius

Satyrica

2.9 192

25–26 179n12

29.1 191

52.1 185n31

83.1 184, 189

83.1–2 183

83.2–3 184

83.7 188

83.7–9 198

83–84 178

83–90 181

84.1 190

85.1–3 190

85.1–87.10 190

85–86 189

88.1 181, 188, 191–192

88.2–6 193

88.6 192

88.10 194

88–89 188

89 194

89.1 185, 194

90.1 189, 194, 198

90.3 194

92–100 190n52

140 179n13

Philostratus

Imagines

1.proem.3 190n53

1 proem 4 189

1.1 135n9, 145n44

1.2 109n115, 145n44

1.3.1 91n88

1.4 135n9, 145n44

1.4 (4) 195n64

1.6 145n44

1.6 (5) 195n64

1.7 135n9

1.13.9 109n117

1.15 109

1.16.4 109, 109n117

1.20 109n115

1.21 109n117, 162, 162n84

1.22 109n115

1.23 109, 109n117, 143, 162

1.23.1 144n37, 147, 167

1.23.1–2 155n73

1.23.2 2n6, 147

1.23.2–3 144

1.23.3 144n41, 145, 165, 168

1.23.4 143n36, 146–147, 153, 170

1.23.5 146

1.28 (1) 195n64

1.28.1 2, 143n36

1.28.2 3n9

1.28.8 91n88

1.29 9, 109

1.29.2–4 9n22

1.30.4 91n88

2.4.4 91n88

2.7.5 91n88

2.11 109n115

2.12 135n9

2.22 109n115

2.31.2 91n88

Life of Apollonius

4.28 37

6.4 37

6.13 187n43

6.20 40n42

6.40 1n3

8.15 18, 19

8.31 226

Lives of the Sophists

2.18 1n3

1.1 (= 481 Kayser) 135n7

Philostratus the Younger

Imagines

proem 1–2 190n53

proem 4 46, 197

5 109n117

13 135n9

Pindar

First Olympian Ode

26–27 127

GENERAL INDEX

Acacesium, sanctuary of the Mistress, 289

Achilles Tatius, *Leucippe and Clitophon*, 5–7, 31, 185, 189, 234

Acropolis: Erechtheum, 36; statue of Athena, 53

Actaeon: and Diana, 291–93, 297; image at Orchomenos, 41

Adam and Eve, 269, 270 (fig. 10.9)

Aegeira, port of, 51–52

Aegeus, 72

Aelius Aristides, *Sacred Tales*, 18, 30–31, 299

Aeneas, 79–83, 85–86

Aeschylus, *Seven against Thebes*, 85

agalmatophilia, 1n3

age, of Narcissus, 154–55

agency, female, 129–30, 219n55

Ahl, F., 129n57

Alberti, Leon Battista, 132–33

altars, within Altis of Olympia, 13–17

amateur, Lucian as, 62

Amphissa, temple of Athena, 54–55

Andromeda and Perseus, 3–11, 172n101

Antioch, 162; House of Narcissus, 162–63, 163 (fig. 6.10)

antiquarianism, 247n56

Apelles (artist), 183, 293

Aphrodite, 172. *See also* Venus

Aphrodite of Cnidos, 25–26, 41, 115, 117–20, 293–94, 293n16, 294–95, 301; Roman version (Colonna Venus), 118 (fig. 5.2), 293

Apollo: at Aegeira, 51–52; at Amyclae, 247; and Daphne, 172; Ismenian (Thebes), 54; Syrian, 60–61, 249–50

Apollonius, *Argonautica*, 68

Apollonius of Tyana, 225–28

aporia, 186

Apuleius: *Florida*, 297–98; *Golden Ass*, 180, 290–302

Arafat, K., 57n24

archaism, 26

architecture of Roman house, 88, 158–62

archival information, and connoisseurship, 52–53

Argus, 74–75

Ariadne: and Bacchus, 73–75; and Dionysus, 88–89; in group depiction, 92–95, 93 (fig. 4.4), 94 (fig. 4.5), 95–96, 95 (fig. 4.6), 96 (fig. 4.7), 97 (fig. 4.8), 98–99, 98 (fig. 4.9), 99 (fig. 4.10); and Theseus, 68–73, 75–77, 80–81, 91–109, 92 (fig. 4.3), 93 (fig. 4.4), 94 (fig. 4.5), 95 (fig. 4.6), 96 (fig. 4.7), 97 (fig. 4.8), 98–99, 98 (fig. 4.9), 99 (fig. 4.10), 101, 101 (fig. 4.11), 102–3, pl. II

Aristocles of Cydonia, 56

ark of the covenant, 273

Arnobius, 120–21

art, and resistance, 253–55

art, Christian, 47–48. *See also* Dura Europos, Syria

art, Greek, Pausanias' chronology of, 54–58

art, religious, 29–30

art discourse: art-historical, 33–38, 46–47; ritual-centered, 33–38, 46–47. *See also* art history; style art history

Artemidorus of Daldis, *Oneirocritica*, 30, 246–47

Artemis, 153. *See also* Diana

Artemis Ephesia, 228–37, 230 (fig. 9.2), 231 (fig. 9.3), 236 (fig. 9.5), 242; copies of cult image, 235–37; gems, 238 (fig. 9.7); iconography, 245; statuettes, 239, 239 (fig. 9.8), 240 (fig. 9.9), 241 (fig. 9.10)

Artemisium (Ephesus), 228–35, 236 (fig. 9.4), 237 (fig. 9.6)

Artemis Orthia, sanctuary of (Sparta), 39–41

art expert, in Petronius' *Satyrica*, 188–96

art gallery, in Petronius' *Satyrica*, 182–96

art history, Petronius' satire of, 192–96. *See also* connoisseurship, ancient

artist, 113–15, 193–94; Narcissus as, 133; Pygmalion as, 121–22, 122n34. *See also names of artists*

arts of memory, 88

art work, as object of gaze, 80–81. *See also* viewing

Asclepius at Epidaurus, 247

Atargatis, 19–22

Athena, 31, 53, 247; at Amphissa, 54–55; in Ariadne group depiction, 99–100, 99 (fig. 4.10); Polias (Erythrae), 53–54

Attis, 243

attribution, artistic, noted by Pausanias, 51–54

Aurelian, Emperor, 225–28, 252

authenticity, of sacred image, 40

autoeroticism, in myth of Narcissus, 151–52

Bacchante, Ariadne as, 69, 77

Bacchus, 73–75

bas-relief: Narcissus (baths of villa, Stabiae), 165, 166 (fig. 6.13), 170

bathing, 220–24

Beazley, Sir John, 50

Belting, Hans, 51

Berenson, Bernard, 57–58

Berger, John, 117

Boscoreale, 89n83

Boscotrecase: wall painting of Perseus and Andromeda, 3–7, 4 (fig. 1.1), 89

Bouphonia ritual, 35n29

Breasted, James, 260

bronze casting, 54–56

Brown, Peter, 257

Browning, Robert, xi–xiv

Bryson, Norman, 24–25, 144n40

burning, in description of love, 71

Callistratus, 32, 133–35, 138–42, 141n26, 146–52, 189

Campanian wall painting, 88–109

Canachus, 54

Catullus, poem 64, 68–73, 78, 80–82, 88; emulators of, 73–77

Cebes, *Tabula*, 185–86, 189, 192

Celts, 59–60, 64–65

Chariton, 220–21

chastity, in myth of Narcissus, 153–55

children, Roman, 215–16

Christianity, 227–28, 243, 250, 252, 282–83, 286–87

christianization, resistance to, 286–87

chronology, Pausanias' interest in, 54–58

Cicero, M. Tullius, 186–87

civic culture, of Ephesus, 232

Clarke, J. R., 181n17

Claudian, 219–20

Claudius, Emperor, 236 (fig. 9.4)

Clearchus of Rhegium, 55

Clement of Alexandria, 120–21, 301

Clonus Eutychides, 85

Code of Justinian, 215

Codex Calendar (Romanus 1 ms, Barb. lat. 2154), 204, 206 (fig. 8.4)

coins, 236 (figs. 9.4 and 9.5), 237–39, 237 (fig. 9.6)

colonialism, Roman, 254

Comaroff, John and Jean, 284

competition, of image with prototype, 140–41

connoisseurship, ancient, 49–51, 65–66

Constantine, Emperor, 252

Constantinople: Hodegetria icon of Virgin and child, 47–48

Corbridge lanx, 205

cult images, 11–13, 25–26, 32, 247–51; danger of, 39–42. *See also names of images;* statue

cult implements, Jewish, 271–73

cultural resistance, 255–59, 281–83

culture, in Petronius' *Satyrica*, 196–99

Cumont, Franz, 243n51

Cybele, 243, 244 (fig. 9.12)

Cyparissus, 163

Daedalus, 26, 82–83, 109

Dalí, Salvador, 132–33, 170

damnatio memoriae, 44

Daphnis and Chloe, 185

David and Goliath, 270

decadence, and satire, 177–81, 192–99

deception: and decadence, 196–99; and naturalism, 125–28, 191–92, 198. *See also* self-deception

"deductio sponsae," represented on Project casket, 210

deity: intervention of, 234; powers of, 21, 39–42; presence of, 16–17, 44–45; viewed by human, 290–302; worship of, 38–39. *See also* cult images; *names of gods and goddesses;* ritual

Delphi, offering of the Orneatai, 42–43

Demeter, Mycalessian, 41

desire: in myth of Narcissus, 133–34, 139, 141, 146; of Pygmalion for statue, 123–25, 128–29

Diana and Actaeon, 291–93, 297. *See also* Artemis

Dio Chrysostom, 234–35

Dionysus and Ariadne, 88–89, 101n105, 104–7, 105 (fig. 4.14), 106 (fig. 4.15), 107 (fig. 4.16), 108 (fig. 4.17), 212n34, pl. III

discourses, contradictory, on Projecta casket, 220–24. *See also* art discourse

display object, adorned woman as, 215–17

Donacon, spring of Narcissus, 150

double portrait, 204

Dover, K. J., 147n50

dreams, and images, 30, 42

dress, female, 218–20

Du Mesnil du Buisson, Robert, 276–77

Dura Europos, Syria, 259–81; Christian house-church, 268–71, 269 (fig. 10.8), 270 (fig. 10.9), 282–83; mithraeum, 266–68, 267 (fig. 10.7); pagan temples, 259–66, 281–82; synagogue, 271–81, 272 (fig. 10.10), 273 (fig. 10.11), 274 (fig. 10.12), 275 (fig. 10.13)–275 (fig. 10.14), 276 (fig. 10.15), 277 (fig. 10.16), 278 (fig. 10.17), 279 (fig. 10.18), 280 (fig. 10.19), 283, pl. X, pl. XI, pl. XII; temple of Adonis, 263; temple of Aphlad, 264, 265 (fig. 10.6); temple of Atargatis, 19, 20 (fig. 1.5); temple of Azzanthkova, 263; temple of Bel, 260–63, 260 (fig. 10.1), 261–62, 261 (fig. 10.2), 262–63, 262 (fig. 10.3), 263 (fig. 10.4), pl. IX; temple of the Gaddé, 263–64, 264 (fig. 10.5); temple of Zeus Theos, 263

East, Roman, 225–28; and visual self-assertion, 251–52. *See also* Dura Europos, Syria; mystery religions; religions, eastern; romanization, resistance to

Echo and Narcissus, 153, 170–74, 172n101, 173 (fig. 6.16), 174 (fig. 6.17), 175, pl. VI

Egeria, *Peregrinatio Egeriae*, 48

ekphrasis, 7, 67–68; in Byzantine context, 47n64; in Catullus 64, 68–73, 82; and decadence, 192–96; in *Golden Ass*, 291–93; of painting, 31–32; in Petronius' *Satyrica*, 182–96; in Philostratus and Callistratus, 135, 138–46, 149–50; in Virgil's *Aeneid*, 78–87

Elagabal, cult of, 252

Elagabalus, Emperor, 252, 254

Elijah, story of, 278

Eliot, T. S., 132

eloquence, art of, 59–60, 64–65

Endoeus, 53

Endymion, 163

Ephesus, Artemisium, 228–35, 236 (fig. 9.4), 237 (fig. 9.6)

Epidaurus, 247

epiphany, in *Golden Ass*, 290–302

Erechtheum (Acropolis), 36

Eros, 32; and Ariadne, 92–95, 93 (fig. 4.4), 94 (fig. 4.5), 95 (fig. 4.6), 96 (fig. 4.7); and Narcissus, 153, 155, 157 (fig. 6.4), 165, 166 (fig. 6.13), 172; and Perseus, 10

eroticism, in myth of Narcissus, 153–55. *See also* autoeroticism; desire; homoeroticism; sexuality

Erythrae, temple of Athena Polias, 53–54

ethnicity, Lucian and, 58–62

eunuchs, 213–14, 214n38

expert empiricism, role in connoisseurship, 54, 188–96

"eye," role in connoisseurship, 52–53

Faraone, C. A., 43n56

female object, 73–75, 215–17

feminization, of Narcissus, 147–48

festivals, 18–19

financial center, temple as, 235

Fitzgerald, William, 69

floor mosaics: lady at her toilette (from private bath at Sidi Ghrib, Tunis), 212, 213 (fig. 8.11), pl. VIII; Mosaic of the Planetary Deities (Orbe, Switzerland), 163, 164 (fig. 6.11); Narcissus (House of Narcissus, Antioch), 162–63, 163 (fig. 6.10)

Fränkel, Hermann, 128

Freedberg, David, 114n15, 117

frescoes. *See* wall paintings

frontality, 22, 22n58

Ganymede, 163

gaze, 67–68; aggressive, 136; alienating, 147n52; in Browning, xi–xiv; in Catullus 64, 68–73, 70n17; in ekphrasis, 68–87; female, 68–73, 75–77, 170, 200, 217–20; focused on work of art, 80–81; in *Golden Ass*, 300; Greco-Roman, xiv–xv; in images of Narcissus, 167–74; male, 73–75; of Narcissus, 147–48; in Ovid's *Heroides*, 75–77; paranoiac, 166–67; in Propertius 1.3, 73–75; reciprocal, 23–24; of statue, 21; unfulfilled, 68–73; in Virgil's *Aeneid*, 78–87

gazes, interplay of, 88–91, 96–98, 171–72

Geertz, Clifford, 253

gem, of Artemis Ephesia, 238 (fig. 9.7), 239–41

genre, in myth of Narcissus, 152

Gombrich, Ernst, 1n1, 22n59, 48n69, 66n48, 117, 122

Good Shepherd, 269, 270 (fig. 10.9)

Gordon, R., 284n88

medallion of Apollonius of Tyana, 226, 227 (fig. 9.1)

megalographic friezes, 89

Meleager plate (Sevso treasure), 205

memory, role in connoisseurship, 52–53

metamorphoses, in Pygmalion story, 128–30

Micon and Pero, 155, 156 (fig. 6.3)

mimesis, 42–45. *See also* naturalism

miracles: Christian, 269; Jewish, 273–76; pagan, 39–42

Mistress, sanctuary of (Acacesium), 289

mithraeum, 243, 244 (fig. 9.11)

mithraism, 243n51, 266–68, 282–83; tauroctony, 243, 244 (fig. 9.11), 267, 267 (fig. 10.7)

Mithras, iconography of, 243, 244 (fig. 9.11), 245

Momigliano, Arnaldo, 257, 257n37

Monastery of Saint Catherine (Sinai): icon of Saint Peter, 62–64, 63 (fig. 3.1), pl. I

Moon, Warren, 277

Morelli, Giovanni, 52–53

mosaics. *See* floor mosaics

Moses, 271, 276 (fig. 10.15)

Muse casket, 202n11, 205

Myron, 193

mystery religions, spread of, 242–46, 250–51, 282–83, 285

Narcissism, 175–76

Narcissus, 2–3, 130, 132–46; rationalization of myth, 146–52

Narcissus, depictions of, 152–76, 164 (fig. 6.11); alone, 133–34, 134 (fig. 6.1), 155–60, 159 (fig. 6.6), 160–62, 161 (fig. 6.8), 162–63, 163 (fig. 6.10), 165–66, 165 (fig. 6.12), 168–70, pl. IV; with Echo, 153, 167–68, 169 (fig. 6.14), 170–74, 171 (fig. 6.15), 172, 172n101, 173 (fig. 6.16), 174 (fig. 6.17), 175, pl. VI; with Eros, 153, 154 (fig. 6.2), 155, 157 (fig. 6.4), 158 (fig. 6.5), 165, 166 (fig. 6.13), 167–68, 169 (fig. 6.14), 170–71, 171 (fig. 6.15), 172; reflective, 153–55

narrator, in Virgil's *Aeneid*, 78–79

naturalism, 1–2, 115–21, 183–85; and deception, 125–28, 191–92, 198; and desire, 123–25, 128–29, 133–34, 137, 139, 141–46; and reality, 117; and visuality, 2–11, 22, 24–26. *See also* Narcissus; Pygmalion

nature, transgressed by art, 127–28

Nelson, Robert S., 50

neokoros, 242n46

nude, female, 218–20; Aphrodite of Cnidos as,

293n16; invention of, 56–57; as object of desire, 117–21; Venus as, 172

objectification: in myth of Narcissus, 136, 147–48; of woman as product, 215–17

ocular culture, Roman, 175

Odysseus, 55

offering, art work as, 42–43

Ogmios (Celtic Heracles), 59–60, 64–65

Olympia, 14, 14 (fig. 1.4), 16; altars in Altis, 13–17

onlookers, in Ariadne group depiction, 98–100. *See also* supernumerary figures

Orbe, Switzerland, 163; Mosaic of the Planetary Deities, 163, 164 (fig. 6.11)

Orchomenos, image of Actaeon, 41

Orneatai, offering at Delphi, 42–43

Orpheus, 113, 122

Ovid (P. Ovidius Naso), 2; *Heroides*, 75–77, 219n55; *Metamorphoses*, 87, 113–15, 121–31, 133, 138, 145n45, 149, 154, 169–70

paganism, 284

Paidize (Sicyon), 38–39

Pallas, baldric of, in Virgil's *Aeneid*, 85–86

panel paintings, 89–91

Paphos, 162

Parabiago plate, 205

Pasiphaë, 109

pastoral setting, for Narcissus images, 155, 160, 168

Pausanias: as connoisseur, 51–54; project of, 57; rhetoric of, 65–66; and ritual, 234n26; and ritual-centered visuality, 12–17, 26, 32–42, 45–48, 229, 289; and story of Narcissus, 150–52

Pausanias, *Description of Greece:* and chronology of Greek art, 54–58; as pilgrimage text, 246–51

Peleus and Thetis, 68–73

Pelops, 127

Perkell, C., 86n73

Pero and Micon, 155, 156 (fig. 6.3)

Perseus and Andromeda, 3–11, 172n101

Peter, Saint, icon of, 62–64, 63 (fig. 3.1), pl. I

Petronius, *Satyrica*, 179–99; *Cena Trimalchionis*, 179–80; figure of Encolpius, 182–88; figure of Eumolpus, 188–96; *Troiae Halosis*, 194–99

phantasia, 186–88, 187n42, 188n44, 195

Phidias, 247

philosopher, in Petronius' *Satyrica*, 188–96

Philostephanus, 129; *Cypriaca*, 120

Riegl, Alois, 64
Rimell, V., 194n62
ritual, 11–22; of Artemis Ephesia, 229–33; described by Pausanias, 34–36; as focus of art discourse, 33–38, 46–47; image and, 38–42; image as, 42–45; personal aspects, 18; setting for, 13–19; use of images in, 32; and vision of deity, 22–24
ritual-centered visuality, 16, 22–26
Robertson, Martin, 1n2, 115
Rodin, Auguste, 115–17
romanization, resistance to, 228, 242–46, 243n50, 247–51, 253–59, 281–86
Rome, Farnesina villa, 89
rules, in Greek religious practice, 234

sacred, and visuality, 22–26
sacred space, 24
sacrifice, 268, 282; in Dura Europos images, 260–66, 260 (fig. 10.1), 261 (fig. 10.2), 262 (fig. 10.3), 263 (fig. 10.4), 264 (fig. 10.5), 265 (fig. 10.6), pl. IX; Jewish, 281
sacrifice of Isaac, 274 (fig. 10.12), 279–80, 280 (fig. 10.19)
saints, Christian, 226; Peter, 62–64; Stylite, 48
Samaritan woman at well, 270
sarcophagi, fourth-century, 204, 211
sarcophagus of Adelphia, 243, 245 (fig. 9.13)
satire, Roman, 177–78; and decadence, 177–81, 192–99; and ekphrasis, 182–88
Scopas, 38, 135n9
Scott, James, 283, 285
Second Sophistic, xvi n11, 30, 33, 37, 46–47, 135, 135n7, 227
self-consciousness, Narcissus and, 144n42
self-deception, Narcissus and, 136–37, 149
self-definition, 284–87; and cultural resistance, 258–59; silent resistance as, 253–55
Seneca, 194
Seneca the Younger, *Natural Questions*, 178–79
Septimius Severus, Emperor, 237 (fig. 9.6)
Serapis, 245
Seroux d'Agincourt, J., 202
Sevso casket, 202n11, 221–24, 222 (fig. 8.13), 223 (fig. 8.14)
sexuality, xv–xvi, 136; female, 218–20. *See also* autoeroticism; desire; homoeroticism
Shelton, Kathleen, 201–2
shields, Virgil's descriptions of, 83–85
Shiff, Richard, 50
Sicyon, Paidize, 38–39
silverware, 200–214
Skoptic epigram, xiv n7

Sémeion, 249
Sol Invictus, cult of, 252
sophisma, 43n56
Spada reliefs, 9
Sparta, sanctuary of Artemis Orthia, 39–41
Stabiae, baths of villa, 165, 166 (fig. 6.13), 170
statue: of deity, 11–12, 30, 39–48 (*See also* cult images); female, as object of desire, 113–15, 117–20, 123–25, 128–29 (*See also* Pygmalion); living person as, 297–98
statuette, of Artemis Ephesia, 239–41, 239 (fig. 9.8), 240 (fig. 9.9), 241 (fig. 9.10)
Stoic philosophy, 186–88, 192
Strzygowski, Josef, 64
style art history, 49–51; Pausanias and, 51–58; and rhetoric, 64–66
subjectivism, in Petronius' *Satyrica*, 184–88
subjectivities, multiple, and cultural resistance, 258
subjectivity, xvi, xvii; female, 215–20; in myth of Narcissus, 146–52
supernumerary figures, 175
supernumerary figures, in wall paintings, 89–91
syncretism, 249, 251–52

tapestry, of Dionysus and Ariadne, 212n34
Tate Gallery, 133
tauroctony, 243, 244 (fig. 9.11), 267, 267 (fig. 10.7)
temple of Aaron, 271, 275 (fig. 10.13)
temple of Dagon, 273, 276, 277 (fig. 10.16), pl. XI
temple of Solomon, 271, 275 (fig. 10.14)
temporal progression, in Campanian wall painting, 103
Theagenes of Thasos, 44–45
theater, Roman, 158–60, 175, 177n5
Thebes, temple of Ismenian Apollo, 54
Theodorus, 54–55
theology, Christian, 39, 47
theoria, 24
Theseus, 75–76; return of, 72; triumphant, 90–91, 91 (fig. 4.2). *See also* Ariadne
Thetis and Peleus, 68–73
Thisbe and Pyramus, 160
topography, sacred, 14–17, 229
Trajan, Emperor, 232
triangulation of viewing, in images of Narcissus, 168–70
Trojan War: frescoes described in Virgil's *Aeneid*, 79–82; in Petronius' *Satyrica*, 194–99
truth-value, in connoisseurship, 65–66
Turnus, 84, 86
Tyana, shrine of Apollonius, 226